W9-BEN-393

MINNESOTA

American Historical Press
Sun Valley, California

MINNESOTA

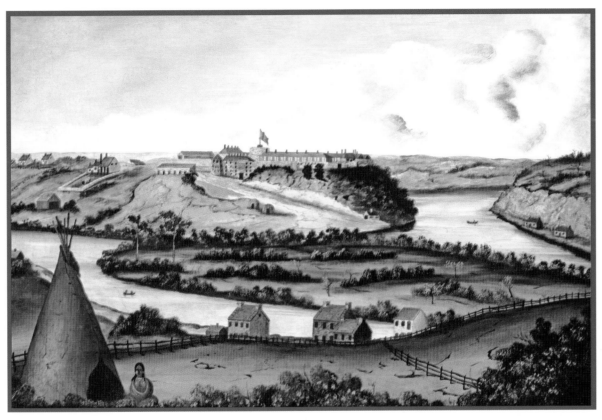

SHAPED BY THE LAND

Deborah Gelbach

DEBORAH GELBACH

Prior page and dust jacket: Fort Snelling *by Edward K. Thomas (1817-1906) was painted circa 1850. It was the growing country's outpost in the 1820s when it was built but today is a tourist must-see. A fort at the junction of the Mississippi and Minnesota Rivers, it has been lovingly rebuilt so that the more than 850,000 visitors can discover for themselves what life must have been like in the wilderness. In 1960, Fort Snelling was listed as a National Historic Landmark. Courtesy, Minnesota Historical Society*

Photos attributed to Ottertail County Historical Society, courtesy Otter Tail County Historical Society. Photos attributed to C.A. Weyerhaeuser Museum, courtesy Morrison County Historical Society. Photos attributed to Northeast Minnesota Historical Center, courtesy Northeast Minnesota Historical Center, Duluth, Minnesota. Photos attributed to Medtronics, Inc., courtesy Medtronic, Inc. Pages 170, 171, and 195, photographer: Louis P. Gallagher. Page 95, photographer: George A. Newton.

Bibliography: page 320
Includes Index

CONTENTS

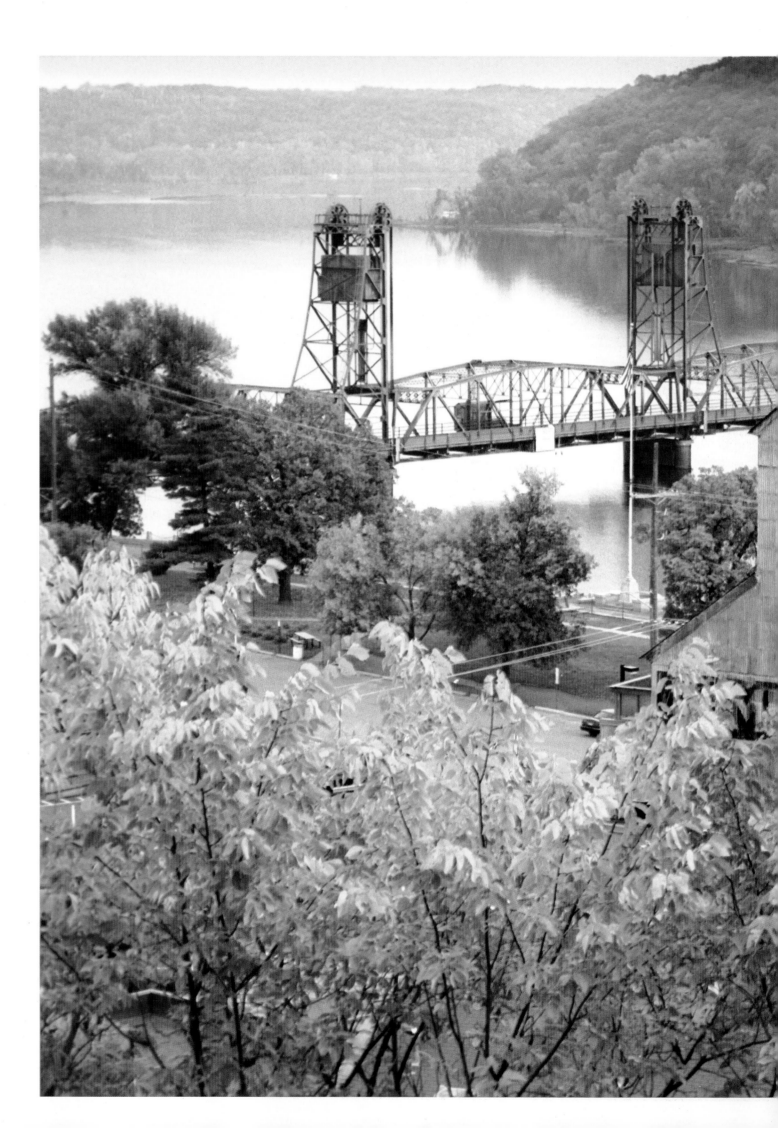

The St. Croix River with its mate, Wisconsin's Namekagon, travel 252 miles south from the Chequamegon National Forest to a point near Hastings where it joins the Mississippi. Once admired by the logging industry for the volume of lumber it could carry out of northern forests, the St. Croix is now beloved by recreational boaters and others who want to immerse themselves in nature. Many historic towns, such as Stillwater, add to the river's enchantment. Shown is the Stillwater Lift Bridge, which is raised every hour so that boats can pass. Courtesy, Debra Chial

Minnesota has an official muffin?

Yes, Minnesota has a state song, "Hail Minnesota" that was adopted by the legislature in 1945. We have a state seal, flag, and flower, the pink and white lady's slipper. Our state tree is the Norway pine and bird, the loon. But there's more. The state fish, walleye, was adopted in 1965 and our gemstone, the Lake Superior agate, became official in 1969. Minnesota even has a state grain, wild rice, adopted in 1977 and a state mushroom, the morel, which joined the state's ranks in 1984. Milk, the state beverage, celebrates the state's leadership in the dairy industry.

We don't know how many other states have an official muffin, but ours is the blueberry muffin. It's a credit to the work of the University of Minnesota Agricultural Experiment Station, which has introduced at least six new blueberry types hardy enough to withstand our winters.

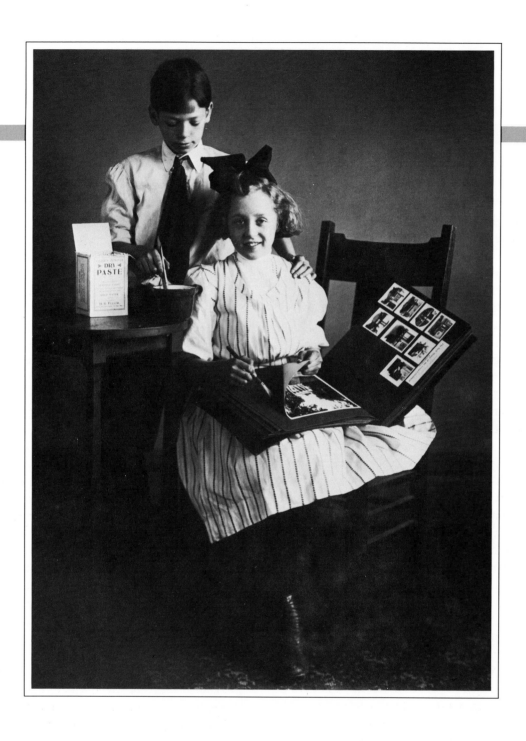

Public interest in photography boosted small St. Paul industry. The H.B. Fuller Co. found a market for its dry paste among people who wanted to preserve evidence of their lives in photograph albums. Courtesy, Minnesota Historical Society

INTRODUCTION

It's fitting that the first explorers of the land that would become Minnesota came out of a European culture that was taking huge forward leaps. Innovative thinkers such as Galileo Galilei, Johannes Kepler, Sir Isaac Newton, and Rene Descartes to name a few, introduced ideas that were transforming the way people lived, worked, and thought about their world. The scientific revolution that occurred in seventeenth century Europe focused on thinking, discovery, and getting a better picture about the size of the world.

Here in the twenty-first century, Minnesota is in the middle of another colossal cultural changeover. In a major burst of speed, the world just left behind a century of breakthroughs—from the invention of the wireless radio signal to the development of the World Wide Web. Today we are all getting used to newly-minted words and concepts such as biotechnology, bioinformatics, nanotechnology, converged technologies, genetic engineering, quantum optics, and electromagnetism.

Mapped during the seventeenth century's scientific revolution, ripened during the industrial revolution, and matured during the technology and scientific successes of the twentieth century, today Minnesota is known worldwide for a culture that indefatigably inspires new ideas. Celebrating that culture is what *Shaped By The Land* is about.

The will and the talent to continually innovate in exceptional ways is the platform upon which the coming "Knowledge Economy" rests. It is a future where the foundations of economic growth and change are no longer labor and capital, but technology and the knowledge on which it is based.

As I researched and wrote this book, it became clear to me that three assets put Minnesota in a highly competitive position. First is the infectious pioneering spirit of the place. Minnesota attracts creative, forward thinking people—perhaps because innovative people already live here or because the state is known for breakthrough ideas. Whatever the reason, Minnesota has the potential to be a Mecca for thinkers and discoverers. The second asset is the skilled workforce, one that is capable of supporting and producing the technologies that are created. The third advantage, but by no means less important than the others, is Minnesota's environment and its concern for the state's land, air, soil, and water.

Many public policy leaders value the connection between Minnesota's economic potential and the volume and quality of its natural resources. People who work hard in their professional lives have tremendous opportunities to rest, relax, or play in the state's woods, prairies, lakes, and rivers. That's why the state's economy is bolstered by nearly $9 billion each year in tourism and recreational dollars.

Just as our seventeenth century forebears couldn't comprehend the progress that lay ahead in the coming centuries, Minnesota residents know that the future holds changes that they can't possibly predict. However, I believe with its history, resources, and innovative spirit, the state will undoubtedly play a valuable role in the future—an exceptional one at that.

Deborah Gelbach

No tree is more reminiscent of the North Woods than the elegant, supple white birch, delight of painters, canoe makers, and boys. Spring light graces these examples along the Big Fork River. Photo by Matt Bradley

CLAIMING AN ABUNDANT LAND

Fourteen years after the Pilgrims reached the coast of America, a Frenchman named Jean Nicolet stepped out of a birch-bark canoe near the site of modern-day Green Bay, Wisconsin. Wearing a silk damask robe embroidered with oriental bird-and-flower patterns, Nicolet believed he was correctly dressed to officially open the trade route from New France, on the St. Lawrence River, to China. With an eye toward the meaning of the moment, he raised his pistol and fired two shots into the air.

On the shore a delegation of Winnebago chieftains observed Nicolet and quietly agreed that they were being visited by a white god. As it turned out, the Winnebago lands were not in China, and Nicolet's ceremonial dress was premature. On the other hand, the country was thick with fur-bearing beaver and muskrat, which the Winnebagos were happy to share with the god from the sea.

It was 1634. The British crown had already imposed the first in a long series of taxes on the New England colonists, and the trouble that would lead to the American Revolution almost 150 years later had begun to brew. But to the north, in the colonies of New France near present-day Montreal, a tiny band of French explorers and missionaries itched to find trade routes to China in the name of their country and their king. They longed for furs to send home and people to convert to Christianity. Since the early 1600s when adventurers first began to explore the lands along the St. Lawrence and Ottawa rivers, there were rumors that just beyond the horizon lay an enormous body of salt water. On the other side, so it was believed, were all the luxuries of the land of Cathay.

Nicolet (pronounced Nic-o-lay) had been selected by New France's founder, the visionary Samuel de Champlain, to find the passage to Cathay. Nicolet believed that France was on the verge of a lucrative trade breakthrough and he wanted to be the man to make it happen. With Huron Indians as guides and emissaries, and canoes filled with trinkets to trade, he followed the rumor west.

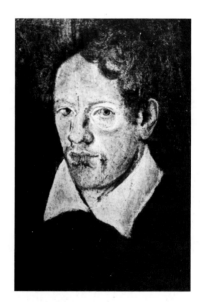

Despite years of service to New France, Daniel Greysolon, Sieur Duluth, never realized his lifelong dream of finding a passage through the wilderness to the Pacific. Courtesy, Northeast Minnesota Historical Center

Although Nicolet was not successful in finding the Orient, he was one of the first French explorers to map the Straits of Mackinac and the northern coast of Lake Michigan. More important to Minnesota history, however, were the enthusiastic stories he carried back to Quebec. His tales enticed other explorers to search for the passageway to China and, along the way, establish working relations with Indians who could supply them with beaver and muskrat pelts.

But in the discovery business, time and patience are key ingredients to success. The headwaters of the Mississippi River were still undiscovered in 1655, and the largest Great Lake—Lake Superior—was, for the most part, uncharted. The land that would become Minnesota was just beyond the horizon for the French explorers.

In 1655 a pair of brash young explorers—Pierre Esprit Radisson and his brother-in-law Médard Chouart, Sieur de Groseilliers—set out to push farther than any previous French explorer had gone. Some historians think the two men reached the south shore of Lake Superior and pushed inland, possibly even reaching Prairie Island on the Mississippi River where Hastings is today.

Leaving his brother-in-law to raise corn for their return trip, Radisson spent another four months traveling and establishing trading relations with the Sioux, or the "nation of the beefe" (buffalo hunters) as he called them. Greatly impressed with the fertility and beauty of the country and astonished by the herds of buffalo and antelope, flocks of pelicans, and the abundance of sturgeon and other fish, Radisson believed that the land west and south of Lake Superior was a land of great opportunity for New France, even if it didn't lead to the mythical Cathay.

When Radisson and Groseilliers returned to Quebec, their canoes overflowed with beaver skins (called "castors" by the early French voyageurs). They carried reports of newly discovered Indian tribes and rich western lands for the French to claim as their own. But politics cut short their heady excitement. The two men had not been properly licensed as French explorers, and their furs were taken away from them. Feeling betrayed by their own country, Radisson and Groseilliers worked their way to England, where they eventually chartered the Hudson's Bay Company—the fur-trading company that would eventually become so powerful that it would leave its mark on two centuries of economic growth in the Americas.

By 1660 New France's trade tentacles reached out in an enormous triangle from Hudson Bay to the watershed between the Mississippi River and Lake Superior, and east to Quebec. As French voyageurs fanned out across the country, their canoes loaded with trade goods, the French Royal government's interest in the new continent was rekindled. Money and management talent were pumped into fur trading, map charting, and exploration. Hardy Jesuit priests accompanied the explorers, sometimes in search of Indians to convert to Christianity and sometimes as explorers in their own right.

So intoxicating were the potential riches along the shores of the Great Lakes and their tributaries that the French government decided to claim the region all for itself. On June 14, 1671, in the same year that John Milton published *Paradise Regained* in England, agents representing the French Royal government held an elaborate ceremony at Sault Ste. Marie to proclaim to all the world that this new paradise belonged to France. A wooden cross was placed high on a hill, and the French coat of arms was nailed just above it. While their Indian guests looked on, a handful of Frenchmen sang a hymn and then listened as an agent of King Louis XIV read a proclamation announcing that the French Sun King was also king of Lake Huron and Lake Superior "and all other countries, rivers, lakes and tributaries, both discovered and undiscovered, bounded on the one side by the Northern and Western Seas and on the other by the South Sea . . ."

It is doubtful that the Indians understood the implications of the elaborate French pageant which ended with a great bonfire in the darkness of the early summer evening.

Before the decade was over, Daniel Greysolon, Sieur Duluth (Dulhut), led another group of French explorers into Lake Superior country. Like so many before him, Duluth

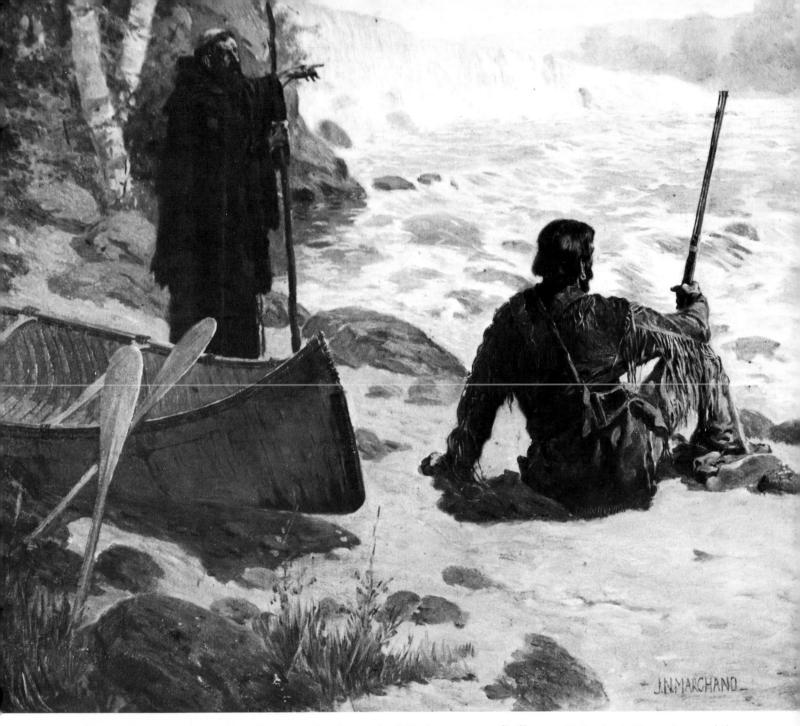

was looking for something more than beaver pelts; he too had his heart set on finding the Northwest Passage to the Orient. Duluth left Montreal in the autumn of 1678, and the following summer reached the shore of Lake Superior where the city that bears his name stands today. That year he made a trip to a large Sioux village on Mille Lacs Lake, where he heard another rumor about a great salt sea to the west. Duluth had no way of knowing that the salt sea was probably Great Salt Lake in Utah.

Nevertheless, the rumor encouraged Duluth. In subsequent months he followed the Bois Brule River (in Douglas County, Wisconsin) and portaged to the St. Croix River. On the St. Croix he traveled to its confluence with the Mississippi.

In the meantime Father Louis Hennepin, a Belgian friar, had joined Robert Cavelier, Sieur de La Salle, in a 1679 expedition of Lakes Ontario, Erie, Huron, and Michigan and the Illinois and Mississippi rivers. After traveling for more than a year the party split up; La Salle returned to Montreal and the rest of the party canoed into the arms of a band of Sioux, who captured them and moved them up the Mississippi River, then northward to the Sioux villages around Mille Lacs Lake.

Rumor of the white men's capture traveled slowly overland, and when Duluth eventually heard it he set out to investigate. Five months after they were captured, Duluth freed Father Hennepin and the rest of the party, and, as the story goes, sharply criticized the Indians for their behavior. The Sioux apparently felt apologetic for betraying the white men's trust, for later that autumn when Duluth, Hennepin, and the other Frenchmen decided to travel south again by way of the Rum River, the chief

Father Louis Hennepin named the mighty waterfall on the Mississippi River for his patron saint, Saint Anthony. Courtesy, Minnesota Historical Society

13

of the Sioux traced the route on a piece of paper and marked its portages. For history's sake, the rough drawing was probably the first map of Minnesota to be seen by Europeans.

The next year, 1682, La Salle led an expedition down the Mississippi and claimed the whole Mississippi River Valley for France.

As the seventeenth century rolled into the eighteenth, the French weren't the only people who were laying claim to the land we call Minnesota. The Sioux (Dakota) and Chippewa (Ojibway) Indian nations had been pushing and pulling their way across the face of northern Minnesota for decades, sometimes boiling over into battle as the Sioux were gradually driven out of the forests by the Chippewa, who were in turn being forced west, out of the northern Great Lakes area, by the powerful Iroquois.

Ownership of the land and its riches were the spoils of the conquerors. The land was bountiful, and possible to traverse. Under a bright blue, early-summer sky it appeared to be paradise.

The Three Maidens rock formations testify to the power of the glaciers that reshaped Minnesota's topography. These three "erratics" transported many miles by moving ice came to rest near Pipestone when the glacier melted. Courtesy, Minnesota Historical Society

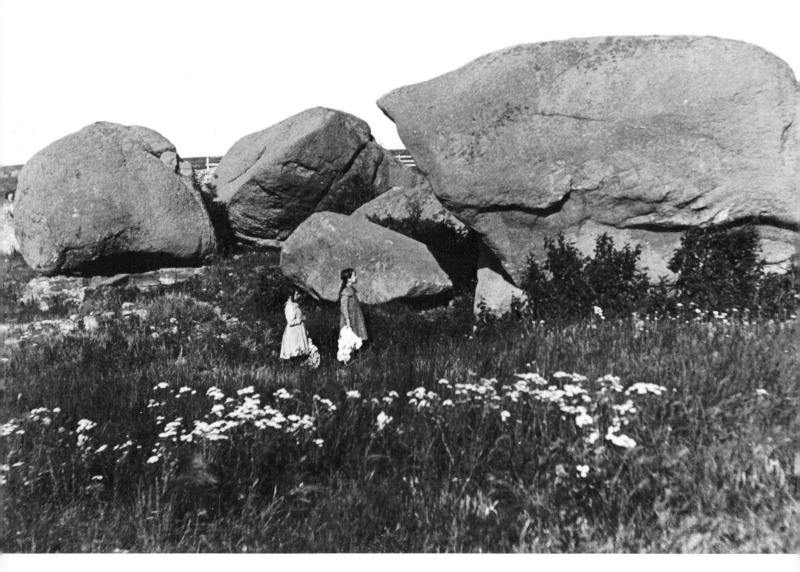

MOTHER OF THREE SEAS

Long before any human beings arrived, about 2,700 million years ago, Minnesota was mountainous, with spectacular volcanoes a common occurrence. Rock formations around Lake Superior are evidence of the volcanic action that shook the land. But time, erosion, changing temperatures, and massive ice sheets altered the landscape. About two million years ago temperatures across the northeastern part of North America and northeastern Europe dropped, and tremendous glaciers spread out over the land. Everything touched by the glaciers was absorbed, including boulders as large as buildings and entire forests, adding weight to the icy masses as they lumbered along.

The glaciers reshaped the face of Minnesota, leaving behind great glacial deposits, and building the network of rivers, streams, and lakes that would make exploration possible for the voyageurs and shipping so inexpensive for the millers, farmers, and lumber barons who would eventually inhabit the land.

From glacial deposits and scratches on rocks geologists have calculated that there were probably four major glacial advances across Minnesota, beginning about two million years ago and ending a mere 11,000 years ago.

About 11,000 to 13,000 years ago the climate began to warm up and the glacial ice melted. Although streams and rivers cut through the silt and other deposits to carry some of the meltwater away, more than 15,000 lakes of all sizes and shapes remained to dot the Minnesota landscape. Minnesotans can thank the Laurentide Ice Sheet for the fact that there is one square mile of water for every twenty square miles of land today.

There were giants among the lakes in those first thousand or so years following the retreat of the glaciers. Prehistoric Lake Aggasiz is estimated to have been about 700 miles long and 250 miles wide; it covered much of present northwestern Minnesota, northeastern North Dakota, southern Manitoba, and southwestern Ontario. Lake Aggasiz' outlet was what is now the Minnesota River Valley, and the fertile agricultural land of the Red River Valley was carved from the ancient lakebed. Of particular importance to the French voyageurs were the border lakes which formed in the wake of the glaciers; these lakes became the pathways to the rich bounty of the interior north.

The Great Lakes were created from the old preglacial basins which had been deeply scoured into the earth by the ice and then dammed up by moraines as the glaciers retreated. Because of the glaciers, the Duluth-Superior harbor is the largest inland port in today's United States.

Glaciation was largely responsible for the fertility and diversity of Minnesota's soils. As the glaciers cut down ancient mountains they left behind gentler slopes that could be farmed by the waves of pioneers who were to come.

By the time the first human discovered the great river network that made long-distance travel possible, the land of Minnesota had become a major source of water for the rest of the continent. Centrally located in North America, Minnesota is a crest from which water drains north to Hudson Bay, south to the Gulf of Mexico, and east to the St. Lawrence River, emptying into the Atlantic. By the end of the Ice Age, Minnesota had become the Mother of Three Seas—north, south, and east.

THE FLEUR-DE-LIS AND THE UNION JACK

The brand of regionalism that would color Minnesota's political history and industrial growth in the eighteenth, nineteenth, and twentieth centuries can arguably be traced back to the glaciers. Because glaciation had created such a variety of soils and land forms, the wilderness became the repository of a rich variety of resources. In the north, vast expanses of coniferous forests attracted a lumber industry that pumped money and labor into the state between 1850 and the turn of the century. In the southern and

The beaver lured trappers and traders in search of fortune into the American wilderness. The fur trade not only helped to satisfy the European taste for beaver hats, but also brought European goods into Indian lodges and formed the foundation for the interaction of two very different cultures. Courtesy, Minnesota Historical Society

western parts of the state, grasslands covering rich black soils lured pioneer farmers, giving birth to agriculture, one of the largest industries in the state. And, like a partial boundary between the two topographic regions, a zone of hardwood forests—elm, oak, and maple—eventually provided wood for shelter and light industry.

Another Minnesota resource was iron ore. Beneath the surface of the earth, changes in temperature, pressure, chemical mix, and oxygen content had been enriching taconite rock deposits with iron for millions of years.

But before iron ore changed the industrial picture in Minnesota, metal—in the form of household items and weapons—played a large part in ending the traditional Indian way of life. First, the Indians learned to depend on the kettles and knives the traders exchanged for their furs. Then, in about 1700, the Chippewa, who lived on the southern shore of Lake Superior, learned to use guns. This gave them the advantage over the Sioux tribes who stood in their way as they continued to push south. For the next six decades the Sioux and Chippewa battled fiercely, the Sioux desperately trying to hold onto the lands their ancestors had lived upon possibly as far back as 600 B.C.

The French had a similar problem. So large were their landholdings in North America that they were nearly powerless to prevent incursion from another major power—such as the British. But the rival British were marching out from the East Coast to establish their own trade relations with the Indians, and there was little that France could do to stop them. And unlike the French, the British had plans to domesticate the wilderness. Under the expansionist monarchy of King George III, the British sent a steady stream of settlers to North America, and intended to add it to their empire.

By 1756 the territorial conflicts between France and Britain had precipitated a world war. Called the Seven Years' War, it spilled over into Europe, India, and North

16

America—wherever the British and French had influence. The North American phase of the Seven Years' War, called the French and Indian War, was precipitated by the British claim to the Ohio River Valley. The French wanted the British to stay east of the Appalachians.

In the North American wilderness the French and their Indian allies were defeated. Across the Atlantic, the Treaty of Paris, signed in 1763, ended the Seven Years' War and France's claim to any military or political power in North America. All land east of the Mississippi fell under British rule.

After the war the British jumped onto the Orient Express. Offering $100,000 to anyone who discovered the legendary waterway from Hudson Bay to the Pacific, Britain's government made the western exploration a top priority. Robert Rogers, then commander of the British Fort at Mackinac, was appointed to lead an exploration overland to the Pacific coast. Rogers sent a young fellow by the name of Jonathan Carver ahead to take a proper British look at the wilderness and to build a working relationship with the Indians.

In early September, 1766, Carver set out from Mackinac for the Mississippi River, arriving about October. Leaving his canoes at the junction of the St. Croix and Mississippi rivers, he walked overland through the gathering winter cold toward the Falls of St. Anthony. Although still loyal to the French, the Indians were friendly enough, and Carver spent the winter with them. In the spring he was invited to join an Indian council that was held in a magnificent cave overlooking the Mississippi River—today called Carver's Cave. There Carver made a long speech to the Indians, telling them of the great power of the King of England and declaring his country's intention for friendship.

With Indian relations established—at least for the moment—Carver happily wrote in his journal that some day mighty kingdoms would rise in the wilderness and "stately and solemn temples, with gilded spires reaching to the skies" would take the place of Indian tepees.

By late spring Carver had hooked up with the exploration party that Rogers had sent. Their first stop was to pick up supplies and trading goods at Grand Portage, a nine-mile stretch of land linking Lake Superior and the Pigeon River. (For more than a century French traders and trappers had used Grand Portage as a gathering spot at the end of the hunting season; under British rule, Grand Portage had become the center of a widening area of trade.) But Carver and his men were disappointed to discover that besides failing to send their supplies, Rogers was in prison—accused of treason. For Carver it was the end of an expedition but the beginning of his career as a travel writer. His book, *The Travels of Jonathan Carver through the Interior Parts of North America in the Years 1766, 1767 and 1768,* became popular among the ladies and gentlemen of British society back in Mother England.

Carver was the first of many earnest young British pathfinders. As the American Revolution heated up on the East Coast, British and Scottish fur traders poured into the new country in a frenzy for furs. But even in the wilderness the law of supply and demand governed economic reality. As competition forced prices down, margins became tight for the traders and their backers. Already a century old, the Hudson's Bay Company of Montreal was virtually a monopoly, and it dictated terms that made the blood of many traders boil.

To protect themselves and to stabilize mounting competition in the fur trade, a group of vigorous Scots and British pulled together as a cooperative in 1783, forming the North West Company—a loose confederation of partnerships backed by Scottish interests in Montreal. It was the North West Company that made border-lake canoe routes famous throughout the world, giving the well-established Hudson's Bay Company a run for its money. With an active inland base at Grand Portage and a number of other posts across the face of Minnesota, the North West Company thrived for thirty years. Then the competition between the two companies became so fierce that they

Jonathan Carver, sent by the British in 1766 to explore the area around the St. Croix and Mississippi rivers and to establish a relationship with the Indians, predicted that their "stately and solemn temples with gilded spires reaching to the skies" would eventually take the place of Indian tepees.

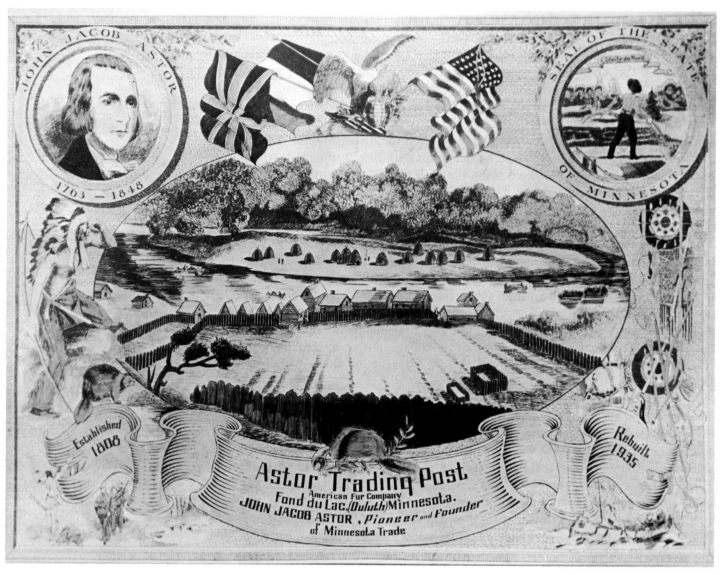

The American Fur Company took over the trading post at Fond du Lac, near Duluth, fifteen years after its establishment. Missionary work, a school, and an experimental fishing industry supplemented fur trading at the post. Courtesy, Northeast Minnesota Historical Center

miles north of present-day McGregor, Pike's cold, hungry, and weary party groped its way through the gates of a North West Company fur-trading post. They rested there for twelve days, well-treated and fed by the British traders, before pushing on to another British post at Leech Lake, some fifty miles to the northwest. In his haste, Pike declared Leech Lake to be the source of the Mississippi River.

History would prove Pike wrong about two things: he missed the actual source of the Mississippi by more than twenty miles, and he misjudged the position of the British traders.

In fact, the days of British authority over Minnesota's resources were running out. American entrepreneurs were beginning to see the potential for wealth that was waiting to be plucked. In New York, John Jacob Astor, a German immigrant, was one of those American entrepreneurs. In 1808 he founded the American Fur Company, which would soon become one of the major forces behind the economic growth of the Upper Mississippi River Valley, the Great Lakes, and as far west as the Oregon Territory.

The American Fur Company would also set the tone for big business in America. Through the first thirty-five years of the nineteenth century, the company amassed money, prestige, and power until it monopolized the fur trade. By diversifying its interests, the company proved to be as nimble as it was lusty. At the same time that Astor was establishing a trade loop that included Leipzig, London, and Canton, his fur company was building up its land holdings in America, developing food-producing farms

for its employees, creating commercial fisheries on Lake Superior, and managing lead and copper mines.

Astor's fingers reached into Minnesota's interior after the War of 1812, when the United States government declared that no foreign country would be allowed to operate a fur trade within its borders. As usual, Astor's timing was right. In 1815 the Sioux nation pledged loyalty to the United States, leaving the military free to build outposts in the wilderness. Besides preserving the peace, they would protect American trade.

THE SELKIRK COLONISTS

They called him the Prairie Chicken because he had a shock of fiery red hair that swept back from his forehead like a crest. His name was Josiah Snelling, and in 1820 he was sent by the U.S. Army to the Minnesota wilderness to build the fort that would bear his name. Colonel Snelling had a temper that matched the color of his hair, but under his leadership in the 1820s, Fort Snelling—the northernmost military post in the United

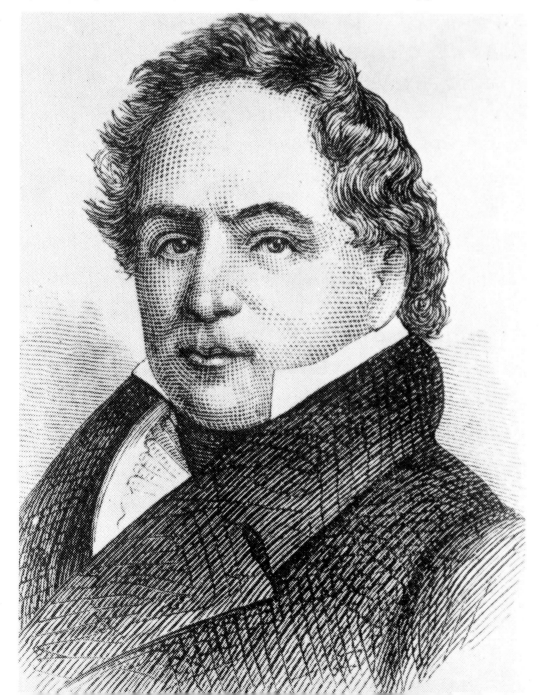

Nicknamed the "Prairie Chicken" because a shock of red hair swept back from his forehead like a crest, Josiah Snelling was anything but a coward. In the 1820s, under his leadership, Fort Snelling became a vanguard of settlement in the West. From Cirker, Dictionary of American Portraits, *Dover, 1967*

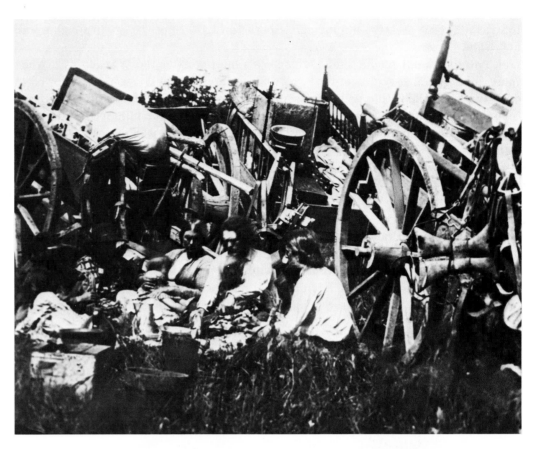

The Métis drove caravans of up to 800 carts along the Red River trails, bringing supplies to the Selkirk settlement near Winnipeg and returning to St. Paul with furs. Each cart carried 800 pounds of goods and traveled from Pembina to St. Paul in thirty to forty days. Courtesy, Minneapolis Public Library

States—became a vanguard of Western settlement. Built high on the bluffs above the confluence of the Minnesota and Mississippi rivers, the fort looked down on a valley where two major cities would be built before the end of the century.

Snelling was a man who explored possibilities. Logs for his fort were cut along the Rum River and rafted down to a sawmill built by his men at the Falls of St. Anthony. Limestone for the outer walls was quarried nearby. In the fertile clearings near the fort, the soldiers grew wheat, oats, corn, and garden vegetables, including 4,500 bushels of potatoes in 1824. Inside the fort, Snelling and his wife, Abigail, promoted cultural events for the officers, their families, and their visitors. Just outside, Indian leaders, Indian agents, and fur traders picked their way through two centuries of hostilities between the Chippewa and the Sioux tribes, trying to maintain a semblance of peace.

Three years after Snelling assumed command, the fort saluted the first steamboat to reach the area. The *Virginia*'s trek marked the beginning of an important communications link between St. Louis and the Minnesota hinterland. It was only a matter of time before settlers, household goods, and investment dollars, as well as mail and news, would flow north.

Within a few years of its founding the great fort offered protection and human companionship for settlers who had fallen on hard times. One such group who needed help was from the Selkirk Colony, a band of Scottish and Swiss immigrants who had settled along the Canadian Red River Valley. The Selkirk Colony had been plagued by disasters from its founding in 1811 to its finale in the 1830s, including floods, droughts, failed crops, and bloody rivalries between the North West Company and Hudson's Bay Company traders.

In 1827 a number of Swiss and French Canadian families broke away from the colony to resettle in the United States. Having heard about Fort Snelling from American Fur Company traders, the families packed their belongings into oxcarts and walked from the settlement near present-day Winnipeg to the fort. Poverty-stricken, hungry, and desolate, the Selkirk refugees sought the protection of the fort while trying to decide what to do next. Many headed down the Mississippi and settled at Galena and other

points south, while others quietly started to farm on military reservation land north of the fort and west of the Mississippi River. Within the next decade, 500 more people arrived at Fort Snelling from the Selkirk Colony. Since settlement of the territory was not officially permitted by law—all the land surrounding the military reservation was Indian land—the Selkirkers who stayed on lived at the favor of the military government.

What was wanted was land on which to build permanent homes and businesses. Pressured by land speculators, lumbermen, and settlers, the government negotiated treaties with the Sioux to obtain the large triangle of land between the St. Croix and Mississippi rivers. When the treaties were ratified in 1838, settlers from the Red River Valley were ordered away from the military reservation land. Pushed from the fort, the settlers from the Selkirk Colony moved down the Mississippi and established a new settlement, which would eventually become St. Paul, today the state capital.

Through the decades, a primitive but workable financial system, based on credit, had been built on the fur trade. But in the 1830s silk became the fashion rage in Europe,

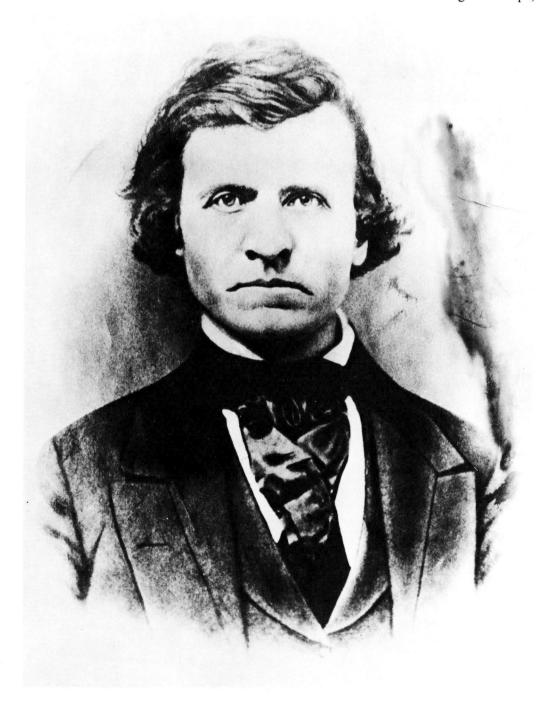

Martin McLeod of Montreal, pictured here about 1850, sought shelter at Fort Snelling in the mid-1830s. He stayed on as a trader for the American Fur Company throughout the 1840s and later exerted his literary influence on the first Territorial Legislature by authoring the bill to establish common schools in Minnesota. Courtesy, Minnesota Historical Society

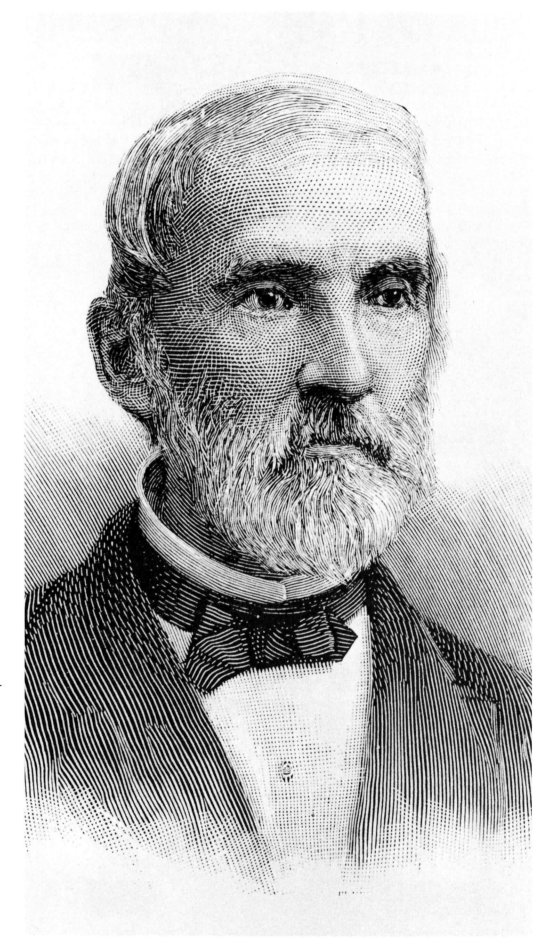

Henry Sibley was asked by a delegation of pioneers in 1846 to lobby in the halls of Congress for the formation of a new territory. At first he was unsuccessful, but three years later, with Senator Stephen A. Douglas' help, he was able to convince Congress to pass a bill creating the Territory of Minnesota. From Cirker, Dictionary of American Portraits, *Dover, 1967*

and the demand for fur dropped nearly overnight. Like toppling dominoes, the effect was quickly felt in the pockets of American fur traders, who were threatened not only by the sudden collapse of their European market but also by the advance of farming, lumbering, and settlements on their trapping territory.

The undoing of the fur industry was a jolt to the struggling frontier economy. Money grew scarce. For the American Fur Company, the Panic of 1837, as the financial crisis was called, was not a total surprise, though management was shocked that it came as quickly as it did. After 1838 the fur trade in the Minnesota wilderness was gradually replaced by logging, milling, and farming.

Once the 1837 treaties with the Sioux Indians were sanctioned by Congress, wavelets of hardy white settlers washed over the ancient hunting and fishing grounds. Many were attracted to the newly opened country by the thick stands of white pine that grew along the St. Croix River, and by the dollars that expanding American lumber markets could offer. By the early 1840s lumbering had become a booming business in and around the ceded Indian lands of the St. Croix River Valley. A few small sawmills cropped up, followed by families of subsistence farmers.

Because early farming was such difficult work—even on Minnesota's rich river-valley soils—agriculture got off to a slow start. Families who were able to cut through the tough prairie topsoil could only provide for themselves. Life was primitive and lonely, with limited rewards for the few who stuck it out.

As families continued to push west, however, the trickle of settlement soon became a steady flow. In Washington, D.C., Congress tried to make sense—and states—out of the territories that were being populated. Between 1834 and 1849 the lands around Fort Snelling west of the Mississippi belonged to four different territorial governments—Michigan, Wisconsin, Iowa, and finally, after lengthy debate, Minnesota.

The people who had made their homes in the delta between the St. Croix and Mississippi rivers felt that they deserved some representation in Congress and a government to provide structure during the westward expansion. Becoming a territory would mean federal assistance for road building and schools. It would also mean mail delivery and courts for trying people who broke the law. In 1846 a delegation of pioneers from the delta area asked Henry Sibley, a deft negotiator formerly with the American Fur Company, to promote their cause in the halls of Congress. For his efforts, and at his own expense, he was able to get a bill passed in the House that would allow the creation of a new territory. But the Senate was less inclined to put its stamp of approval on the idea. Of overriding concern to members of Congress was the simmering slavery issue, and Sibley understood that he would have to bide his time before trying again.

In his memoirs Sibley wrote that a number of names had been suggested by various House members for the proposed territory, including "Itasca," "Algonquin," "Chippewa," "Jackson," and "Washington." By compromise, the House chose "Minnesota," derived from a Sioux word meaning "water with clouds on it."

By 1848 the push for status as a territory had become a hot political issue. On the Fourth of July the citizens of Stillwater organized a parade and celebration to demonstrate their serious intentions of becoming a full-fledged territory of the United States. Six weeks later, a convention of sixty-two representatives was held at Stillwater to add an official delegation to the voice of its citizens. Once again Sibley was asked to go to Washington on behalf of the Minnesota territory. This time, with considerable help from Illinois Senator Stephen A. Douglas—a friend and long-time colleague—Sibley was successful. The bill passed on April 3, 1849. Bordered by the St. Croix and Mississippi rivers on the east, the new territory extended to the Missouri River on the west. Within the boundaries of the new territory were about 25,000 Sioux and Chippewa, and a mere 5,000 settlers.

Six days later the whistle of a steamboat rounding the bend of the Mississippi called out the news to the townspeople of St. Paul, the newly named capital. A major battle had been won.

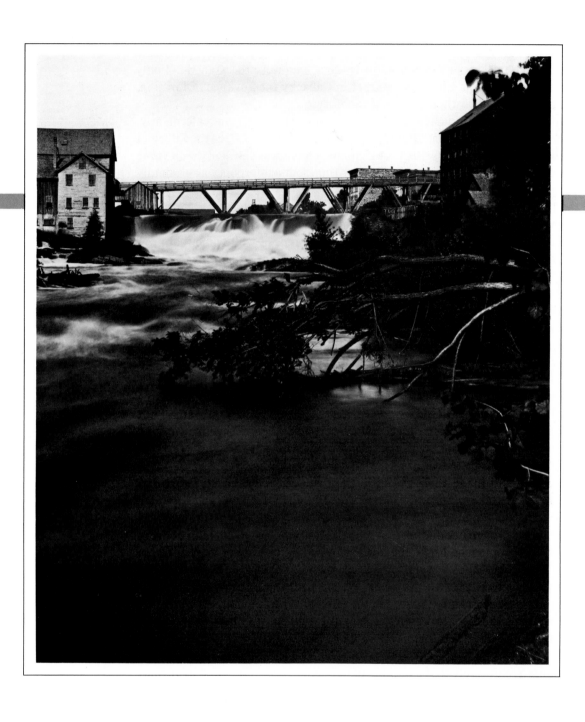

*For Yankees the music of St. An-
thony Falls reverberated with the
rhythm of water wheels driving
sawmills, flour mills, and wood-
working machinery. Courtesy,
Minnesota Historical Society*

INDUSTRIALIZING THE FRONTIER

T hrough the 1850s America was in a mood to celebrate. To show the world it was made of the right stuff, America held a world's fair at New York City's Crystal Palace in 1853. Only four years old, the Minnesota territorial government grabbed the opportunity to promote settlement and business growth along its riverbanks, appointing William G. Le Duc, a pioneer Minnesotan, as the director of Minnesota territorial marketing. Le Duc was given an expense budget ($300), a mission (to captivate the New York City press), and a directive (to attract potential settlers). With an Indian canoe, a few photographs of the landscape, wild rice from the northern lakes, furs from the timberlands, and grains from an infant farming belt, Le Duc put together a rustic exhibition that, for many Easterners, put the Minnesota Territory on the map. Legend tells that Le Duc also transported a live buffalo with him to New York City. For all his trouble, however, the buffalo was declined entrance at the door.

Minnesota was not lacking for boosters like Le Duc, and their words echo the thriving sense of optimism abroad in the territory. In 1849 the *Minnesota Pioneer* lauded Minnesota as the "new" New England. "Minnesota, we foresee, will be the destination of the largest current of emigration from the Eastern States . . . ," the newspaper proclaimed.

> Here they will find an unqualified healthy climate, fertile and well drained lands, and upon the Mississippi, the best market for mechanical products in the Union. With such a population will come not only arts but science and morals. Our Falls of St. Anthony with hundreds of water powers upon other streams will be turned to manufacturing purposes. Thrifty towns will arise upon them. Our undulating prairies will rejoice under the hand of husbandry; these hills and vallies [sic] will be jocund with voices of school children, and churches shall mark the moral progress of the land.

To advertise "the undulating" prairies and "thrifty towns" along Minnesota's waterways, the Territorial Legislature appropriated money in 1855 to pay a full-time immigration commissioner whose job was to meet every incoming ship of immigrants in New York City's harbor and describe to them the bounty of the land. Between ship arrivals the commissioner wrote pamphlets for those Europeans who hadn't yet made the journey to America.

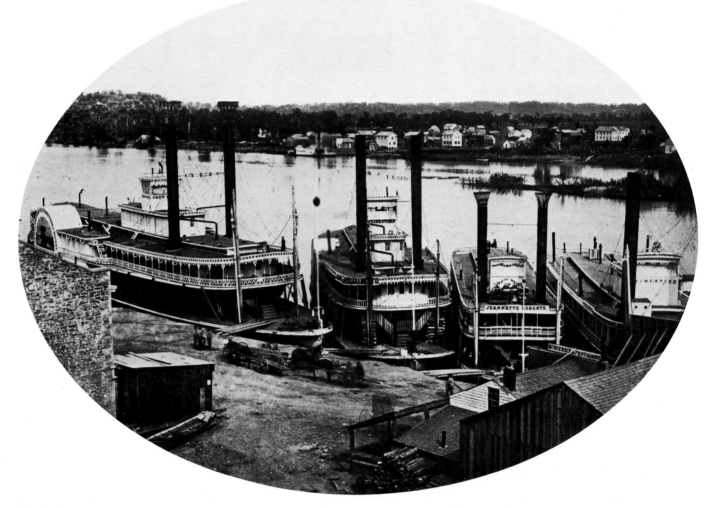

Thousands of settlers disembarked from steamboats at the St. Paul levees on their way to claim land on the prairies. The influx of people in the 1850s broke all migration records in spite of the fact that boat traffic was limited to fewer than nine months of the year. Courtesy, Minnesota Historical Society

Between 1849 and 1860 Minnesota's population soared—from 5,000 to 172,000. Throngs of immigrants bound for Minnesota helped propel the Mississippi steamboat industry to new levels of success. By 1858 sixty-two steamboats were regularly plying their way to St. Paul, carrying potential settlers—many from Germany and Norway—looking for good farming soil. Steamboat traffic flourished on the Minnesota River as well. After the building of Fort Ridgely, near present-day New Ulm, steamboats carried pork, flour, and other goods upriver to the soldiers, and gold for the Indians in payment for the lands they had ceded. By 1858 Fort Ridgely counted 394 steamboat landings within the year.

The Red River of the North was the third major river system in Minnesota to carry steamboat traffic. This traffic was necessary to open up the northern regions of the territory, and the St. Paul Chamber of Commerce in 1858 offered a cash prize to anyone who successfully navigated the river. Businessman and hotel builder Anson Northrop sailed a steamboat to Crow Wing on the Mississippi River, then took the boat apart—board by board, gear by gear. With thirty-four teams of oxen, he hauled his steamboat across more than eighty miles to the Red River, where he launched his craft and claimed his prize. It was a number of years, however, before steamboats regularly appeared in Breckenridge and Ortonville and the other Minnesota communities that were springing up along the river.

Each spring when the ice finally broke up, usually in late April, dozens of hardy steamboats chugged their way through a countryside that was becoming increasingly dotted with towns. On the lower Mississippi, citizens in the villages of Winona, Wab-

asha, Read's Landing, Red Wing, Frontenac, and Hastings stood on the banks, waving the steamboat crews on to St. Paul.

Beyond the rapidly growing towns of St. Cloud and Sauk Rapids, St. Anthony and its sister city, Minneapolis, snapped with importance as the logging industry stretched its enterprising fingers into the white pine forests of the north country. Along the Minnesota River, villages such as Shakopee, St. Peter, Mankato, and New Ulm attracted families of immigrants who transplanted their traditions and ethics of hard work into the Minnesota prairie.

The Minnesota Territory was fast becoming a land of business opportunities. Minnesota could offer water power for milling and manufacturing, pine for lumbering, waterways for inexpensive transportation, and rich soil for farming.

In the 1850s, breweries, tanneries, and foundries grew up alongside shops, hotels, physicians' offices, and lawyers' firms. Underpinning the growth was capital, brought upriver by the financiers whose banks soon marked the main street of every town and village. Building towns became a favorite occupation of land speculators who were willing to gamble that they had the formula that would attract enough people to make their town a successful venture. Between 1855 and 1857, 700 towns were laid out, with platted lots for many thousands more people than were actually living in the territory at the time.

SEALED FATE

While young farming families unloaded their baggage from the steamboats, policymakers in St. Paul were busy authorizing and designing a seal that would signify the territory's potential. In 1849 Territorial Governor Alexander Ramsey and congressional delegate Henry Sibley supervised the selection of the design. After considerable thought they agreed that the best drawing was offered by Seth Eastman, an Army cap-

Steamboats linked Minnesota and the rest of the country until after the Civil War. The winter freeze, however, halted the flow of goods and people for several months, and by March supplies ran low. So, a bonus was offered to the first boat that would brave the thawing river in the spring. Courtesy, Minnesota Historical Society

tain stationed at Fort Snelling whose illustrations of contemporary Indian life were well regarded.

What Eastman's penwork communicated was that the white man's civilization was pressing the Indian into obscurity. Against a distant background of Minnehaha Falls, an Indian brave on a horse is seen turning away from a settler who has cut into the soil with his plow and into a tree with his ax. Eastman's drawing, later incorporated into the state's seal, forecast the heavy price the Sioux and Chippewa nations would pay throughout the nineteenth century. Mary Henderson Eastman, the artist's wife, wrote a poem reflecting her husband's work. Her words are poignant, not because she crafted her thoughts well but because they represent the zealousness of the new arrivals that doomed the two proud Indian nations.

> Give way! Give way young warrior!
> Thou and thy steed give way!
> Rest not, though lingers on the hills,
> The red sun's parting ray.

The spread of civilization across the face of Minnesota was sure and steady. Lured by promotional pieces such as the small book called *Minnesota and Its Resources*, families from Maine to Ohio joined the steady flow of immigrants from western Europe. What they wanted was land—land on which they could build farms and homes for themselves and as a heritage for their children. What they brought with them were energy and determination, qualities that fostered Minnesota's entrepreneurial spirit.

Having conquered the hardships of their westward adventures, the new arrivals felt increasingly hemmed in by the Indian lands that surrounded them. They complained ruefully to their territorial leaders that more land should be tamed for farming. The public and the press argued that too many dollars were leaving with the steamboats in payment for foodstuffs which could be better and less expensively grown by Minne-

The pastoral image of St. Anthony Falls attracted Southern gentry seeking summer vacations in the north, and their patronage supported riverfront hotels. Courtesy, Minnesota Historical Society

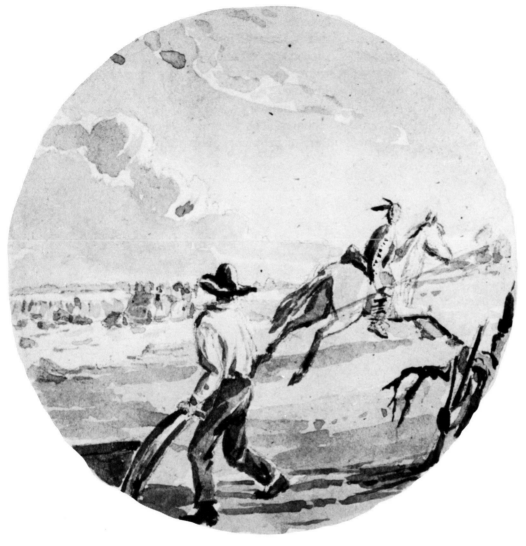

sota farmers. In the 1850s, almost everyone believed that farmlands were the key to Minnesota's long-term economic solvency.

Two treaties were signed with the Sioux in 1851, expanding the agricultural potential of the territory west from the Mississippi River. For a little more than $1.6 million, the federal government bought 24 million acres of land, reaching across the lower half of Minnesota from the Mississippi on the east to the Bois des Sioux and Big Sioux rivers on the west.

With such a wide expanse of rich agricultural land available, many farmers began planting more than their own families or animals could eat, and selling the rest. As transportation to markets grew better, agriculture fostered new spinoff industries. Within the decade twenty-two meat-packing plants were opened to handle a growing livestock business down on the farms. In 1854 a mill opened at St. Anthony to commercially process local wheat. The mill's owners had a difficult time when it first opened, but only four years later eighty-five flour mills were thriving across the state in such places as Marine, Northfield, Winona, and Hastings, as well as St. Anthony, Minneapolis, and St. Paul.

In 1855 the first agricultural fair was held in Minneapolis to celebrate a diverse and strong agricultural base. Families from the surrounding countryside hauled their best crops and livestock to town. Shanghai and Chittagong chickens, Leicester sheep, yellow dent corn, butter and cheese, squash, pumpkins, and potatoes were admired as if they were the crown jewels of England.

Indian land holdings were also hemming in another infant industry. Ancient white pines—so big, legend says, that it took sixteen grown men standing fingertip to fingertip

to reach around one of them at the base—crashed to the earth as teams of loggers moved north on the St. Croix and Rum rivers. Demand for Minnesota pine was on the upswing. Wood was needed for houses, shops, schools, and churches in the brand-new towns, but more titillating to the businessmen paying the loggers' wages was the profit to be made downriver from their white gold.

No one doubted that the lumber industry needed elbowroom. The industry itched for the pine in Lake Superior country. The federal government accommodated by tempting the Chippewa with offers of payments and trading credits in exchange for

The Falls of St. Anthony gave Minnesota great industrial potential, and by 1863 mills flanked these Mississippi River falls. Courtesy, Minnesota Historical Society

the land east of the St. Louis River. In 1854 the first of a number of treaties was signed in the north country to secure land for Minnesota settlers and speculators. By the end of 1855 the Indians had signed away their rights to most of the land in Minnesota Territory.

Traveling up nearly any river in the 1850s, it was common to see smoke rising from the chimneys of settlements. Too impatient to wait for the federal land surveys that followed treaty signings, homesteaders marked their property lines by blazing trees or building small fences. Under the 1841 Preemption Act, families could choose 160 acres of land, build a home and begin farming, and not pay for the land until the government got around to putting it up for sale. Then the family living on the land had first claim to it and could buy it at the lowest price.

MINNESOTA

AND

ITS RESOURCES

BY

J.W. BOND

FALLS OF ST. ANTHONY

REDFIELD

110 & 112 NASSAU STREET

NEW YORK.

1853.

Though this book contained only two illustrations, its powerful words created pictures in people's minds that made them pack their belongings and move to Minnesota. Courtesy, Minnesota Historical Society

cant land grants and tax breaks to four railroad companies empowered to build lines across the countryside. The goal was to quickly connect towns with points East. Under the act, as soon as a railroad company completed a twenty-mile stretch of road, it was to receive title to another 120 sections of land, until every village in Minnesota Territory could call itself a whistle stop.

When the panic hit, however, the chartered railroad companies—the Minnesota and Pacific Railroad Company, the Transit Railroad Company, the Root River Valley and Southern Minnesota Railroad Company, and the Minneapolis and Cedar Valley Railroad Company—suddenly found themselves in a tight spot. To take advantage of the land grants, the four companies would have to raise money for the construction of the first twenty miles of track. Their dilemma, of course, was that there was no money in the territory to raise. The Transit Railroad Company—a corporation that was empowered by the legislature to build a road from Winona through St. Peter to the Big Sioux River—even tried to sell 500,000 acres of its land grant at one dollar an acre. Finding no buyers, the owners fled back to the state capital and pleaded for help.

The public was more than sympathetic to the plight of the railroads. Wanting a national rail system was patriotic, and everyone dreamed of a system that would pull the territory together—politically and geographically. By February 1858, a little over six months after the panic had begun, a bill appeared in the Territorial Legislature to provide $5 million in bonds, backed by territorial credit, to help the railroads begin work.

With the introduction of the $5 million loan bill, legislators demonstrated their belief that supporting big business also supported the little guy who needed to work, and that pumping some money into the economy would help to get things moving again. The bill declared that upon the completion of grading any ten miles of railroad, a railroad company would receive secured bonds in $100,000 increments, for which it would pay interest and the principal when due. The bill passed easily, and a popular election held in May 1858 confirmed the public's overwhelming support of the $5 million loan. Winona town officials reported that out of 1,182 votes, only one person voted against the measure.

But financial disaster still prevailed in the late summer and fall of 1858, when the railroads began construction and were expecting to use the new state's support to invigorate their cash flow. Money was still tight, and the value of the state's bonds sank owing to the depression. Railroad company executives soon realized that they were trapped in a quicksand from which there was no escape. By 1859 the public's confidence in the railroads' ability to keep their end of the financial bargain had been lost, so much so that critics proclaimed that the companies had never intended to lay tracks at all, that they had tricked the good citizens of Minnesota from the first. And where grading had been done, the quality was inadequate. Furious, citizens pointed to a public outlay of $2.25 million in special bonds that had provided 240 miles of poorly executed, discontinuous gradings.

Translating the so-called railroad scheme into cartoon form, an illustrator named R.O. Sweeny circulated to the papers in the state a broadside drawing showing a team of gophers in top hats pulling a cartload of legislators down a railroad track. From beneath, the track and the gopher train were supported by the backs of Minnesota citizens. So widely known was Sweeny's cartoon at the time that the new state quickly became known as the "Gopher State."

THE "BANNER WHEAT STATE"

Elected the second governor of the state of Minnesota in 1860, Alexander Ramsey defeated his personal friend and political rival Henry Sibley, launching a tradition of Republican political domination that would last nearly forty years. As he took his oath

of office, Ramsey spoke of two missions he wanted to accomplish within the first months of his administration. With his term coming on the heels of the depression, he first intended to tackle cost-cutting policies in state government; within a year he cut expenditures by 36 percent. His second goal was to turn his state's support to the Union cause, marching whenever possible against the onslaught of secessionist and pro-slavery foes.

In the spring of 1861 he was in Washington, D.C., appealing for federal financial aid for the state, when he heard that Fort Sumter (at Charleston, South Carolina) had fallen and that Union troops had been forced to evacuate it. Ramsey hastened to the office of the Secretary of War and pledged 1,000 men to help defend the Union. Thus

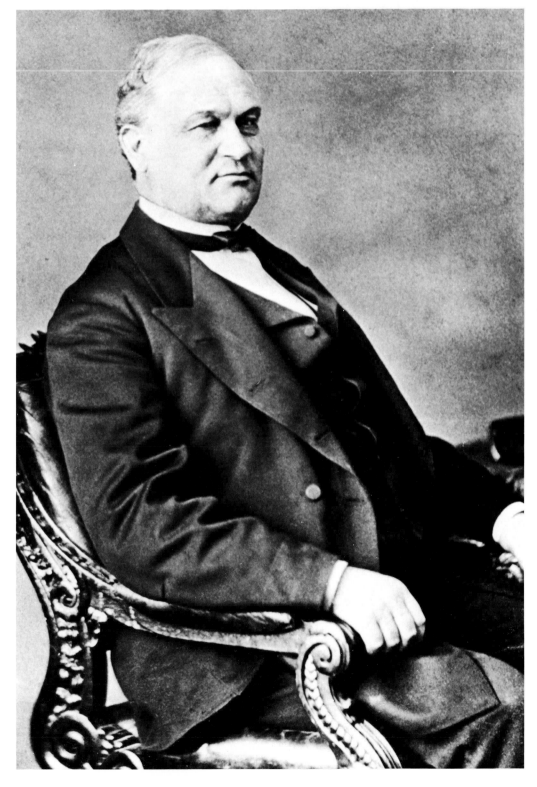

In 1860 Alexander Ramsey became the state of Minnesota's second governor. He was the first governor, however, to volunteer his state's men for the Union army. Courtesy, Minnesota Historical Society

Chief of the Sandy Lake tribe of Ojibway, Po-go-Nay-ke-Shick carried on the perpetual struggle between his people and the Dakotas. The fighting ended with the banishment of the Dakotas after the uprising of 1862. Courtesy, Minnesota Historical Society

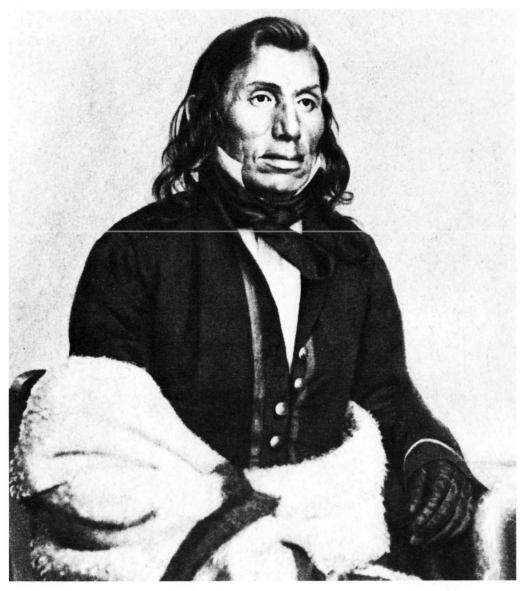

Little Crow's participation in the 1862 uprising has obscured his role as a negotiator. As chief of the Mdewakanton Sioux, he sought peaceful ways for Indians and whites to live together until he saw no alternative but the use of force. Courtesy, Minnesota Historical Society

Minnesota became the first state to answer President Abraham Lincoln's call for troops.

The Civil War revived the sense of national loyalty that had been flagging for a few years in Minnesota. Setting their own financial worries aside, Minnesotans pitched in with their support to help settle the slavery issue once and for all. Accompanied by furled flags and blaring trumpets, more than 25,000 men left for the battlefields of Bull Run and Chickamauga.

In the early days of the war, no one could imagine the devastation that lay ahead for those men, their families, and the country. At Gettysburg, 215 of the First Minnesota regiment's 262 men lay dead or severely wounded on the battlefield.

On the homefront, the Sioux Indians, who had ceded most of their hunting and fishing grounds in the treaties of 1851, were now confined to reservations in the Minnesota River Valley. They deeply regretted the loss of their ancestral lands, and their disillusion was intensified when their crops failed during the summer of 1861. Bureaucratic holdups in Washington had delayed land payments to the Sioux, making it impossible for the Indian tribes to buy the supplies they needed, thus compounding their resentment toward the white society. Finally, one late-summer day in 1862, four wandering Sioux hunters killed five settlers at Acton, in Meeker County. The Indian nation, led by Chiefs Little Crow and Shakopee, rallied in an all-out commitment to war. Before Minnesota's political leaders received word about the murders the next morning,

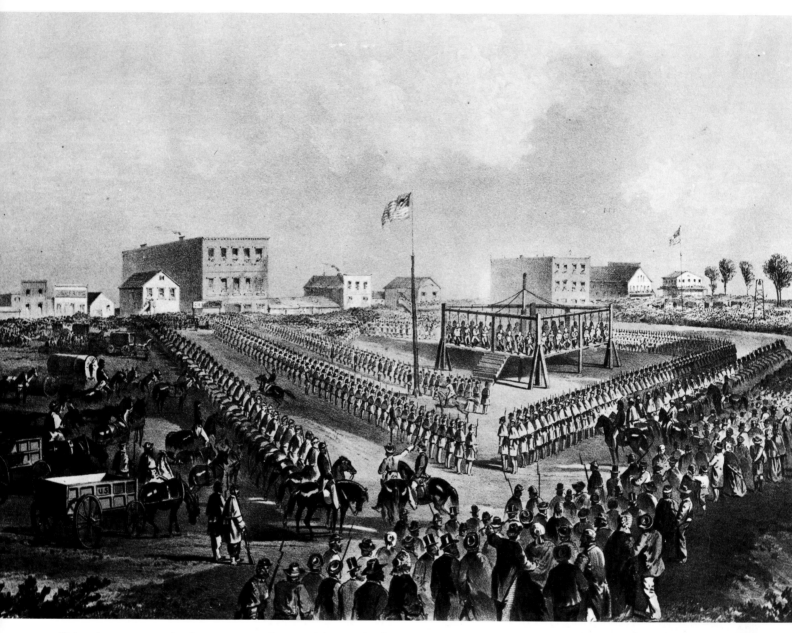

Delays in government land payments to the Sioux made it impossible for the tribes to buy necessary supplies. These bureaucratic holdups, coupled with the Sioux's resentment over the loss of their ancestral lands, precipitated a bloody Indian war. In retaliation, President Lincoln ordered the hanging of thirty-eight Sioux warriors. The mass execution, pictured here, took place in Mankato. Courtesy, Minnesota Historical Society

a large war party had already attacked the Lower Sioux Agency, looting and burning the buildings and killing traders. Like a prairie fire, the Indians' bitterness burned across the countryside, quickly turning into one of the nation's bloodiest Indian wars. Governor Ramsey called out extra troops and put Henry Sibley in charge of the entire force.

Within five weeks, the white man had once again achieved the upper hand. As many Indian families attempted to flee to Dakota Territory for safety, more than 1,700 Sioux and mixed-blood sympathizers were captured. Three hundred of the more serious offenders were tried immediately, sentenced to death, and held for the final word of condemnation from President Lincoln. Lincoln's decision, however, reflected leniency. On the day after Christmas in 1862, thirty-eight Sioux, instead of 300, were hanged at Mankato in a mass execution. Ironically, Chiefs Little Crow and Shakopee were not among them; they had escaped capture. The remaining prisoners were banished to a reservation in what is now South Dakota.

With demand for Minnesota wheat at an all-time high to feed the boys in blue, the farmlands deserted during the Indian war were again put under the plow. New threshing machines, combination reaping and mowing machines, and improved plows—manufactured in Minnesota plow factories—helped ease the farmers' job. Be-

40

tween 1860 and 1865 the state's wheat harvest more than doubled, from a little over 5 million to 9.5 million bushels.

During the Civil War, Minnesota was an official "banner wheat state" for the country, and ambitious entrepreneurs capitalized on the need to grind wheat into flour so that it could be shaped into loaves. In 1860 there were only eighty-one flour mills in the state. Over the next decade more than 400 more were built, primarily in the heart of the wheat-growing region in the southern half of the state. By 1869 there were thirteen mills in Minneapolis alone, producing 250,000 barrels of flour in one year. Minnesota had the winning combination of rich soil for raising wheat and water power for grinding it into flour. Along the Root, Mississippi, and Minnesota rivers, mills symbolized the domestication of the land.

The need for food in the Union camps also helped stimulate the growth of a healthy beef and pork market. And Minnesota wool was used for army uniforms. By the time the war-weary survivors straggled home to their farms late in 1865, Minnesota's econ-

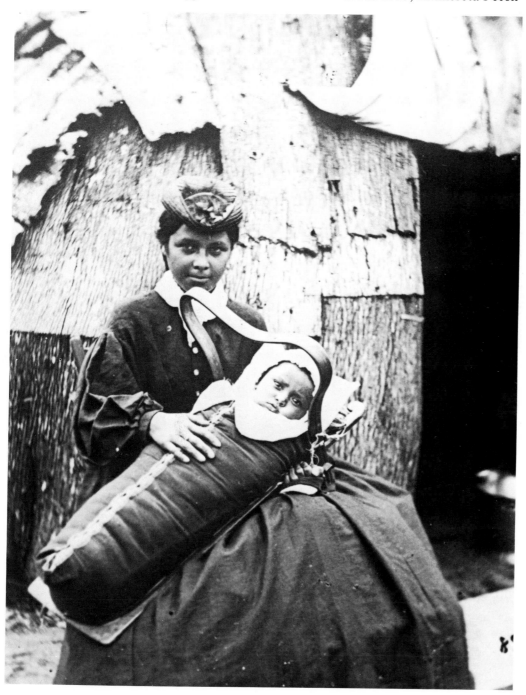

Indian people such as this Ojibway woman adopted white dress even as they continued to build traditional dwellings and confine their children in cradle boards. Courtesy, Northeast Minnesota Historical Center

41

omy had blossomed. Farmers saw wheat prices triple between 1861 and 1866, and a sense of confidence was slowly working its way across the state.

Encouraged by the Homestead Act, which Lincoln had signed into law in 1862, a wave of young families arrived. The act enabled them to settle on 160-acre plots, improve the land over a period of five years, and eventually buy their farms from the federal government for small administrative fees. Towns like Winona and New Ulm flowered as the state's population blossomed. From 172,000 citizens in 1860, the state grew to 440,000 within the decade—a population increase matched only by Kansas and Nebraska.

Still smarting as a nation from the severe depression following the Panic of 1857, the Lincoln administration took steps to reduce the possibility of future bank failures and wildcat lending. The National Bank Act, passed in 1863, established a system of federally run banks and the eventual national control of banking transactions. For the hundreds of new businesses starting up in Minnesota after the Civil War, the act helped restore confidence in bank notes. Still to come, however, was relief from the exorbitantly high interest rates that could be demanded because of a general lack of available money.

Farmers and small businessmen were not the only ones looking for more opportunities following the war. The lumber business was growing into a sizable industry as millions of board feet of Minnesota white pine were floated down the Mississippi to

Six years after the Panic of 1857, the National Bank Act was passed, establishing a nationwide system of federally run banks. The First National Bank in Minneapolis, pictured here in 1866, provided office space for other businesses. Courtesy, Hennepin County Historical Society

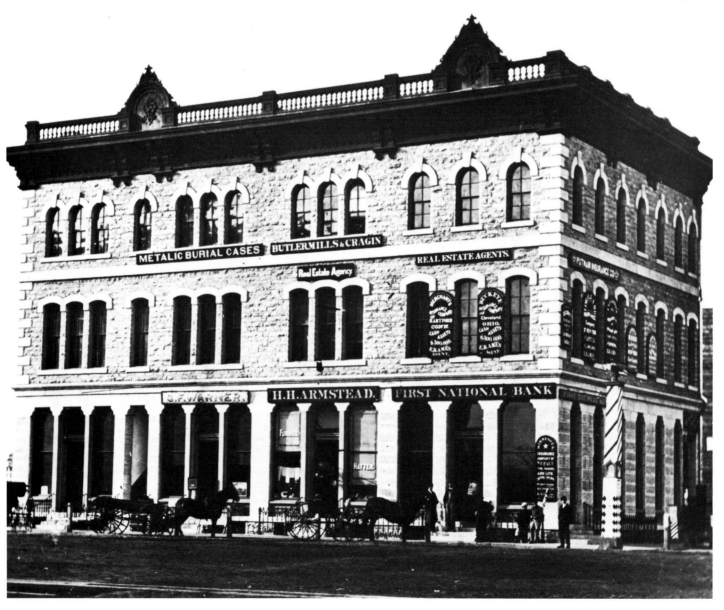

markets in Chicago, Rock Island, and St. Louis. For the returning Civil War veterans the industry's prosperity was good news. Lumber companies were as hungry for manpower as they were for stands of pine. Commercial mills grew in the wake of the lumbermen's advance around the Falls of St. Anthony, at Stillwater and Marine on the St. Croix River, and at Winona where John Laird, his brothers, and his cousins, James and Matthew Norton, processed the logs that floated down the streams of Wisconsin and Minnesota. The Laird, Norton Company eventually became one of the largest lumbering operations in the upper Midwest.

Minnesota lumber played a large role in the Midwest's growth. Cities such as Kansas City, Des Moines, and Omaha were built from the rafts of lumber that arrived steadily throughout the last half of the nineteenth century. But lumbering was a highly competitive business and through its heyday in Minnesota, nefarious land deals—taking advantage of the bargain prices offered to settlers by the Homestead Act—were negotiated among lumber barons in smoke-filled rooms. The newspapers of the day hinted loudly that great fortunes were being made behind the backs of Minnesota's citizens. As in all economic growth, there is a trade-off; and here a loss of wilderness resources was the price that was paid for development. From the St. Croix north, the land was ruthlessly stripped, leaving behind a wasteland of stumps and slashings. For places such as Duluth and Cloquet, lumbering greatly contributed to the growth of the community and the prosperity of the citizens who lived there. But in the years following the Civil War, it was hard to keep the trade-offs in balance.

TRACKING PROGRESS

Minnesota shared the economic prosperity that permeated the new Midwest after the Civil War. Like its sister states of Kansas, Iowa, and Wisconsin, Minnesota was transforming itself from a frontier territory to an industrial center. Progress was marked by immigrants coming in and foodstuffs going out at the wharves.

By the end of the 1860s, progress was also marked by the type of transportation that carried eager settlers, produce, and grain in and out of the river towns. Prompted by President Lincoln's signature on the Pacific Railroad Act in 1862, the railroads were swiftly working their way across the country, linking landlocked Midwestern towns with the ports of Europe and the Orient.

At first, railroad trafficking and agricultural development were considered equal partners in success. As they moved away from subsistence-level farming, Minnesota farmers realized that they needed a system of transportation that would move their produce and grains to the user swiftly. Besides wanting to keep their crops from spoiling, the farmers wanted to be sure they were able to move their wheat when it was advantageous to sell. The railroad companies did more than their share in stimulating settlement along the tracks. For them, long-term gain was directly related to their ability to establish the dependence of both shippers and receivers on the railroad. Railroad corporations also needed to sell the lands the government gave them in order to finance construction.

Once again the Minnesota Legislature rolled up its sleeves to try its hand at railroading. Soon the Minnesota and Pacific Railroad Company rose from the ashes of the recent depression, renamed the St. Paul and Pacific Railroad. Construction began as soon as plans and state statutes were formulated. Money was found to link St. Paul and St. Anthony in 1862, to extend to Anoka the following year, and to stretch to Sauk Rapids, fifty miles to the north, by 1866. Little Duluth, poised at the edge of Lake Superior, waited patiently for the chance to build a major shipping business, but it wasn't until 1871 that a railroad linked the port with southern farms.

Trade between the Middle West and the East Coast was humming as railroad lines laced their way across the countryside. But along with the whistle of the train

Oliver H. Kelley, who arrived in St. Paul in 1849 from Boston, settled in Itasca in 1850. Though city-bred, Kelley became a "book farmer" and advocated experimentation and information exchange among farmers. In 1864 Kelley became a clerk under the U.S. commissioner of agriculture, and two years later he came up with the idea of a national farmers' organization. The following year Kelley and six friends founded the Order of the Patrons of Husbandry, also known as the Grange. From Cirker, Dictionary of American Portraits, *Dover, 1967*

came new problems for farmers. Minnesota farmers in the 1860s and early 1870s took their crops to the nearest collecting point, where they were paid the regional price minus a dealer's commission for handling the grain and the price of shipping it to market. Prices fluctuated along with the speculative spirit of the East Coast commodities market. Farmers had no control over the payment they would receive for their work.

On the other hand, the railroad companies had considerable control over the amount they could charge for hauling. They used their increased clout to command higher and higher shipping rates, squeezing dealer margins and eventually the farmers' profits.

In the first decade of growth, the railroads held most of the cards. Frequently, there was not enough competition to force railroad companies to hold the line on rate increases. They considered the level of competition (the transportation options in the area), the nearness to a regional market, and the personal goodwill they felt toward each shipper, and then charged what the traffic would bear. It became common practice for the railroads to set preferential rates for larger shippers or to underweigh and underclassify grain shipments. For Minnesota farmers the rate fluctuations were a bitter pill to swallow, as prices for wheat dropped after the Civil War. What was needed—and needed immediately—was a uniform and fair system of grain inspection and grading, and a rate structure that would be the same for everyone.

Hoping to fight fire with fire, the St. Paul Board of Trade tried to form a cooperative in 1865 that would pull together all the upper Mississippi River grain collection points. Although it was a weak attempt, and failed because of local rivalries, it was the springboard for an agrarian crusade that lasted a number of decades.

In 1867 Oliver H. Kelley, a Minnesota farmer and a clerk at the Bureau of Agriculture in Washington, D.C., recognized that farmers would not be able to strengthen their position unless they joined forces against the railroads and elevator operators. To help them, Kelley founded the National Grange. In 1868 he returned home, and Minnesota farmers were ripe for his ideas. Grange meetings were organized in tiny halls across the state, and by the following year forty Granges had been established in Minnesota. Five years later Kelley's idea had exploded into 20,000 chapters located throughout the country.

Through the last half of the 1860s and most of the 1870s, Grangers collaborated to influence public opinion and legislative action. Along with Congressman Ignatius Donnelly, Minnesota's renowned orator and social reformer, Grangers helped pave the way for regulation of railroad rates. Laws passed in Minnesota during 1871 and 1874 established railroads as public highways, set maximum levels for shipping rates, and created the position of Commissioner of Railroads as overseer of all railroad business within the state.

The Grange movement also laid the foundation for other important movements in Minnesota that would eventually attempt to unite the interests of farmers and laborers against exploitation by big business. It was a standoff that would root itself in the politics of Minnesota and feed sectional conflicts in the state throughout the last quarter of the nineteenth century and well into the twentieth.

While the rhetoric heated in town halls and meeting rooms, the railroad companies were laying tracks across the state. And with the growth of the network came the growth of competition. The Southern Minnesota, the Winona and St. Peter Railroad, and the Hastings and Dakota Railroad ran parallel lines west. To the north, the Lake Superior and Mississippi Railroad was cutting pathways through the pineries toward the port city of Duluth, while the St. Paul and Pacific Railroad was heading toward the fertile Red River Valley. In 1869 a golden spike was driven into a railroad tie at Promontory, Utah, where the Union Pacific and the Central Pacific met to finally link West and East. On hand to watch that moment in history were 500 Minnesota citizens.

Minnesota had its own brand of railroad heroes. In 1873 James J. Hill, a young immigrant from Canada, began reorganizing the failed St. Paul and Pacific Railroad,

Ignatius Donnelly won a place in the hearts of ordinary folk by his outspoken defense of their interests in his publications and in the Minnesota Legislature. He is also remembered as first resident and promoter of the "paper" town of Ninninger, Minnesota, and as a science-fiction author. Courtesy, Minnesota Historical Society

James J. Hill earned the nickname "Empire Builder" by constructing a network of railroads that linked St. Paul with Canada and Duluth with the Pacific. His business succeeded because he matched a keen head for juggling materials and men with his own persistent hard work. Courtesy, Minnesota Historical Society

and thus began a long upward battle to build his own railroad line across the northern plains of the Dakotas, over the mountains of Montana, and west to Puget Sound. Hill's Great Northern Railroad, when completed in 1893, opened new stands of pine to the lumber barons as well as trade opportunities with the Orient. Within months Hill was shipping southern cotton to Seattle for shipment to Japan, as well as flour from Minneapolis, textiles from New England mills, and ores from Colorado mines.

As a power broker and empire builder, Hill was unmatched throughout the last half of the century. His ability to wheel-and-deal his way through the fine print on railroad-regulating legislation dazzled his opponents. His drive and ambition juxtaposed with his paternalistic care of those he favored has become as legendary as his vision.

46

No Going Back

By the early 1870s the landscape of Minnesota was dotted with new centers of settlement, which were linked together by the telegraph and more than 800 miles of railroad track, fed by a booming agricultural industry, and enriched with the products Minnesota manufacturers could provide—boots and shoes, agricultural implements, and clothing. Clustered around the confluence of the Minnesota and Mississippi rivers, the cities of St. Paul, St. Anthony, and Minneapolis prospered as logs rolled through the rapids around the millraces, grain filled local storage elevators, and tourists seeking a healthful climate paraded along the boardwalks.

Lumbering, flour milling, and transportation powered Minnesota's growth, bringing dollars from the rest of the country with every blast of a steamboat or locomotive whistle. By 1872, when St. Anthony and Minneapolis became one city, the area was known as a center for railroads, manufacturing, milling, and finance. As the head of navigation on the Mississippi River—and the jumping-off place for many new arrivals—St. Paul was a transportation hub as well as a center for the banking, insurance, and printing industries.

Above the Falls of St. Anthony, Minneapolis cradled the lumber that roared downriver from the north and built mills and furniture manufacturing plants. An animal feed industry grew fat with the grain that arrived daily on trains that were reaching farther north and west. Bakeries thrived. So did a clothing manufacturing industry that put bread on the table for an increasing number of laborers.

The seeds of civilization were swelling in other towns as well. From surrounding farms, produce and dairy products arrived regularly in villages such as Crookston, St. Cloud, Winona, and Albert Lea, where elevators, cheese factories, and creameries soon sprang up. In Duluth, businessmen looked eastward toward the Great Lakes and speculated that grain could be brought by train to the inland port, then shipped through the lakes, down the St. Lawrence River, and eventually to the waiting tables of Europe. In fact, Duluth's potential as a great shipping center was so well known among the great financiers and builders of the day that Jay Cooke, promoter for the Northern Pacific Railroad, made Duluth the eastern terminal for his railroad line. By the 1880s the city was becoming a port known throughout the world.

The success of hundreds of farm families hung on the decisions of these members of the Northern Pacific Expedition, who plotted the route of the Northern Pacific Railroad in the summer of 1869. The men are pictured in their camp at Glenwood, Minnesota. Courtesy, Minnesota Historical Society

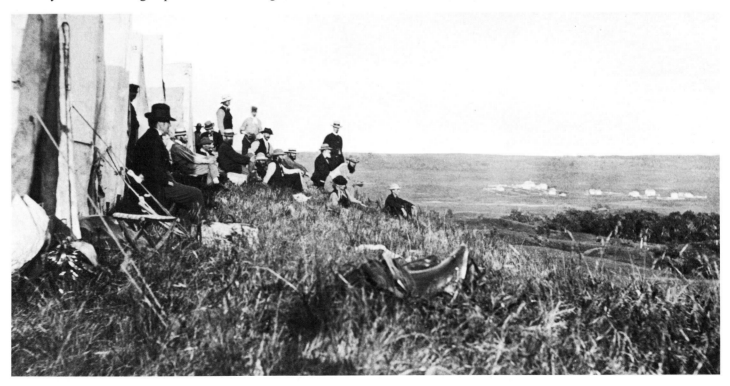

Only two decades after Minnesota had become a territory, a subtle shift began in its economic foundations. Instead of living off the land, some families looked for steady wages in the factories and mills. Instead of living on isolated farms, they wanted neighbors, the convenience of grocery stores, and regular mail delivery. Instead of living from one growing season to the next, these Minnesota families hoped to put some money away for a rainy day, order a new stove from Montgomery Ward, or even visit the Boardwalk in Atlantic City.

While Minnesota's pine swirled in the eddies around the lumber mills and industrial chimneys belched smoke, a new class system slowly worked its way into urban life. Frustrated by poor working conditions, low wages, and long hours, working men and women pulled themselves together against those they believed profited from their toil. By 1883 the first labor union—the Knights of Labor—had an active organization in the state, touching off a political rivalry between business and labor interests that

Soft sandstone underlying the hard limestone ledge around the Falls of St. Anthony gave way to the persistent scouring action of moving water, and on October 5, 1869, a tunnel built there collapsed. Courtesy, Minnesota Historical Society

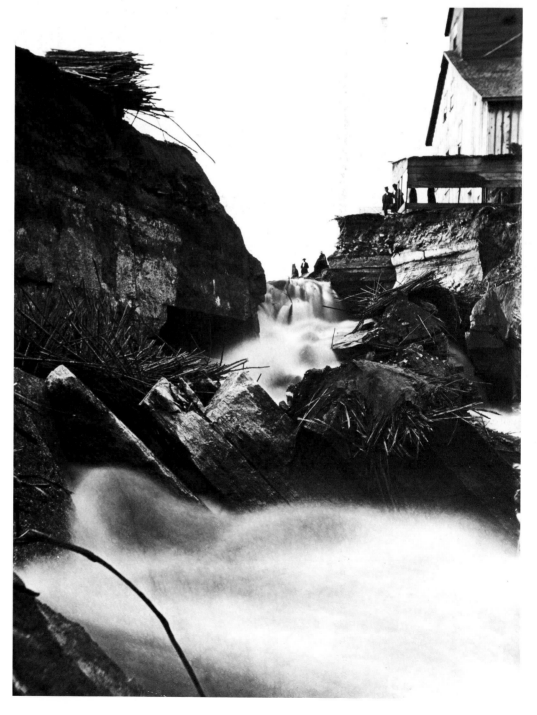

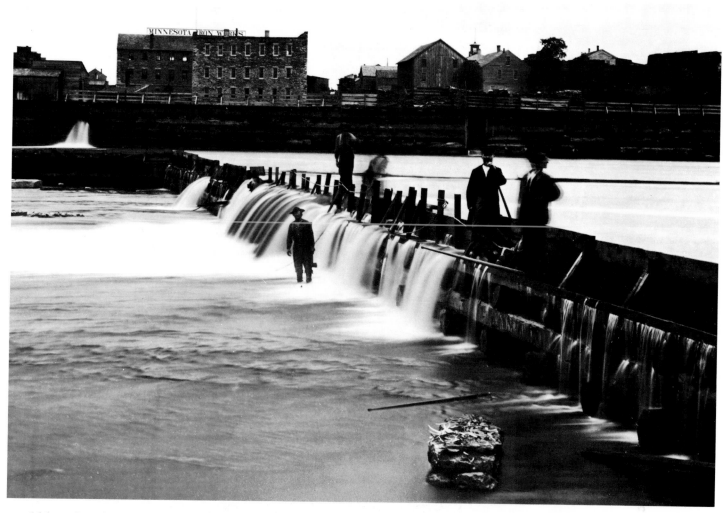

would last decades, paralleling the efforts of the Grangers who represented the small Minnesota farmer.

Between the end of the Civil War and the country's centennial, the citizens of Minnesota learned to accept the accelerated pace of change that accompanies industrialization. It was a time when interests were divided between labor and business, city and village, north timber country and southern farmland—even between those who were concerned about the preservation of Minnesota's natural resources and those who favored exploitation.

It was also a time of learning just how far civilization can push before it starts to destroy its own foundation. On Tuesday, October 5, 1869, a tunnel that had been built between Hennepin and Nicollet islands collapsed. The river formed an enormous maelstrom, whirling its way through the tunnel, ripping the roof as though it were made of sand. People from Minneapolis and St. Anthony hurried to the riverbank where they watched three mills on Hennepin Island tumble into the Mississippi River.

A wave of fear choked many of those who watched as word spread that the Falls of St. Anthony would be destroyed. The general assumption that the waterpower of the falls was inexhaustible was gone forever. On October 6, 1869, the *Minneapolis Tribune* acknowledged that the Falls of St. Anthony were vital to the economic security of the state's industries. "Every moment of time, is how precious no man knows, so long as that mighty rush of water, irresistible in its power of demolition, is free to undermine and subvert the prosperity of these two cities," it declared.

As hundreds of men worked day and night to save the falls in the days following the tunnel's break-up, Minnesotans learned that a strong economic future could not be taken for granted.

The 1869 collapse of the tunnel between Hennepin and Nicollet islands proved only a temporary setback in the taming of the mighty Mississippi. The following year engineers persisted in their efforts to harness the waterpower. Courtesy, Minnesota Historical Society

Mueller and Company Grocers of Rochester decorated a young lady in dried fruit to lure people to their shop in the 1880s. Courtesy, Olmsted County Historical Society

GILDING "THE LILY OF THE WEST"

CHANGES IN THE WIND

Early in the summer of 1873 the homesteading farmer in southern Minnesota had good land beneath his feet, credit when he needed it, and a market for all the grain his family could produce. Before him—as far as the eye could see—was the wheat that would guarantee his future.

But riding the early-June wind were hordes of Rocky Mountain locusts, swirling and gnawing their way east through the tender grasses, stripping the countryside. The farmer and his family could do little but watch as the grasshoppers dropped into their fields and demolished the waving stalks of wheat. When the swarm moved on, the family was left with only the hope that they could survive the winter to plant again in the spring.

They weren't alone in their troubles. Throughout the state, newspapers reported swarms of locusts so large that they eclipsed the sun. The roar of their frenzied feeding sounded like a prairie fire. From Rock, Pipestone, Lincoln, Redwood, Renville, Brown, Watonwan, Blue Earth, and Faribault counties, farmers reported losses totaling millions of dollars that summer.

What had been a bad dream for the farmers in 1873 became a nightmare in 1874. The grasshoppers had done more than ruin crops—they had laid eggs. The following spring, black clouds of young hoppers erupted in field after field in search of food, and within days Minnesota was again under siege. The locusts consumed crops as far north as Becker and Aitkin counties and as far east as the Mississippi River.

Pluck, determination, and charity carried many Minnesota farming families through the next three winters. With each spring thaw came hope, and with each planting came disaster. As grasshopper swarms crossed and recrossed the state in search of new feeding grounds, the crisis made inroads into the mainstream economy. Local businesses extended credit to farmers until the money ran out, while food prices soared.

In 1876 newly elected Governor John S. Pillsbury encouraged Minnesotans to do everything they could think of to fight the pests, and listened patiently while one person after another offered solutions. A teacher from New Ulm, Gustav Heydrich,

John S. Pillsbury went into milling when he came to Minnesota in 1855, but his nephew started the company that still flourishes today. In the 1890s, as governor, he encouraged Minnesotans to invent ways to rid the state of the grasshopper plague. Courtesy, Minnesota Historical Society

In this library, Ignatius Donnelly produced both political tirades in support of common people and science-fiction dramas of the past and the future. Courtesy, Minnesota Historical Society

proposed a horse-driven machine that would sweep grasshoppers into a bin and then crush them under the machine's heavy wheels. A Willmar citizen, Andrew Robbins, invented a tar-filled metal pan that would scoop up and trap grasshoppers as the pan was dragged across a field; several hundred of the inexpensive "hopperdozers" were put into operation. In 1877 the town of Le Sueur advertised a bounty of 20 cents a quart for dead grasshoppers, but the number caught so far exceeded the town's coffers that the bounty was reduced to one dollar a bushel. Still the grasshoppers came.

A legislative relief committee, chaired by prominent St. Paul politician Henry M. Rice, distributed many thousands of dollars across the state, feeding and clothing 6,000 people during the winter of 1876 and appropriating $75,000 in 1877 for buying seed grain. Help also came from the National Grange, which collected $11,000 to spread among the stricken families in Minnesota and in other states.

In the spring of 1877 the next crop of locusts hatched and Minnesotans prepared for another year of disaster. But instead of eating their way through the state, the grasshoppers lifted their wings and rode the wind across the border. The ordeal was over.

The grasshopper plague was only one of a series of misfortunes that hit Minnesota farmers in the years after the Civil War. Farm families felt increasingly cut off from the prosperity that the rest of the country enjoyed. Droughts, floods, hailstorms, crop disease, and insects plagued the wheat fields during the 1870s. In addition, farmers felt manipulated by the railroads and by grain-buyers, whom they accused of unfairly grading their wheat.

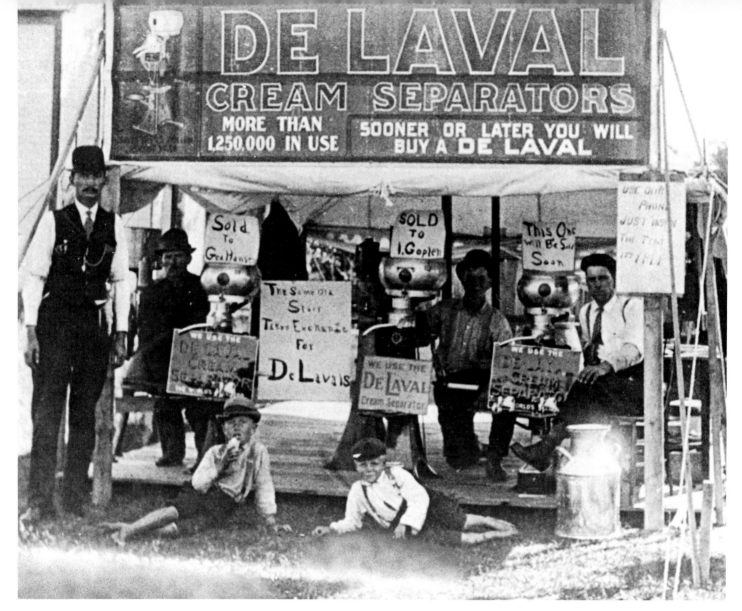

The De Laval Cream Separator booth at the Morrison County Fair relied on user testimony and a free telephone to boost sales. The separator made possible the production of dairy products on a large scale. Courtesy, Morrison County Historical Society

At the heart of the farmers' troubles was the fact that wheat prices had dropped from an all-time high of $1.50 a bushel during the Civil War to 80 cents a bushel by 1870. Farm families complained that to make ends meet they had to produce two bushels of wheat for every one they had grown in better days. But to grow more crops, they needed more equipment, and that was costly. Life down on the farm had become a struggle.

Through the Grange movement the farmers turned their fears into action. The Grange movement was instrumental in helping to establish a state commissioner of railroads in 1871, and a board of railroad commissioners in 1874, which had the power to develop a rate schedule. The Grange also introduced farmers to the concept of cost savings through cooperative purchasing. The Werner harvester was manufactured and sold through local Granges at half the cost other manufacturers were charging.

In 1875, at the height of its political strength and with a national membership of more than 1.5 million, the Grange movement began to crumble under its own weight. With so many members, it could no longer effectively secure every farmer's needs. Internal dissension eroded its membership base, and within five years the movement lost 85 percent of its membership. By the early 1880s, farmers across the country would regroup into the national Farmers' Alliance. First described as a lobbying organization on behalf of farmers, within a decade the alliance would transform itself into a third party with an agenda all its own.

When wheat became the state's primary cash crop during the Civil War, it breathed life into Minneapolis. Flour mills quickly banked St. Anthony Falls, and dollars for flour pumped up the Mill City's finances. In the Red River Valley, mammoth farms—many thousands of acres in size—supplied wheat for the whole country.

But growing wheat year after year in the same fields depleted the soil, and farmers were left with weakened crops vulnerable to disease and pests. They dismally accepted the fact that an acre of Minnesota soil that grew twenty-two bushels of wheat in the 1860s could only produce eleven bushels in the 1870s. At the same time, rising property

taxes and ballooning operating costs made it imperative that a family get the most out of the soil. Advances in machinery—steel plows, binders, threshing machines—made agricultural mass production a possibility, even a necessity.

Properly done, diversified farming could help replace soil nutrients, and at the same time spread the risk of crop failure. By the middle 1870s many farmers in the southeastern counties of Minnesota had augmented their wheat crops with small dairy operations, growing feed crops such as corn and oats for their own use.

By 1878 enough cows were being raised in Minnesota to invigorate the growth of the dairy industry. That year the Minnesota Dairymen's Association was organized to help develop local markets, and the De Laval cream separator opened up the possibility of building large-scale production facilities for dairy products. By the middle of the next decade, sixty creameries and forty cheese businesses had laid the foundation for a cooperative marketing movement that would eventually make Minnesota the nation's largest producer of butter and a leading dairy state.

Thanks to three pioneers in agricultural diversification, Minnesota farmers learned new ways to vary their crops and thus build better lives. Wendelin Grimm, an immigrant from Germany, experimented with an alfalfa seed that could survive Minnesota's winter. Grimm alfalfa quickly became a staple for the state's cattle-raising industry. Another settler, Peter M. Gedio, moved to the shores of Lake Minnetonka where he experimented with fruit trees. His "Wealthy" is today one of the state's most

The importance of a creamery to local farmers is clear in this view of wagons full of milk arriving at the Lake Elizabeth creamery about 1891. Courtesy, Minnesota Historical Society

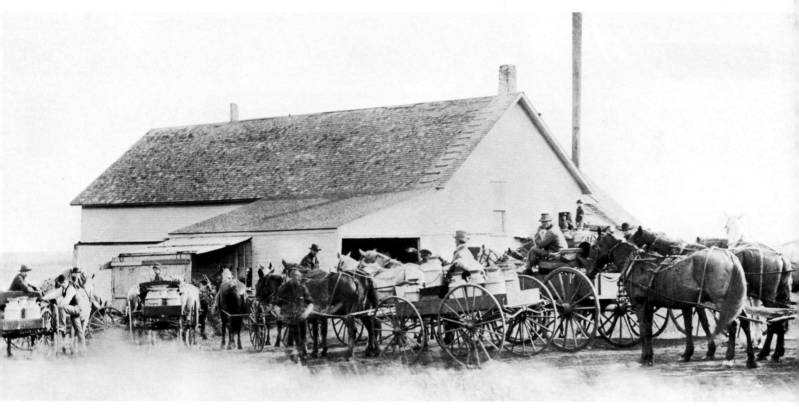

popular apples. Oren C. Gregg was one of the first Minnesota farmers to try dairying. Having tried and had trouble raising wheat, in the mid-1860s he decided to build a dairy business in the rich grasslands of Minnesota. Gregg's success with winter dairying eventually attracted the interest of officials from the University of Minnesota who wanted to find a way to educate farmers. In 1886, Gregg was hired to carry his message out to the fields and the small towns. One year later he was made chairman of the newly organized Farmers' Institute at the University of Minnesota.

For many years Gregg and his staff provided farmers with much-needed information on crop production, also offering rural women information about the domestic side of running a farm. Through the institute he helped farm families change from single

crop farming to diversified agriculture, thus stimulating the growth of the dairy and livestock industries. Under his guidance the day's scientific discoveries in the laboratories were taken out into the farmers' fields.

THE MIDDLINGS PURIFIER AND WASHBURN'S FOLLY

In the post-Civil War Midwest, inventors were making discoveries that were to have far-reaching consequences. In the early 1870s the invention of the middlings purifier, a sifting mechanism used in grinding wheat, bolstered the growth of the milling industry. Despite their troubles with disease, weather, and pests, many Minnesota farmers continued their love affair with wheat through the last quarter of the nineteenth century. But the flour ground from their wheat was poor in quality and appearance. Since the early days of the territory, farmers had been harvesting a hard red wheat that could be planted in the early spring. The more typical winter wheat grown in other parts of the country, which had to be planted in the fall, could not survive Minnesota's severe winters.

Although the early-spring wheat solved the farmers' problems, it caused headaches for the millers. The kernel of the spring wheat, containing the gluten and wheat germ, was too hard to be crushed properly and so was sifted out with the bran. The loss of the "middlings" meant the loss of the wheat's leavening agent as well as important nutrients.

A few small mills in Hastings, Dundas, and Winona discovered ways to make a better-quality flour from spring wheat, but none that could be used in large-scale production. So when Cadwallader Washburn, one of the founders of General Mills,

Right: *Though Minneapolis gained international fame as a milling center, smaller millers also established local reputations of their own. This miller's shop in Waseca offered its own brand, "Waseca White Rose." Courtesy, Waseca County Historical Society*

Facing page: *Cadwallader Washburn, one of the founders of General Mills, was instrumental in revolutionizing the milling industry by helping to perfect the middlings purifier. Courtesy, Minneapolis Public Library*

Growth in the new manufacturing sector paralleled the fortunes of the major players in Minneapolis and St. Paul, and statistics show an impressive spurt in production between Minnesota's territorial days and the end of the century. In 1850 the gross value of manufactured products was calculated to be about $58,000. By 1880, however, it had increased to $76 million, and ten years later had more than doubled again. Industrial progress in those five decades was so intense that Minnesota rose from thirty-fifth to fifteenth in the nation in number of industrial employees.

But urban working families recognized early on that a healthy business did not necessarily translate into better living conditions for its workers. In fact, quite the opposite was true. Every day more people stepped off the trains or steamboats looking for the key to their fortunes or, at the very least, for steady jobs in the bustling cities of Minneapolis, St. Paul, and Duluth. But as the labor supply grew, wages dropped, as did the workers' influence with their bosses.

Organized protest was not altogether new in Minnesota. In 1854, the journeymen tailors of St. Paul had struck for higher wages, and two years later, St. Paul printers gathered together to discuss their situation. In 1867, difficulty with a subcontractor caused the construction workers who were building the Faribault School for the Deaf, Dumb and Blind to walk off the job, while fifty-two Germans in Minneapolis founded a workingman's society that supported member families without income and helped members find work.

Railroad transportation gave places like Fergus Falls the role of market town, supporting shops and services like barbershops. In this shop patrons could keep their own personal shaving mugs. Courtesy, Ottertail County Historical Society

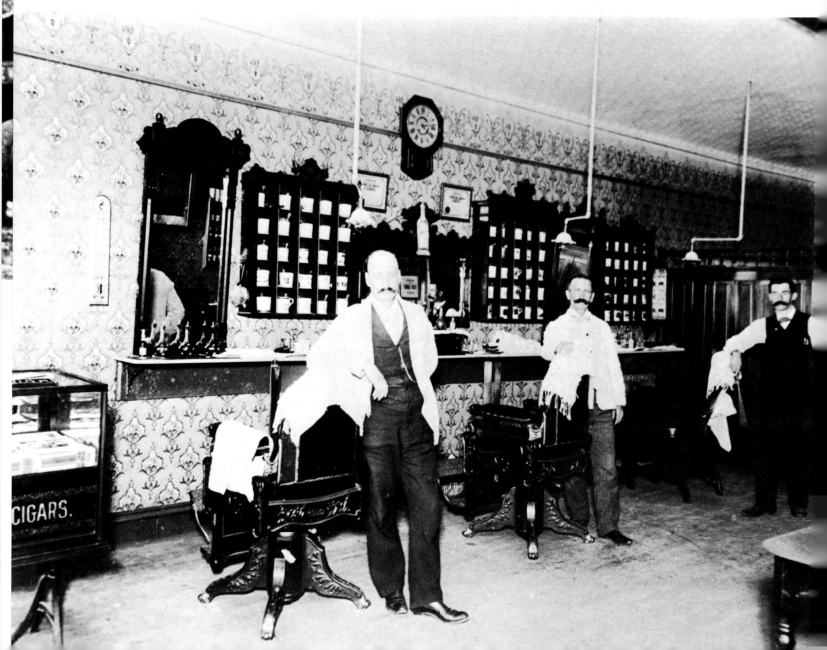

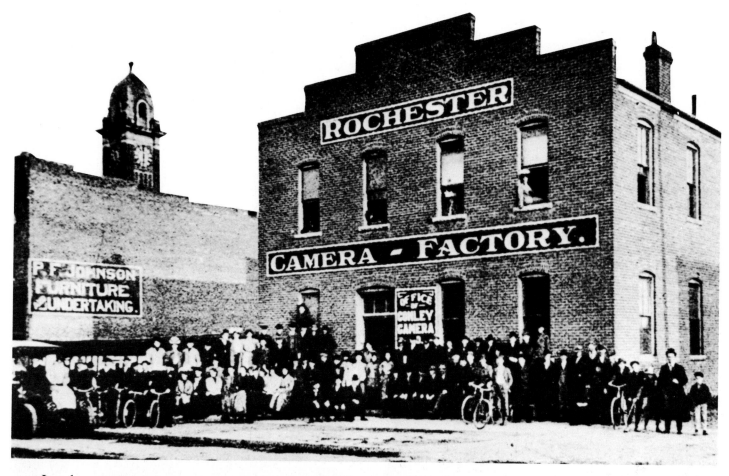

Conley Camera in Rochester, Minnesota, supplied the Sears, Roebuck Company with cameras. Conley capitalized on Kodak's reputation by using "Rochester Camera Factory" as its name. Courtesy, Minnesota Historical Society

In subsequent years, newspaper accounts show that the journeymen cigar makers, coopers, and mechanics also pulled together to gain strength in bargaining for their respective trades. Unions were formed in small towns such as Lake City and Farmington. Marine engineers united in Duluth.

As the railroads cut across the land, brotherhoods evolved for the workers who were cutting the forests, hammering through the rocks, and laying down the steel bars. In 1870 a Brotherhood of Locomotive Engineers was founded in Austin, followed two years later by a division in St. Paul. Over the next few years railroad brotherhoods spread from one corner of the state to the next. In their infant stage these groups were a fairly congenial reminder to the bosses that labor could organize. But by 1876, when railroads and industry felt the effects of a rising economy, railroad brotherhoods came out swinging, demanding better working conditions and a bigger share of the profit. In 1877 a national strike led by the Knights of Labor against the Union Pacific Railroad made headlines in Minnesota, when the union forced the giant corporation to rescind a number of wage cuts. The following year 6,500 laborers belonged to Minnesota chapters of the Knights of Labor, and with an increasing membership and the sympathy of the newspaper-reading middle class, labor's demands grew into hot political issues. The more than seventy strikes called between 1881 and 1884 cut deeply into the heart of the state's economy.

On the national scene, President Grover Cleveland formed the U.S. Department of Labor, partly in response to the violent Haymarket Square Riot in Chicago. That same riot stepped up the political pace in Minnesota, as farmers and laborers began recognizing common bonds and joining together to influence legislation. In 1886 the Minnesota Farmers' Alliance called a joint meeting with the Knights of Labor, and the result was a list of demands taken to the leaders of both the Republicans and the Democrats.

Whatever their circumstances, a steady stream of African Americans and their families found Minnesota the right place to build or rebuild their lives. A few were slaves, brought to Fort Snelling by officers. But by the 1880s, African American physicians, teachers and lawyers were recruited to serve the growing population in the Twin Cities. By 1900, African Americans had established themselves throughout the economy. Shown here is the first African American policeman in Saint Paul, thought to be James H. Burrell. Courtesy, Minnesota Historical Society. Location # HV9.11 r3, Negative # 46286

John H. Stevens characterized the first generation of Minnesota settlers. He earned the title "Father of Minneapolis" by helping to organize the first school, church, library, and agricultural fair in what became Hennepin County. Courtesy, Minnesota Historical Society

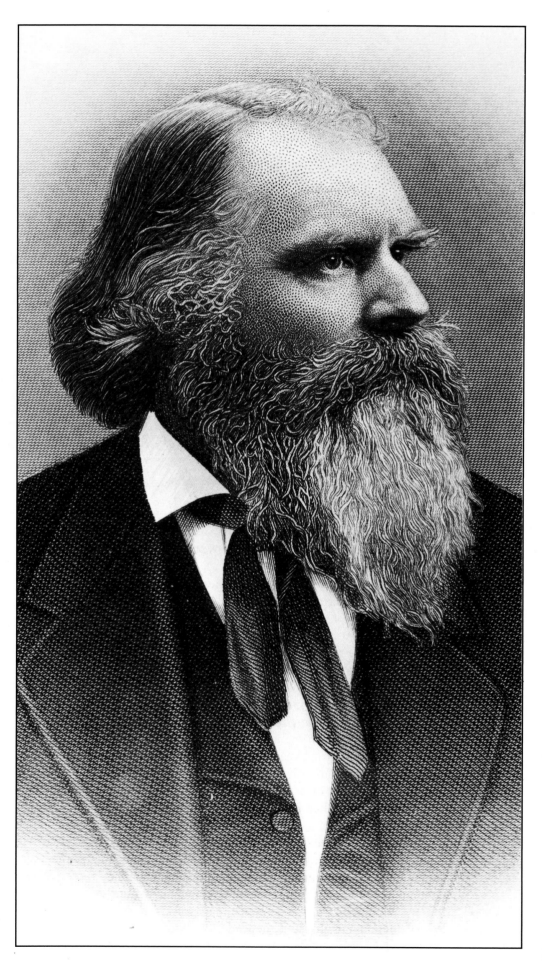

Energized and aggressive, the coalition of farmers and laborers pushed for major reforms, instigating a number of legislative bills. But the legislators' interest quickly cooled, and many of the coalition's demands—such as reduced railroad and interest rates, employers' liability laws, and prohibition of child labor—were shelved.

Feeling that they were not being served well by either the Democrats or the Republicans, farmers and laborers across the country soon came to the conclusion that they would have to create a party of their own. In May 1891, 1,400 delegates with a wide range of affiliations gathered in a Cincinnati, Ohio, music hall for the National Union Conference. Proclaiming, "United we stand, divided we fall" and "Opposition to all monopolies," the delegates were rallied by the passionate oratory of Ignatius Donnelly to join the People's Party and nominate a presidential ticket for the 1892 election. After lengthy debate and numerous squabbles, the delegates created a platform that contained the litany of demands the farmer and labor groups had been calling for through the previous three decades.

Members of the People's Party were called "Populists" or "Pops," and what they wanted more than anything was more government regulation of the banking and railroad magnates. Mortgaged to the hilt, many Populists called for a free and unlimited

A surprising array of small industries employed people in large towns and small cities. Little Falls had its own cigar factory in the late nineteenth century. Farmers in Stearns County, just down the Mississippi River, still grow the shade tobacco used for cigar wrappers. Courtesy, Morrison County Historical Society

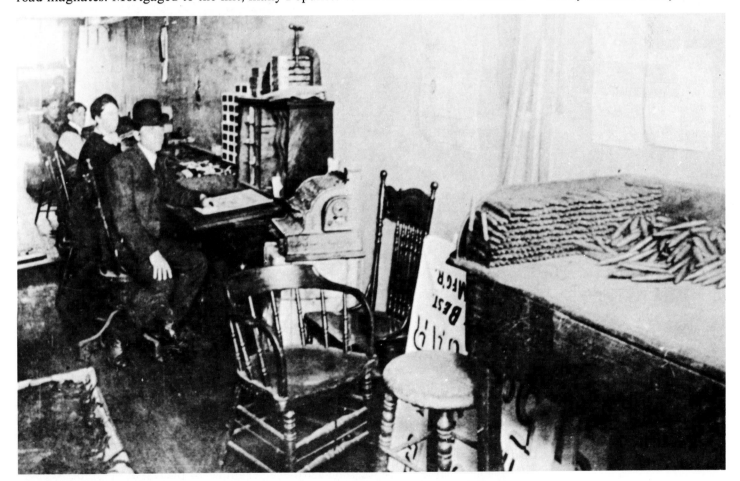

coinage of silver—a move, they claimed, that would help them pay their debts. Further, the Populists wanted the government to put an end to speculation in stocks, options, and futures, and they wanted the president of the United States to be elected by a direct vote of the people.

Although the Populist party faded on the national level within a few years, it wove new ideas into the texture of society and enabled workers to be heard as loudly as their bosses. In Minnesota, the roots of populism ran deep. And populism would have its say in the state's political future. The balance between the needs of business and those of its workers would become the focus of much political debate in the twentieth century.

TALL TALES AND TALL TIMBER

They say that every time she took a step, another Minnesota lake emerged. And when she bellowed the whole continent shook. She was Babe, the Blue Ox, and she measured forty-two axe handles from eye to eye. As Paul Bunyan's sidekick, the Blue Ox was one of the many legends that grew out of logging camps and followed the logs downriver.

The pine forests of Minnesota were as legendary as the giant lumberjack. Growing to more than 180 feet tall and a typical diameter of three to five feet, the white pines helped finance a diversified industrial base for Minnesota. Lumbering was an essential

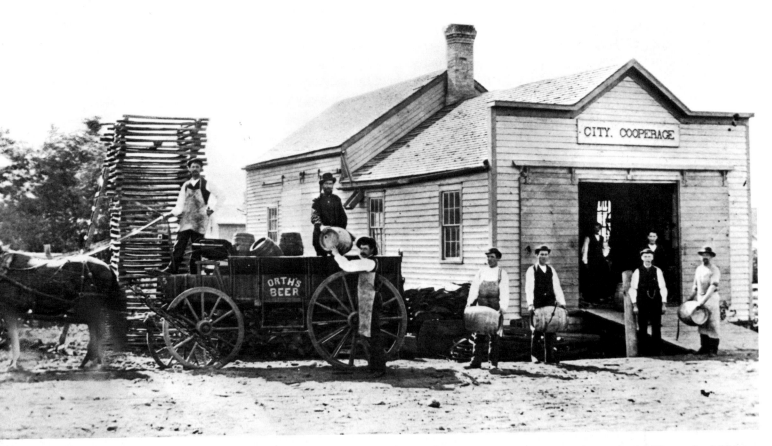

Minneapolis needed more coopers than most cities in order to supply barrels for her flour mills and breweries. Schon and Schnitzius enjoyed a convenient location just a few blocks from the Falls. Courtesy, Minnesota Historical Society

ingredient in Minnesota's growth for a hundred years—from the 1830s to the 1930s—but the boom years were the two decades between 1880 and 1900.

Sawmills at Little Falls, Elk River, St. Anthony, Marine-on-the-St. Croix, Anoka, St. Francis, Clearwater, and Princeton were among Minnesota's first businesses, some dating back to the earliest days of the territory. By the late 1860s, Stillwater was considered the state's leading lumber town, drawing logs from the St. Croix River and its tributary, the Snake. But the lands around the St. Croix Valley, which had been vigorously logged since the 1830s, soon became an example for the rest of the state. Accessible pine was disappearing and woods cruisers—men hired to stake out new territories for logging—moved north on the Rum and Mississippi rivers, looking for thicker and better stands of virgin timber.

By 1870, 4,000 men with 2,000 horses and oxen were following the Mississippi River north to log the winter away in Beltrami, Itasca, and St. Louis counties. Duluth was becoming a shipping center for northern-cut pine, and Minnesota lumber was finding its way to construction sites in such cities as New York, Boston, Cleveland, and Chicago. In Minneapolis, fifteen sawmills sliced through logs brought from the lands along the Rum and Mississippi rivers, while Winona flourished as a gateway to

the budding southern and western markets, fed by logs from the Mississippi and the Chippewa.

Over the next three decades the lumber industry grew in size and importance as lumber companies found quicker and cheaper ways to get the pine out of the woods and into the mills. The 1880 census shows that Minneapolis had 234 mills which turned $4.5 million worth of logs into lumber worth nearly $7.5 million. By 1890 a number of new businesses—such as planing mills and factories for making sashes, doors, laths, blinds, shingles, furniture, wagons, and boxcars—had grown out of the Minneapolis lumber industry, employing nearly 4,000 people and pumping $1.8 million in wages into the city's development.

Between 1857 and 1889 the number of board feet cut from Minnesota timber jumped from about 100 million to 1 billion. The state boasted that it rose from fourteenth to fourth place nationally in terms of the size of its lumbering industry.

Sawmilling records of all kinds were set in the 1890s. The H.C. Akeley Lumber Company in Minneapolis reported cutting more than 50.5 million board feet in 1890. Two years later a mill in Little Falls—owned by Frederick Weyerhaeuser, a major player in Minnesota's lumber industry—cut 32 million feet; and in Winona, the Laird, Norton Company and the Winona Lumber Company each produced 40 million feet.

With the exception of two or three years following the Panic of 1893 (caused by inflated land prices and a railroad industry that had built its power on credit), the last years of the nineteenth century were the glory days of the lumber industry. Unfettered by concerns about the future of Minnesota's forests, businessmen exploited what they could as cost-efficiently as possible.

This broom factory in Fergus Falls used local raw materials to manufacture a basic necessity for rural as well as village residents. Courtesy, Ottertail County Historical Society

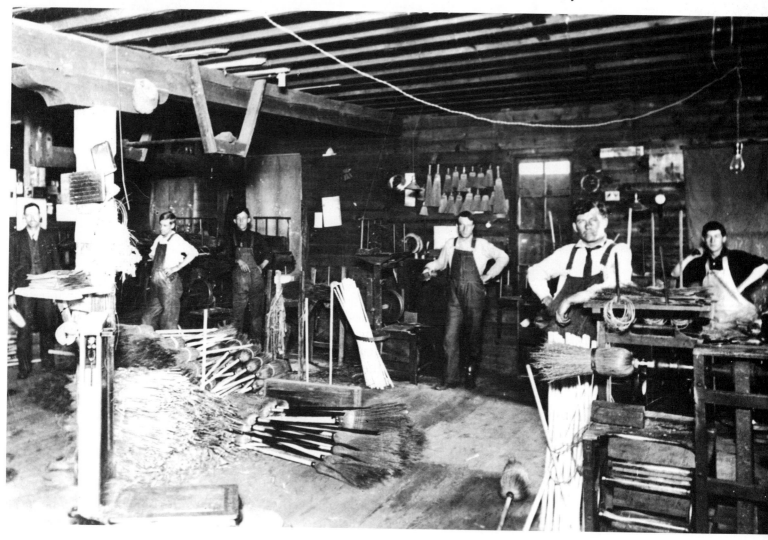

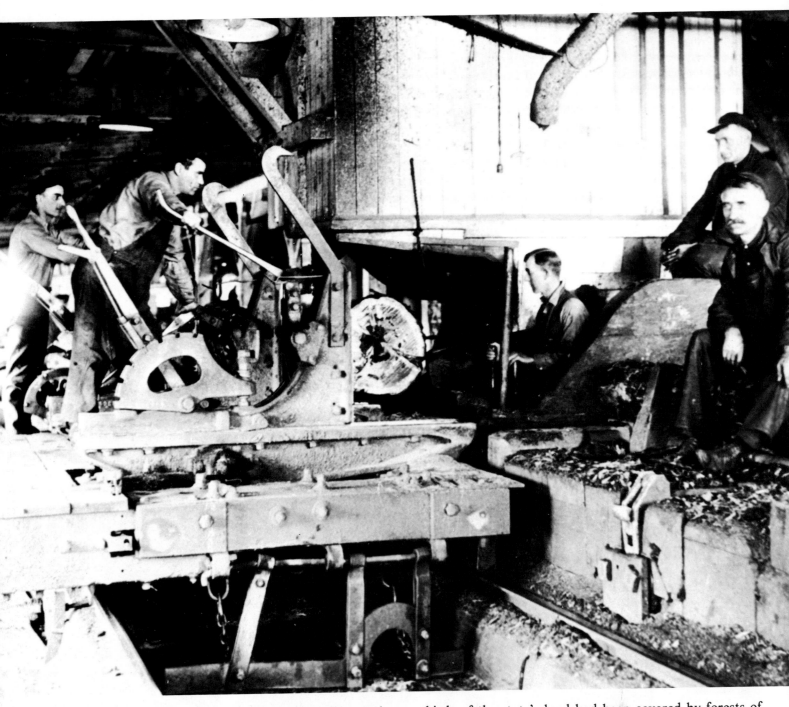

Northern Minnesota's iron ore resources were more than matched by her timber resources. The Virginia Rainy Lake sawmill manufactured lumber to build Range cities and to ship from Duluth harbor. Courtesy, Iron Range Research Center, Pederson Collection

Originally, nearly two-thirds of the state's land had been covered by forests of commercially valuable woods, including white and red pine, spruce, balsam fir, jack pine, white cedar, and tamarack. With the introduction of new machinery and methods, such as steam traction engines for hauling logs out of the woods and narrow-gauge railroads for carrying them to a local mill, loggers were able to move away from the rivers and into the interior of the state.

It took grit to successfully buy and sell Minnesota stumpage. It also took foresight, capital investment, and a good measure of luck. The typical lumberman's philosophy was to buy land cheap, cut timber fast, get out, and move on before bad luck caught up with him. Fortunes teetered while loggers fought logjams on sluggish rivers and diseases such as smallpox in the camps. Major forest fires, ignited as easily by the sparks from a train engine as by lightning, exploded fireballs of pine across uncut timber stands. In 1894 more than 418 people, 248 from the town of Hinkley, died in a forest fire that burned over five counties.

But as the stakes grew and the price for stumpage increased, a small number of businessmen emerged with control of large tracts of forested land. By the end of the nineteenth century, the lumber industry, like the flour-milling industry, had become big business, concentrated in the hands of a few who had the formula to make it pay.

Frederick Weyerhaeuser was one of those men. Socially reclusive, he knew how to build an organization and how to time the acquisition of new land, often skirting the edges of the land laws. As his holdings grew northward from Rock Island, Illinois, in the 1870s and the 1880s, and westward in the 1890s, he made lumbering history. As early as 1872, Weyerhaeuser laid the foundation for a lumbering syndicate called the Mississippi River Logging Company. Though only one of 100 partners, he was the one who knew the size of the others' holdings, and he dictated the terms of the syndicate through its climb to power over the next forty years. The objective of the syndicate

As logging moved further north, timber had to be hauled further to the sawmills. Some logging companies laid tracks into the woods to get the trees out, but few of these lines survived the decline of the industry. Photo by William Roleff, Two Harbors, Minnesota. Courtesy, Minnesota Historical Society

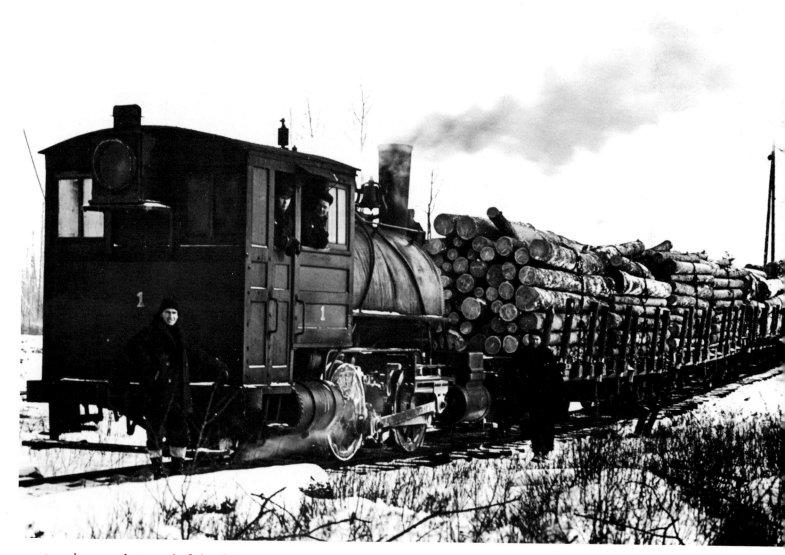

was to gain enough control of the rivers to monopolize the logging traffic from Minnesota and Wisconsin. The syndicate acquired rich lands, logged them, and then divided the revenue according to the amount of stock each syndicate partner held.

The key to the company's success was capital, organization, and political clout. By the 1890s, Weyerhaeuser and his associates had also learned the value of working in close harmony with the railroads. In 1890, Weyerhaeuser purchased the Minnesota land grant of the Northern Pacific Railroad. The next year, he moved his offices next

Right: *Life in a lumber camp was rugged and routine. The men spent most of their time in the woods, so their quarters were strictly utilitarian. They spent their free time washing clothes, playing cards, and making music. Photo by William Roleff, Two Harbors, Minnesota. Courtesy, Minnesota Historical Society*

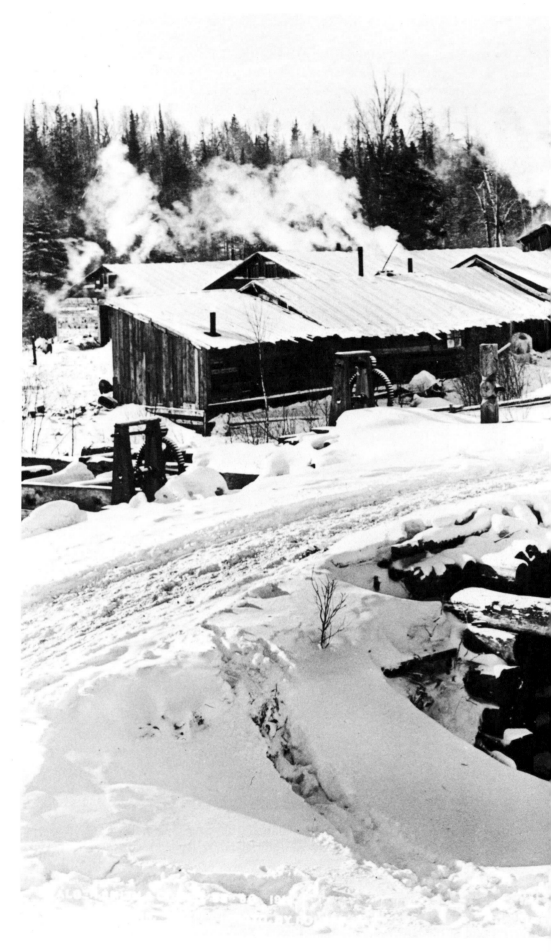

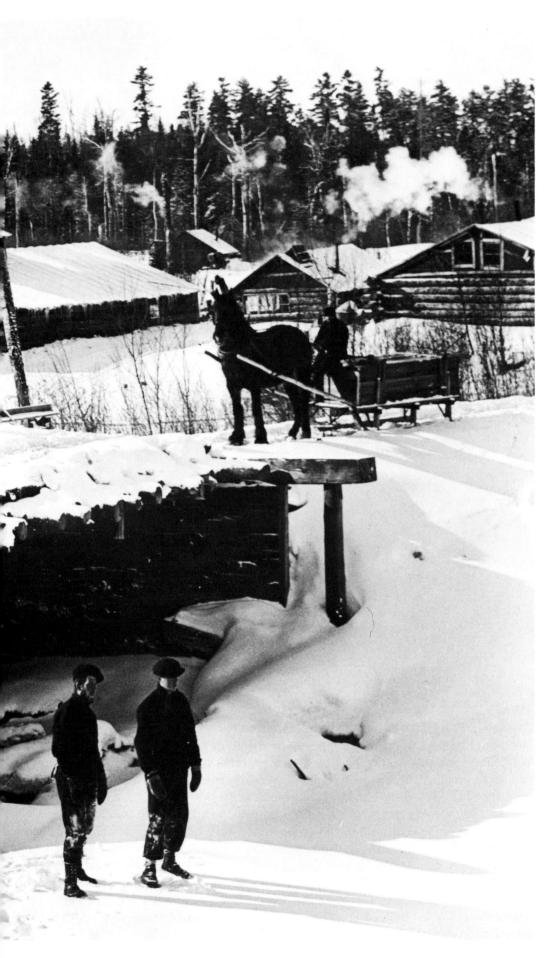

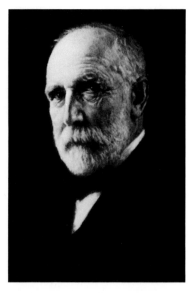

Above: *Frederick Weyerhaeuser appears in this turn-of-the-century oil painting. At about the time this portrait was painted, Weyerhaeuser's Pine Tree Lumber Company formed the economic backbone of Little Falls, Minnesota. Today the family fortune helps support the Morrison County Historical Society, which is housed in the F.A. Weyerhaeuser Museum. Courtesy, Minnesota Historical Society*

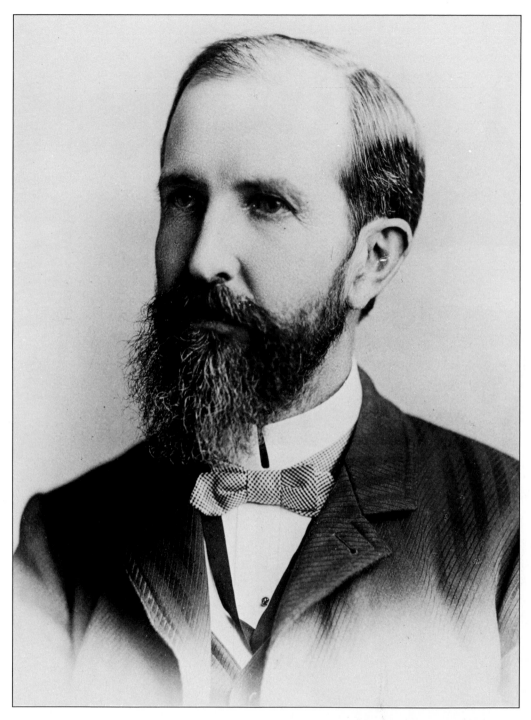

Thomas B. Walker is pictured about 1880. Nineteenth-century big business left a cultural legacy in Minnesota. T.B. Walker's fortune endowed one of the nation's premier modern art museums, the Walker Art Center. Photo by J.A. Brush, Minneapolis, Minnesota. Courtesy, Minnesota Historical Society

door to James J. Hill, who had just consolidated his vast railroad interests into the Great Northern Railroad. The two men grew to be friends as well as business allies. In 1892 Weyerhaeuser's organization bought 50 million feet of stumpage from the St. Paul and Duluth Railroad. Two years later, Hill sold Weyerhaeuser 990,000 acres of timberland from the old St. Paul and Pacific land grant.

In 1900 the Weyerhaeuser Timber Company was formed to purchase the vast tracts of land in the West held by the ailing Northern Pacific Railroad, which had been left gasping for breath by the severe Panic of 1893. During the first decade of the new century, the Weyerhaeuser Timber Company had bought considerable land in Washington, Oregon, Idaho, and California, causing land prices to skyrocket. Having bought timberland in Washington for $6 an acre, Weyerhaeuser sold it a few years later for $120 an acre. When he died in 1914, his empire included 10 million acres of timber extending from Canada to Mexico, from Maine to Puget Sound.

Thomas B. Walker was another businessman who understood how to use the railroads to build a lumber empire. Walker came to Minnesota in 1862 to sell grindstones. Finding the market poor, he took a job as a surveyor for the St. Paul and Duluth Railroad. While working on the crew, Walker learned how to read the commercial value of a forest—a skill that would earn him a place in history as one of Minnesota's leading lumber barons.

Over several years, Walker learned that it was much less expensive to ship dried lumber than to haul green logs. He also discovered the value of building small mills close to the logging site, eliminating the costs and uncertainties of river drives.

Walker was attracted to the rich pine along the upper Red River. Through the 1880s he operated the Red River Lumber Company on the Clearwater River, a tributary of the Red River. Once the logs were cut into lumber, they were hauled by rail from Walker's mill at Crookston to Winnipeg. A new northern market was tapped for the first time.

In 1887 Walker began doing business with H.C. Akeley, a businessman from Michigan who intended to build a sawmill at St. Cloud. Walker offered to sell Akeley half interest in his northern timber tracts, which were potentially valuable but remote from the main river systems. Walker had a plan. By crisscrossing their timberlands

Railroad construction continued throughout the nineteenth century as more lines linked every county in the state to the national network. As the prairies filled up with farmers, there was plenty of freight to support dozens of different companies. Photo by Manderfeld and Goede. Courtesy, Minnesota Historical Society

with rail lines, the two men would be able to haul the pine to their mills easily. The method proved to be much more cost-efficient than the river drives, especially since few logs were lost or damaged. The Walker-Akeley mill at St. Cloud grew quickly, and during its heyday was one of the largest sawmills in the world.

Minnesota's industrial triumvirate—lumber, flour milling, and the railroads—established the state's position in international trade. The industries drew strength and capital resources from each other, and the respective barons frequently dabbled in each other's affairs. Minneapolis politician and lumberman William D. Washburn, a member of the flour-milling family, financed the building of the Minneapolis, St. Paul and

The Minneapolis and St. Louis Railroad provided an essential link between farmers in southern Minnesota and the flour mills in Minneapolis. Like the Soo Line, the M & St.L.R.R. was a miller's road, built to gain independence from competition in Chicago and Milwaukee. Courtesy, Minnesota Historical Society

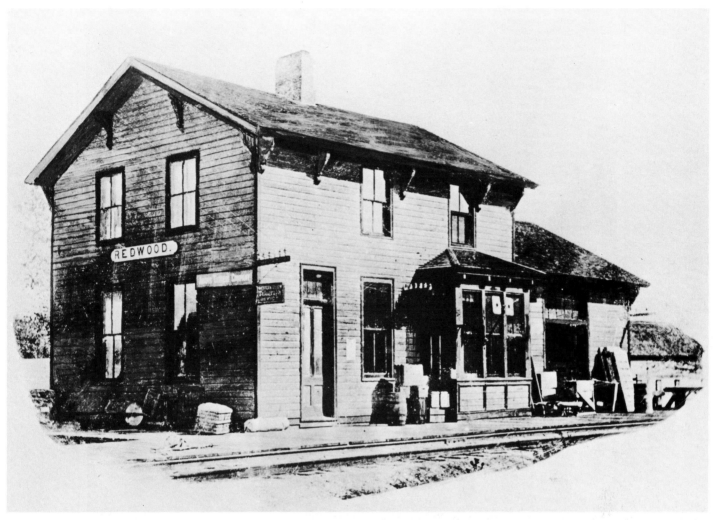

Sault Ste. Marie Railroad to provide a more direct route for shipping Minneapolis flour through the Great Lakes to the East Coast. The Soo Line, as it was soon to be called, also gave the Washburn interests access to fine forestland in the north. By 1890, 31.93 percent of the Soo Line's tonnage was in lumber, while 24.77 percent was in grain.

The railroads of Minnesota were powered by major decision makers such as James J. Hill, the Washburns, and Walker, but they were built by teams of laborers who scraped up topsoil, laid tracks, and built bridges through summers that were too hot and autumn rains that chilled them to the bone. Side by side, workers of many nationalities inched their way across the state—a mile a day—for a solid daily wage of two dollars.

In 1872, fifteen railroad companies had laid about 2,000 miles of track in Minnesota. Rail connected the Twin Cities and Lake Michigan, as well as Duluth and the Red River Valley. But railroad construction was only in its infancy. Capitalized by an industrial base that was growing stronger every day and vitalized by an exploding population, by 1890 the railroads had woven a network of more than 5,000 miles.

For Minnesota, the railroads were the key to every dimension of its growth. Its industrial base, agricultural prominence, population expansion, and financial strengths were directly linked to the tracks that had helped industrialize every corner of the state. A Pullman car made travel to Minnesota comfortable and it helped encourage a fledgling tourism industry. Refrigerated railroad cars boosted southwestern Minnesota's cattle business by ensuring that Midwestern meat would be fresh when it was delivered to U.S. tables. Wheat, flour, and lumber—representative of Minnesotan ingenuity and hard work—were mingled into the global economy. The railroads had brought the world to Minnesota.

Spawned by the railroad, one Minnesota business dramatically improved the material comfort of millions of Americans. A young station agent, Richard W. Sears, began his business in 1886 in this depot in N. Redwood, Minnesota. He quickly relocated to Minneapolis, and then to Chicago to take advantage of better rail connections. Courtesy, Minnesota Historical Society

The Merchant's National Bank opened this new building in St. Paul in 1915. Urban banks celebrated their success with monumental flamboyance. Courtesy, Minnesota Historical Society

MANAGING BIG BUSINESS

A GIANT BURIED IN THE HILLS

For turn-of-the-century Minnesotans reports of international war may have seemed as commonplace as changes in the weather. In 1898 the United States waged a naval war against Spain, then two years later joined an alliance with Britain, France, Germany, Russia, and Japan to quell a Chinese nationalist uprising called the Boxer Rebellion. In the White House, President Theodore Roosevelt was awarded the Nobel Peace Prize for the part he played in ending the Russo-Japanese War, and there was hopeful talk around the country that another Hague Peace Conference would end worldwide hostilities once and for all.

But in July of 1907, disturbing news closer to home caught the public's attention. On the Mesabi Range, in northern Minnesota, a bitter feud between the miners and the Oliver Iron Mining Company (a subsidiary of the United States Steel Corporation) ended in a labor walkout. It was the first time miners had organized a strike in Minnesota. Backed by a spirited and vocal national union, the Western Federation of Miners (WFM), 16,000 Mesabi miners demanded payment of wages by the day rather than by the amount of ore they mined. They also called for a pay increase and an eight-hour work day.

Many Minnesotans worried that a long strike would hobble the state's accelerating economy. As it turned out, the miners' strike wasn't violent or long-lived. Through August, a few minor scuffles between the strikers and deputies ended in injuries on both sides. But the Oliver Iron Mining Company broke the labor action by calling in immigrant strike-breakers, who understood neither the language nor the meaning of collective bargaining. Trainloads of imported laborers arrived daily in the mining towns. By October most of the miners had returned to work, their demands once again only dreams.

Although the Mesabi Range had at that time been producing iron ore for only fifteen years, the great open-pit mines were massive testimonials to the fact that the range was producing half of the nation's iron ore. Mesabi iron ore was not only plentiful, stretching southward to within fifty miles of Duluth and southwest to the thriving lumber town of Grand Rapids, it was also relatively inexpensive to mine. The loose red ore lay under just a few feet of topsoil. It was easily scooped up in steam shovels and dumped into train cars for shipment to Eastern mills.

The Mesabi Range was the second of three mining areas discovered in Minnesota between 1875 and 1911. The Vermilion Range, near Vermilion Lake, was the first. The Cuyuna Range, which runs southwest from Aitkin for about sixty miles, began shipping its iron ore in 1911. Particularly high in manganese (an important ingredient in producing steel), Cuyuna Range iron ore was critical to American industry during World War I when manganese imports were curtailed.

But the leader in iron ore production was clearly the Mesabi Range. By the turn of the century there were more than thirty working mines on the Mesabi Range. Ironically, the Mesabi Range—which single-handedly turned Minnesota into the largest iron ore-producing state in the union—had been bypassed a number of times by explorers and scientists looking for the mother lode.

For twenty-five years, Leonidas Merritt, one of seven brothers, had been ridiculed by his peers as he searched for iron ore in the upper Mississippi wilderness. Merritt

By the 1920s, improved mining techniques and machinery enabled underground miners to work in much safer conditions. Courtesy, Iron Range Research Center, U.S. Steel Collection

80

Head frames marked the sites of underground mines on the Range. These were worked by experienced Cornish miners brought by the mining companies from Michigan's upper peninsula. Softer ore in horizontal formations in the Mesabi Range lent itself to strip-mining, which required less specialized skills. Courtesy, Iron Range Research Center, Opie Collection

worked as a timber cruiser, and he used a dip compass and a woodsman's persistence to map the areas he believed held ore. In 1890, he took out 141 mining leases and put together exploring parties which he hoped would find enough iron ore samplings to prove his claim. In November, one of the parties struck ore four miles west of present-day Virginia. The discovery rapidly led to the opening of the Mountain Iron Mine, currently one of the largest mines on the Mesabi Range. The following summer, another Merritt explorer noticed how red the soil was around the roots of a fallen tree. His sharp observation led to the opening of the Biwabik Mine.

"Mesabi" is a Chippewa word meaning "a giant buried in the hills." For Minnesota the name was particularly appropriate. When the word about the rich ore reserves leaked out, the north country exploded. Towns such as Ironton, Hibbing, Eveleth, Chisholm, Virginia, and Babbitt sprang up overnight, and the population of St. Louis County more than quadrupled between 1880 and 1910. Many of the newcomers to northern Minnesota, often penniless and lacking in skills, were new to America as well, arriving from Scandinavia, Yugoslavia, Italy, Poland, and Greece. They offered strong backs and, at first, gratitude for the work that would give them a fresh start.

For the miners and their families, life centered around the mines. Daily blasts of dynamite in the pits shook buildings, frightened children, and broke crockery. Their lives were scheduled by whistles that announced the end of shifts and the arrival of the ore trains. The mines were like living organisms, nibbling away at the land around them. The towns of Hibbing and Eveleth had to be moved from their original sites to accommodate the needs of the mines.

Embarrass, Minnesota, was an interim stop on the Duluth and Iron Range Railroad. The railroad was built to carry ore from the Vermilion Range to the ore docks on Lake Superior. The first sixty-eight miles from the Tower-Soudan mines to Two Harbors were completed in 1884. Courtesy, Iron Range Research Center, Tower Soudan Historical Society Collection

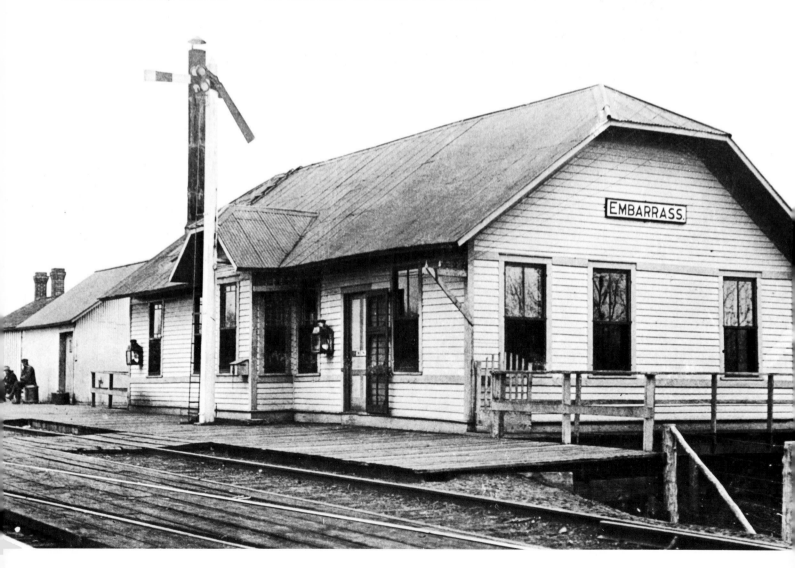

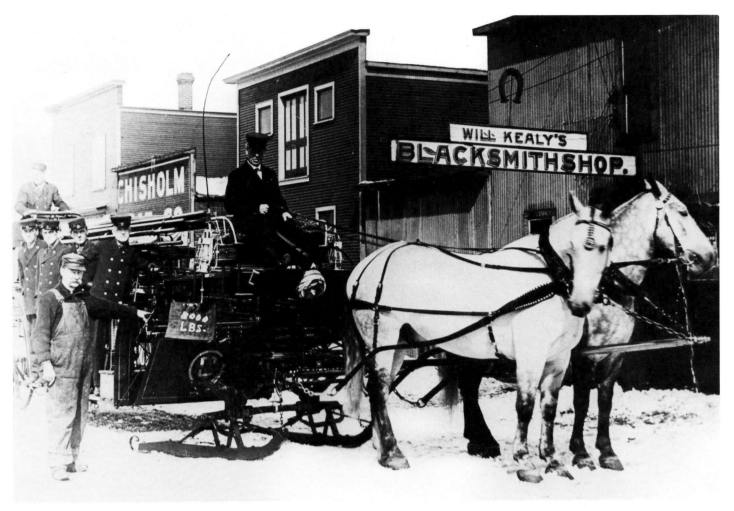

Although the Mesabi ore lay in Minnesota soil, the profits soon padded the Eastern industrial coffers of John D. Rockefeller, J. Pierpont Morgan, and Andrew Carnegie. Understanding how critical iron ore was to the new industrial age, John D. Rockefeller was the first major businessman to invest in the Mesabi Range. In 1890, Leonidas Merritt and his brothers were trying to figure out how to transport their iron ore from the range to the shipping docks at Duluth. Neither the Northern Pacific nor the St. Paul and Duluth railroads would have anything to do with their mining venture. Forced to build their own railroad, they created the Duluth, Missabe and Northern Railway, going in debt to do so. By the end of 1892 their debts totaled approximately $2 million.

But the brothers had only begun to spend money; they still needed to buy mining equipment and to build ore docks at Duluth. Early in 1893 they took out a bond for $1.6 million and found an eager buyer in Rockefeller, who took one-quarter of the offering. Astute financial giant that he was, Rockefeller knew that he would move in for a bigger piece of the action when the time was right. As it turned out, the time was right sooner than he expected.

The Panic of 1893 strangled investment markets, and the Merritts quickly realized that they would not be able to sell any more bonds. Once again they placed their future in Rockefeller's hands. He formed a parent company called the Lake Superior Consolidated Iron Mines Company. The Merritts traded their holdings for stock in the company and were left in control of the mining operation. Rockefeller then placed his own mining holdings in the company, invested another $500,000 in the Merritts' railroad, and took first mortgage bonds in the new company.

Over the next two years the brothers—now overwhelmed by the amount of cash they needed to keep their mining operations going—continued to issue stock. But it did not move in the depressed investment market. For the third time, the Merritts

Cities blossomed along Minnesota's Iron Range as merchants flocked to fill the daily needs of mining families. These substantial population centers in the north woods needed a full range of public services. The Chisholm Fire Department fought winter fires with this ski-mounted rig. Courtesy, Chisholm Free Press

Last names of boys on Chisholm High's 1911 baseball team speak eloquently of the ethnic diversity of Minnesota's Iron Range cities: Nealy, Talus, Rahja, Hirstio, Hudy, Reilly, Kneebone, Anderson, Crellin, and Portugue. Courtesy, Chisholm Free Press

turned to Rockefeller. Obligingly, Rockefeller bought 90,000 shares of their Mesabi stock at $10 a share, granting them an option to recover 55,000 shares within a year at the same price. Only one of the brothers took him up on his offer. By 1895 Rockefeller's name was synonymous with iron ore on the Mesabi Range.

As the Merritts learned, it was not possible to build a mining business on a budget. But there was room on the range for others who had the wit and capital to withstand the lean years. One of those men was Henry W. Oliver, who heard about the Mesabi Range in his hometown of Pittsburgh. In 1892 Oliver paid the Merritts $75,000 to lease the Missabe Mountain Mine, forming his parent company, the Oliver Iron Mining Company. Under the terms of the agreement, Oliver Iron Mining would pay a royalty to the Merritts for each ton of ore shipped.

Almost immediately Oliver recognized the need to infuse more cash into his company so that he could lease more Rockefeller mines and build his operations. He introduced giant steam shovels to make it more cost-efficient to get the ore out of the ground, and also helped form the Pittsburgh Steamboat Company for carrying the iron ore to the steel cities of the East. Correspondingly, he tapped Henry Frick, a manager of Andrew Carnegie's steel companies, and suggested that they make a deal. For $500,000 up front, Carnegie would receive half the control of the growing Oliver company. Over the years Carnegie's power increased along with his interest in Oliver's company.

Far away from the propriety and pleasantries of the Eastern Seaboard, an agreement was made on the Range that helped build the Rockefeller and Carnegie fortunes, and eventually transformed the Mesabi Range into the industrial colossus that it was in the first half of the twentieth century. Rockefeller and Carnegie came to an amiable working agreement: Rockefeller would stay out of the mining operations business, and the Oliver-Carnegie interests would use Rockefeller transportation to get their raw material to the mills. By 1901 Rockefeller owned sixty ships which regularly left the Du-

luth harbor bound for the East. Oliver and Carnegie agreed to pay Rockefeller a royalty of 25 cents on every ton of ore mined and another 65 cents for every ton of ore carried on one of his ships. In return, Rockefeller stayed out of the Oliver Iron Mining Company's operations.

At the turn of the century four major corporations pulled most of the strings on the Mesabi Range. Carnegie and Oliver operated the Oliver Mining Company; Rockefeller oversaw the expansion of the Lake Superior Consolidated Corporation; J. Pierpont Morgan backed the Federal Steel Company, a holding company that bought and operated mining railroads and ore ships; and James J. Hill formed the Lake Superior Mining Company. Hill originally formed his company to buy Mesabi lands, and eventually placed his properties in a holding company called Great Northern Iron Ore Properties.

These hunters near Hibbing were proud enough of their prize of small game to set up an elaborate photograph to record it. Courtesy, Iron Range Research Center, Opie Collection

The desolate stretches of Minnesota's mining regions had become the playing field for big business. The seats of power were held by men who knew when to move and when not to blink. J. Pierpont Morgan was a master of the game. Envisioning an empire that would lock up iron-ore mining and shipping profits, Morgan sent his negotiators to deal with Andrew Carnegie. In 1901 Carnegie sold him his Mesabi holdings for $500 million. Carnegie next tapped Rockefeller, who by that time was building a petroleum industry, and suggested that Rockefeller sell his mine properties and ore ships. For a little less than $90 million, Morgan took over Rockefeller's interests. Morgan then formed the United States Steel Corporation—the first billion-dollar corporation in the country. United States Steel was a conglomerate of horizontal and vertical holdings that included iron ore and coal mines, steel plants, railroads, and ore ships. The Oliver

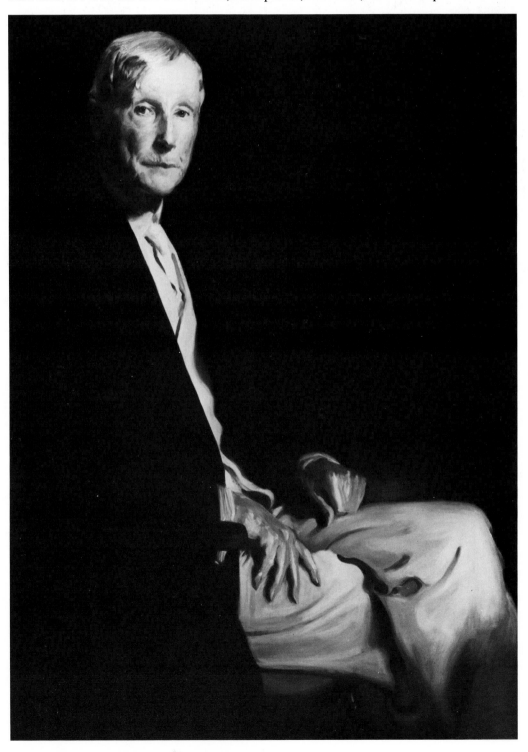

In 1893 John D. Rockefeller became the first major businessman to invest in the Mesabi Range, and by 1895 his name was synonymous with iron ore in the area. Oil on canvas by Adrian Lamb. Courtesy, National Portrait Gallery, Smithsonian Institution, Washington, D.C.

Mining Company became a subsidiary of United States Steel, running the conglomerate's mining operations.

Nevertheless, United States Steel was missing one critical component up on the Range. The corporation did not own James J. Hill. Hill, who had vast landholdings on the Mesabi Range, knew that the huge company was already concerned about the day its mines would run out of iron ore. In 1907 Hill made U.S. Steel an offer. In return for allowing the corporation to explore his lands for new iron ore deposits, Hill asked them to pay him a royalty of 85 cents per ton—an unusually high royalty. He also wanted an agreement that their ore would be shipped to Superior on his Great Northern Railroad, at 80 cents per ton. United States Steel sourly accepted his offer. Before the contract was terminated in 1914, the corporation had paid Hill more than $45 million in royalties.

While the newspapers from coast to coast were filled with stories about what the Morgans, Hills, Carnegies, and Rockefellers were doing with their money, there were many who believed that something was fundamentally wrong with the country. When the miners went on strike against the Oliver Iron Mining Company in 1907, nearly seven-eighths of the wealth in America was owned by one percent of the population. It would be six more years before the state would adopt a compensation system to protect workers against industrial accidents and before the unsafe conditions in the mines would draw attention to the plight of the Range worker. The first two decades of the new century were a time when socialism and collectivism seemed like a plausible solution for the worker—and the split between business and labor an insurmountable chasm.

When the Minneapolis Club opened its doors in 1908, its members numbered among the select few who owned motor cars. By the time these prominent businessmen started driving themselves, finding parking space in downtown Minneapolis had become a challenge. Courtesy, Minneapolis Public Library

A boy from Ely posed with some of his toys about 1900. Courtesy, Iron Range Research Center, Opie Collection

HOOKERS AND WHALEBACKS

It was late November 1905 and the steel-gray sky above Lake Superior gave notice of the winter ahead. As Duluth citizens went about their morning business, four freighters, loaded with the last ore shipment of the year, left the protecting arms of Minnesota Point and turned their bows toward the blast furnaces of the East. Looking to the sky, the crews gambled that they could outrun one of Superior's infamous early-winter storms.

But one hour out of Duluth, all bets were off. With tremendous force, a storm blasted the four freighters, dancing the multi-ton ships on the mammoth waves. Every

crewman knew that the only hope for survival was a retreat back to the Duluth-Superior Harbor. As townspeople watched, two of the four freighters managed to make it back to the relatively calm waters behind Minnesota Point. The third, although damaged as it rounded the point, limped to safety.

The fourth freighter, the *Mataafa*, was not so fortunate. Churning, frigid water ran fierce and high out of the narrow channel of Minnesota Point, spinning the 4,840-ton *Mataafa* like a top. In the same moment, the freighter was struck from behind by a blast of wind and thrown against the pier. Pelted by sleet and icy water, the crew saw the rudder ripped from their ship and felt the shudder as it was split in two by the waves and rocks.

Miraculously, Captain R.F. Humble and fifteen of his crewmen lived to tell about the storm. The men had made it through the night huddling around a bonfire built of the captain's furniture in the windlass room of the ship. The tragedy, however, lay in the stern of the freighter, where nine men had either frozen to death or were drowned. In the heyday of the iron ore industry—between 1890 and 1920—such drama at sea was a way of life. Without radar, electronic communications, or even the equipment to accurately forecast weather, freighter crews were at the mercy of their shipping schedules and the moody Great Lakes. More than fifty ships were lost on Lake Superior in the 1890s. Between 1900 and 1910, 350 ships had major accidents, at least 84 ships were destroyed, and 250 sailors lost their lives.

To this day, most Saint Paul Eastsiders know "Swede Hollow," the cluster of homes north of Payne Avenue. It's not a derogatory name. It's a description of the vibrant life that thousands of Swedish families found for themselves between 1845 and World War I. Arriving by train, many immigrants found their way to their relatives' homes using notes pinned to their coats. Courtesy Minnesota Historical Society. Location # MR2.9 SP2.2 p10, Negative # 18604

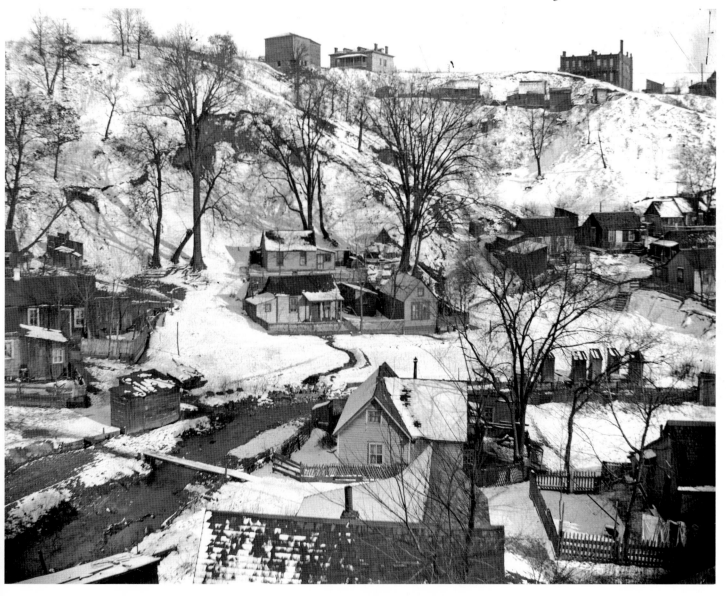

The frequency of shipping disasters paralleled the explosion in the shipping industry at the turn of the century. Standing as sentries to one of the world's best harbors, Duluth and its neighbor, Superior, Wisconsin, grew from sleepy logging towns into thriving cities. The two cities reigned over the vast inland resources of lumber, iron ore, and grain. Transcontinental railroads and local mining railroads made beelines for the Duluth-Superior docks.

Not long after the discovery of Minnesota's abundant iron ore, it became obvious that shipping ore through the Great Lakes was the cheapest and most efficient means of getting the raw material to Eastern mills. A Great Lakes freighter could cover 800 miles with a shipment of ore for about 70 cents a ton, while shipping ore the same distance by railroad could cost up to $5 a ton. It wasn't difficult to calculate the advantage of using Duluth's harbor.

While Mesabi Range ore was being gobbled up by the New York, Pennsylvania, Ohio, and Illinois steel mills, the Eastern states—particularly Pennsylvania—were flush with coal. Coal was needed in Minnesota and points west to fire the turn-of-the-century industrial boom. Lake Superior became a two-way shipping street, and by the mid-1880s five coal docks were built in Duluth. In the next decade, more than 2 million tons of coal were hauled to Duluth, and much of it was used to power the steam shovels that dug the ore on the Mesabi Range. Hand in hand, the coal and iron ore industries grew together. By 1913, Duluth had twenty-four coal docks.

For many years following the discovery of iron ore on the Mesabi Range, the call was out for bigger ships with more holding capacity, greater speed, and more efficient loading and unloading capability. In 1889 a Scottish-born Great Lakes captain,

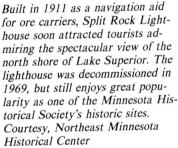

Built in 1911 as a navigation aid for ore carriers, Split Rock Lighthouse soon attracted tourists admiring the spectacular view of the north shore of Lake Superior. The lighthouse was decommissioned in 1969, but still enjoys great popularity as one of the Minnesota Historical Society's historic sites. Courtesy, Northeast Minnesota Historical Center

Alexander McDougall, designed a steel ship with a flat bottom that could carry great amounts of cargo. His dream was to replace the unreliable wooden vessels that he had known from his youth. From his Duluth home, McDougall sought financing for his ships, which he called "whalebacks" because of their shape. Investors laughed at his design, calling it a "pig boat" because of the flat hoglike bow, so McDougall decided to build the ship himself. His first whaleback barges—No. 101 and No. 102—were built on the Duluth waterfront. As homely as they were, they did what McDougall said they would do—carry the greatest volume of ore at the lowest price. No. 102 hauled nine railroad cars of ore to Cleveland in 1892.

Feeling as if he were on to something big, McDougall wanted to develop a shipbuilding company in Duluth. Again he met with resistance—this time from a coalition of citizens who objected to the potential noise and filth of the operation. McDougall packed up his plans and some investment dollars from Colgate Hoyt (a Rockefeller associate) and moved to West Superior, where he built the successful American Steel Barge Company. During the next three decades his company built nearly three dozen whaleback-shaped barges and steamers, and even a 362-foot luxury whaleback for the 1893 World Columbian Exposition in Chicago. Called the *Christopher Columbus*, McDougall's passenger ship had five decks and all the accoutrements of the finest luxury liners of its time. In subsequent years the ship carried more than 2 million passengers around Lake Michigan.

The whalebacks were the workhorses of the iron ore shipping industry. But their design limited their size, and soon longer and sleeker ships were crowding the waterways. When the Bessemer Steamship Company was formed in 1896, its first fleet of twenty-one ships included the *Queen City*, 400 feet long with a carrying capacity of 3,785 tons. Still, draftsmen of the day tinkered on prototypes of longer ships. By 1904 a 540-foot ship, the *Augustus B. Wolvin*, surpassed all Great Lakes records by loading

McDougall's shipyard built whalebacks to carry Minnesota iron ore from Duluth across the Great Lakes to the steel mills of Ohio and Indiana. Courtesy, Northeast Minnesota Historical Center

91

HIT THE ROAD, JACK

Huffing and puffing along the dirt road, a line of Model T Fords rolled through the countryside outside of Clarkfield in Yellow Medicine County, American flags and campaign signs for Charles A. Lindbergh, Sr., fluttering from their open windows. Leading the Ford parade that fine May morning in 1918 was Lindbergh himself, bouncing along the rural backroads of Minnesota to deliver his message.

Banned in Duluth, hanged in effigy in Red Wing and Stanton, Lindbergh had often been dragged from the platform when making speeches against the war. But the small-town voters of the Sixth Congressional District had returned Lindbergh to Congress five times, from 1907 to 1917. Now they wanted to make him their governor. With his Progressive Republican philosophy he was an able and dedicated enemy of big business and big-city political muscle—one who clearly articulated what they so strongly felt. A staunch opponent of America's entry into World War I, Lindbergh believed that the United States should mend its own fences before tampering with its neighbors'. The people of his hometown, Little Falls, agreed with him.

In March 1918, the Farmers' Nonpartisan League—an organization (founded in 1915) that advocated state control of agricultural marketing businesses (elevators, stockyards, flour mills, etc.)—nominated Lindbergh to run against the Republican incumbent, Governor Joseph A.A. Burnquist, in the June gubernatorial primary. Lindbergh and the league were an excellent match. Lindbergh had savvy, Washington

Lake Superior whitefish once graced tables all over the country, but over-fishing caused the industry to collapse. Today smoked fish enjoys a limited statewide market, while the spring smelt run draws fishermen from throughout the region to the mouths of Lake Superior's tributary streams. Courtesy, Northeast Minnesota Historical Center

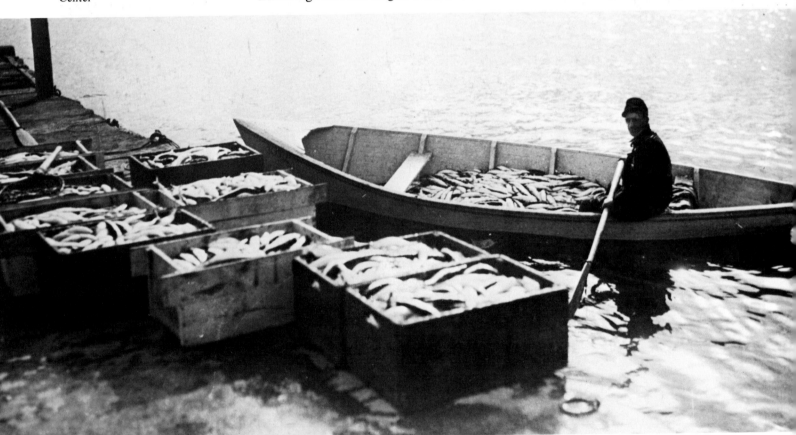

connections, and a plain talking, kind style of speaking. The league was fresh, energetic, and swelling with new members. Together, they reckoned, they could burst upon the Minnesota political scene and put things right for the farmer.

Although the Nonpartisan League was not a political party, it had an agenda which it wanted a political party to adopt. Its founder, Arthur C. Townley, had recruited enough farmers in North Dakota to gain control of that state's Republican party in 1915 and of the governorship and legislature the following year. He and his followers

94

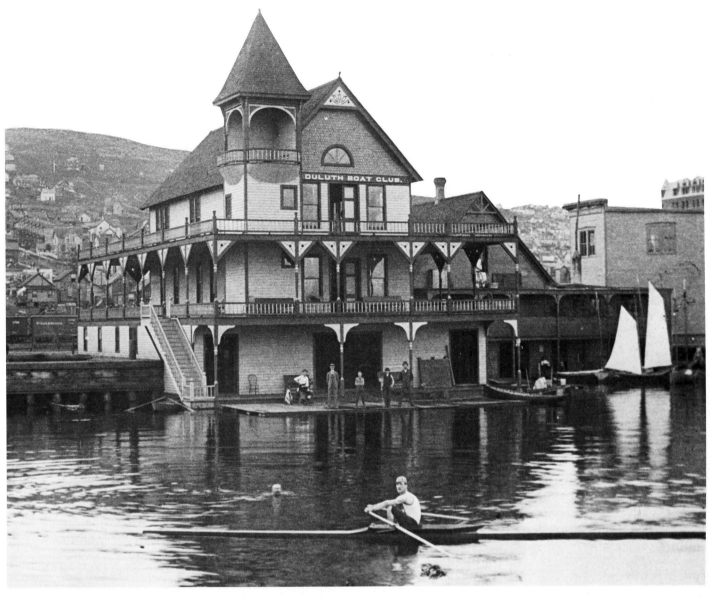

turned their attention to Minnesota in 1917. Buying 260 Model T Fords, they fanned out across the state in an all-out effort to influence the 1918 elections.

Townley and the Minnesota farmers felt that they had suffered at the hands of big-business interests, and they wanted economic relief. Buoyed by the belief that they could organize themselves into an active political voice that could change their lives, Minnesotans eagerly paid their $16 membership fee and flocked to meetings. By 1917, 150,000 members in thirteen states were receiving the league's official news magazine, *The Nonpartisan Leader.*

But at 8:30 p.m. on April 2, 1917, when President Woodrow Wilson faced a joint session of Congress and requested that war be declared on Germany and its allies, the country was hurtled into war. In Minnesota the issues that had been heating up the campaign of 1918 were suddenly chilled by the realities of World War I. Economic issues took a backseat to political issues.

While he was a congressman, Lindbergh vehemently opposed any American involvement in the war. But once war was declared, he supported the country's actions. Despite this, he was suspected of being pro-German, and was villified as a man who opposed everything that his county stood for. And because the Nonpartisan League supported his candidacy for governor, that organization was tarred with the same brush.

In June 1918 Burnquist won the gubernatorial primary. But the election was also a show of support for the league, as Lindbergh received three times the number of votes

The Duluth Boat Club made a name for itself long before summer recreation became a statewide industry. With two clubhouses bracketing a two-and-one-half-mile watercourse, the club trained championship rowing teams. Courtesy, Northeast Minnesota Historical Center

95

Charles A. Lindbergh, Sr., carried his Nonpartisan League message from farm to farm. The League, however, suffered from accusations of pro-German sympathies, so Lindbergh lost to the war governor, Burnquist. Courtesy, Minnesota Historical Society

as there were league members in the state. Still the lesson was clear—the voice of the farmers in Minnesota still couldn't be heard over the roar of big business. To increase the size of their voting bloc, they needed support from another embattled group—labor.

By August 1918, the Nonpartisan League had a plan. On August 25, a joint committee of the Minnesota State Federation of Labor and the Nonpartisan League endorsed a candidate to represent their combined views in the gubernatorial campaign. To make certain that their candidate's name appeared properly on the ballot, they organized the Farmer-Labor Party. It was a coalition that would remain firm—in spite of their loss the following November to Burnquist—and it would gather enough momentum through the next decade to significantly change conditions for working people and farmers.

In 1922 the Nonpartisan League and its sister group, the Working People's Nonpartisan Political League, selected Henrik Shipstead, a dentist from Glenwood, as their senatorial candidate to oppose popular statesman Frank B. Kellogg, a traditional Republican and the incumbent. The Farmer-Labor platform included recommendations for conservation programs, payment of a soldier's bonus from an excess-profits tax, use of the unemployed on state-sponsored public works programs, and an enforced economy in public expenditures. It also recommended a tonnage tax on all iron ore mined in Minnesota, an issue that had been held at bay by the clout of United States Steel since the turn of the century. Shipstead handily defeated Kellogg. For the Farmer-Labor Party, it was a moment to savor.

BUSTING UP THE BUSINESS BOOM

In 1922 the tax on iron ore tonnage passed as an amendment to the Minnesota Constitution. This was an important development for every voter in Minnesota. On one side, businessmen worried that the tonnage tax would doubly tax mining companies, setting

a poor precedent for future business legislation. They pointed out that, for a number of years, an *ad valorem* property tax had been imposed on the mining companies by the Iron Range communities. Companies operating mines within a town's corporate limits paid property taxes based on the mine's value from the time the iron ore was discovered to the time the mine was played out. Until 1921, there was no limit on the percentage of ore value that a town could force a mining company to pay. A state tonnage tax would place an additional burden on the mining companies, business argued, by increasing operating costs, which could eventually mean layoffs for the miners.

On the opposite side of the issue were the many taxpayers who believed the tonnage tax would fairly check what they believed were excess profits made by businessmen such as Carnegie and Oliver. They believed it was only right to make the out-of-state investors pay for destroying their wilderness and consuming a nonrenewable resource.

And there was another compelling reason for voters to support the tonnage tax. Public hostility toward big business was growing throughout the United States. Until

Many people saw the progressive spirit of the turn of the century as a threat to morality. They suspected that urban living undermined traditional values. The city missions sought to rectify the trend by preaching to the populous on the streets of Minneapolis. Courtesy, Minneapolis Public Library

Top: *A substantial town like Little Falls had several fire stations by 1900 as well as a younger generation eager to grow up to be firemen. Courtesy, Morrison County Historical Society*

Bottom: *The* Nonpartisan Leader *carried the agenda of the Nonpartisan League to its members with hard-hitting editorials and cartoons as well as articles that provided examples of effective action. Courtesy, Minnesota Historical Society*

IN THE NAME OF PATRIOTISM!

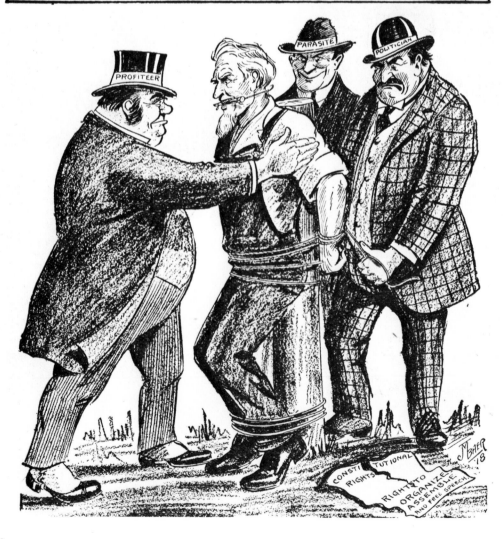

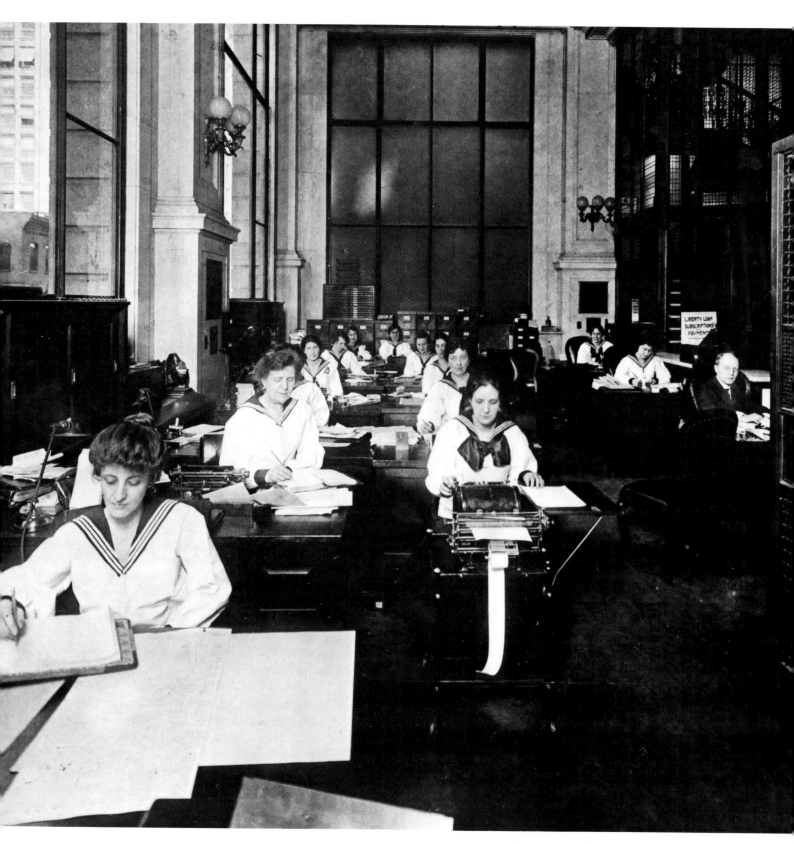

The Liberty Loan department of the First National Bank of Minneapolis really got into the spirit of the war effort in 1916. World War I stimulated a great deal of business in urban as well as rural banks. Courtesy, Hennepin County Historical Society

Joseph A.A. Burnquist (pictured here) won the 1918 gubernatorial primary over Charles A. Lindbergh, Sr. Burnquist, who served in the Minnesota legislature from 1908 to 1912, as lieutenant governor from 1912 to 1915, and as governor from 1915 to 1921, gained both respect and hatred for his suppression of dissenters during World War I. Photo by Paul Thompson. Courtesy, Minneapolis Public Library

the Sherman Anti-Trust Act was passed by Congress in 1890, business did pretty much what it wanted to do. The Sherman Act prohibited corporations from monopolizing interstate or foreign trade to inhibit normal competition. In the wake of the Sherman Anti-Trust Act, politicians across the country took up the cause of the "common people," and it looked as though big business had finally met its match.

The Sherman Act gave Minnesota Governor Samuel R. VanSant a legal foothold to stop a massive railroad merger in 1901-1902 that would have consolidated the Great Northern, Northern Pacific, and Burlington railroads into a single railroad network called the Northern Securities Company. The giant trust had the potential to manipulate the price of both travel and shipping in the United States. One of the company's helmsmen was James J. Hill, president of the Great Northern Railroad; others involved were Edward H. Harriman, head of the Union Pacific, and J. Pierpont Morgan, of United States Steel fame. Led by VanSant's administration, the Northern Securities Company merger was stopped by a decision of the United States Supreme Court in 1904 on the basis of the Sherman Anti-Trust Act.

In 1914 the Sherman Act was bolstered by another anti-trust law, the Clayton Act, which established the Federal Trade Commission, banned price discrimination, barred interlocking directorates, and prohibited certain types of contractual agreements among businesses.

It was in this climate of business reform, led by Minnesota's Progressive Republicans, that legislation for a Minnesota tonnage tax was introduced again and again after the turn of the century. First passed by the legislature in 1908, a tonnage tax calling

100

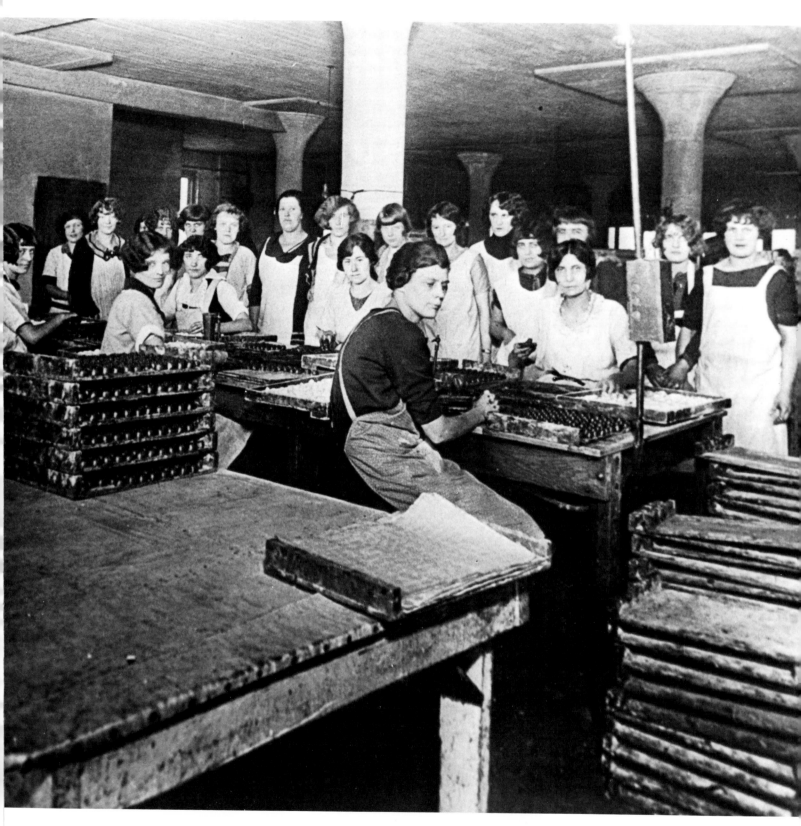

Small factories like the Wahl Candy Company in Duluth depended on women to staff their labor force. These newly enfranchised workers helped spur the Farmer-Labor Party on to victory in the 1922 gubernatorial election. Courtesy, Northeastern Minnesota Historical Center

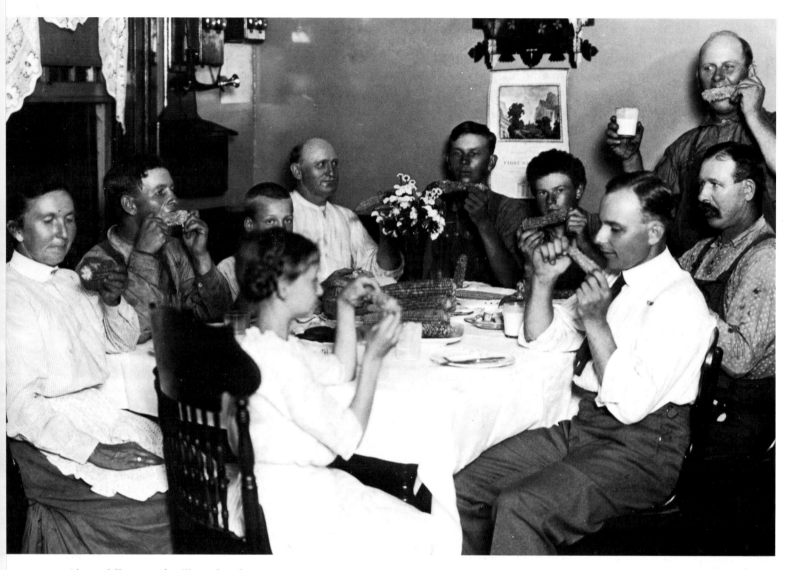

Above: *Minnesota families enjoyed the return to normal life after World War I. Rural people, such as the Abrahamsons of Lanesboro, enjoyed a brief prosperity before the agricultural depression of the early 1920s settled in. Courtesy, Minnesota Historical Society*

Facing page: *St. Paul's lowertown boasted several shoe factories whose skilled workers supported middle-class families living in the comfortable "streetcar" neighborhoods surrounding the city center. Many of these firms, like the Foot, Schultz Company pictured here, constructed modern work space in the first decade of this century. Courtesy, Minnesota Historical Society*

Rural bankers, who had become pillars of their communities, were the first to feel the effects of the new policy. Suddenly a bank's daily business was hardly enough to cover its operating expenses. Many banks closed, and depositors lost their savings and their belief in the banking system. Between 1921 and 1929, 320 state banks and 59 national banks locked their doors. The decrease in the value of Minnesota crops was just as disheartening. In 1919 farming brought about $500 million into the state; ten years later, harvest values had sunk by nearly $20 million.

In the exuberant years of the Charleston, the Model A Ford, and the first sound newsreel, farming families had a difficult time believing that America was the land of plenty. Trying to meet their extensive debts, they were choked by escalating production costs and taxes that tripled during the decade. But their troubles were only the beginning of a depression that would spread nationwide. It was a time to watch, wait, and worry.

PULLING TOGETHER

In spite of their problems, farmers and small-business people across Minnesota were encouraged by the lawmaking successes of the Nonpartisan League and the farmer-labor coalition during the 1920s. In 1922 the legislature opened commodity exchanges and livestock markets to cooperative selling agencies and expanded the range of activities open to dairy and other co-ops so that they could better compete in the marketplace.

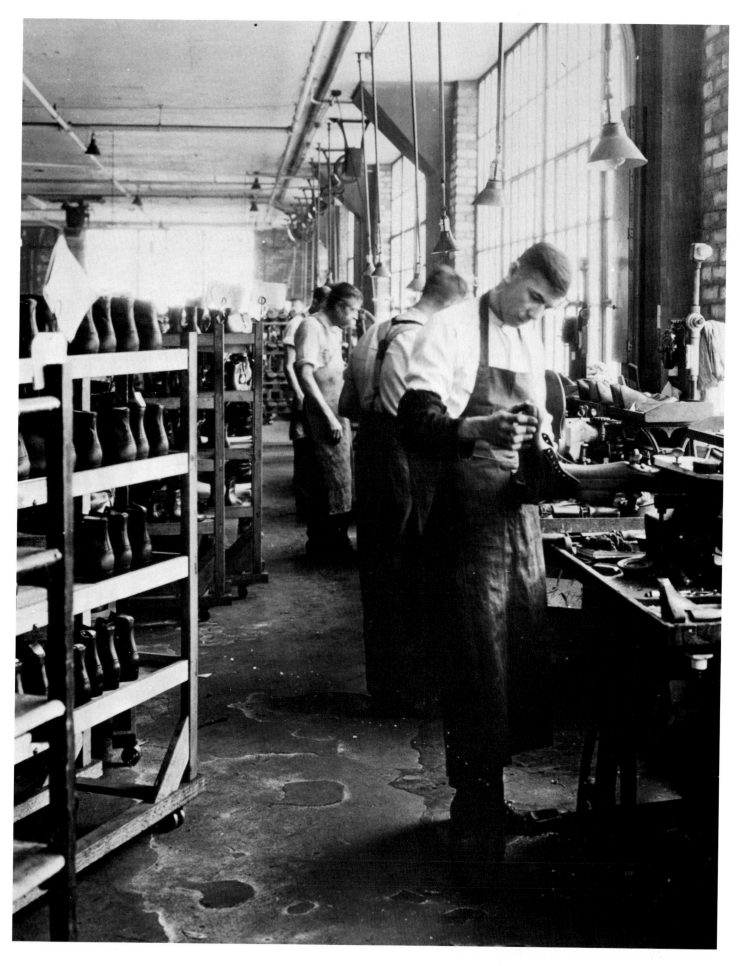

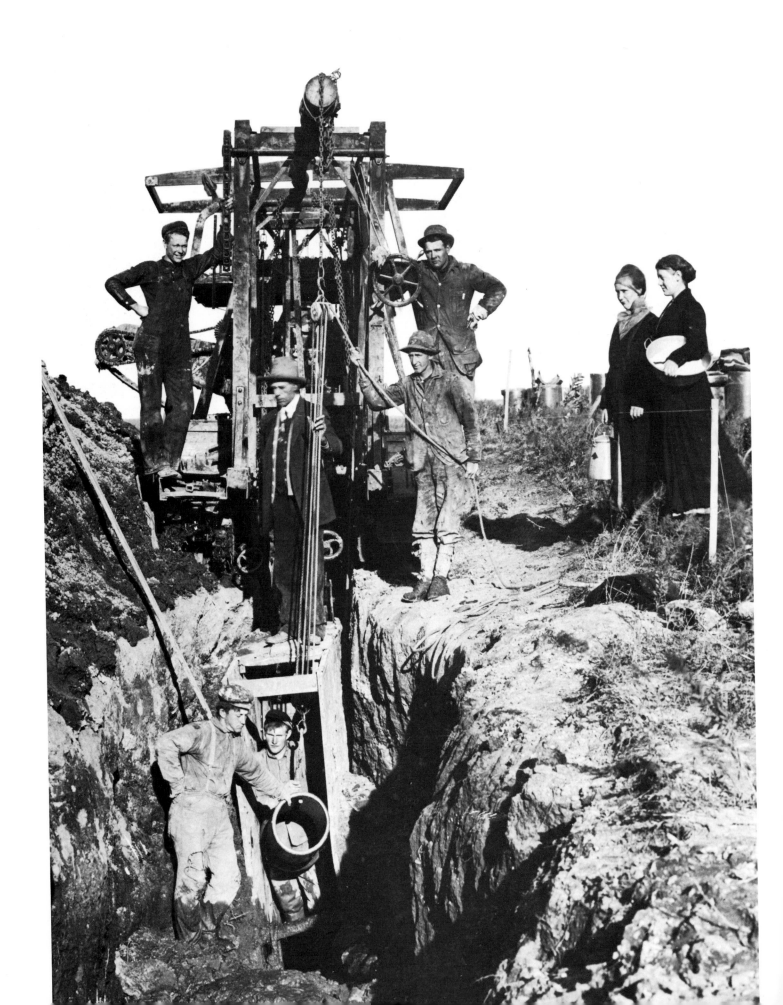

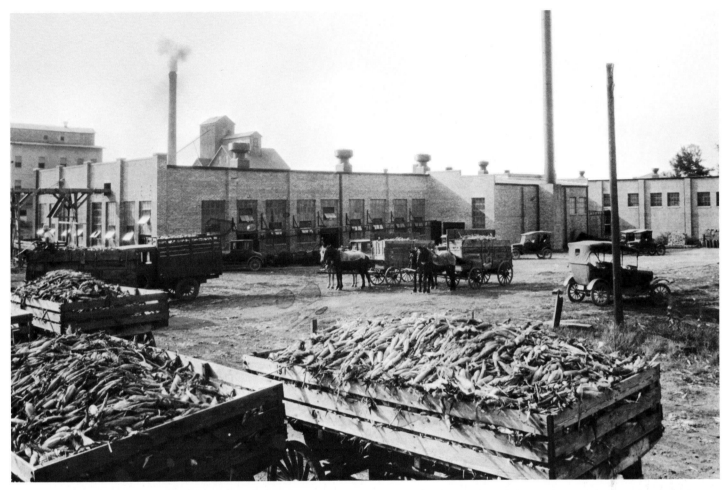

For Minnesota's farmers the legislature's support of cooperatives was terrific news. In fact, the whole concept of marketing and buying products and services through cooperative clout was probably the best thing they had heard of since the nickelodeon. By 1922 there were approximately 4,500 cooperative associations in the state. The majority were marketing cooperatives, but their number also included buying, producing, insurance, and telephone organizations. In 1921, state cooperative revenues added up to $144 million. Six years later, they had grown to $200 million, a 38 percent increase.

Founded in the same anti-big-business spirit as the Nonpartisan League, dairy cooperatives helped to give farmers control over the market. Led by the spirited Theophilus L. Haecker—a former newspaperman, dairy farmer, assistant to the governor of Wisconsin, and dairy instructor—the co-op movement had begun before the end of the century. By the early 1900s, chapters of the American Society of Equity appeared across Minnesota, fighting an all-out battle with the middleman, who, association members believed, was gaining profits at the expense of the farming family.

After 1907, cooperative marketing efforts for grain farmers were extended from the local market to the terminals in the larger cities. In the spring of 1908 an Equity Cooperative Exchange was organized in Minneapolis to compete with the Minneapolis Chamber of Commerce (the original name of the Minneapolis Grain Exchange). The plan was to create a terminal grain marketing organization that would buy grain from friendly local cooperative elevators. The battle between the two exchanges played across the headlines over the next several years.

Nevertheless, cooperatives had become as much a part of Minnesota as its lakes. In 1921 the Minnesota Cooperative Creameries' Association was organized and immediately attracted 335 members. By shipping their butter in carloads, association members discovered they could save half a cent per pound in shipping costs—a substantial savings. Between 1917 and 1922 the number of shipping cooperatives for potato growers

Above: *Local canning companies provided a tax base for rural towns while ensuring farmers a good price for produce. Contracts between the canning companies and growers took some of the risk out of both enterprises. Courtesy, Le-Sueur Museum*

Facing page: *P.G. Jacobson's ditch and tile machine eased the back-breaking job of draining the prairies of southwestern Minnesota. Minnesota's rich, black soil inspired the name "Blue Earth" for both a county and a city, but the heavy clay needed drainage before it could realize its agricultural potential. Courtesy, Minnesota Historical Society*

increased by 113 percent, and the number of wool growers' co-ops increased by 40 percent.

In the ten years before the bottom fell out of the Wall Street stock market, agricultural cooperatives grew until they gained equal purchasing power with the large private manufacturers and food processors. Many cooperatives joined forces and set up federations. By 1929 Land O'Lakes Creameries, Inc., was a major federation representing 460 creameries and more than 100,000 farmers. While Land O'Lakes fattened the size of its operation, Minnesota became the leading butter-producing state in the country.

During the 1920s an increasing number of other businesses drew sustenance from Minnesota's rich agricultural base. Food processing companies such as the Faribault Canning Company, the M.A. Gedney Company, the Minnesota Sugar Company, and the Minnesota Valley Canning Company built plants in or near the heart of the Minnesota farming country. Trucks carried vegetables from the fields to the canneries, ensuring Minnesota-brand freshness on tables across the nation.

By 1925 the Minnesota Valley Canning Company had created its first "Green Giant" product and was marketing cream-style corn and peas around the country. Six years earlier the state's first sugar beet crop was grown by a Crookston farmer who was financed by a small coalition of businessmen from East Grand Forks. Called the Red River Sugar Company, the coalition (in association with the Minnesota Sugar Company in Chaska) built the state's first sugar beet plant (in 1926 at East Grand Forks). Turning the beets into sugar became an important Midwestern industry over the next two decades.

Facing page: A scientist from Redwing, Minnesota, Alexander Anderson opened the door to the cold cereal industry in 1901 when he discovered a process for puffing wheat and rice. Courtesy, Minnesota Historical Society

Below: Iron workers offered many services in rural towns. Riebold's Blacksmith and Foundry in Waseca made wagons, bobsleds, and harrows, while the foundry cast sash weights, columns for buildings, and other cast-iron products. Courtesy, Waseca County Historical Society

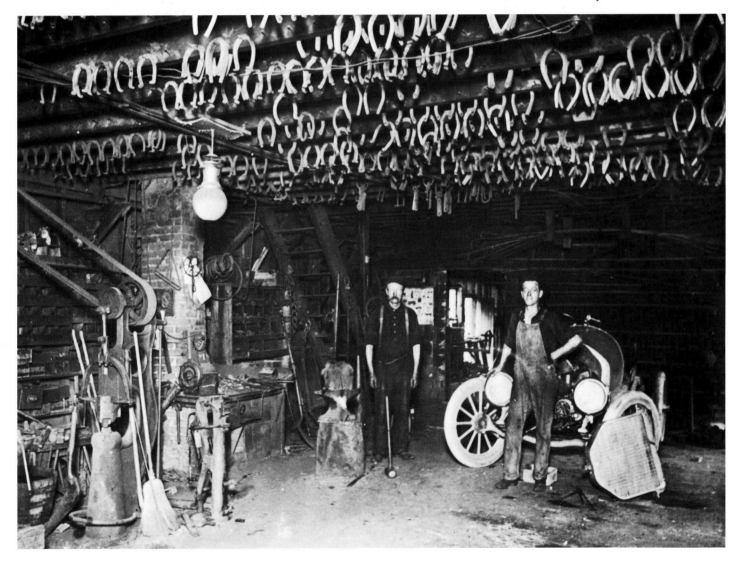

Right: *Automobiles changed the way Americans did business. Rural people could get to town more often, and they often drove further to get "big-city" prices. As a result, many rural shops went out of business in the wake of the automobile era. Courtesy, Minnesota Historical Society*

Below: *Cars brought changes to many small-town businesses. Former livery stables became service stations. The Norr blacksmith shop in Little Falls became a machine shop when they shifted their business from wagon repair to automotive work. Courtesy, Morrison County Historical Society*

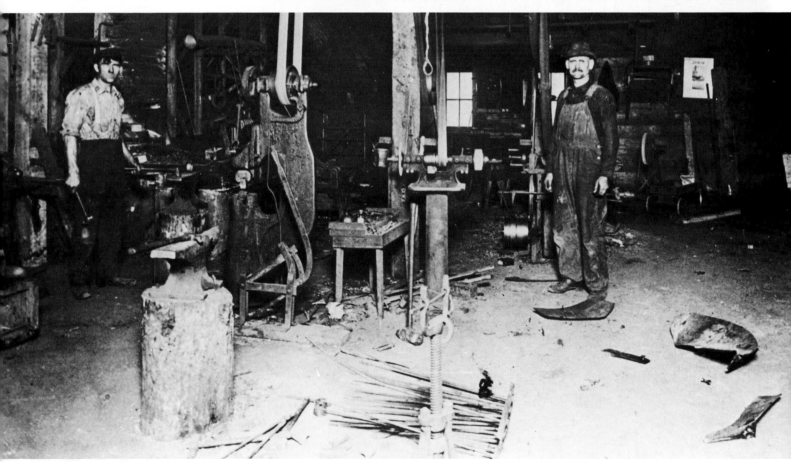

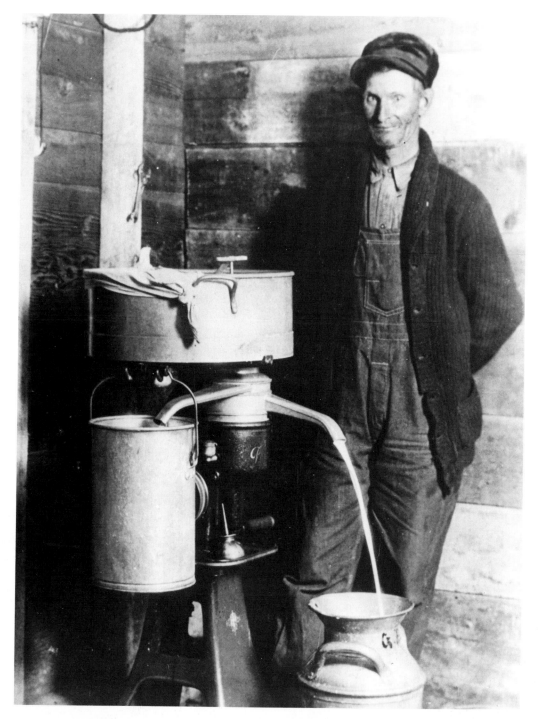

W.A. Cady poses next to his electrically driven cream separator in 1924. Electric service in small towns created a gap between rural and village living standards, and farmers wanted modern conveniences. In 1923 Northern States Power teamed up with the University of Minnesota to build a rural line. The Red Wing Experimental Line proved the usefulness of rural electrification. Courtesy, General Electric Company

In the 1920s the meat-packing industry flourished, drawing livestock from the southwestern cornbelt section of the state. Companies such as Geo. A. Hormel and Company in Austin, Armour and Company, Swift and Company, and the South St. Paul Union Stockyards Company in South St. Paul, the Elliot Packing Company of Duluth, the National Tea Packing Company in Fergus Falls, and the Landy Packing Company in St. Cloud employed an increasingly large percentage of Minnesota's workers. By 1929, 7 percent of the Minnesota work force was employed by the meat-packing industry. For many farmers, growing livestock had become more lucrative than growing wheat.

And while businesses that processed farm products cropped up across the state, another change was occurring down on the farm. With electricity and trucking, farming families were discovering convenience. When times were good they were eager to buy the products and services that would break their isolation and ease their labor.

Left: *After a general store, a hotel, and a livery stable and blacksmith shop, a newspaper office was the next most essential business in a small town. Like many others throughout the state, the* Pierz Journal *gave a voice to local people and their problems even as it carried news of the outside world into each of their homes. Courtesy, C.A. Weyerhaeuser Museum*

Below: *Minnesota had one of the first hydroelectric generating stations at the Falls of St. Anthony in 1882. Distribution costs, however, delayed the growth of electrical utilities in sparsely populated areas. Ottertail Power Company took advantage of many waterpower sites among the glacial moraines of western Minnesota to develop one of the most far-reaching utilities in the state. Pictured is one of Ottertail's dams. Courtesy, Minnesota Historical Society*

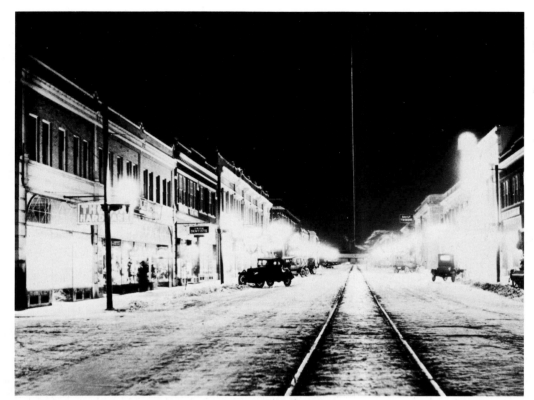

Right: *Hibbing boasted munici-pally owned water and light systems within four years of its founding. Relocation of the town in 1919 made modernization of street lighting easy. The resulting "White Way," pictured, gave the town one more claim to fame. Courtesy, Iron Range Research Center, William Opie Collection*

Below: *When this photograph of Bridge Square was taken in 1885, gas lighting was already giving way to electricity. Minneapolis had seen its first electric street lamp in 1883, soon after the St. Anthony Falls hydroelectric station began operation. Courtesy, Minnesota Historical Society*

The Otter Tail Power Company in Fergus Falls is an example of the type of company that rapidly turned a luxury into a necessity for rural people. Having built a small hydroelectric power station in 1909, four Fergus Falls businessmen created one of the area's first full-fledged electric utilities which could run home appliances, turn on lights, and pump water. The only problem for the new utility was how to string the lines from the plant to a growing number of consumers. By 1919, forty-four small towns around Fergus Falls were linked to the generating plant. Three years later eighty-eight towns had been connected to the electric plant. By 1926 the number of towns with electricity had doubled once again, stretching as far as North Dakota. Before the decade was out, electricity was running many farms in the Red River Valley.

Electricity in the backyard corners of Minnesota meant social changes that would sweep out the last traces of isolation for most Minnesotans. By the late 1920s radios were bringing news of people in such faraway places as Rome and Oslo, and up-to-the-hour information that broadened every citizen's horizons.

Horace Mann School in St. Paul offered students access to radio technology in 1922. Minnesota had demonstrated its commitment to education by establishing state-supported schools in the first territorial legislature in 1849. Courtesy, Minnesota Historical Society

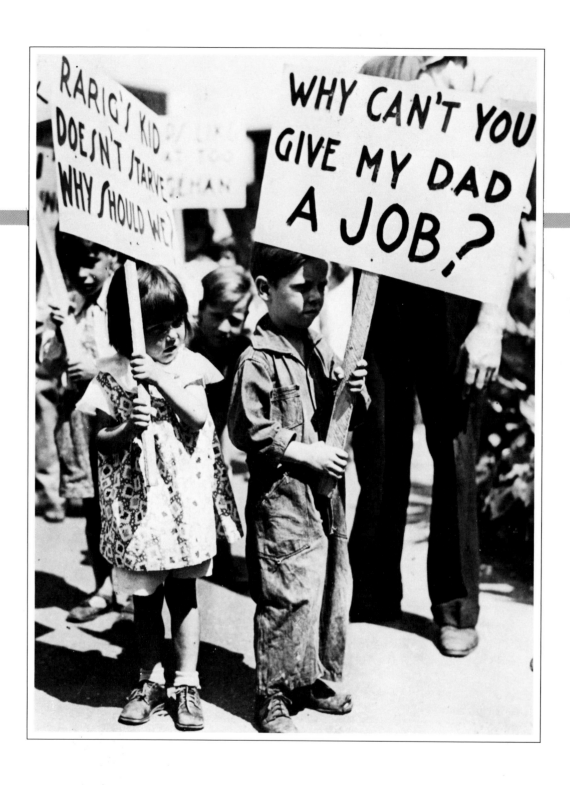

Children picketing in front of
Mayor Gehan's office in St. Paul
in 1937 gained publicity but
brought little change in the city
welfare system. Courtesy, Minne-
sota Historical Society

WEATHERING THE STORM

AGAINST ALL ODDS

I
t was an adventure to make a prosperous country proud—a daring young man bound for Paris in a plane he had helped design. Alone, on a late May day in 1927, Charles A. Lindbergh, Jr., set out from New York. This would be only the second transatlantic flight in history—and he would be the first to go it alone.

The people in the United States sat by their radios as Lindbergh's *Spirit of St. Louis* clipped its way across 3,600 miles of sea. A little more than thirty-three hours later, Lindbergh shyly climbed down from the plane at Le Bourget Field in Paris, cheered by 100,000 Europeans.

The warm welcome Europe gave Lindbergh paled next to the frenzy with which the Americans greeted their newfound hero. When Lindbergh and the *Spirit of St. Louis* returned to the United States on the USS *Memphis,* he was met by 200 boats and seventy-five airplanes. On a platform adorned with garlands and American flags, President Coolidge presented the young aviator with the Distinguished Flying Cross. In New York City he was showered with 1,800 tons of ticker tape and blinded by flashing camera bulbs in a parade along Fifth Avenue.

In the following months Lindbergh toured the forty-eight states, telling crowds what aviation could mean for the future of America, and leaving a trail of enthusiastic believers. The "Lindy Hop" was an overnight dance craze and the song "Lucky Lindy" celebrated his "peerless, fearless" success.

Back in Lindbergh's hometown—Little Falls, Minnesota—the aviator's success was every citizen's triumph. On his victorious return flight to Little Falls, Lindbergh circled his hometown, thrilling the crowd of 50,000 with his favorite stunts. He was carried through town in an open Pierce Arrow automobile in one of the largest parades ever seen in Little Falls. Marching bands from Brainerd, Royalton, Pierz, Silver Lake, Red Wing, Chisholm, and Faribault took part, as did the Hibbing Ladies Drum Corps. In a speech at the fairgrounds following the parade, Senator C. Rosenmeier declared, as reported on page one of the August 26, 1927, *Little Falls Herald,* "while Lindbergh's trip across the Atlantic all alone was a great accomplishment and a real service, his greatest service was the setting up of the ideals of fitness and purpose."

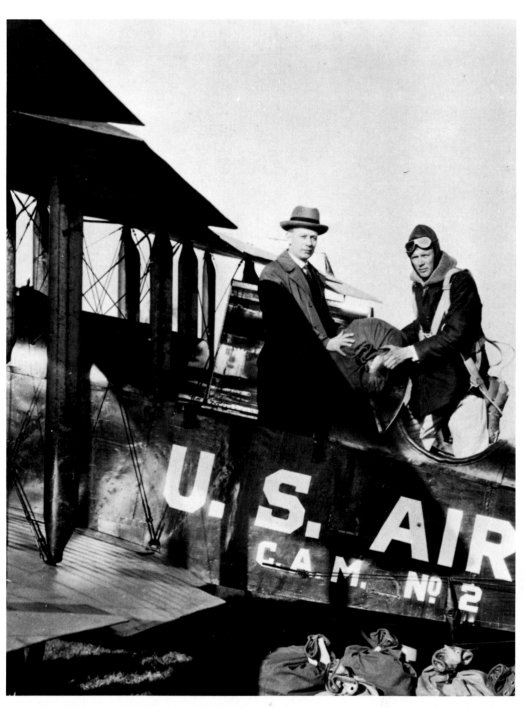

Charles Lindbergh, Jr., made history in Minnesota by flying the first airmail routes in 1926. World-wide fame from his trans-Atlantic flight a year later never diverted him from his devotion to aviation. Courtesy, Minnesota Historical Society

However, the Lindy Hop and the hero worship were soon to become memories from a happier past. On October 29, 1929, the inflated stock market, which had camouflaged an unsound economy, plummeted. Between late October and mid-November stocks lost more than 40 percent of their value, resulting in an economic depression that shook up American business from coast to coast.

In Minnesota, the effects of the crashing economy arrived unforeseen and with unique force. People who had believed President Coolidge's 1925 declaration that "the business of America is business," and who had tied their future to the business boom, were overwhelmed with the catastrophe.

Between 1920 and 1929, Minnesotans—like the rest of the nation—had quintupled their purchasing power through credit. They had over-consumed, buying pianos, washing machines, vacuum cleaners, radios, refrigerators, and automobiles on the installment plan. Now jobs were lost as corporations went bankrupt. Banks foreclosed loans. Credit dried up. Banks failed.

118

By 1934 one-third of the working people in Hennepin County were unemployed. Men and women who had lost their jobs and exhausted their savings, and in many cases forfeited their homes, had no choice but to "go on relief." Those who were employed were paid so little that they were barely able to pay for their necessities.

The Great Depression that followed spared no part of the state. By 1932, 70 percent of the miners on Minnesota's Iron Range had lost their jobs. By 1933 most of the Iron Range was shut down as industrial activity failed.

Commodity prices went into a slide that would not abate for years. Between 1929 and 1932 wheat prices fell from $1.20 to a little less than 50 cents per bushel. In 1931 the income of Minnesota's dairy farmers was one-fourth what it had been before the crash.

Minnesota citizens faced additional problems over which they, now, had no control. The timber resources of the state were almost depleted. Minneapolis was losing its leadership position as a flour milling center to Kansas, Missouri, and New York. Drought and clouds of grasshoppers ravaged the fields. Transportation lines between the East and the West were being rerouted, and goods were being shipped through the Panama Canal instead of through the Twin Cities and Chicago.

The Panama Canal quickly undermined the transcontinental freight business, so the Fairbanks-Morse Company, a St. Paul scale manufacturer, set up this display of its wares to travel around the upper Midwest in search of better sales. Courtesy, Minnesota Historical Society

These men gathered in front of the Minnesota State Capitol building about 1935 to demand effective unemployment insurance. Courtesy, Minnesota Historical Society

It was in this climate of gathering desperation that Floyd B. Olson became the first Farmer-Labor governor in 1930, winning the election by a comfortable majority. Olson's talents combined political idealism with backroom negotiating savvy. Through his three terms as governor, he called for reform after reform, with only moderate success, having insufficient legislative or judicial backing to build a comprehensive state program. However, some noteworthy laws were passed in his administration. A state income tax to support the public schools in Minnesota became law in 1933. In February 1933 this governor ordered that there be a two-year period between delinquency and mortgage foreclosure, which the legislature reluctantly made into law. Injunctions in labor disputes were banned.

In his second term (1932-1934) Olson and the new President of the nation, Franklin D. Roosevelt, were philosophically in tune. Roosevelt's New Deal called for two R's—recovery and reform. People needed work today and security for tomorrow. The New Deal quickly put into place programs designed to put money into the hands of the people, thus relieving immediate distress. At the same time, Roosevelt believed his New Deal offered an economic foundation upon which a system of permanent em-

ployment could be created, including public works projects and compulsory unemployment insurance.

Olson's objectives for Minnesota were right in step with Roosevelt's plans for the New Deal. When Roosevelt spoke at a Jefferson Day banquet in the Twin Cities (April 18, 1932), he referred to Olson as "my friend and colleague." In his speech Roosevelt repeated his call for a fairer distribution of the national income, and focused his remarks on recommendations for helping farmers, factory workers, small-business people, and professionals to get on their feet again.

Roosevelt's speech received rave reviews across the state. Newspaper accounts noted the close alliance that was building between Roosevelt and Olson. Through the next several years President Roosevelt and Governor Olson kept in close communication. Rumors circulated that Olson would be asked to take a cabinet position. No offer was publicly extended, but the governor's policies were flavored with New Deal purpose.

During his administration Olson directed much of his attention at two bank-holding corporations: Northwest Bancorporation (or Banco) and First Bank Stock Corporation (which later changed its name to the First Bank System). These holding corporations were formed in 1929 by Midwestern bankers to strengthen the Ninth Federal Reserve District's weakened bank system and to prevent their banks from being consumed by Eastern interests. Minnesota bankers knew there was strength in numbers. Under the new system member banks continued to operate fairly autonomously while the parent holding company provided specialized services and capitalization against economic adversities.

The holding company concept worked well, even in the worst years of the Depression. Within a year Northwest Bancorporation had acquired ninety banks in several states. By 1931 this holding company had a controlling interest in 127, many of them from small Midwestern towns. While banks failed across the country, no member of either corporation was forced to close its doors.

In spite of the fact that the two banking systems provided financial stability during a chaotic period, Olson was convinced they were growing too big and too powerful, too fast. He launched a legislative inquiry, followed by an investigation by the State Banking Department. A suit was brought against the officers of Northwest Bancorpo-

Dunwoodie Industrial Institute retrained people who had lost their jobs. In this 1937 bread-baking class, men learned new skills in the hope of entering a different line of work. Courtesy, Minnesota Historical Society

ration for fraudulent stock sales and manipulation. Though these measures did not turn up enough evidence to indict Banco's officers, the holding company suffered from the negative publicity. By February 1936, all charges had been dropped against the company. Nevertheless, Olson remained convinced that the bank system in Minnesota should be reformed, a belief he held until his death later that year.

Of all the problems Olson faced during his years as governor, he is probably most remembered for the actions he took during the truckers' strike of 1934. In 1934 Minneapolis truckers earned between $12 and $18 for working fifty-four to ninety hours a week. Trapped in a seemingly endless national depression, the truckers, along with other Minnesota workers, were becoming desperate. At the same time the Citizens' Alliance, a group of 800 Minneapolis business leaders, was as vehement about management's rights as the truckers were about theirs. Through the 1920s and into the 1930s the alliance had held the line against the formation of unions in Minneapolis. But its grip was weakening.

In 1933 Congress passed the National Recovery Act to help the country begin its long convalescence. Section 7a of the Recovery Act was the ray of hope that truckers and their compatriots had long been waiting for. Section 7a gave labor the right to bargain collectively, and it prevented employers from firing employees who joined unions.

In Minnesota some of the first to organize were the truckers. Their first big success was a coal driver's strike in February 1934, which completely tied up all coal deliveries in Minneapolis. Next on the agenda for Local 574 of the Teamsters Union was an all-out battle for all truckers. And at the end of April 1934, Local 574 announced its demands for shorter hours, an average wage of $27.50 per week, and overtime pay. The situation was serious, for Minneapolis was a major distribution center in the Upper Midwest, and a truckers' strike could bring the city to a standstill. The *Minneapolis Journal* advised housewives to stock up on groceries and noted that a milk shortage might occur.

Members of the Citizens' Alliance, refusing to bargain with the truckers, waited. On May 16, a strike vote was taken; and within a day, truck traffic was reduced to

Truck farmers in Hennepin County, who had long enjoyed a booming business at the Minneapolis central market, suffered mightily when the truck drivers' strike cut them off from consumers. A temporary market outside the city gave some of them an outlet for produce. Courtesy, Minneapolis Public Library

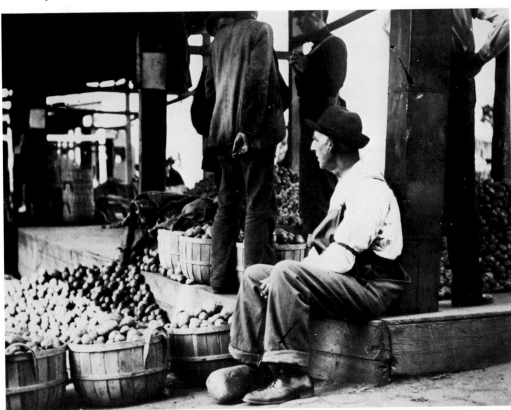

124

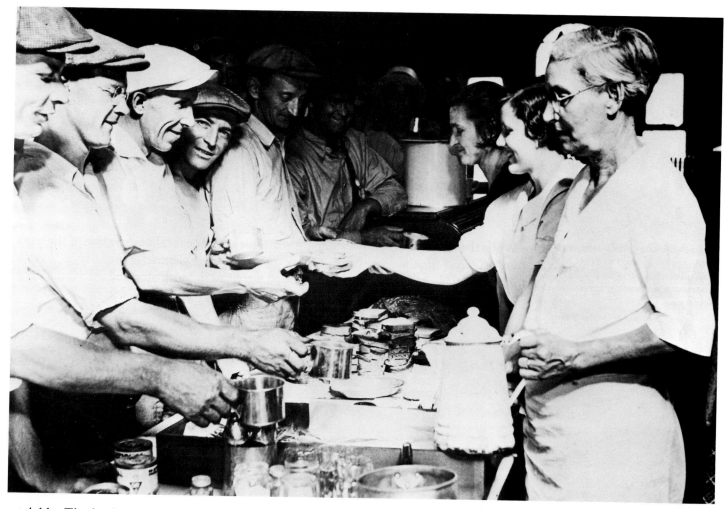

Soup kitchens helped feed truckers during the four-month strike. Camaraderie over meals helped strikers keep up their morale. Courtesy, Minnesota Historical Society

a trickle. The business leaders, who heartily disliked the governor, hoped he would be forced to choose sides between the strikers and the public good. Caught in the middle, Governor Olson threatened to call out the National Guard to distribute food and other necessities if negotiations did not prove fruitful.

In response to the governor's threat, a prominent businessman, Totten Heffelfinger, called for the mustering of citizens—a citizen's army—to help get trucks through the picket lines and distribute food. On May 22, 1934, more than 20,000 people gathered at Minneapolis' central market. Special deputies from the citizens' army squared off against the truckers. Local radio stations covered the event, play-by-play. When a striker tossed a crate of tomatoes through a plate glass window, the fight began in earnest. Two leaders of the citizen's army were shot and killed and scores of people were injured.

The following day Governor Olson ordered in the National Guard, and a temporary truce was called while negotiations between the opposing groups proceeded. The trucks were moving, but the tension remained, and both sides were preparing for the round. Then the employers broke off the talks again, and on July 16, 1934, union members voted to strike once again.

This time violence was a certainty. Four days later, when a truck was sent out on the Minneapolis streets with an armed convoy of police, a striker's truck attempted to block it. The police, armed with shotguns, opened fire at the truck. Within ten minutes sixty-seven people had been wounded; two were dead.

A friend of the working class down to his socks, Governor Olson agonized over his next decision. When the federal mediator, Father Francis J. Haas, declared that a plan for settlement had been drawn up, Olson called for agreement from both sides. When he didn't get it, Olson brought in 3,400 troopers from the National Guard to impose martial law on the city of Minneapolis. Special permits were given to certain

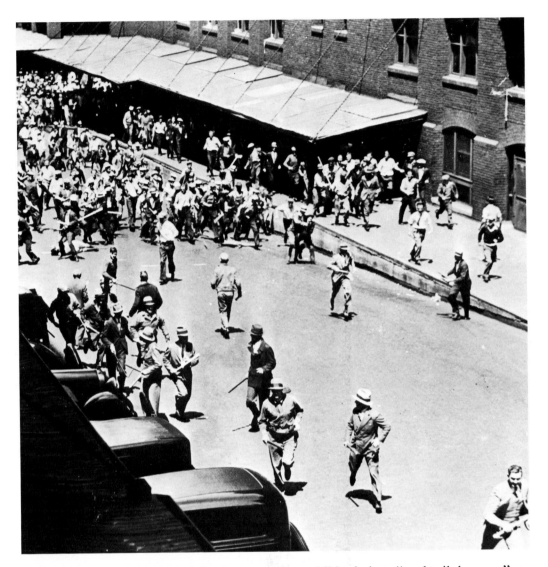

Right: *In May 1934 sixty-seven people were injured and two were killed when an armed convoy of police fired into a crowd of striking truck drivers gathered at the Minneapolis City Market. Courtesy, Minnesota Historical Society*

Facing page: *Millions of smiles such as that on the face of this bartender at Schiek's restaurant in Minneapolis greeted the repeal of Prohibition. Courtesy, Minnesota Historical Society*

with meals. The old kinds of saloons were prohibited, but "cocktail lounges" or "cocktail bars" were allowed. The sale of liquor by the bottle or by the drink by licensed retailers was legal except in communities which had voted to remain dry.

In deference to the dry side of the political aisle, only one bottle-store license could be issued per 5,000 citizens in the large cities, and one license per small town of 1,000 people or more. On-sale licenses could be issued to hotels and clubs as well as to restaurants in cities with over 10,000 people.

The repeal of Prohibition quickly translated into jobs. Breweries that had been closed since 1920 now offered jobs and a hopeful future to job-seekers. In Minneapolis, for example, the Minneapolis Brewing Company renovated its plant and hired 100 new employees. In St. Paul, the Yoerg Brewing Company started up again and the Peerless-LaCrosse Beer Company opened a distribution company to handle the local sales of beer made by the LaCrosse Breweries, Inc. By 1939 there were twenty breweries in business throughout the state, employing 1,700 people.

Abstinence quickly became a forgotten issue for mainstream Minnesotans. The Gluek Brewing Company in St. Paul even targeted sales of their pilsner pale beer to women. An ad in a 1934 issue of the *Minneapolis Journal* read:

> Women who like to serve and eat good cheese, cold meats, smoked salmon, kippers, potato chips spread with roquefort, etc. have learned that the mellow, full-bodied flavor of Gluek's beer is the perfect accompaniment. And the chances are that for six months their husbands have also been Gluek enthusiasts. Here's a chance for real family harmony—order a case today.

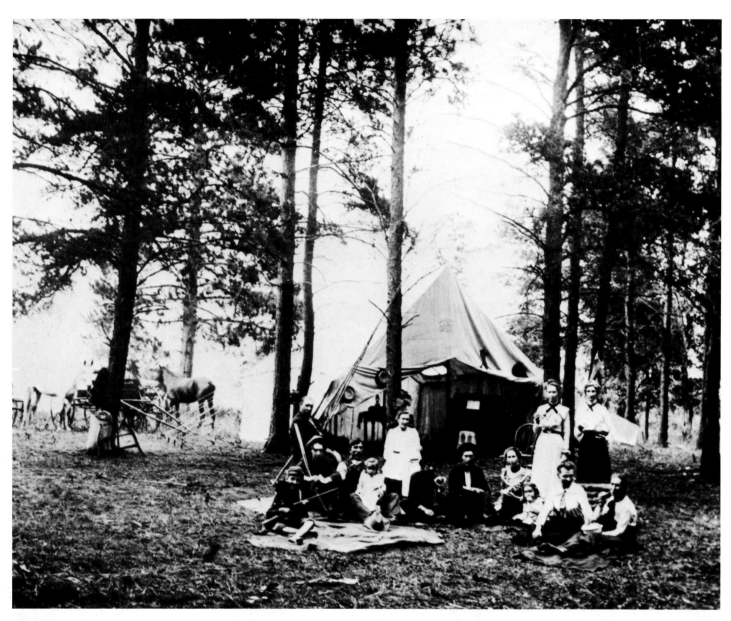

The woods drew people looking for peace and quiet like members of this camp meeting in Morrison County. Courtesy, Morrison County Historical Society

People from all walks of life were seeking some relief from their trouble, and while social drinking appealed to some, others looked for heroes and excitement on the playing field. Sports became a national obsession during the 1930s. In Minnesota, winning a baseball game became a matter of civic honor.

In the 1880s two professional baseball teams had been formed to represent Minnesota in the American Association. Over the years, the Minor League Minneapolis Millers and the Saint Paul Saints fought hefty battles on the baseball diamonds while their fans simulated those contests before, during, and after the games with plain old civic rivalry. In an article written on August 31, 1934, a veteran sportswriter for the *Minneapolis Journal* captured the spirit of the contest: "Minneapolis has a gaudy lead in this American Association race, a lead of seven games over Milwaukee but, in case you are lighting the old pipe and seeing pennants in the smoke, remember this—the Millers have 19 games left and 15 of them are with St. Paul and Milwaukee." So popular was the civic rivalry during the years of the Depression that hockey teams sporting the same names as the baseball teams carried the contest between Minneapolis and St. Paul into the winter months.

But nowhere were sports quite so popular a draw as they were in the small towns, where dads and moms could watch their sons and daughters compete on a Friday night. In Sauk Centre—home of Sinclair Lewis' fictional *Main Street,* which had been pub-

lished a decade earlier—1935 newspaper headlines celebrated basketball upsets over Upsala and Osakis. The February 7, 1935, edition of the Sauk Center *Herald* cheered even the girls' drill team, which entertained the "rooters" at the Sauk Centre-Melrose game, proclaiming that "by their yells and gestures and by their contribution Sauk Center can really show visiting towns that they have a team of which they can be proud."

In the 1930s most people believed that women would not need to develop competitive skills to help them in the business world, but women did have opportunities to participate in small-town sports. In Hibbing a coed sports program offered at the Hibbing Junior College taught badminton, basketball, deck tennis, shuffleboard, volleyball, field hockey, archery, swimming, tennis, golf, and Danish gymnastics. Women's competitive sports were so popular that by 1935 the Hibbing Women's Athletic Association had grown into one of the largest organizations at the college.

Enthusiasm for Minnesota-born brawn fanned out across the state as the Depression tightened its hold. Radio sportscasters broadcast the latest successes of the University of Minnesota's Golden Gophers. Native son and former Golden Gopher, Bronko

Eisel's Cafe in Little Falls always served as a meeting place for farmers to discuss economics or politics over platters of bacon and eggs or "beef commercial" (hot beef and mashed potatoes swimming in gravy). Courtesy, C.A. Weyerhaeuser Museum

Nagurski, was making national news on the Chicago Bears professional football team. He was still a home-state favorite.

University of Minnesota Head Coach Bernie Bierman became a legend in those years, as he took his teams into the Big Ten conference championships in 1934, 1935, 1937, 1938, 1940, and 1941. Known for brute power and indefatigable rushing strength, Bierman's teams put their foes to the test and showed Minnesotans a spirit that helped people cope. No matter what else happened during the week, it seemed that everybody wanted to go to the game.

Minnesotans also escaped the Depression at the movies. Business at theaters throughout the state was booming. For two bits an out-of-work miner could watch Clark Gable romance Jean Harlow in *China Seas* or vicariously take on the bad guys with Randolph Scott in Zane Grey's *Thundering Herd.* Laughter helped heal heavy hearts.

You could go to forget, and come home with some dishes if you held a lucky ticket stub. Grand Rapids was the childhood home of Judy Garland, who delighted the whole nation with her rich voice and wholesome appeal, and Minnesotans claimed her as their own.

Horseshoe tournaments fetched considerable local competitive talent as well. Each week players from the Windom, Mountain Lake, Jeffers, Storden, and Westbrook horseshoe clubs went up against each other in fierce rivalry. In fishing country, the city of Brainerd sponsored one of the first Paul Bunyan Expositions.

Federally funded programs of the Depression era did much to build Minnesota's image as a vacation wonderland. Through the Works Progress Administration (WPA) and the Civilian Conservation Corps (CCC), highways, bridges, parks, and playgrounds were built for the traveler's convenience and pleasure. Not only could people get around Minnesota more easily, but there were now places for them to go and things for them to do. In the 1930s, fishing resorts grew like waterlilies in a quiet bay. By 1938, approximately 1,200 lakeside resorts attracted more than 2 million tourists from all over the Midwest.

To the tune of ringing cash registers, the sky-blue waters and the call of the loon across a moonlit lake quickly became the refrain of Minnesota's northern charms. With equal speed, Minnesota towns in the lake country, hard hit by falling farm prices and layoffs in the mines, set themselves up as vacation spots.

The city of Minneapolis began, in 1940, a tradition of holding an Aquatennial in the heat of the summer. Led by an honorary Commodore and a Queen of the Lakes, parades displayed elegant floats representing various businesses and activities; and there were summer sports events and invitational regattas for sailboats on its lakes.

A Virginia Hockey Team posed for a group portrait about 1935. No sport could top the popularity of hockey on the Iron Range. Youngsters grew up on skates, hoping to play on the professional Eveleth Rangers. Although the Rangers have moved away, hockey still reigns supreme in northern Minnesota. Courtesy, Iron Range Research Center, Carl Pederson Collection

The Virginia High School baseball team posed about 1925. Schools in Minnesota's Iron Range cities boasted extensive modern facilities where they trained championship teams in many competitive sports. Courtesy, Iron Range Research Center, Carl Pederson Collection

Lakes and rivers lured anglers with crappie, walleye, sunfish, northern pike, muskie, and smallmouth bass, while the woods crackled with game and the sun baked out whatever ailed a person. In 1937, 37,000 fishing licenses were issued. Six years later the number of issued licenses had more than doubled.

While some people tested their patience with a line over the side of a rowboat, other vacationers preferred to test their personal best on the golf links. By the end of the Depression, approximately 260 golf courses of varying size, shape, and difficulty had appeared throughout the state, from Alexandria to Winona. Birdieing their way across the greens, Minnesotans celebrated the fact that the work week had been shortened to five days. Weekends had become one of the best things about having a job. Leisure time also meant dollars in the pockets of Minnesotans who waited on tables, cleaned cabins, and drove trains and buses.

For many years Otis Lodge, southwest of Grand Rapids on lovely Sugar Lake, was one of the most glamorous of the lake country resorts. Arthur Otis was way ahead of his time during the Depression years. He built airstrips around the resort and lured planeloads of vacationers with free chicken dinners. Otis even set up an exhibit at the

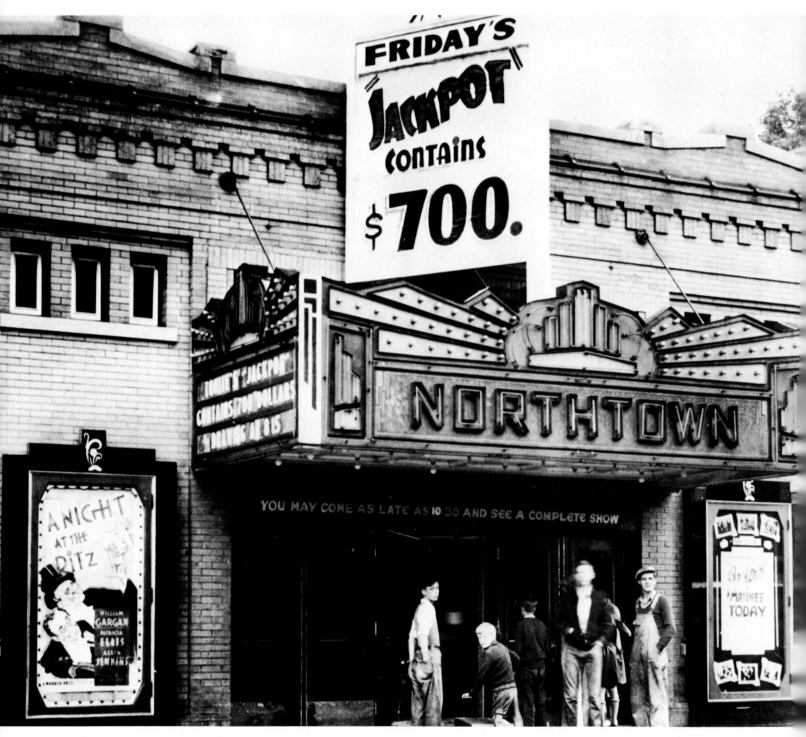

Movies provided some distraction from the grim realities of the Depression. This north Minneapolis theater organized a jackpot drawing to attract customers with the prospect of financial relief as well. Courtesy, Minneapolis Public Library

1937 air show at the Chicago Coliseum, betting that those who liked to fly also liked to fish. By 1940 an expanded airfield received forty-seven planes, including a Northwest Airlines plane filled with twenty-four people.

Minnesota's enterprising tourist industry even warmed the state's pockets during the winter months. Southwest of Minneapolis (near present-day Eden Prairie), a mammoth ski slide was built in 1935. The Minneapolis, Northfield and Southern Railway packed in spectators who would travel to watch ski-jump tournaments in which competitors might make jumps of 200 feet. During the 1930s Minnesota was considered one of the ski capitals of the world.

In the spirit of celebration, the city of St. Paul also revived its citywide Winter Carnival in 1937, after a lapse of nearly twenty years. Here began the tradition of King Boreas of the North, the Winter Carnival parade, fireworks, and outdoor sports events.

Across the river in Minneapolis, Winter Sports Week offered competitions in ice hockey, skiing, skating, ice boating, log rolling, tobogganing, and sleighing.

By the end of the decade, vacationers had brought nearly $140 million into the state's flagging economy. Tourism—the latest industry based on the rich resources left behind by the glaciers—showed promise.

VOICES IN THE DARKNESS

Journalist James Madison Goodhue had stepped off the steamboat onto the docks of St. Paul in 1849, when Minnesota was still nine years away from being a state. Determined that the little territory should have a newspaper, within ten days of his arrival Goodhue had the first issue of Minnesota's first newspaper available for distribution.

In Waseca, Herter's Style Show helped to boost the local economy. People who turned out for the entertainment spent money in town, strengthening the local retail businesses. Courtesy, Waseca County Historical Society

135

Duluth's incline railway carried residents and tourists up the steep hill to Skyline Drive from 1891 to 1939. Courtesy, Northeast Minnesota Historical Center

Farther north, where the water going over Koochiching Falls drops twenty-four feet, the Minnesota and Ontario Paper Company mill had become a major source of income for Minnesotans living at International Falls. With the mill operating day and night, workers could produce 1,100 feet of paper every minute. Next door, a mill turned waste from the paper plant into wallboard, roofing, and insulating materials for centrally heated homes. Paper manufacturing jobs brought relief to a region that was feeling the pinch of layoffs in the mining industry.

All across the state an increasing number of radio stations brought news, weather, sports, comedy, and a break in the isolation that many people felt. Three major stations served the Twin Cities area: WCCO, WDGY, and KSTP. In the middle of the decade

138

the *Minneapolis Tribune* and the *St. Paul Pioneer Press,* together, invested in a new radio station they called WTCN.

WCCO Radio, founded in 1924, understood the power of the personal message, and its programming reflected this. For farming families, WCCO provided daily market information broadcast from the stockyards in South St. Paul and from the commodity trading floor of the Minneapolis Chamber of Commerce. Through the grim decade of falling prices, market announcer Mildred Simons was a note of stability. Farmers believed she understood what it was they needed to know. Calling her the "Market

Ice boaters on Lake Superior had enough room to work up more speed than they could in their cars on winter roads. Courtesy, Northeast Minnesota Historical Center

Lady," they made her one of the state's first radio personalities in the new era of rapid communications.

In 1930 an experimental radio station was established in Elk River to monitor the progress of the Byrd Expedition to Antarctica. This station communicated with WFAT, the call letters of the radio transmitter on the expedition's supply ship, the SS *Eleanor Bolling,* and allowed residents of Elk River to follow the expedition as closely as if it were a serialized adventure series.

During the Depression, newspapers and local radio stations reported business growth across the state as though it were a beacon in a black sky. When a company expanded and offered the community jobs, it was news. New products were news, too, because every promising step businesses took signaled an opportunity ahead for the unemployed.

Business optimism was expressed in Minnesota during the Depression with enough frequency to keep hope alive. The Minnesota-based 3M Company, for example, was

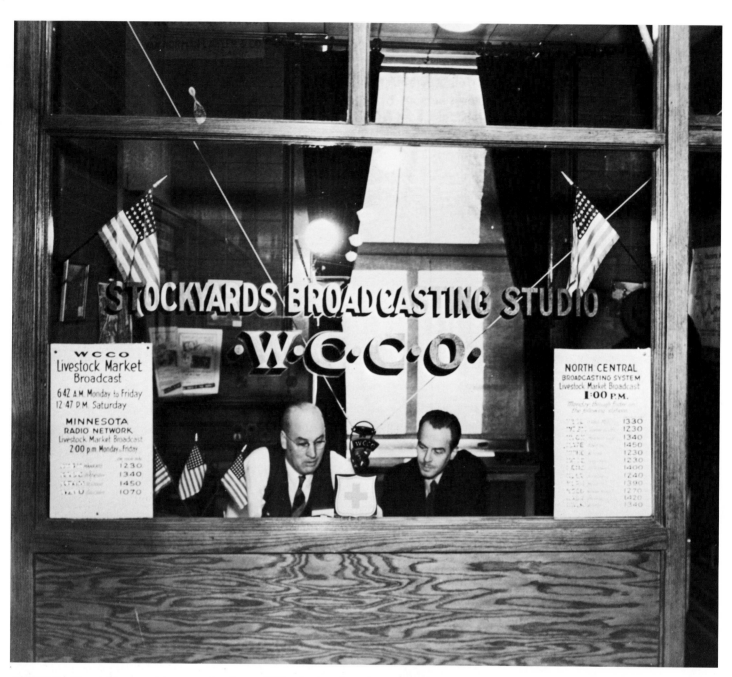

WCCO Radio quickly earned its place in farmers' hearts. Its clear-channel frequency carried current market prices directly into the kitchen, so a farmer could listen for the latest livestock prices directly from the stockyards in South St. Paul before deciding to set out with his stock. Courtesy, Minnesota Historical Society

having a difficult time keeping up with orders for its new line of colored coating materials for asphalt shingles. On the day the federal government closed down the banks across the country to prevent a nationwide run (March 6, 1933), the 3M Company opened a new roofing manufacturing plant in Wausau, Wisconsin. When questioned by the press, William McKnight, the aggressive young president of the growing company, told reporters that business growth could help to loosen the stranglehold of unemployment. "If every business concern which can afford to do so would undertake now to do work required in the reasonably near future, it would stimulate employment and hasten the return of prosperity. Such companies would find that surprisingly low building costs prevail."

The Minnesota news media were quick with their praise of risk-taking businesses. When demand for products from the Despatch Oven Company of Minneapolis had fallen off so sharply that most of the plant's employees were idle, its visionary president, A.E. Grapp, invented a device that would help miners extract gold from glacial deposits without the use of water. According to news reports in March 1934, Grapp's invention would be snapped up by the mining industry, and could be easily produced by the oven

140

plant's machinery with little additional capital outlay. Whether or not it happened, such attitudes kept people employed a little longer and kept hope alive.

Through the 1930s the news media and regional businesses worked hand in hand in an attempt to stimulate consumer buying. From 1926 to 1936, Betty Crocker's voice over WCCO radio guided homemakers through the problems of feeding their families frugally while providing good nutrition. Through the voice and personality of Marjorie Husted, General Mills could reach directly into each homemaker's kitchen. As the Depression worsened, Betty Crocker was right at the listener's side, providing her with low-cost menus, recipes, and recipe books. Beginning in 1932, coupons in flour products were redeemable for pieces of silverware. The idea was close to marketing genius. Homemakers would get something tangible for consistently using one manufacturer's product. Betty Crocker received the undying loyalty of thousands.

Media and business leaders in Windom also learned that they could help each other. With the town suffering from the poor agricultural market, the *Windom*

3M's first profitable product was sandpaper. Here, St. Paul workers cut rolls of sandpaper into smaller sheets appropriate for industrial or retail uses. Attentive to the needs of their clients who painted cars, 3M soon diversified into the masking tape business. Courtesy, 3M

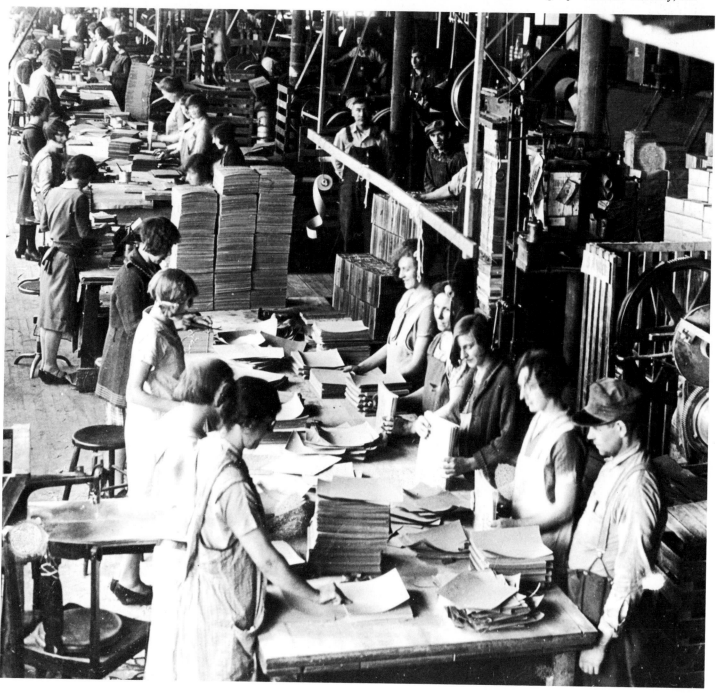

Reporter gladly filled its pages with news about special celebrations sponsored by the business community. In the fall of 1935, business people sponsored the second annual Halloween party and treasure hunt, with free costume hats and whistles for the children and a dance for grownups in the evening. Clues to the citywide treasure hunt were available with each purchase in a sponsoring merchant's store. Active businesses such as Foss Mercantile Company, Van Nest Motor Company, and Thompson Lands Seed Company also provided their customers with tickets for "Free Silver Day" that same fall. Silver dollars were awarded to those whose tickets were drawn. The grand prize of $25 drew thousands of hopeful players. News reports show that the day was highly successful for everybody.

THE FORGOTTEN ONES

Will Rogers, the cowboy philosopher and social critic, once said the federal government's farm relief policy seemed to mean that the Feds had a responsibility to relieve farmers of everything they owned. His words stuck in the throats of many Minnesota farming families who were battered by falling market prices and periodic droughts.

Roosevelt's New Deal package of help for farming families came in the form of the Agricultural Adjustment Act (AAA). This program, passed in 1933, was based on the theory that restoring farm purchasing power was essential to national economic recovery. The AAA had two primary purposes: to reduce farm production to a level

where it would supply the country's staple needs but would not result in surplus for storage or foreign trade, and to push prices up enough so that farmers could get back on their feet. To help finance the crop curtailment programs that were the backbone of the AAA, the new law also imposed a processing tax to be paid by companies that turned farm products such as wheat, corn, rice, hogs, and milk into food products.

The AAA was quickly followed by a supplementary spoonful of federal medicine. Called the Farm Credit Act of 1933, it was designed to help relieve the heavy mortgages farmers carried. Within a year and a half following its enactment, the Farm Credit Act had refinanced more than one-fifth of all farm mortgages.

The AAA's processing tax immediately caused problems by forcing major food-processing corporations to pay sizable sums just to conduct their business. In Minnesota, the processing tax levied against the General Mills Corporation forced it to pay the equivalent of $2.12 on every share of common stock. General Mills joined others in the industry to take action against the processing tax in 1935. They obtained federal injunctions to restrain the government from collecting this tax until the Supreme Court heard the case. In 1936, the Supreme Court halted all farm production control activities.

There was another serious flaw in the construction of the AAA: it did not offer immediate solutions, which the farmers so badly needed. In the fall of 1933, the governors from Minnesota, North Dakota, South Dakota, Iowa, and Wisconsin met to draft a price-fixing proposal to boost prices on staple commodities, such as corn and wheat, high enough to see farmers through the next growing season. They believed that driving prices up through production control would take time they did not have.

But Washington was not in the mood to talk about price fixing. Governor Floyd B. Olson, who presented the governors' proposal to Roosevelt, was stunned by the president's resistance to his pleas. Governor William Langer, of North Dakota, was resentful. He was quoted in the *Minneapolis Journal* on November 5, 1933, as saying that "everybody else, the banker, the insurance man and the railroad man was ahead of the farmer and got their money. There is nothing left for the farmer. The farmer is the forgotten man."

As the motion picture news cameras began to turn, Olson's words had a serious sound:

> Whereas industry has known this Depression for only three years, the farmers have known it for twelve years. In those twelve years, the farmer has seen the prices for his goods go down and down, and the prices of the things he must buy go up and up. All we are asking is parity price for him, a return to him of his purchasing power so that he can buy all the paint you make, all the leather goods you produce, and many other products, and then the Depression will end.

The headlines reporting the president's rejection of a price-fixing program stimulated a fury that swept across the state. Anger turned to threats of striking and blocking highways so that food commodity shipping would be stopped. John Bosch, president of the Minnesota Farmers Holiday Association—a descendant of the defunct Nonpartisan League—urged farmers to fight for their rights and to do whatever they must to hit the economy where it would hurt the most: at the consumer's dinner table.

In Meeker County 400 farmers voted to support a national strike and, despite the fact that the end of the harvest season was only days away, called for immediate action. Activist farmer Evald Nelson wired the state headquarters of the Minnesota Farmers Holiday Association that his county would be off-limits to any farm shipping from that November day forward. In Pipestone County picketing began immediately, and all farm product distributors were coerced into closing their operations. In Chippewa County, Holiday leaders requested that milk distributors pay two cents—to support the costs of the pending strike—for every quart of milk sold. They also demanded that distributors send a supporting appeal to President Roosevelt on the farmers' behalf.

Dairy cooperatives kept the rural economy alive in the 1930s. The Fergus Falls Farmers Cooperative Creamery provided a market for farmers and produced butter at reasonable prices. This woman was photographed cutting butter at the creamery in 1937. From the St. Paul Dispatch-Pioneer Press. *Courtesy, Minnesota Historical Society*

But the anger demonstrated by farmers who poured their milk into the fields and allowed their crops to rot on the land did not stop the policies that would forever change agriculture in Minnesota. As people lost their farms and moved to the cities in search of work, the population of the state began to shift away from rural areas. At the turn of the century, two-thirds of Minnesota's citizens lived on farms or in small towns of fewer than 2,500 people. But the farm crisis of the Great Depression changed that. By 1940 there were nearly as many people living in the cities as there were in rural communities, and fewer of those people were working on the farms.

Many towns in rural Minnesota actually prospered from the employment programs and money the federal government pumped into the state during the Depression. In the town of Roseau near the northern border, WPA labor built an auditorium and school and repaired the highways. When the federal government established the Rural Electrification Administration (REA) in 1935, it began a massive effort to ensure that every farming family could be plugged into modern life. Battling a lack of interest and resistance to change among the rural families—and sometimes a lack of money—the REA slowly brought electricity to every corner of the state.

Slowly the programs of the New Deal changed the way the larger population centers of Minnesota looked. In Moorhead the Central Junior High School and the first Moorhead Country Club were built with WPA labor and materials, and hundreds of people were employed in the construction. As in so many other places across the state, when the buildings were built, community pride was built as well, even when news reports were dismal.

The Great Depression forced Americans to look closely at their lives. When old ways fail, new methods must be tried. Minnesotans resolutely took part in this reconstruction of their society, which they hoped would be better for everyone.

Reconstruction of historic sites made excellent public works projects. Men in Duluth were put to work rebuilding the Fond Du Lac Trading Post near the mouth of the St. Louis River. Courtesy, Northeast Minnesota Historical Center

145

a projectile or bomb at a predetermined distance from a target. Minneapolis Moline produced artillery shells, and Crown Iron Works in Minneapolis developed steel parts for portable bridges, barbed wire entanglement posts, and pontoons. Crown also produced 20,000 tons of fabricated steel used in building military ships at shipyards in Superior, Wisconsin, and Savage, Minnesota.

Like many other small companies that manufactured and sold consumer products, the Owatonna Tool Company (OTC), in Owatonna, had made a good business out of selling tools door-to-door to farmers and mechanics. With the start-up of the war, OTC was one of many to stop its production lines and make some radical changes. OTC's gear pullers were sent to the front by the thousands, and mammoth wrenches for use on America's ships were sent to shipyards by the boxcarload. OTC—bought in 1985 by the Sealed Power Corporation of Muskegon, Michigan—was one of only a few plants in the Upper Midwest to receive five Army-Navy "E" (for excellence) awards during the war.

Larger companies also put the bulk of their production into the war effort. Minnesota Mining and Manufacturing (now called 3M) produced large quantities of adhesive-backed tape which was used for window protection during bombing raids as well as on ships, jeeps, and airplanes. The company also manufactured sheeting used for airplane wings. American Hoist and Derrick, in St. Paul, became a major supplier of marine deck equipment for combat ships and built the cranes, hoists, and derricks that were used in military shipyards.

By the summer of 1942 a second United States army was marching off to work every day—an army of women and men who never saw an enemy's gun but who knew the intimate details of the Allies' weaponry. An employee newspaper for the Federal Cartridge Corporation, the *Twin Cities Ordnance News,* noted that this new production army had its own war cry:

> 'Keep 'Em Shooting!' That's the new war cry you'll hear on every worker's lips these days! . . . That means that heavy responsibilities rest upon all of us engaged in Ordnance Production: . . . the responsibility to make every minute count; the responsibility to do our work with thoroughness and care . . . to work together as a team.

Northern Ordnance Incorporated, a subsidiary of Minneapolis-based Northern Pump Company, built twin gun mounts and other hydraulic equipment for naval destroyers. Employees of the company were ecstatic when they received a telegram in May 1943 from Rear Admiral W.H.P. Blandy, chief of the Bureau of Ordnance in Washington. "You will be pleased to know that ordnance of your manufacture played a prominent part in the successful action of a United States naval task force which recently fought a Japanese fleet twice its size in a four-hour surface duel off the Komandorski Islands," Rear Admiral Blandy reported, noting that the company's gun mounts, powder, and projectile hoists had helped the Navy outmaneuver and outshoot the enemy. The admiral went on to say that the task force had "executed their almost suicidal mission in magnificent style."

In northern Minnesota the three Iron Ranges hungrily gobbled up new workers as the country's steel mills called for more iron ore. In fact, iron ore shipments to steel plants in the United States nearly doubled between 1939 and 1942, and 66 percent of those iron shipments originated from the Mesabi Range. When the mines needed electrical power, the utilities announced that they would be able to provide sufficient power for all customers, particularly the mines. The Minnesota Power and Light Company informed the public that no federal funds would be required to build additional power facilities during the war effort.

"We recognize our responsibility in the defense program," M.L. Hibbard, president of Minnesota Power and Light, declared in a statement to the *Crosby Courier* in 1941, "and you may be assured that our Company has prepared itself to meet every emergency which may arise in this program of preparedness." Of particular concern

Above: *Although the production work that E.F. Johnson did for the military was top secret, the company received public praise for its contribution to the war effort with the presentation of the Army-Navy "E" award in 1944. Courtesy, Waseca County Historical Society*

Facing page: *Honeywell's experience with women workers during World War II taught the company that women's dexterity and attention to detail made them excellent assemblers. Courtesy, Minneapolis Public Library*

to Hibbard was the Cuyuna Range, which he explained was one of the vital spots in the nation's program. A year and a half later the Cuyuna Range reported record shipments of iron ore.

Electricity was also essential for farmers who were suddenly feeding a nation at war. Of 726 Minnesota farms without electricity surveyed in 1942, most had the capability of greatly increasing their yields if electricity were provided. Outside of Warren, in northwestern Minnesota, farmers were able to double the number of laying hens, turkeys, and geese. When electricity was installed, Warren farmers added 415 milk cows, 241 beef cattle, 224 brood sows, and nearly 1,000 feeder pigs.

But private industry wasn't the only source for the war effort. The federal government built a number of munitions plants around the country. Two such plants were located in Minnesota—one in Rosemount, a few miles south of the Twin Cities in Dakota County, and another in New Brighton, then a tiny suburb of St. Paul.

Some of the unsung heroes of the war were the farming families who sold their land to the government and the parents who raised their children in homes close to munitions plants. In Rosemount, the federally run Gopher Ordinance Works spread across thousands of acres of farmland. Although most of the homes were destroyed or moved, a few were kept for use as small satellite offices away from the main plant. An editor for the *Dakota County Tribune* wrote of the stark contrast between the county before and after the war began. "Grotesquely, these farm homes stand out," he noted in December 1942, "the only peaceful reminder of the rolling farmland which soon will be devoted to the outpouring of explosives to blast our way back to a victorious peace."

ica were opening the familiar blue cans to serve SPAM—between slices of bread, as an appetizer, and in casseroles.

In 1941 under the provisions of the Lend-Lease Act, SPAM and several other Hormel products went abroad. In his 1942 Christmas Eve broadcast, Edward R. Murrow explained that the British people would have a nice Christmas because, even though "the table would not be lavish, there would be SPAM for everyone."

Minnesota SPAM also attracted the attention of military procurement officers. The day after the attack on Pearl Harbor, the Hormel plant received word that SPAM was to become part of the government's war effort. Just like the ordnance plants that were springing up around the Twin Cities, Hormel's factory was immediately surrounded with steel fences and floodlights. Employees either wore badges to work or were denied entry. Once inside, they turned out thousands of cans of SPAM and combat rations like pork and apples, beef and pork, and ham and eggs. Parachute packs were filled with Hormel luncheon meat. Thousands of tins of Hormel whole chickens were sent to men who would spend the war years far from home.

Hormel's meat-packing business was designated an "essential" industry by the federal government during the war. When the company ran out of nails—one of the many products rationed between 1942 and 1945—the government moved quickly to find a source so that Hormel could close up its shipping crates.

To meet the increased military demand for its products, Hormel expanded its production facilities to four double-shift lines. Even as many employees exchanged their aprons for Army uniforms, Hormel steadily increased its labor force to satisfy Uncle Sam's needs. By the end of 1943 Hormel had hired 1,000 women; the number had increased by approximately one third by 1944, when Hormel's labor pool showed more than 5,000 men and women on its rolls and 1,150 more on military leave.

Companies such as Hormel recognized their obligation to returning service people and assured them they would have jobs waiting for them when the war ended. Hormel went so far as to forward copies of *The Squeal*, its employee publication, overseas. In December 1944, Jay Hormel, president of the company and son of founder George A. Hormel, wrote a letter to his employees serving in the military, telling them, "we still are hoping to be able to offer a full-time annual wage job to everyone who is now on our payroll. That includes those who have come on with us since the beginning of the war as well as those who are on military leave. Your old job will be here for you—the fellow who has taken your place will have to find the next best thing for himself."

As any military strategist would point out, one of the advantages the Allied countries had was access to nutritious food for their armies. But getting food to the "men over there" was frequently as much of a feat as producing the food in the first place. When tin shortages resulted in severe problems for Hormel and other Minnesota-based food supply corporations, packaging became a science.

The Pillsbury Flour Mills Company took the packaging issue seriously, investing in bags that could withstand the stresses of overseas shipping. Reporting on his company's success, Philip Pillsbury noted that they had passed an important milestone in the war effort when the company developed "sacks that could be dropped into the ocean out of Japanese artillery range." The tide would then float the sacks to servicemen on the beachheads.

The ability to adapt to the country's needs was a top issue with corporate management in most major Minnesota companies during the early war years. General Mills turned some of its corporate attention to the production of "roll correctors" for the British Admiralty and eight-inch gun sights for the United States Navy. By 1942, when United States Marines invaded the Japanese-held island of Guadalcanal, the Navy was using torpedo directors developed and manufactured by General Mills. In later months employees of the growing company's Mechanical Division created the "jitterbug" torpedo, which baffled Japanese trackers with its ability to twist and turn through the water.

Physicists and physicians at the Mayo Clinic collaborated to design a G-suit that would enable pilots to maintain consciousness under acceleration conditions. Ralph Sturm and others volunteered as human guinea pigs on a centrifuge in the laboratory until the suit design was perfected in 1946. Courtesy, Mayo Clinic

Urged on by the military's pressing needs, General Mills quickly learned the value of diversification. From its shipping docks went boxes filled with gun sights, breakfast foods, vitamins, dehydrated eggs and soups, and sandbags—all carrying the General Mills label. The company also established research facilities to turn soybeans into animal feeds, oils, breads, and other foods. Soybeans came to assume a critical role in Minnesota's postwar food production industries.

World War II was a catalyst for change in many Minnesota industries. Synthetic fibers began to attract the public's attention even before the war, but the need to reserve the bulk of the country's wool for military use prompted the appearance of synthetic-and-wool-blended blankets on the home front. The Faribo Woolen Mills, since 1865 the manufacturer of the Faribo woolen blanket, produced 250,000 olive-drab woolen blankets between 1942 and 1945.

Like many other industries, Faribo Mills took a long look at the changes spurred by the war. And like many other industries, the woolen mill decided to push on with the changes. By 1954 the word "synthetic" had become part of the American vocabu-

Facing page: Efficient transportation played a key role in fuel conservation. An improved channel on the Mississippi River made it possible to ship bulk commodities in fleets of barges. Courtesy, Minnesota Historical Society

lary, and Faribo Mills was producing a line of blankets made entirely of an acrylic called Acrilan. Orlon was later added to make Faribo blankets meet the changing needs of postwar consumers.

"Conservation" was another word that took on added importance for industry during World War II. Most Minnesota manufacturers took seriously their responsibility to conserve the state's resources. Construction materials, industrial metals, rubber, fuel oils, and many foodstuffs were rationed for private use so that they would be readily available for those in combat. Northern States Power Company (NSP), for example, enthusiastically supported the conservation efforts of its employees. At the Black Dog generating plant, workers built a warehouse from wood scraps and railroad ties, and when the company ran out of transformers, it purchased them from secondhand dealers.

NSP's advertising frequently contained messages about the company's conservation efforts. Glowing with pride, the electric utility company reported that it had salvaged 2,519,000 pounds of copper, brass, steel, lead, zinc, rubber, and paper through the war years. "Enough tonnage to build approximately 75 medium-size war tanks to fight the enemy," said one ad.

Above: The rising fame of the Mayo Clinic created a demand for public transportation between Rochester and the Twin Cities. The Jefferson Bus Line, which got its start transporting patients to the clinic, later commissioned an extraordinary series of landscape sculptures for the enjoyment of its passengers. Courtesy, Minneapolis Public Library

Minnesota's commercial banks played an essential role in the financing of World War II. Besides lending to other bond buyers, the banks both handled the large volume of war bond sales and invested heavily in bonds themselves.

The sale of war bonds had a lasting effect on the way Minnesotans conducted their banking business: customers began to demand convenience. The Farmers and Mechanics Savings Bank in Minneapolis was one of the first institutions in the Twin Cities to offer a payroll deduction plan for employees who wanted to purchase bonds. In addition, the bank was open on Monday nights. The payroll deduction plan was so popular that Farmers and Mechanics had more business than it could handle and even stopped taking applications from companies that wished to take part in the plan. In its corporate

Below: This food preparation class display helped Minnesotans get reacquainted with Armour products. Photo by Norton and Peel. Courtesy, Minnesota Historical Society

Facing page: The postwar boom brought prosperity to farmers and businesses alike. These happy farmers won cash prizes for their malting barley. Buyers from Fitger's Brewery in Duluth served on the panel of judges. Courtesy, Fitger's on the Lake

history, Farmers and Mechanics notes that more than half a million bonds were purchased through the payroll deduction department during the war. The bank received a special citation for writing 20 percent of all E bonds sold in Minneapolis.

By buying bonds Minnesotans learned that saving money can pay off in the long run. Saving regularly was a new experience for many workers—during the Depression they did not have much money to save—but peer pressure to sign up for defense bonds helped the idea take hold. Twin Cities Ordnance Plant employees were told by a jubilant management in 1942 that it was the largest plant in the country with 100 percent of its employees signed up for some type of regular contribution to war bonds.

But there was another reason why many people put their money into the 3-percent savings accounts offered by local savings and loan associations—there just was not that

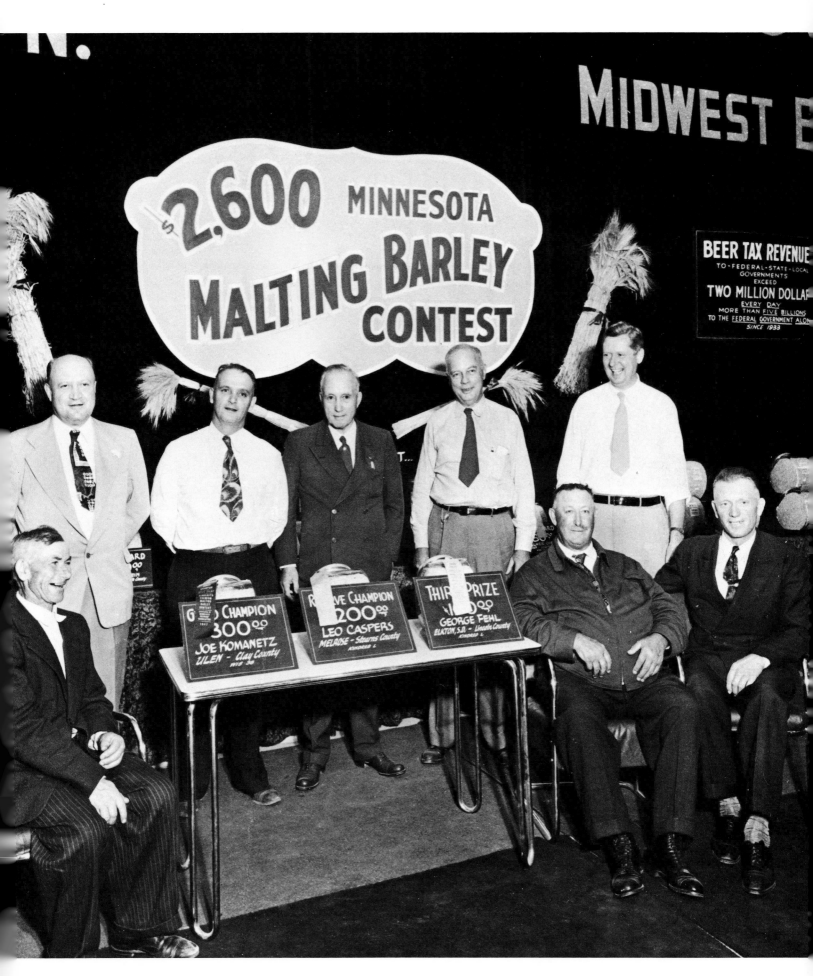

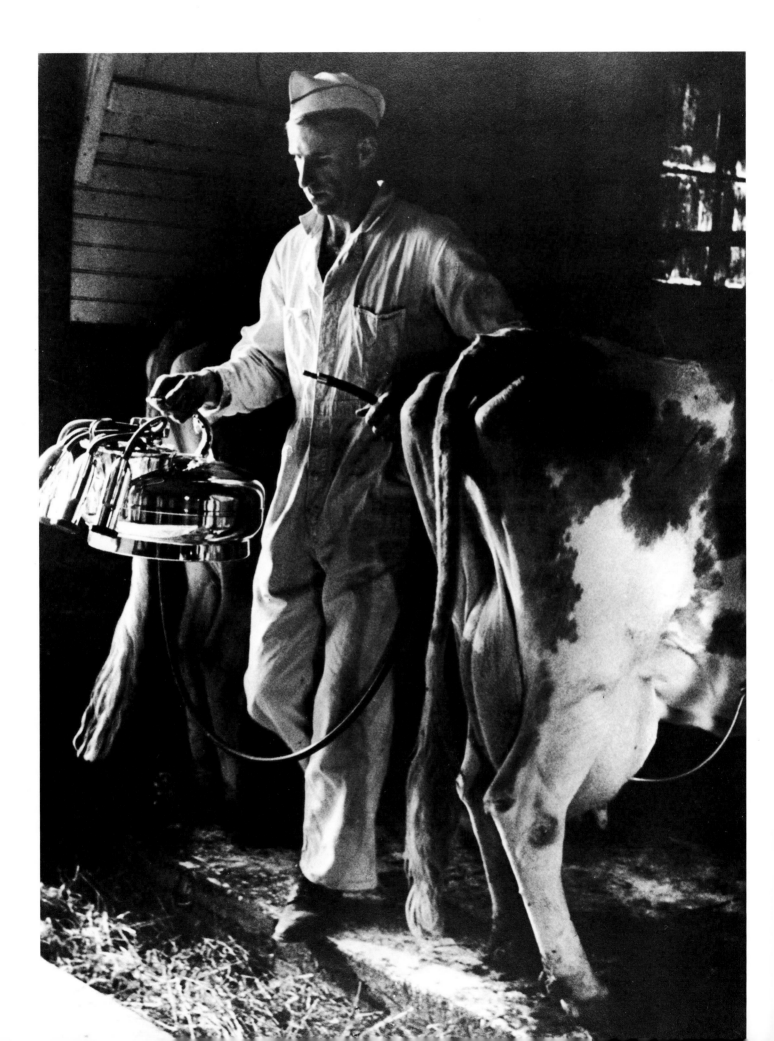

much to buy. New cars were rare, new furniture was often poor in quality, and gasoline rationing limited the traveling that people could do. One Minnesota institution, Twin City Federal Savings and Loan, showed an amazing record of growth during the war years—it more than tripled its savings deposits and doubled its mortgage loans.

Consumer buying habits changed considerably after World War II. When new products came on the market, the public snapped them up. With their checking and savings accounts larger than they had been in years, returning veterans and their families bought cars and appliances, even if it meant putting their names on the dotted lines of credit-package offers.

The major bank corporations in Minnesota felt flush at the end of the war. Banco and its 70-plus affiliated banks across the Upper Midwest (now Norwest Banks) reported that their consolidated deposits had risen from $527 million at the end of 1941 to $1.345 billion at year's end in 1945.

Twin City Federal (TCF) officers were as elated as their counterparts at Norwest. During the 1940s, TCF became, temporarily, the largest federal savings and loan in the United States, growing from a respectable portfolio of $10 million in 1940 to a whopping $200 million in 1950.

Facing page: Dairy farmers praised the advent of electric milking machines, which enabled them to expand their herds. Before rural electrification, few farmers milked more than thirty cows. Courtesy, Minnesota Historical Society

Despite some grumbling from economists who predicted a depression similar to the one that followed World War I, the optimism shown by Norwest Bancorporation, First Banks, and TCF was indicative of the banking industry's overall belief in the growth potential of the Upper Midwest. And the great bank shakeout of the Depression meant that fewer banks were competing for business.

By the end of the decade Minnesota's future looked as happy as a Norman Rockwell illustration. Manufacturing and agriculture were competing for first position in the value of goods produced, and the electronics and plastics industries were coming around the corner. Oil exploration in the Williston Basin in North Dakota had begun, and there was talk on the Iron Range about reclaiming a low-grade iron ore called taconite. Tourism and its attendant business, the recreation industry, sparkled once again after the dark days of gas rationing.

HOMECOMING

Optimism at the end of the war brought weddings, baby announcements, and housewarmings. Along with the burst of technological innovation during and after World War II came shifts in Minnesota's population. In 1940, 30 percent of the state's total population worked on farms; by 1950 only 22 percent of the population farmed. For the first time in Minnesota history, more people lived in urban areas (incorporated towns or cities with populations over 2,500) than in farms and rural villages.

One of the factors in the change was farm mechanization. Farm machinery became more specialized and powerful. Now there were beet lifters, beet loaders, combines, corn pickers, disc harrows, feed grinders, fertilizer spreaders, hay balers, milking machines, and potato diggers. Much of the new equipment was built by Minnesota companies in Minneapolis, St. Paul, Winnebago, Mountain Lake, Glenwood, and Green Isle. With all the diesel-powered muscle available, farmers could do most of the work themselves and had little need for hired hands.

Migrating Minnesotans usually had no trouble finding employment in the cities. Jobs of all kinds were so plentiful that there were often too few applicants for the work available. An article in the *Fairmont Sentinel* on November 14, 1947, announced that jobs were open for individuals with almost any kind of skill: "In fact, there are so many jobs now available for so many varieties of occupations that the employment service has given up trying to keep a full up-to-date list posted on its bulletin board."

Minnesota's urban population was becoming heavily concentrated in three regions: the Twin Cities metropolitan area; the southeast, including Rochester, Austin,

United States Steel's Duluth works
enjoyed the two-fold convenience of
a nearby supply of iron ore and in-
expensive water transportation.
Coal came by boat to the Zenith
Coal Dock (pictured here) to fire
blast furnaces that began produc-
tion on the eve of World War I.
Courtesy, Northeast Minnesota
Historical Center

and Winona; and the northeast, including Duluth and the Iron Range cities in St. Louis
County. Counties in and around the Twin Cities, such as Anoka, Hennepin, Ramsey,
and Washington, experienced the greatest growth.

In Duluth, Minneapolis, and St. Paul—and to a lesser extent, in a few of the
smaller towns—new housing communities began to circle the urban cores, frequently
in advance of adequate highways, sewers, and good water supplies. Social commenta-
tors watched suburban growth with a rueful eye, predicting that America was building
pockets of homogeneity that would have a negative effect on the country's spirit.

By the early 1950s the shortage of housing for new postwar families in Minneapo-
lis was forcing them to move to the suburbs south and west of the city, and pressure
was put on policymakers to find funds to develop a grid of highways that would make
commuting more convenient for those people who lived in the "burbs" and worked

downtown. L.P. Pederson, a Hennepin County engineer from 1953 to 1966, remembers trying to convince a busload of legislators that the state should build a highway that would cross the southern section of the Twin Cities, linking the airport with the core of Minneapolis.

As Pederson tells the story, the legislators stepped out of their bus onto a field and tried to imagine a highway that would cross the county from east to west. "Doesn't make much sense to me," one of the legislators noted. "Why would anyone want to spend the taxpayers' money on a highway this far out?"

But in spite of the legislator's attitude, the cities grew and suburbs added suburbs of their own. The first piece of the Crosstown Highway was added to the expanding and increasingly complex highway system in 1967. Today more than 114,000 cars

The Bridgeman-Russell Company established a dairy business in Duluth in 1935 that grew to statewide proportions. Today a person wanting lunch or an ice cream treat in any substantial town looks for the Bridgeman's soda fountain and restaurant. Courtesy, Northeast Minnesota Historical Center

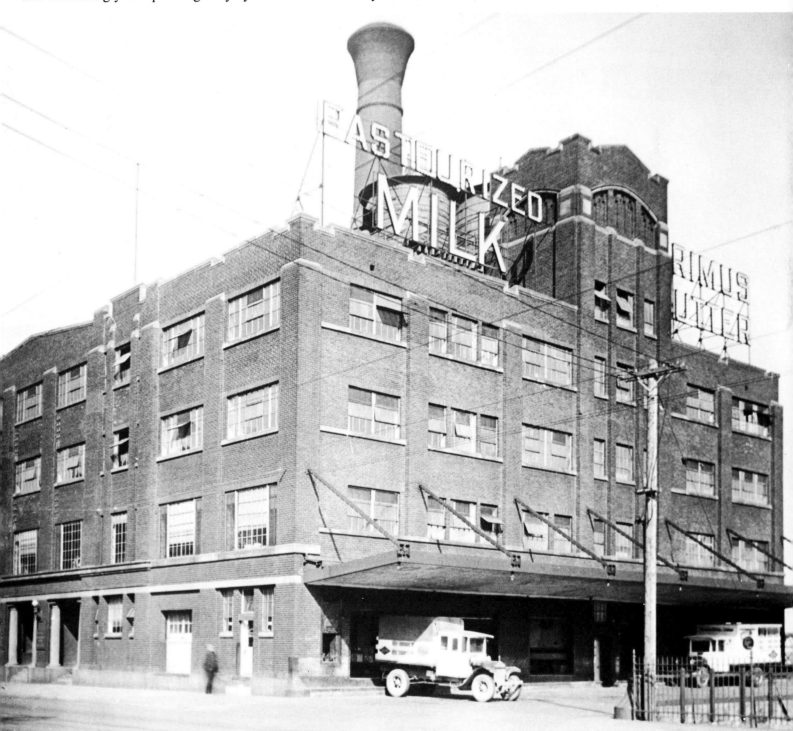

Above: *Two Naval veterans put their technical skill to work in civilian life as they search for a drowned boy in Minneapolis in 1947. Courtesy, Minneapolis Public Library*

Facing page: *After World War II, suburban growth quickly filled the farm fields surrounding Minneapolis and St. Paul. The John Tierney Farm in Richfield was photographed in 1954. From the* Minneapolis Star. *Courtesy, Minnesota Historical Society*

squeeze onto the busy highway every day, a testimony to the fact that city growth frequently takes on a life of its own.

As the 1950s dawned like a sunrise on a summer's day, Minnesotans forgot the troubles they had weathered through the Depression and the war years and began to taste the good life. According to the corporate history of Northern States Power, electrical and gas consumption set all-time records in 1950. That same year NSP added 20,000 new customers—all those new homes and families!—who eagerly plugged in television sets, electric ranges, and phonographs as the costs of electricity continued to decrease.

In the first year of the new decade, living-room stars Ed Sullivan and Arthur Godfrey teamed up to tell the country that color television was right around the corner. People moved out of their kitchens and dining rooms and ate on TV trays. The mood was up—America was strong. In the heart of the country, Minnesotans looked ahead, not behind, and took the job of building progress seriously.

Minnesota celebrated its statehood centennial in 1958 in appropriate form by fitting out a train to carry the celebration throughout the state. Courtesy, Minneapolis Public Library

MINNESOTA MEETS THE WORLD

He had been vice president of the United States for seven months when he returned to Minnesota to speak at the 1965 commencement ceremony at St. Olaf College. Under a brilliant early-summer sky, Hubert Horatio Humphrey leaned into the microphone and reminded the graduates that technology wasn't the only answer to the world's problems. "We must recognize technology's effect on society and insure that it continues to serve us, and not itself," he noted. "There is only one certain way we can achieve this," he said soberly. "It is through education . . ."

The vice president's speech was reported faithfully, without editorial comment, on the front page of the *Northfield News.* But few people paid much attention to his words. For nearly two decades, technological advances had put spirit back into a country that was worn out from war. For a young country on the move, technology was exciting.

Technology brought color television, contact lenses, Sputnik 1, copy machines, aerosol cans, stereo record systems, lasers, and satellite communications. Technology was a computer built at the University of Pennsylvania that could complete 5,000 additions every second; when it was operating, it dimmed the lights of the surrounding city. Clearly, technology was the power of the future. Even as the vice president convinced those St. Olaf graduates of the validity of his message, he was too late. Technology was already in charge of America's destiny.

A new era of space exploration was created when, in 1961, Russian cosmonaut Yuri Gagarin was launched into space aboard a tiny capsule only seven and a half feet wide. When he lived to talk about how it felt to leave earth's gravity, the new era was christened the Space Age.

Far away from the nation's major space centers, Minnesota technology played an essential role in early space experiments. In cooperation with the National Aeronautics and Space Administration (NASA), the G.T. Schjeldahl Company, of Northfield, built a massive communications balloon, 135 feet in diameter and approximately thir-

teen stories high, that would inflate in space. Launched just a year and a half before Humphrey gave his talk on technology, only blocks from the Schjeldahl plant, the "Satelloon" was called ECHO II, and it would circle the earth—from pole to pole— in a little over two hours, deflecting communications signals as it moved. Four years earlier, ECHO I, also made of Schjeldahl "superpressure" fabrics and Schjeldahl know-how, had captured the imagination of millions as it circled the earth, transmitting radio signals from one part of the globe to the other. By the time the highly sophisticated ECHO II inflated in space in 1964, its older and more primitive sister had traveled nearly 500 million miles and was reportedly beginning to show wear and tear.

Founded in 1955, the Schjeldahl Company would be involved in twenty satellite programs through the decade. But Gilmore Schjeldahl ("Shelly"), founder of the company, used the materials and processes he invented for the space program to build more profitable products as well. Schjeldahl technology made the dome popular—especially as the public got wind of a "Schel-Dome" at Lutsen Resort on Lake Superior, where winter guests could bask by a covered pool as if it were the middle of summer. Schjeldahl technology also created less glamorous products such as packaging machinery.

At the annual meeting of the Packaging Machinery Manufacturers Institute in Gaylord, Michigan, soon after ECHO's launch in 1960, Shelly was asked to talk about his firm's role in building ECHO I. "The ECHO I Satelloon is a good example of packaging," he quipped. "We are the first country in the world to package gas in space."

Whether in preparation for the exploration of outer space or in readiness for an information age that was right around the corner, Minnesota's industrial base swelled with growth possibilities in the first two decades after the end of World War II. Minnesota's adaptable labor pool was heady with new job opportunities as technically oriented companies popped up all over the state. Between 1956 and 1961, the number of new-tech companies increased from 86 to 140, employing more than 40,000 people and commanding $720 million in annual sales. Prompted by an entrepreneurial spirit and available venture capital, companies in Minnesota began manufacturing data processing and mass memory systems, tape recorders, hearing aids, heat-regulation equipment, electronic circuits, sound and video recording tapes, military components, and the prototypes of implantable medical devices.

Surrounded by young upstart companies at home, the father of Minnesota's electronic industry, Minneapolis Honeywell—now, simply, Honeywell, Inc.—ranked 129th among *Fortune* magazine's listing of the 500 largest industrial companies in the United States. In 1958, Honeywell reported sales of $329.5 million—a long way from the $6.6 billion it reported in revenues in 1985—having increased its sales by almost 2,000 percent between 1939 and 1959. In 1958, with 14,000 employees and an annual payroll of approximately $70 million, Honeywell was the state's largest private employer.

The key to Honeywell's growth was diversification and sophisticated responsiveness to the changing demands of the world. Founded in 1885 to manufacture heat regulator controls, Honeywell created missile guidance systems, instruments, controls, and other components for the military after World War II. By 1959, 25 percent of the company's sales were to the military. At the same time, however, Honeywell was able to maintain its dominant position in electrical controls for residential and industrial heating and cooling systems.

Another company that clearly understood the need for diversification in those years was General Mills. By the end of the 1950s, General Mills was the country's largest flour miller and the 75th largest corporation in the United States. Fifteen percent of General Mills' employees worked for the Mechanical Division, producing navigation and guidance systems, instrument and testing equipment, digital computers, and nuclear equipment engineering. Further, General Mills supported considerable research in optics and meteorology, including high-altitude balloon research. In 1947, General Mills launched one of the first unmanned balloon systems to collect informa-

tion about the earth's atmosphere. Called Project Skyhook, it was launched at St. Cloud carrying a payload of sixty-three pounds; it soared more than 100,000 feet before it landed at Eau Claire, Wisconsin.

St. Paul's claim to corporate fame, 3M (formerly called Minnesota Mining and Manufacturing) ranked 106th in the *Fortune* magazine list of the 500 largest companies in the U.S. In 1959 its electrical products division reported $65 million in revenues. But the company was also gaining international attention for its Thermo-Fax-brand copiers—the world's first dry copiers—and its Scotch-brand tapes. 3M variations of its original "Scotchlite" tapes of the 1940s were used by the electronics industry in the memory units of giant data-processing systems, and by the music industry in recording equipment.

In 1959 the nation's agricultural machinery industry was producing equipment that could harvest grain and can crops quickly and efficiently. Courtesy, LeSueur Museum

178

In Minnesota, the young computer industry was energized by the appearance of new and tiny companies that would focus on one solution to one problem, and learn how to do it better than anyone else. Frequently these little companies had inexperienced management, unable to withstand the pressures of growth. Often they failed when their product was placed on the market; or they were eaten up by larger, better-managed corporations. Such was the case of Engineering Research Associates, which produced the country's first feasible memory storage system; it was soon acquired by Sperry-Rand (now known as Unisys).

In the late 1950s, Control Data Corporation was considered one of the more promising faces on the computer industry block. Having begun in 1957 with twelve employees, Control Data rapidly strengthened its computer and digital systems operations until, in 1961, it proudly reported having more than 1,250 employees. But as rapid as Control Data's growth was in the first few years of its life, its management was able to nimbly guide it through its entrepreneurial stages without stumbling. One of the reasons for the company's success was its ability to keep one step ahead of its markets, and it concentrated on producing products for the industries its management understood best.

By the late 1950s more than 25,000 Twin Citians were working in technology-related fields, receiving an annual payroll of $120 million and helping to attract sales of more than $400 million. Lured by the profitability of the industry and the optimistic mood of the state's economists, high-spirited entrepreneurs formed and fostered new ventures by the dozens. In March 1959, *The Minneapolis Star* surveyed the metropolitan area to find out just how many new electronics companies were doing business in the area. The newspaper discovered forty-seven new firms employing nearly 4,000 people—many of whom were engineers. Annual gross sales figures for the forty-seven little companies was $50,500,000. Small electronics firms in the Twin Cities at the time included the American Electronics Company in Minneapolis, which manufactured relays, transformers, and switches; Audio Development, which built miniaturized transformers; and Research, Incorporated, which engaged in specialized research in aerodynamics, heat transfer, instrument development, and electronic component production.

Outside of the metropolitan area, even deep in the heart of Minnesota's hunting and fishing centers, other Minnesota electronics firms flourished. A notable example is the E.F. Johnson Company in Waseca, which in the early 1960s was one of the world's largest manufacturers of amateur radio transmitters as well as electronic components and ultra-miniature capacitors for printed circuit equipment. Founded with $1,500 in capital as a mail-order house for ham radio operators in 1923, E.F. Johnson realized its first great surge of growth in 1950, when amateur radio transmitters became popular. In 1961, E.F. Johnson consolidated its operations from several plant locations to a facility costing well over $1 million to build.

Red Wing was the home of Central Research Laboratories, a small company that built laboratory research apparatus and instruments, to be shipped throughout the world. In Mankato, another company that exported many of its products was AEMCO, Inc., which built time switches and controls. Dow-Key Co., Inc., producer of electronic and mechanical coaxial connectors, was located in Thief River Falls. In the middle of Minnesota beer country was the John Oster Manufacturing Company, near New Ulm, which built small motors for use in aircraft. In Rochester, the Waters Corporation built electro-medical instruments.

In the late 1950s rural Minnesota also attracted out-of-state corporations looking for new places to build their production facilities. IBM (then called International Business Machines Corporation) was one such corporation. IBM selected Rochester as the site for its $25 million data-processing plant, and hired close to 2,500 employees. In 1961, T.J. Watson, Jr., then president of IBM, responded to a survey of the quality of business conditions in Minnesota (the survey was conducted by Northern States

Facing page: A Green Giant research lab and greenhouse were photographed about 1960. The Minnesota Valley Canning Company took its Green Giant brand name from a hybrid pea developed in its own laboratory. The company's commitment to research and development generated the "Heat Unit Theory," which enabled it to pinpoint a "fleeting moment of perfect flavor" and harvest three-quarters of the crop as "fancy" grade. Courtesy, LeSueur Museum

Power Company, First National Bank of Minneapolis, and Northwestern National Bank of Minneapolis):

> From the time our survey team first arrived in Rochester, we have been given the very finest kind of cooperation and assistance in establishing ourselves there. Local and state governmental officials, as well as business leaders and civic groups, have gone out of their way to make us feel welcome and have helped us in many different ways.

> We have been impressed with the progressive attitude and the interest and belief in American business which are characteristic of the people of Minnesota, and are delighted to have so many Minnesotans joining our organization.

JUDGED BY THE COMPANIES WE KEEP

By the middle 1950s more than 3 million people made Minnesota home, and a third of those Minnesotans lived in the three major metropolitan centers of Minneapolis, St. Paul, and Duluth. In 1956 Governor Orville Freeman publicly announced that the labor pool of the state had become one of Minnesota's greatest resources. What Minnesota needed to bolster the economy was enough new industry to keep taxpayers from leaving the state in search of better jobs. In an open marketing letter to the industrial captains of the country, Freeman noted that "Minnesota firmly believes we are judged by the companies we keep. We are proud of those we have, and we are doing our best to increase their number." Freeman added that state policymakers were planning to create legislation to make it more profitable to build a business in Minnesota. But what did he have right away that was better than any other state? People, the governor reminded his readers—a labor pool that was "skilled of hand, steady of mind, and intensely ambitious," displaying the "rugged individualism, the high productivity, and the stability of their forebears."

Additionally, Minnesota had 44 percent fewer labor stoppages than the national average. Minnesotans were well trained for industrial jobs, said the governor. Nearly one-third of the government dollars that were spent for vocational education were applied to trade and industrial skills. And the entrepreneurial spirit was alive and well in Minnesota. People liked to tackle new ideas—in their garages during the long, cold winter months, and in their basements while they escaped August's heat and humidity. Out of those garages and basements in the early 1960s came prototypes of new products that would begin to change the way people lived their lives.

The early 1960s was a creative time for business development, and venture capitalist noses twitched with new business expectations. It was also an optimistic time for new businesses. For the first time in the state's history, manufacturing revenues exceeded the state's agricultural receipts by more than $400 million.

In no Minnesota industry was creative genius quite so busy as in biomedical research. A cousin to industrial electronics, the biomedical business thrived on the unlikely combination of medicine and engineering. Creative sparks flew when physicians and engineers sat across the table from each other. And some of those sparks lit fires that energized a number of Minnesota's major industries.

Earl Bakken, founder of Medtronic, Inc., today one of the country's leading medical electronics companies, was a young electrical engineer in 1949 when he quit his job to form a medical equipment repair company with his brother-in-law, Palmer Hermundslie. In their 600-square-foot garage they built their servicing business and talked to researchers from medical equipment manufacturers who had ideas about better medical products but didn't know how to build them. In the mid-1950s, a leading pediatric cardiologist at the University of Minnesota, Dr. C. Walton Lillehei, approached young Bakken about designing a battery-powered pulse generator that would

help pace abnormally slow heartbeats. By the time John F. Kennedy was elected President, Medtronic had outgrown its little garage and, with twenty-five employees, was refining the world's first implantable cardiac pacemaker. Over the next twenty-five years, more than one million Medtronic cardiac pacemakers would be in use by people around the world.

As the biomedical engineering industry gathered steam, there seemed to be no end to what the Minnesotan entrepreneurial mind could dream up. In Atlantic City, a tiny St. Paul company, Electronic Medical Systems, thrilled the 1961 American Hospital Association conventioneers with a prototype of a portable electronic device that could transmit electrocardiogram (EKG) information over the telephone. This was a breakthrough for rural hospitals, which had been sending EKG tests through the mail for analysis by cardiologists: the telephone transmission system could provide EKG evaluations for patients in four minutes instead of four days.

That same year a seminar in medical electronics was held for the medical staff of Minneapolis General Hospital by Whitehall Electronics and Epsco Medical—both

Even Minnesota ingenuity failed to find a machine that could match a person's ability to taste peas. Minnesota Valley Canning Company moved into the modern era of advertising in 1950 by changing its name to Green Giant. Now part of Pillsbury, Green Giant's quality control is still done by people. Courtesy, LeSueur Museum

181

local television stations. But before the presses began again on August 7, employees had lost more than $3 million in wages and 13,000 carriers and other distributors had missed out on $1.4 million in earnings.

The action of the fleet drivers had other far-reaching consequences. Not only were the *Tribune*'s circulation and advertising revenues damaged, but business activity throughout the Upper Midwest deteriorated. It was several months before the public's confidence in the newspaper was restored.

THE BITTER IRON PILL

Medtronic's pacemakers helped young patients as well as old. The University of Minnesota Medical School also benefited from the opportunity to pilot the new equipment. Courtesy, Medtronics, Inc.

Although labor boldly squared off against its opponents on the issues of wages, benefits, automation, and workers' compensation, it had an Achilles' heel. Up north on the Range, where the mining industry had once pumped high employment and dollars into the communities through its 400 mines, jobs and family security were now in question.

Between 1956 and 1966, 211 iron mines were shut down because they had exhausted their high-grade, economical-to-mine ores. Worse, mines in countries such as Canada and Venezuela were able to ship high-grade iron ore to the United States at competitive prices. Between 1950 and 1960 iron ore imports nearly quintupled. Mining management up on the Range knew that they would have to keep a tight grip on the prices of their ore if they were to compete in an international marketplace. For many, taconite seemed to be the best answer; taconite mining would bring the Mesabi Range back to health.

The taconite issue was hot up on the Range—as well as in the hallways of the Capitol—through the 1950s and 1960s. Taconite is a hard, fine-grained gray rock containing between 15 to 30 percent iron—a low-grade ore. Identified in the 1870s, taconite was studied in 1911 at the University of Minnesota's newly organized Mines Experiment Station and was considered a potential replacement when the high-grade ore played out. With state research funds, the problems of how to crush the rock were overcome. In 1951, the Reserve Mining Company and the Erie Mining Company announced plans to build a commercial taconite industry. High labor and production costs seemed the only remaining obstacles.

Optimism soared throughout the state. Not only was Reserve Mining Company building an open-pit mine that would produce more than 11 million tons of taconite a year, it would also build a primary crushing plant at Babbitt and a private railroad to transport the taconite across Minnesota to the shore of Lake Superior at Beaver Bay. The company was predicting that it would also build two new towns for about 5,000 people each, and each town would have the very latest in "modern homes, schools, medical facilities, sewage disposal plants, water supply systems, paved streets, recreation centers . . . stores and other modern conveniences."

People of the north country who could still recall the glory days of the early mining and timber industries in Minnesota began to hope that their families would soon see prosperity as they had never seen it before. By the early 1960s two commercial taconite plants and one pilot plant were in operation. Public policymakers—who were counting votes—searched for ways to help the iron mining companies further invest in Minnesota's labor pool.

Members of the legislature next turned to the taxes that had traditionally been imposed on mining companies. An old provision in the state's lawbooks had provided for a form of double taxation on iron mining companies and the ore they produced, and it was the legislature's idea to make certain that taconite (and other specified minerals, including copper and nickel) was not being taxed more heavily than other industries were.

Liberals in the state house had a difficult time deciding which way to bend: if they leaned to the right (no double taxation of mining companies), they would be conceding to the demands of big business; if they shifted left, they could use the extra tax revenues to help stimulate investments in the north that could change the course of the Range's economic future. Meanwhile, conservatives pointed out that iron mining taxes virtually supported the northern communities. In 1960, for example, mining companies paid 99.8 percent of the total taxes levied in the towns of Franklin and Fraser, 95 percent of the taxes in Coleraine and Taconite, and 64 percent in Hibbing. Mining company officials noted that they were reluctant to invest the large sums necessary to build and operate the plants in Minnesota because they expected that the state's policymakers would do to the taconite industry what they had once done to the owners of high-grade ore—legislate high taxes which would hurt potential profits.

In an uncomfortable coalition, both major political parties threw their weight behind the iron mining industry of Minnesota. The vote was eventually put to the people in the form of a "Taconite Amendment," which was intended to stabilize the taconite tax policy for twenty-five years and, it was hoped, invite new investments and expansion in the industry. But Governor Karl Rolvaag worried that public apathy would result

in a "no" vote on the amendment, and he appointed Dr. Charles Mayo, chairman of the University of Minnesota's Board of Regents, to form a bipartisan publicity committee. The sole purpose of the committee was to ensure that the public understood how critical the Taconite Amendment was to the health of the state. On the publicity committee were an array of political stars, including former Governor Elmer L. Andersen, Lieutenant Governor A.M. "Sandy" Keith, and Attorney General Walter F. Mondale.

In subsequent months, more than 600 major state organizations rallied to support the amendment. Minnesota had never seen such publicity for an economic issue. Bumper stickers as well as television and radio announcements urged the public to vote "yes." Special taconite stamps were issued to help raise dollars as well as awareness.

But the media move of the year was still to come. In the middle of the campaign, the Ford Motor Company and the Ogelbay-Norton Company (a mine management company) announced that they would jointly begin the development of a taconite plant at the little village of Forbes; the company they would create to operate it would be called the Eveleth Taconite Company. The two parent companies were going to begin work on the plant, they said, because management was convinced that voters would go for the Taconite Amendment.

In their voting booths the public remembered to say yes to taconite by a whopping seven-to-one victory. Within days, the iron mining industry returned the favor. U.S. Steel agreed to spend $100 million on a taconite plant at Mountain Iron, and the Hanna Mining Company announced that it would build two plants, one at Nashwauk and another at Keewatin. Further, Erie Mining Company and Reserve Mining Company— the two original taconite players—said they would each expand their operations to the tune of another $80 million. Taconite shipments increased from 38.9 percent of the total ore shipped in 1964 to nearly 60 percent five years later. By 1970 more than $1 billion had been invested in the taconite industry. In the last five years of the 1960s, direct benefits to the state in the form of wages, supply and utility revenues, royalties and taxes amounted to between $125 and $150 million annually.

With the passage of the Taconite Amendment, the employment future looked good and both business and labor leaders were pleased with a job well done. In St. Louis and Lake counties, mining employment increased substantially, further linking the economy of the area to the fortunes of the mining industry. New secondary industries sprang up. A liquid oxygen plant at Babbitt built by Union Carbide Corporation, an American Brake Shoe steel casting plant at Two Harbors, a grinding ball production firm at Hibbing, and blasting agent plants belonging to Dow Chemical and Spencer Chemical at Biwabik were examples of second-string production that benefited from taconite production successes. As iron and taconite mining pumped dollars into the state's economy, leaders reveled in the thought that Minnesota had the capacity to produce 64 percent of the total national iron ore and taconite output.

But these heady days didn't last. Looming ahead were economic and environmental questions that would have to be resolved in order for Minnesota to maintain its hard-fought leadership in national taconite production. In a 1970 speech given to the Minnesota Commission on Taxation and Production of Iron Ore and Other Minerals by J. Kimball Whitney, then Commissioner of the Minnesota Department of Economic Development, the audience was reminded that another $1 billion needed to be invested in plants and expansions in order for the industry to reach a production capacity of nearly 62 million tons annually.

Additionally, there was some question about how much the taconite industry was actually able to increase employment on the Range. Metal mining employment reached a peak in 1957, when taconite-related jobs represented only 19 percent of the total number of mining jobs. In the years between 1958 and 1970, however, taconite employment rose threefold while metal mining jobs as a whole fell by nearly 28 percent. By 1975, of the 15,000 workers employed in metal mining, approximately 13,250 worked in taconite production. According to Commissioner Whitney, ". . . it is difficult to see

University of Minnesota engineer E.W. Davis worked for twenty years to find a way to process the hard Mesabi taconite into usable form. Davis found a solution just in time to keep the iron industry from collapsing after World War II. Courtesy, Iron Range Research Center, LTV Steel Collection

whether, in net, taconite development will be able to offset fully the decline in total metal mining employment resulting from the loss of direct shipping ores."

Increased competition from both domestic and foreign ore producers was another gremlin for the state in the early 1970s. Costs and quality were scrutinized by the steel companies and the wolf was always at the door as steel imports rose dramatically through the 1960s. In 1965 and 1968, for example, imports rose 61 percent and 57 percent respectively.

Closer to home, the public began to wonder if they had made such a wise decision in boosting the taconite industry. Minnesotans have long been proud of the crystal-clear quality of their lakes, and when Reserve Mining requested permission to draw water from Lake Superior for taconite processing, citizens grew concerned. They grew even more concerned when they learned that Reserve's Silver Bay plant was returning the processing water to the lake along with waste particles (tailings) created during taconite production. The lake around the Silver Bay plant turned a strange color—proof enough to most people that the tailings were polluting the water. In 1971 the federal government, as well as Minnesota and other states, sued Reserve Mining.

The public became frightened when scientists discovered that the tiny asbestos fibers contained in the tailings could be linked to cancer. Even more alarming was the discovery that the tailings had found their way into the Duluth water supply. After a hotly contested legal battle, Reserve was finally ordered to find an on-land waste disposal site. With the increased costs of converting to land disposal, Reserve Mining was caught in a bind, and it was a situation that would become very familiar through the next decade: how to balance the cost of doing business with the demands of conserving a very precious environment.

Where the Prairie Meets the Sea

Murmurs of disbelief could be heard as the speaker made his point, and he stopped for a moment to let his words sink in. Four hundred Minnesota businesspeople shook their heads and sat back waiting to be convinced. Handpicked personally by Governor Orville Freeman to attend a 1959 conference on the problems and potential of the Duluth area, these business leaders weren't in the mood for fantasy.

On the platform was Alex Freeman, a Canadian investor who was audacious enough to announce that the city of Duluth would make an economic comeback. Not only that, he said solemnly, he and his backers believed that, with a little help from sound business investment, Duluth's population would double by 1970. No one in the room held much hope that the north country would ever again have the commercial success it had enjoyed decades before in the glory days of the logging and mining industries. Yet the Canadian investor was pledging $100 million for development of the Duluth port area. His investment decision was based on the potential of the little city—a potential that could be realized in the form of the St. Lawrence Seaway.

As Freeman continued his presentation, members of the audience listened attentively as he talked about the profitability and timing of the venture. The St. Lawrence Seaway, a project that had been under construction since 1955, could bring Minnesota into competition with seaboard states. No doubt it would change the economic outlook for the Midwest, and it would add another critical resource to the state's business environment—inexpensive transportation for exporting the raw materials of the country's midsection.

The St. Lawrence Seaway project was the brainstorm of the Canadian government in the early 1950s. The Canadian government wanted to provide passage for large oceangoing vessels through the Great Lakes and to build major hydroelectric plants that would supply power to Canada's growing cities. Technically, the St. Lawrence Seaway is a 200-mile stretch of the St. Lawrence River between Lake Ontario and Montreal which, when developed, would lead to the opening of the entire 2,300 miles of the Great Lakes-St. Lawrence River waterway. By 1953 President Eisenhower had seen the wisdom of the plan and had elbowed the United States government into the action. Construction of the Seaway and power project began in 1955, and when the Seaway opened four years and $471 million later it included three major dams, seven new locks, and a number of canals. Additionally, the United States government spent another $65 million dredging major Great Lakes harbors to make them navigable for oceangoing ships. As a result of the Seaway project, major cities in the United States and Canada—Buffalo, Cleveland, Toledo, Detroit, Chicago, Milwaukee, Montreal, Duluth, Toronto—would be turned into seaports.

Back in Duluth, city planners, under the leadership of port Director Robert T. Smith, knew that the day of the Seaway was inching closer and that opportunity was about to come knocking at Minnesota's back door. Rallying business interest wherever they could, Smith and his co-workers created business confidence in the port and attracted significant investments in it. And they are credited with creating one of the

Facing page: *Inside a taconite plant the hard rock is crushed and ground and the iron is extracted with magnets, formed into pellets the size of marbles, and hardened with heat. The resulting taconite pellets contain twice the iron of the original rock. Courtesy, Iron Range Research Center, LTV Steel Collection*

191

best-planned harbors in the world. Designed to withstand heavy traffic, the Duluth harbor facilities included three major berths plus another marginal berth. The berth area was serviced by four railroad tracks, two tower floodlights, heating facilities, and pumps. According to an article in the premier issue of *Duluth Port,* a magazine created by the Seaway Port Authority of Duluth, one of the most spectacular equipment assets of the Duluth seaport of the day was the pair of ninety-ton gantry cranes which, in tandem, had a lift capacity of 180 tons—"the greatest one in the Great Lakes."

Private enterprise quickly responded to the Port Authority's development frenzy. F.H. Peavey and Company, for example, a Minneapolis grain handling company, announced a multimillion-dollar expansion of its harborside facilities so that it could handle the flood of grain expected to move through the port. Following Peavey's lead, twenty-one other grain elevator companies in Duluth and Superior modified their structures to match the projected increased need. At the same time, they formed the Duluth-Superior Grain Terminal and Exporters Association, which would help smaller companies learn the ropes of exporting.

In an all-out effort to prepare for the expected increase in grain exports, the Farmers Union Grain Terminal installed a special dump for unloading trucks carrying 600 to 650 bushels of grain per load. Trucks hauling grain were expected to come from as far away as Montana. At a number of grain elevators, including those owned and operated by General Mills, the Norris Grain Company, Capitol Elevator (a division of International Milling Company), Occident Elevator, and the Cargill Company, elevator loading spouts were raised to accommodate the ships, and grain slips were deepened to help increase each vessel's load.

When the first foreign oceangoing vessel reached the Duluth-Superior harbor on May 3, 1959, unofficially heralding the opening of the St. Lawrence Seaway, the citizens of Duluth kept their fingers crossed that prosperity was just around the corner. Blasting their horns, foreign ships from Britain, Liberia, Norway, Germany, Panama, and Denmark entered the harbor, eager for export grains. In languages that reminded many citizens of their parents and grandparents, sailors bargained for trinkets to carry home to their families thousands of miles away. By July, seventy ships bearing foreign flags had entered the Duluth-Superior harbor to pick up grain for shipment overseas. Skeptics who had not believed that Duluth would ever become a foreign port ate crow as new vessels crowded around the harbor waiting for berths.

The Seaway brought hundreds of new job possibilities to the north country: warehousing and cold storage, dredging, shipbuilding, and dry dock repair, as well as restaurants, cafes, hotels, movie theaters, stores, truck stops, and tourist attractions.

Even before Duluth had its sea legs as a foreign port, scores of trucks and trailer rigs filled with grain pressed their way into town, reminding citizens that the harbor would benefit the more than 15 million people living in the Upper Midwest. Lumbering around the edges of the city, five major railroad systems—the Milwaukee Road, the Chicago and Northwestern, the Great Northern, the Northern Pacific, and the Soo Line—hauled grain, bentonite clay, powdered milk, flour, honey, and farm machinery to the docks for export. Imported goods—including steel, ferrosilicon, wire, machinery, furniture, glass, granite, carpeting, autos, shoes—were hauled by railroad to waiting Midwestern factories and homes. In Minneapolis, Alexandria, and Park Rapids, a father could buy an English bicycle imported direct from the British Isles; camera buffs could snap wildlife photos with German cameras; coffee gourmets could grind beans that only months before had been growing on the mountain slopes of Colombia.

The opening of the Seaway was celebrated in a week-long festival between July 9 and 14, 1959, which was planned to demonstrate the impact the Seaway would have on every Minnesotan. On July 12, the governors from Montana, South Dakota, and Minnesota, and the U.S. Secretary of the Interior, Fred A. Seaton, dedicated the Duluth public marine terminal by pouring water collected from the seven seas of the world into the harbor. In an open-house celebration that lasted throughout the week, Duluth's

industries showed off their new operations: the Duluth, Missabe and Iron Range Railway showed visitors how ore boats were loaded; the Northwestern-Hanna Fuel Company allowed guests to watch coal being unloaded from ships; the Soo Line freight house offered guided tours; and at the Nicholson Transit Company and Zalk-Joseph docks, people could see automobiles being lifted onto the docks and grain being loaded.

Along with all the noise, color, and bustle that the Seaway brought to Minnesota, it offered a new perspective on the world. Independent of the key seaboard cities, the state could play an important part in worldwide commerce. In fact, Duluth is 525 miles closer to Rotterdam and 225 miles closer to the Straits of Gibraltar and the Suez Canal

than is New Orleans. The distance through the Seaway between Duluth and Rotterdam is 492 miles less than the distance from Duluth to Rotterdam through New York, a route that formerly required 1,376 miles of more costly overland transportation.

Transportation costs had become a critical factor to shippers, who scrutinized their profitability margins in the fluctuating worldwide commodity market. What attracted many private shippers was the 40 percent savings they could realize by moving grain from Minnesota to the Netherlands through the Seaway. The *Duluth Port* reported that ships could carry wheat from Duluth to Rotterdam for 21.4 cents a bushel if they had return cargoes; the previous lowest charge was 35.3 cents. And there were other important advantages to Great Lakes shipping from Duluth. Because the cargoes were shipped directly overseas, less handling was required, and material packaging did not have to be as elaborate as was necessary when products were transported overland to the seaboard wharves.

Fitger's brewery was one casualty of the move to eliminate industrial discharge into Lake Superior. After nearly 100 years of brewing, Fitger's was closed by the state in 1969. Consumers of Fitger's beer and mixers maintain that the brewery served as a scapegoat when larger companies proved hard to control. Courtesy, Fitger's on the Lake

With tracks stretching into the heart of the Plains, bringing in ever-larger volumes of raw materials for export at the Seaway ports, railroad lines lowered their carrying rates. By the summer of 1959, some railroads had slashed their rates by as much as 25 percent.

Between 1959 and 1962, four groups of bulk commodities—agricultural products, bituminous coal, iron ore, and petroleum—constituted 75 percent of the tonnage transported on the Seaway. But grain quickly proved to be the shipper's gold, and the growth of grain shipments from Duluth-Superior directly overseas outstripped the most optimistic predictions. In 1958, one year before the Seaway had been completed, grain shipments from U.S. Great Lakes ports were about 100,000 tons, or 4 percent of the total U.S. grain exports for the year. Four years later, lake ports shipped 5.8 million tons of grain, or 18 percent of all U.S. grain exports.

On the rich farmlands of states within trucking or railroad shipping distance of

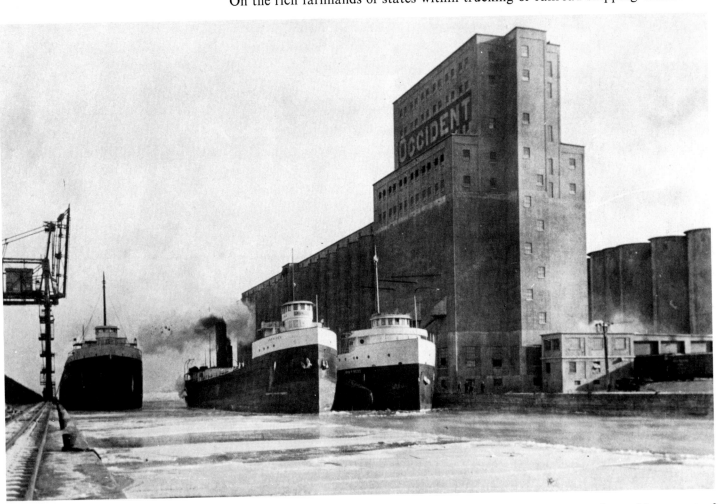

Grain traffic through the port of Duluth spurred more than the shipping and storage industries. The city benefited from expanded work opportunities, particularly pasta factories that processed hard North Dakota wheat. Courtesy, Northeast Minnesota Historical Center

the Twin Ports of Duluth-Superior, 75 percent of the country's wheat, 80 percent of the corn, 60 percent of the barley, and nearly 90 percent of the soybeans were harvested. Hard spring wheat from the Dakotas, Montana, and western Minnesota, which was valued for its high protein content, was shipped to the breadmakers of Europe. Durum wheat raised in the Plains States and used to make macaroni and spaghetti was sent overseas, as were corn, oats, rye, barley, and flaxseed for animal feeds and industrial uses. Soybeans were also becoming an essential staple in a number of different foreign industries. Soybeans, it had been discovered, could be used in making plastics, calking compounds, candles, paints, inks, mayonnaise, margarine, animal feeds, cosmetics, medical preparations, and even as a component in anti-knock gasolines.

But while the Seaway looked like the complete solution to the economic problems that had plagued the Duluth-Superior area for many years, it would not be able to

Construction of the St. Lawrence Seaway transformed Duluth into a world port. After 1959, foreign ships could pick up their cargo of Midwestern grain in the heart of the North American continent. Courtesy, Northeast Minnesota Historical Center

overcome some critical obstacles. For one thing, the Duluth harbor was only open eight months out of the year—from May through late November—and weather conditions often caused lengthy delays at lock and harbor entrances and in canals and channels. This unpredictability slowed shipments and caused headaches for the shippers. Cargoes shipped from Great Lakes ports to an overseas port such as Liverpool continued to arrive two to three days later than if they had been transported through the Port of New York. Further, the barge lines carrying grain from the central states to the Gulf port fought the Great Lakes shipping system with rate reductions of their own. Railroad companies, which frequently had some ownership interest in Mississippi River barge companies, also announced rate reductions on export grain moving from the Midwest to the Gulf. And early in 1961, several western rail lines reduced their rates on wheat that was moving from the Great Plains to ports in and around New Orleans. By 1963, export grain traffic at Gulf and Pacific ports not only had not been adversely affected by the Seaway, it was increasing, due in part to the reduced joint rail-barge rate packages. Duluth-Superior did attract some shipping business away from the Atlantic-side ports. The proportion of U.S. grain exported through Atlantic ports declined from 25 percent in 1958 to 13 percent in 1962.

Nevertheless, Duluthians and their neighbors in the taconite cities on the Range saw good fortune ahead as the 1950s pressed into the 1960s and the country was caught up in the Camelot mood of the Kennedy Administration. Expectations that tomorrow would be better than today made many voters forget how closely intertwined are industry and the land upon which it is built. Up ahead were more hard times for the region's businesses. But, for many, the rose-colored glasses of a temporary economic boom made the future difficult to see.

A pedestrian mall with trees and lights turned the central Minneapolis shopping district into a fantasy land. City residents responded by turning Nicollet Mall into a retailing bonanza. Courtesy, Minneapolis Public Library

HEADING TOWARD THE 21ST CENTURY

HOT DAYS IN VACATIONLAND

Minnesota businesspeople have a saying that most new enterprises quickly assume the shape of one of two animals: a cash cow or a cash hog. Cash cows generate revenues. Cash hogs gobble their way through profits. In the business world, cash hogs are either made into cash cows or they become corporate history lessons.

In 1973, Harvey Paulson, president of Scorpion—a manufacturer of snowmobiles in Crosby, Minnesota, and a subsidiary of Atlanta-based Fuqua Industries—had a heart-to-heart chat with Carl Patrick, president of Fuqua. Scorpion was a cash hog and both men knew it. When corporate economists predicted that sales of snowmobiles would slide because of the rising gasoline prices, Scorpion began to suffer even more. Patrick wanted to sell the company. But just before Scorpion was put on the public auction block, he agreed to give Paulson a hand in reshaping the company.

Although Paulson was a native of the Arrowhead vacation country and knew something about the way Americans spend their money on pastimes and special interests, he didn't feel confident that he could steer a snowmobile company through the changing economic times. But Paulson did thoroughly understand two-cycle engines and quality control. He also knew that if he could keep Scorpion running, his friends and neighbors would keep their jobs.

Paulson bought the company—liabilities, risk, and all—and joined the ranks of other entrepreneurs who believed that snowmobiles would revolutionize winter sports in snow country. They were encouraged by the proportions North American snowmobile sales had reached by 1971—something on the order of 500,000 units. Paulson figured that if he and his peers in the snowmobile business could steer around the OPEC oil embargo and the poor snowfall of 1974, open country might lie ahead.

There was fierce competition, however, among the snowmobile manufacturers in Minnesota. Sales in northern Minnesota, which was known internationally as the home of the snowmobile industry, were led by two separate companies that had been founded by the same man—Edgar Hetteen. In 1954, Hetteen chose Roseau as the site for Polaris E-Z-Go, an arm of Textron, Inc. In 1961 Hetteen founded Arctic Enterprises, the manufacturer of Arctic Cat snowmobiles, in Thief River Falls, a mere seventy miles from the Polaris E-Z-Go plant. Both companies were known around the world for building snowmobiles of durability and sleek design.

International Snowmobile Industry Association figures for 1978 (the best sales year for snowmobiles ever) showed that Minnesota was manufacturing 75 percent of the snowmobiles made in the United States, and 43 percent of those manufactured worldwide. Nearly $100 million in revenue poured into the state as a result of the 1978 snowmobile sales.

After several dry winters in the 1970s, record snows during the winters of the early 1980s put Polaris E-Z-GO back on a solid footing. Courtesy, Polaris Industries, Inc.

It was also in 1978 that Scorpian allowed itself to be absorbed by Arctic Enterprises. With little capital for developing new product designs and promotions, Scorpion found that it could no longer withstand the competition from other snowmobile manufacturers. Arctic Enterprises, on the other hand, was thriving. Energized by its success, it stretched into new seasonal products such as the Wetbike—a water-borne motorbike. It even added a marine-products division by acquiring Larson Industries of Little Falls, a manufacturer of fiberglass boats.

The decision for Arctic Enterprises to diversify into the summer recreation business was based on a new trend among consumers to "relax" as hard as they work. In 1965, a study by the Minnesota Outdoor Recreation Resources Commission (ORRC) had forecast a startlingly large increase in consumer demand for recreational equipment, facilities, and opportunities. The study had projected that between 1965 and 1976, public interest in summer camping would grow 276 percent, while participation in winter sports would jump 285 percent. In addition, better highway systems were already providing travelers with greater mobility, and a steady increase in per capita income made it possible for many people to enjoy recreational opportunities they had not dreamed of even a decade before.

Through the 1960s and the early 1970s, the recreation industry in Minnesota seemed to coincide with ORRC projections. The tourist travel dollar doubled during the 1970s, reaching nearly $900 million in 1972. Half of this total came from visitors from other states. In 1974, 2.5 million fishing licenses were issued and some 400,000 boats and canoes were registered in Minnesota. By the early 1970s Minnesota had ninety-eight state parks, and in 1971 Congress added Voyageurs National Park, near the Boundary Waters Canoe Area, to provide more than 3,000 miles of open trails for hardier vacationers. In 1973 snowmobile lovers registered a record 300,000 snowmobiles.

198

Nevertheless, there was tough sledding ahead for the industry. Anticipating a record year, Arctic Cat went into the 1979–1980 season hyped up to have a record sales year with 600,000 snowmobiles ready for sale. But across the north country, snow refused to fall. By March, Arctic Cat management tabulated a 26 percent decline in sales and losses of $11.5 million.

Depite this, hope continued to lead the company forward. Although Arctic Cat believed that such a dry year could never happen again, it reduced its available inventory of new snowmobiles by more than half in preparation for the 1980–1981 season. But the worst happened: again no snow fell. Arctic Cat's losses were estimated to be about $16 million for that fiscal year. On February 17, 1981, the company filed for reorganization under Chapter 11 of the Bankruptcy Act.

The company spent the summer of 1981 selling the remaining snowmobiles, service parts, and accessories under a court order that allowed the profits to be used for continuing operations. By the time the last 1981 product was sold, Arctic Cat could still claim 38 percent of the market share, even as the company was dissolved.

A number of companies considered buying the Arctic Cat plant, including John Deere, Suzuki, and arch-rival Polaris. In January of 1982, Polaris announced that it intended to acquire Arctic Enterprises, but the deal fell through. Certified Parts Corporation purchased Arctic's parts, tooling and licenses in May, while the remaining assets were slated for an auction to be held that summer.

A core group of former Arctic Cat employees attended that auction and purchased those components essential to starting a snowmobile factory. Under the name Arctco, Inc., the group pursued the financial backing of individual investors and their bank. When Thief River Falls received an Enterprise Zone Block Grant, the Arctco group gained momentum. The key to their financing was to obtain "irrevocable domestic letters of credit" from dealers interested in selling Arctic Cats. With guaranteed pre-production sales Norwest Bank backed the new venture.

The first year, Arctco had orders to build 2,700 new machines. Operating from a leased portion of the old plant, Arctco fulfilled all orders as promised. With the marketing slogan "The Cat Is Back," dealers sold out of the 1984 models as the company posted an after-tax profit of $600,000 on sales of $7.3 million.

As oil and gas costs and interest rates declined, sales continued to be brisk. Total sales for fiscal 1986 were over $25 million, with Arctco posting a profit of $1.9 million. Though below the figures from snowmobiling's heyday, Arctco sales convinced even the skeptics that the Cat was indeed back.

But beyond the snowmobile industry's economic frustrations, a public relations problem was beginning to develop. Many people considered snowmobiles noisy and a nuisance. When Voyageurs National Park was designated a wilderness preserve by Congress, some people insisted that snowmobiles be banned from it. Later, a system of trails would be built to accommodate snowmobilers.

THERE IS NO "AWAY"

The proposed ban on snowmobiles in Voyageurs National Park was part of a larger issue. As more Minnesotans spent time outdoors—paddling canoes along the shores of lily-laden bays, stalking ducks in frosty sedges, following winter deer trails through the deep pine forests—they began to worry about the future of the land and the creatures living on it. Outspoken leaders turned to policymakers for help, asking for limits on the use of resources so that future generations would be able to appreciate the land's bounties as well. In a 1971 speech before the 67th legislature, newly elected Governor Wendell Anderson delivered a special message that reflected this rising concern for the restoration and preservation of the land. "We are no longer in a position to exploit our resources without regard to the immediate and long-range effects of

that exploitation," the governor told the assembly. "As long as man remains in Minnesota, we will have to fight to repair and prevent his damage to the natural environment that sustains his life."

Anderson's formula disturbed people whose grandfathers had been lumberjacks and whose grandmothers had burned off prairie grasses and cut through the deep crusted sod. He told his audience that Minnesota's "environmental problems are primarily a result of our continuous failure to take into account the full consequences of our actions." This set the tone for the regulatory state government that was to come.

Anderson proposed an Environmental Policy Act that introduced the state's version of an environmental impact statement. He advocated that polluters be put on the defensive in the state's courts and prove that their actions were not polluting the air, water, land, or other natural resources. (Previous judicial policies had placed the burden of proof on the plaintiff.) Anderson contended that Minnesota required a statewide program of sewage treatment, and supported a proposed moratorium on the building of nuclear power plants as well as legislation that would control the level of waste discharges into state waterways.

The erosion of rich soil and pollution of the air, surface water, and groundwater worried every Sunday gardener who sifted dirt through his or her fingers and every individual who turned on the tap for a cold drink or whose breath was labored on a brisk walk down a city street.

A clash of wills between business and industry leaders and environmental activists over the question of environmental quality was inevitable. In Duluth, the question came to a head when giant U.S. Steel requested that it be granted a variance so that it could continue to operate its plant while updating antipollution facilities. Environmentalists sounded a warning, hoping that U.S. Steel would be forced to make the changes to its plant before further irreversible damage was done to Lake Superior. The corporation countered with concern for the jobs and lives of the 1,800 people who worked in the steel plant.

By the end of the 1970s, business and government leaders were wrestling with problems that had no immediate solutions.

Business leaders and environmental activists were squaring off over the hazardous-waste issue. Moving ceremoniously between the two camps, state administrators tried to find compromises that would appease both the public and the state's industries. What was clear to everyone—business person, policymaker, and ordinary citizen—was that it was easier to produce new technologies, chemicals, and products than to understand what would happen when they were unleashed upon the earth.

The Minnesota State Fair marks the end of summer for thousands of people who would not miss attending for anything. Each visitor has his or her favorite event. Butter sculpting gives form to the products of local dairies while giving viewers a chuckle over the idea of wearing coats in the late summer heat. Photo by Bruce M. White

Hazardous wastes are defined as those industry by-products that are flammable, corrosive, and highly reactive when mixed with water, or that are toxic (which means that they can harm anything on contact). Over the decades, mammoth volumes of waste chemicals have been poured into barrels and stored underground. They include mutagens, which are suspected of causing genetic damage; teratogens, which cause birth defects; and carcinogens, which cause cancer. By the early 1980s, Minnesota industries—from major manufacturers to small metal-fabricating firms—were producing 174,000 tons of hazardous waste each year. Every day, management in major Minnesota businesses desperately searched for an out-of-sight, out-of-mind place for this waste.

In 1980 the Minnesota legislature passed the Waste Management Act, which created a temporary Waste Management Board and issued a directive that a hazardous-waste management plan be developed. In general, industry leaders were enthusiastic about the new law because they had been unable to find new, safe, and inexpensive places to dump waste products. They hoped for a government-sanctioned dump site within the state's borders, which would save on shipping costs. Small businesses, in particular, hoped for a state dumping site, burdened as they were by the escalating costs of shipping and storing.

But before long the questions became even more complicated. People diagnosed as having serious and even life-threatening diseases demanded that the businesses that had dumped wastes into the earth decades ago pay for personal damages. When boiled down, the question was much more simple than the answer: In what year should industries have known that their wastes would have a long-term effect on the health of people?

At the same time, the state's fund for cleaning up hazardous wastes was quickly depleting, and the need for hundreds of thousands of dollars for new clean-up projects was clear. In the early 1980s it was discovered that pollution sites in St. Louis Park, New Brighton, and Arden Hills, surrounding the Twin Cities, were threatening the purity of the Prairie du Chien-Jordan aquifer—the groundwater reservoir that supplied drinking water to most of the Twin Cities. The hazardous waste problem was now in every citizen's backyard.

To address both the personal liability and clean-up issues, a Minnesota superfund bill was introduced to the legislature in 1983. The superfund caused a major split between business leaders and the liberal administration of Governor Rudy Perpich, inciting Lewis Lehr (then chairman of 3M) to enter the fray. Of particular concerns were the retroactive liability clauses in the bill, which made corporations vulnerable for wastes dumped as far back as 1960. "We have testified in favor of such legislation and strongly support the clean-up provisions," Lehr wrote. "Please understand: 3M should be held responsible if we pollute the environment. But we should not be liable to personal-injury suits relating to pollution that may have been caused by someone else's materials."

Public pressure did little to solve the disposal problems. The high-technology companies of which Minnesota was so proud, were the hardest hit by stringent regulations for hazardous-waste disposal. Many continued to pay high transportation costs to have wastes hauled out of state.

Waste disposal sites of various sizes, shapes, and locations were proposed—each ardently rejected by people who lived nearby. No one was convinced that underground storage technology had progressed far enough to be fail-safe; and few people understood enough about above-ground storage to seriously consider it. A moratorium was placed on storage site selection between 1984 and 1986, until tempers cooled and advances in the industry were made.

The hazardous-waste issue touched another nerve among Minnesota's small-business owners. With the introduction of the superfund, insurance companies reviewed their business liability policies and decided that Minnesota businesses were simply

3M's early commitment to research launched a $20-billion company which is known for its innovative thinking and products for industrial, consumer, office and healthcare marketplaces. Headquartered in Saint Paul, 3M products today are sold in about 200 countries. Courtesy, 3M

too hot to handle. Policy costs soared and small businesses pleaded for relief to lobbying organizations such as the Minnesota Association of Commerce and Industry. In Osseo, a metal-plating shop owner complained that liability insurance rates were so high that they could put him out of business. "We are being condemned for acts that were accepted by society and government officials until the 1970s, when environmental issues became of greater concern to everyone," Art Joyner was quoted in a September 1983 article for *Corporate Report/Minnesota*.

The message got through to the legislature, and in 1984 an amendment that would limit third-party liability was introduced. The amendment got hung up in the house, but during a special session called by the governor it passed.

In its amended form, the superfund law more closely resembled the federal law after which it was originally patterned. While continuing to give the state a strong basis to pursue pollution violations, the amended law followed accepted principles of causation for liability cases. This fundamental change soothed business and industry leaders, and environmental protection ceased to be a major business issue.

WITHOUT A SINGLE VOICE

They're called the grandfathers of Minnesota technology future—3M, Honeywell, Univac (now Unisys), and Control Data. These companies began as tiny Minnesota

snowballs and rolled into major avalanches by the 1980s. In 1981, these four companies employed more than 50,000 people out of a total state industrial work force of 325,000. They have been role models in the high-tech explosion. Young entrepreneurs have followed their leadership in risk-taking and creativity. Small companies were born and grew healthy in the nurturing climate that surrounded the success of Minnesota's top four corporate giants.

Entrepreneurs and venture capitalists have prospered hand in hand in Minnesota. Venturers have found fertile ground for products or technologies that are on the ground floor of an industry and show promise for early expansion. A rule of thumb for some venture capitalists in the medical field is that a start-up company must achieve $20 million in sales within the first five to seven years. Typically, venture capitalists seek returns of five to fifteen times the original investment within five years and 40 percent annual sales growth. Minnesota venturers boldly put their money on the line. In 1984, for example, venture capital firms raised more than $200 million, placing Minnesota among the top five states for the amount of venture dollars raised.

A case in point was Norwest Growth Fund, which in 1961 lured Robert Zicarelli from Chicago. Zicarelli liked Minnesota-bred companies and had already invested in Control Data and Memorex. With Norwest Growth Fund, he also affiliated with Cray Research, today a leading designer of large-scale scientific computers, and Network Systems, now a manufacturer of high-performance data communications equipment. In a little over two decades, Zicarelli's investments helped Norwest Growth Fund increase assets of $2.5 million into more than $85 million. The successes of winning companies such as Medtronic, Cray Research, and Network Systems continue to entice venturers.

Working against every venturer is the normal evolution of a business's growth. A high-technology venture investment could become a loser even before the product is ready for the marketplace.

Nevertheless, Minnesota's venture capitalists were the first-string supporters of new business in the state, and dozens of new companies have succeeded because the necessary dollars were pumped in when the going was the toughest.

Although Minnesota was proving to be an excellent place to found a business in the 1970s and 1980s, many business leaders were losing confidence in the state as a place to expand their corporations. It became clear that business leaders were discovering that they were no longer speaking with a unified voice in regard to business-related legislative issues. For manufacturing and construction companies, workers' compensation was a hot issue through the last half of the 1970s and into the 1980s. High-technology companies, on the other hand, were having a difficult time finding sources of ready growth capital. Middle-sized corporations were groaning under the weight of Minnesota's 12 percent corporate income tax, while larger corporations worried that high personal income taxes would keep top management candidates from coming to live in the state.

The issue that united small and medium-sized companies during the 1970s and 1980s was workers' compensation. Workers' compensation coverage had become compulsory for Minnesota employers in 1937 and had quickly converted into a political football between business and labor. Through the years, as amendment after amendment was passed, labor hammered out such a comprehensive workers' compensation program that Minnesota's compensation rates were considered some of the highest in the country. In 1981, for example, the cost of workers' compensation insurance premiums for Minnesota's businesses approached $500 million.

Workers' compensation soon became the focal point of the problems facing businesses. Small manufacturing firms, such as high-technology companies, protested that lower workers' compensation rates could make the difference not only between profit and loss but in a company's ability to grow—and even survive—within the state's borders. In the late 1970s and early 1980s, the Minnesota Association of Commerce

The Butler Brothers warehouse became Butler Square in the mid-1970s. This first successful adaptive use of a warehouse set the stage for the restoration of the entire Minneapolis warehouse district into a popular area for eating and shopping. Courtesy, Hennepin County Historical Society

and Industry (MACI), then business's strongest voice in the legislature, fought to limit the types of work-related injuries eligible for claims and to establish fairer guidelines for determining when payments should begin and the length of payments. MACI's goal was to ensure that vocational rehabilitation of employees would become a state objective. In 1979, an extensive review of workers' compensation yielded improved rehabilitation provisions.

Another major concern of the state's corporations was unemployment compensation. When the legislature met in 1982, the state's unemployment trust fund was $114 million in debt to the federal government. Within one year, the debt had nearly tripled. When the legislature met in 1984, it was determined that Minnesota had paid out more in unemployment insurance benefits than it had collected in taxes for seven of the previous ten years. Studying the issue, members of the Senate's employment committee agreed with business leaders that the state either had to get itself out of debt or incur penalties from the federal government. Suggested reforms included capping rate in creases until the benefit structure had been reviewed, retaining a 1.5 percent per year limit on the employer's contribution escalator, and preventing wage credits from being granted to people who had been discharged from jobs due to misconduct.

During the 1984 legislature, labor and business factions settled down to negotiate a compromise bill that was to restructure the state's in-debt unemployment compensation system. The interests of both sides were clear. Labor would not allow any significant reduction in benefits to workers; business leaders were demanding lower taxes. As reported in the April 24, 1984, issue of the *International Falls Daily Journal*, the executive director of the Minnesota Business Partnership (a lobbying organization for business leaders) declared that "Minnesota is the only state we can see in this region in which our unemployment rate is well below the national average and our benefits paid

above...our system pays out more than it should relative to other states." Business groups complained that Minnesota provided benefits to well-paid seasonal workers such as forest, construction, and shipping workers, that workers were paid for longer periods of time than in most other states, and that the amount of benefits was overly generous.

The 1984 bill that emerged was a typical compromise bill—loved by no one and a point of frustration for everyone. Business taxes would be increased by $274 million and benefit increases reduced $69 million from 1984 to 1988, thus sparing Minnesota employers the $360 million in federal taxes and interest charges that would otherwise be incurred in 1987 and 1988.

Despite the backing of such organizations as the Minnesota Retail Association, small businesses outside of the Twin Cities could not support the bill, taking with them the votes of a loose coalition of rural representatives known as the "Wood Ticks." Soon to follow was the support of Dayton Hudson, a major retailer and a provider of thousands of jobs in the Twin Cities metropolitan area; the National Federation of Independent Businesses; the Greater Minneapolis Employers Association; and a number of smaller chambers of commerce. Their complaint was that business lobbyists had not gone far enough in restricting benefit increases. The defeat of the 1984 bill was a turning point in the history of political battles between business and labor because it demonstrated clearly that business did not always speak with a single voice. The unemployment compensation issue would continue to boil.

Another issue, the corporate tax rate, had dismayed business leaders since the late 1960s. Despite reforms in the state's dual formula for corporate income tax—which meant businesses were no longer taxed for goods sold outside of the state—incorporated businesses continued to pay the fourth-highest corporate income tax rate in the country. Small-business owners fought for the passage of a graduated income tax plan— a battle still being waged in the 1980s.

Minnesota's product-liability laws have cut deeply into the hearts of a number of Minnesota's manufacturing companies during the last two decades. Because the judicial branch of the government redefined tort laws in favor of plaintiffs in the 1960s, corporate management felt stripped of its defenses against product-liability suits.

In 1979, for example, the state Supreme Court ruled six to two that Allis Chalmers was liable for injuries that a Beltrami County farmer suffered while operating one of the company's corn-harvesting machines. Although warnings in the owner's manual and on the machine said not to clean the machine while it was operating, the farmer attempted to remove corn that clogged the machine, losing most of his arm in the process. He sued, and Allis Chalmers lost the suit.

Reforms to state product-liability laws and correspondingly high rates for Minnesota companies have received considerable attention from MACI and other major business lobbying groups who have pressed for a statute of limitations for a manufacturer's responsibility for a product.

In the 1980s business property and casualty insurance rates began to rise in Minnesota, as well as in other states, as lawsuits between consumers and businesses multiplied. Yet for many insurance companies serving Minnesota businesses, significant rate increases could not offset their cash flow losses. To be profitable, many left the high-risk markets and focused on more traditional and predictable products such as automobile and homeowner insurance. Liability coverage options began to decrease for Minnesota's business management, and before long the public felt the effects of the insurance crisis as well.

THE PICTURE CHANGES

Until the early 1950s, agriculture was both Minnesota's major money-maker and its largest employer. The land beneath their feet was what made a farming family's

Home of the nationally-cherished "Prairie Home Companion," Minnesota Public Radio is known for its innovative programming and is today the largest station-based producer of national public radio programs. Begun in Collegeville in 1967, it burst onto the Twin Cities media scene in the 1980s but has expanded into a network of thirty-seven stations around the upper Midwest with in-depth news reporting, affiliations with both the Canadian Broadcasting Company (CBC) and the British Broadcasting Corporation (BBC) and classical music listening. Courtesy, Minnesota Public Radio

future promising. So, too, the land beneath the farmers' feet was what made the state's future secure. But population shifts, a decade of inflation and high interest rates, as well as a national policy to set agricultural commodity prices at artificial levels, radically changed the outlook for Minnesota's farming families by the 1980s. Added to the dismal formula was the fact that a strong U.S. dollar overseas had inhibited the growth of foreign commodity trading. In 1983, payments on interest were nearly 14.5 percent of all cash operating costs on the Minnesota farm. By 1984, 20 percent of Minnesota farmers were 40 percent in debt and one-third of the state's 45,000 full-time farmers were facing crippling cash-flow problems. According to an August 11, 1985, article in the *Minneapolis Star and Tribune*, the value of Minnesota farmland, after adjusting for inflation, decreased 40 percent, on average, between 1980 and 1985, and was equaled only by the declining value of assets such as farm machinery. Bankers faced with the odious task of foreclosing on family farms realized that the collateral value of land and equipment might not cover a farmer's debts.

By 1985, one-third of the state's farmers had debt-to-asset ratios of 70 percent to 30 percent or worse. A study by the University of Minnesota Agricultural Economics Department showed that in current dollars, Minnesota farmland fell from a statewide average of $927 an acre in 1984 to $686 by the following year. It seemed clear to everyone that the day of the traditional family farm in Minnesota was coming to an end. Forecasters predicted that 5,000 farms would be lost before the end of the decade and 10,000 more in the next decade, and that the impact of these changes in many parts of Minnesota would be devastating. As an indicator of financial industry anxiety, Norwest Corp. (now Wells Fargo & Company) and First Bank System (now U.S. Bancorp), the two regional bank holding companies in the Twin Cities, took quick steps to sell many of their rural bank properties in the Upper Midwest. Nevertheless, the two bank corporations carried loan portfolios that would continue to tie them tightly, and permanently, to the agricultural industry. Norwest, the largest commercial bank lender of farm credit in the north country, showed a loan portfolio in 1985 of $820 million the second largest in the United States.

Throughout Minnesota, food processors, warehousers, and shippers were all affected by the pressures of farm industry changes. Large regional cooperatives such as Land O' Lakes, Harvest States, and Cenex reevaluated their operating systems and reorganized to better withstand the downturn. Life insurance companies, long a major source of mortgage financing, announced that they would wait until land prices went up again before financing any more farms. The American Council of Life Insurance, a major trade association for insurance companies, noted that life insurance companies had taken possession of Minnesota farms valued at $33.1 million during 1984. The pain of such foreclosures was felt throughout the state. Late in 1985, farmers' rights activist Jim Langman prepared his family for the loss of his 480-acre farm to Travelers Insurance, a Connecticut-based insurance company. As the sheriff stood on the courthouse steps in Glenwood to auction off the farm on behalf of the insurance company, tempers flared and 600 farmers stormed the little courthouse in protest. Organized by Groundswell, a grass-roots protest farm organization, the rally gave the Langman family a temporary reprieve.

The problem—and it was a serious problem that would change the face of agriculture in the Midwest—was that independent farmers were strangled by tight money and high interest rates. Families couldn't retire their debts. At the same time, they watched the value of their farms and farmland slide. Standing on a Minnesota field harvesting a good crop, it was difficult to understand that massive global forces were shaping their futures like never before. Prices were down in the United States. But overseas markets still believed them too expensive.

In the place of Minnesota-grown family farms comes the mega-farm: a consolidation of business acumen, capital, technology, and mono-cropping. By buying up acres of liquidated farmland and using purchasing and marketing clout, major farm corporations of 500 acres or more could be the key to Minnesota's ability to rank in the top five states for the production of food commodities such as corn, soybeans, sugar oats, barley, peas, turkeys, milk and cheese, non-fat dry milk, and butter.

Technology has become the master of the farm—and of farm prices. The *Minneapolis Star and Tribune* reported in the August 11, 1985 issue that, by 1980, technology had made it possible to more than double the average cow's milk production and the average acre of wheat produced and triple the amount of corn that it could produce thirty years ago.

But, as every high school freshman understands, a consistently growing supply eventually forces lower prices at the market. If demand doesn't follow supply, then farmers cannot make enough money to pay for the crops they produce. In the United States, price supports have filled the growing gap between the costs of production on the farm and the prices charged at the cash register. For Minnesota's farmers, price supports have been a necessary savior in this technologically-driven economy. Between 1982 and 1983, price support payments as a share of Minnesota total net farm income rose fourfold.

In 1890, nearly half of the state's population lived or worked on a family farm. Today, however, less than 10 percent of its people make their living from the soil. Over the past fifty years, two out of every three farms have disappeared, and the backlash from this loss of farms has been felt deeply in the rural communities and small towns across the state. In the Economic Report to the Governor, 1987, it was noted that, for the first time, no county in Minnesota could boast that a majority of its income was directly generated from farming.

The fall-off in profitability of farming and mining is symptomatic of massive global changes that are beyond the control of communities, industrial regions, states, or even countries. Since 1980, the definition of a good business climate has been altered by new economic realties—shifting away from a regional market based on mass-production and low-skilled labor to an internationally based market which requires flexibility, adaptability, and ingenuity on the part of business management. To survive, many corporate decision-makers have had to come to terms with the fact that they must make incisive changes in the structure—even philosophy—of their corporations.

208

There is no better example of an ability to try to right a sinking ship than Control Data Corp. (CDC). Since its founding in 1957, the giant company had gathered a reputation as a company that gambled on wide diversity—that stretched itself—and then stretched again. Analysts on Wall Street were split on their opinion of CDC's founder, CEO and Chairman William Norris. Norris believed that a business has an obligation to meet the social needs of its economic community. Under his leadership, CDC entered new arenas such as financial services and family farm and inner-city support—programs that were only tangentially related to its main business: computer systems, peripherals, and data services. Some regarded Norris as an entrepreneurial leader, while others worried that the company was losing track of what it did best. So much so, the pundits noted, that the company was too encumbered to do well in the increasingly competitive international computer marketplace.

By 1984, CDC had begun to weaken. In the first half of 1985, the company announced a $14.8 million loss, while inventory towered at $900 million.

Troubles at CDC occupied front-page headlines for months as revenues in their disk-drive and peripheral businesses continued to fall. As Norris stepped aside in 1986 and Robert Price, former president and CEO at CDC took the reins, Minnesotans held their breath. Could the company reestablish itself as a major player? What would be the repercussions in the secondary supplier industries—those companies whose life-blood had been CDC for twenty years or more?

The results of CDC's fits and starts presented both good and bad news for Minnesotans. The bad news was that CDC troubles sent serious shock waves through Minnesota industry. But the good news was that business leaders read beyond the headlines and learned a valuable lesson—that industries have to focus their attention on the technologies that will make them globally competitive, and not stray too far away from their core businesses.

In the years following the 1981–1983 recession, which drastically affected the computer and electronics manufacturing industries, Minnesota employment remained fairly buoyant. In fact, between 1983 and 1985 the state's employment picture was brighter than the country's as a whole. Total employment in those years increased by nearly 9 percent, compared with 8 percent nationally. Employment growth was in the services, manufacturing, and retail trade sectors. Significant statewide employment increases were also noted in finance, insurance, real estate, transportation, and communications industries.

MINNESOTA ENTERS THE NEW CENTURY

It's been well over three centuries since Jean Nicolet put on his silk damask robe to celebrate what he thought was the opening of a new trade route between New France and China. He—and the men who followed him into the seventeenth century wilderness—understood the basics of a global economy. The forests, lakes, rivers, wildlife, rich soils, and minerals had the potential to yield commodities upon which to build trade.

Since that time, Minnesota's economy has lost some of its primordial ties to the land, but it has come to depend on what its people can provide—in accurately identifying problems, developing technological solutions, being flexible in adapting to world market changes, devising cost-effective methods of producing products and services, and having to compete in the far-flung marketplaces of the world.

The Ojibwe Indians named the 110-mile ridge of iron-rich land stretching from Grand Rapids to Babbitt, the Sleeping Giant. Iron mining drove northeastern Minnesota's economy until the 1950s when the natural iron ore supply was depleted. Mining was reinvigorated when new technologies developed through University of Minnesota research enabled iron extraction from a waste rock called taconite. Today's six taconite mines are supplying two-thirds of the iron ore used for America's steel. Ironworld Discovery Center in Chisholm celebrates the industry's history. This trolley travels along the two and a half miles at the upper edge of the former Glen open-pit mine, which was active between 1903 and 1935. Courtesy, Ironworld Discovery Center

PIONEERING IN THE INFORMATION AGE

THERE'S A WHOLE LOT OF THINKING GOING ON

The millenium celebrations were over. Gone too was the fiscal exuberance of the '90s. The new era had arrived, but so had an economic downturn. Just like many other parts of the country in the first few years of the twenty-first century, layoff notices were piling up and many jobs were moving overseas. Forecasts in most industries were bleak.

The Iron Range, Minnesota's once-glorious iron ore mining country, was one of the examples of a new century kicked off with bad news. The mining industry wasn't healthy. Steel manufacturers were buying less of Minnesota's taconite. Jobs in the mining towns were at a premium.

Town cafes and hardware stores filled with jittery locals, hanging on the news for information about their industry. People began to think about moving. The old joke wasn't so funny any more: "The last one to leave, be sure to turn out the lights."

The taconite industry is a venerable part of Minnesota's economic equation so there was tremendous pressure on government and foundations to help rebuild it. Nevertheless, a bitter lesson had been learned: resuming dependence on taconite mining alone was not good. The days when mining would be the major employer were gone.

Today on the Iron Range and all over Minnesota there is an all-out search for ideas. Not just new ones—exceptional ones. Ideas that will change the way business is done at the very least, and alter the entire economy at the greatest.

Once called "the Sleeping Giant" by the Ojibwe Indians, the Iron Range entered into recovery phase and strategists recommended taking baby steps. A case in point is Minnesota Nugget LLC in Silver Bay. The business was not so big that it was on everybody's lips, but it was a good example of exceptional thinking—a company with an idea that could lead the taconite industry's revitalization.

Minnesota Nugget introduced a different process for manufacturing taconite nuggets, one that offered steel companies a more environmentally friendly, less expensive alternative. Kobe Steel, a huge diversified industrial firm headquartered in Japan, bought the processing technology, but to date, the focus of the firm's pilot project has been kept in Minnesota. And things have been going well. Taconite nuggets are being shipped and expansion is in the works. Plans call for an additional plant in Hoyt Lakes, north and west of Silver Bay with the potential for about 300 additional jobs.

Not only has Minnesota's mining industry grown soft, but logging, another staple of the state's early growth, has been in flux too. Mills have been closing. Minnesota timber isn't as competitive as it once was. Families are feeling the serious pinch of lost jobs.

The state's economic leaders are preaching that the region must be bolstered with new ideas and fresh perspectives because few predict that the timber industry will come back as it once was.

For northeastern Minnesota and the economically ailing "Iron Range," "Goods from the Woods," was the right idea at the right time. "Goods from the Woods" helps entrepreneurs in the Grand Rapids area reevaluate available resources, identify creative concepts that may have commercial potential, learn to market their crafts and products by successful artists and craftspeople. As part of a Goods from the Woods class, this young man is carving spoons from birchwood, using hand tools in true Scandinavian fashion. Courtesy Goods from the Woods 2004

Larex, Inc. is taking a small step in the right direction. At its main manufacturing plant in the Iron Range town of Cohasset, Larex has been quietly identifying ways to use natural compounds gathered from Minnesota's abundant tamarack tree. The company has already created edible fiber products, approved by the Federal Food and Drug Administration, which are marketed to manufacturers of health bars and drinks. They've also developed skin lotions and other fiber enhanced foods. Business seems to be hopping for the seventeen Larex employees, as food, health, medical, animal health, and nutrition companies around the world learn about the possibilities the company's products offer.

Stories about Larex and Minnesota Nugget LLC may never make the cover of *Business Week*. But according to the Bureau of Labor Statistics, 97.9 percent of the state's businesses have fewer than 500 employees. It's the aggregate of those nearly 230,000 smaller-sized businesses, pumping up their profits every day with fresh approaches and new ideas that are changing their industries.

And Minnesotans aren't afraid to try new ideas. In the 2000 census, Minnesota recorded a new business increase of nearly 14,000 companies. Those are pretty good signs that intrepid entrepreneurs are populating the state from border to border. There's a lot of good thinking going on in Minnesota.

APPLAUDING THE GOOD, COPING WITH THE BAD, AND ACCEPTING THE UGLY

Chalk it up to a solid historical base of a hard work ethic, blended with cultures representing every corner of the globe. Or, attribute it to the Minnesota convention of always trying to go one better. Whatever it is, start-up companies have been popping up out of Minnesota garages, laboratories, and kitchen cupboards from the beginning. Some of the best survived, and grew into giants. Some even presided over their industries.

The test of a true Minnesotan is whether or not he or she knows that Scotch® tape was invented here. The answer, "Yes, by 3M inventor Richard Drew." Minnesota old timers can boast about some of our legends such as Seymour Cray, who has been called "the father of the supercomputer" and Earl Bakken, an electrical engineer who was inspired by pioneering heart surgeon Dr. C. Walton Lillehei, the "father of open heart surgery." Bakken built the first wearable external cardiac pacemaker. Medtronic, a $9 billion diversified medical technology leader is the result of Bakken's ingenuity.

Minnesotans are not only proud of their legends, they're working hard to create new ones. Every year, thousands of people flock to the southwestern Minnesota city of Redwood Falls to showcase their ideas at the Minnesota Inventors Congress. Every

one of the exhibitors, no matter how successful, has the right idea: don't just be innovative—be an exceptional innovator. Change the way people live, work, and think.

A few of the ideas introduced at the congress are not only great ideas, they can also be manufactured and marketed. The wire basket shopping cart, for example, was introduced by Saint Paul's N. H. Brost at the Inventors Congress. Merlin Halvorson of Mound created the first powered golf cart and that idea is flourishing in just about every part of the world. Less widely known is the Alt chair. Altimate Medical, Inc. in Morton, however, today helps hundreds of disabled people stand on their own, using their device.

Minnesota is the "Land of Ten-thousand Lakes" and thousands of companies—many on their way to becoming smaller sized, but still notable, legends in their own right. There's Hearth & Home in Lakeville, which is the world's largest producer and installer of hearth products. Since 1927 when they invented the first air-circulating fireplace, the company has been expanding its product line to include clever products that have changed consumer expectations for warming, relaxing, and outdoor cooking.

Anyone who uses a computer and depends on its performance every day can appreciate another Minnesota legend in the making—Hutchinson Technology. Headquartered in Hutchinson, Minnesota, Hutchinson Technology is one of the world's major manufacturers of suspension assemblies for disk drives. Its stand-alone research and development center has had to really scramble in order to keep up with the accelerating expectations for disk drive speed and capacity. Hutchinson Technology's primary clients are the major worldwide disk drive manufacturers. This accounted for the double digit growth it reported in 2003, and its ongoing addition of employees at a time when it seemed no one else was hiring. Today Hutchinson Technology reports about 3,600 staff members at its offices around the world.

Bayport's Andersen Corporation is a world leader in the window and patio door market. Among its long record of accomplishments is the development of Fibrex™, a major advance in composite material that uses reclaimed wood fibers as a primary ingredient. Fibrex™ has not only been valuable in Andersen's traditional product line, it spurred the creation of Renewal by Andersen, one of the top worldwide manufacturers in the replacement window business. Courtesy, Andersen Corporation

Hearing loss affects about 28 million people in the United States, but only one out every five who need a hearing aid actually wear one. Starkey Laboratories in Eden Prairie has been the world's leading manufacturer of custom hearing instruments for many years. Founded in 1967 its approach has been consistently innovative, not only in its technology but in the programs it offers customers. The "worry-free" warranty program which was introduced by Starkey has not only become accepted practice, but it's a legal requirement in many states. Today Starkey has thirty-three facilities in eighteen countries throughout the world.

Fingerhut Companies, Inc., a significant employer and catalog retailer in Minnetonka, Saint Cloud, and Plymouth, is in the category of the "near miss" legend. Early in 2002 Fingerhut's owner, Federated Department Stores, announced that soft sales required Federated either to sell or close. At risk were 6,000 families. In play were state and city leaders plus chambers of commerce members, who worked diligently to find a buyer. Minnesotans saw the Fingerhut story as emblematic of an economy turning sour and there was a collective sigh of relief eight months later when two Twin Cities businessmen worked out an arrangement. Not long afterward, a much leaner Fingerhut began to rehire 800 employees.

While the public story of Fingerhut was unfolding, thoughts drifted back to the early 1990s when Control Data Corporation, the venerable manufacturer of some of the world's fastest computers, seemed to collapse. The company laid off hundreds of people who thought they had jobs for a lifetime. The job loss upset the natural order of things as Minnesotans had always known it.

As it turned out, Control Data restructured itself into two companies: Control Data Systems, now absorbed into BT Syntegra (a global e-business consulting and systems integration corporation), and Ceridian, a $1.3 billion information services company. Ceridian is another Minnesota success story. It survived the nasty public relations fallout from the Control Data debacle to make its own mark on the state's economy.

It was the Control Data downsizing that focused Minnesotans on the meaning of the changes that had begun to embed in the national economy. In the 1990s, it became popular to talk about corporate loyalty—or the lack of it: "Why should I be loyal to my company?" they asked. "It's not going to be loyal to me." The new Minnesotans were a little more hip, a little more pugnacious, and a little more cynical.

REDEFINING REENERGIZING

The night of his inaugural in 1999, then-new Minnesota Governor, and former wrestler and Hollywood personality, Jesse "The Body" Ventura proclaimed that "We shocked the world!"

He was referring to his election on the third party Reform ticket, of course. And it's true that there were many Minnesota voters who hadn't seen his election coming. Strong cups of coffee the morning after did nothing to help alter the fact that the Minnesota polling results had proffered a brand new independent face—one that was not only untested but one that had the potential to give the two party system a migraine.

Ventura's administration was as colorful as he was energetic. He was blunt. He disturbed people's conventional thinking. And he probably put the final touches on any residual public apathy toward its elected leaders. But as the next gubernatorial campaign season came into view in 2002, campaign chairpeople contemplated how cleverly Ventura's die-hard crusaders had used the Internet to attract the very targeted voters he needed to win.

It could be argued that the Internet came out of the closet with the Ventura campaign. More than an email tool, or for word processing, playing games, or posting a web

For thirty years, Martinez Corporation in Eagan has been helping transportation, aviation, urban planning and utility companies make decisions about the future. These organizations require absolute precision because the choices they make will require millions of dollars in investments. The Martinez proprietary project mapping software ensures that the company is cost effective and efficient. It has helped one of its customers, the Minnesota Department of Transportation, to map highway systems that offer engineers the most effective tools for planning and designing future roadways. For another, the Houston international airport system, Martinez identified and mapped land use for future airport growth. Courtesy, Martinez Corporation

page, Ventura's campaign proved that the Internet was a persuasion system.

People across the state gained renewed interest in the power of the World Wide Web. And it wasn't much of a leap for rural policy leaders to begin asking how the heck they were going to attract new businesses unless their communities were broadband linked. In 2003 a rural summit was held to discuss this topic, and in 2004 a report was issued by the Center for Rural Policy and Development in St. Peter. "We are at a time and place in history when business productivity technologies are available to help small business be just as competitive in a global market as their larger counterparts," says the introductory website of the Minnesota Rural Summit '03. The focus, of course, was broadband.

The World Wide Web, e-commerce, and access to both of them is a big challenge for economic developers in many rural communities. No matter where they're located, broadband telecommunications can be key to the global marketing edge they need.

To help stimulate interest in broadband the Blandin Foundation introduced the "Get Broadband" program in 2004. "Simply put," as one Blandin representative says, "those communities that get broadband will be competitive; those which don't will struggle" Communities that have already adopted broadband telecommunications are beginning to enjoy some new jobs and economic benefits.

The trend to increase broadband capacity outside the Twin Cities metropolitan area is under way, but is meeting some community resistance. One of the critical ingredients in a community's willingness to increase broadband capacity in its region is a strong, persistent champion who can help market the concept to residents and market the town as a good place for a service provider to invest in. Luverne, a southwestern town of 4,700 people was fortunate to have such a person. The city's finance director helped to raise awareness of broadband capabilities among the municipality's leadership. Today the city has five service providers plus a new employer in town, Total Card, Inc. A growing credit card service business, Total Card was delighted with the state's exemption package. But the 300 new jobs Total Card is offering at the Luverne call center are all possible because the city mobilized enthusiasm for bringing in broadband capabilities.

In another community, Alexandria, the broadband champion is the municipal electric utility. Alexandria Light and Power began exploring the dial-up technologies in 1996. By 1999 the utility became the fiber optic provider and today, the city of Alexandria benefits from the 300-plus jobs that Tastefully Simple provides at its Alexandria headquarters.

Tastefully Simple, is an upscale gourmet foods, direct sales company that appreciates the speed and efficiencies offered by the fiber optic connection in processing and fulfilling orders. Management says the company offers "small indulgences for busy lives." But whether customers buy from its website or in a home party from one of its more than 20,000 consultants around the United States, they savor the personal service—as much as the company's Bountiful Beer Bread Mix™. In 2000 *Inc.* magazine ranked the company the fortieth fastest growing in the United States. It's clear that e-commerce capabilities help keep it on track toward ongoing success.

Some intrepid companies are willing to locate their business in a community that doesn't offer competitive broadband technologies. One such example is Piragis Northwoods Company, a popular supplier of canoe and kayak-related wilderness gear in Ely. In 1996 this retail and mail order catalog supplier figured out how to paddle its own canoe when it launched the "buy online" component of its website. Local broadband options weren't available, so the owners selected web hosting and the transmission of customer orders in other states. Today Piragis, a canoe and kayak specialist, gets 15 percent of its orders over the Internet, and those orders, like the rest of the company, are growing quickly. Fortunately for the customer service staff, the forty employees who work at Piragis and their thousands of customers, broadband capabilities in the Ely area are growing, too. E-mail transmission is moving in quickly.

Northern climate residents wait patiently for the ripening of the Honeycrisp apple in the fall. Exceptionally crisp and juicy with just the right amount of sweetness, it's been called the star of the apple world and the University of Minnesota Horticultural Research Center, Chanhassen, is the one to thank. Established in 1908, the Center's horticulture scientists set out on a mission to develop apple varieties that would thrive in the Minnesota climate. Through the decades they have created 12 new varieties, beginning with the Haralson in 1922. The Honeycrisp was introduced in 1991, 30 years in the making researchers said. Today, it's the most widely planted variety in Minnesota orchards. Courtesy University of Minnesota Horticulture Research Center

EXAMINING THE EXPECTATIONS OF TOMORROW

If Minnesota community economic developers expect to attract exceptional innovators then they need to do some exceptional thinking of their own. For communities it may mean dumping traditional ways of solving economic growth problems and going all out for an idea that's just unconventional enough to work.

Clustering is one example. Conventional thinking is that competing companies don't want to be located near each other. A different, but riskier, way of looking at the problem is that competing companies can grow faster when they're located near each other.

We learned about clustering in the 1980s and 1990s when California's Silicon Valley lured fast track, high-tech companies into the area. With those businesses came the suppliers, knowledge base, technically trained employees, and venture capitalists that were needed to make the area thrive.

Clustering is making sense in Minnesota particularly for biosciences companies. Bioscience researchers manipulate living cells or human, animal, or plant structures to solve problems, change expectations, or even create entirely new products. Bioscience research has made significant advances in agriculture, environmental science, medicine, and pharmaceutical development.

Public policy-makers are working hard to create major league biosciences cluster in Minnesota. In December 2003, Governor Tim Pawlenty announced a tri-city bioscience zone designed to provide tax incentives for biotechnology entrepreneurs who build or expand their companies on designated properties. These included locations near the University of Minnesota's Saint Paul and Minneapolis campuses or in zones near the campus of the Mayo Clinic in Rochester. On the positive side for bioscience's future in Minnesota is a commitment to aggressive investment in research and development by the Mayo Clinic and the University of Minnesota, as well as by many corporations. On the downside is the problem of enticing the large amount of venture capital and developing the financial structure needed to help fund new start-up companies

For now, however, Minnesota's energy and enthusiasm about building bioscience clusters appears vigorous and bioscience research is making news particularly in the

area of crop genetics, agriculture, and life sciences. In recent years, genetically modified (GM) crops have gained interest from farmers because of their resistance to pests and tolerance to herbicides. At the same time they have also angered many who believe that genetic modification is a slippery slope for the environment and for long-term health issues in humans.

Nevertheless, many Minnesota farmers are attracted to the concept of genetic modification because of the high crop yield per acre. In 2004, 63 percent of the state's corn plantings were genetically modified and 82 per-cent of the soybean plantings. Farmers, whose livelihood depends on the output of their fields, rely on Minnesota companies to provide them with seeds and techniques to continually increase production. Genetic modification may be a good answer.

Land O' Lakes, known throughout the Midwest for its food products, is a national food and agricultural cooperative that has become one of the leaders in improving agricultural yield, economy, and efficiency. Its brand, Croplan Genetics in Shoreview, is today the fourth largest farm seed company in the United States. With products sold through cooperatives in more than 40 states, Croplan understands the importance of biotechnology advances and has produced many innovative concepts including a forage management system that boosts the nutritional value of livestock feed while reducing storage loss.

CHS, an agricultural cooperative formed by joining two agricultural leviathans, Cenex and Harvest States in 1998, is another major bioscience research company producing crop protection products. CHS invests in soybean research to create innovative uses such as the refined oils used in hundreds of commercial products, flour, and animal feed. The company has also developed soy applications for plastics, adhesives, crayons, paint, and in 2004 made soy based biodiesel products available to consumers. Finding new uses for the soybean, CHS notes, has only just begun.

Davisco Foods International, headquartered in LeSueur, is an agricultural science company that has improved the healthfulness of many prepared foods worldwide. Since 1943 this $500 million privately-held company has been conducting research on how the proteins in whey (the watery part of the milk that separates from the curds as cheese is made) can produce nutritional and health benefits such as reduced blood pressure. As a result of Davisco's work more than 50 percent of the prepared foods stocked by grocery stores contain some form of whey protein.

Few residents realize how large the sugar beet industry is in the state or that Minnesota and North Dakota together form the "nation's sugar bowl." But American Crystal Sugar Company, headquartered in Moorhead, produces about 15 percent of the country's sugar and in the process contributes about $3 billion to the region's economy. The raw material comes from sugar beets and there are about 500,000 acres of them in the fields along the Red River Valley, on the border between North Dakota and Minnesota. Courtesy, American Crystal Sugar

Cargill Dow LLC, located in Minnetonka, is an independent joint venture between Cargill and Dow Chemical. The company is attracting considerable attention for engineering plant fibers into polymers which are used in packaging, for fibers and many other industrial and consumer products. Cargill, Incorporated, also in Minnetonka and a Minnesota legend in agriculture since the nineteenth century, is a global provider of bioscience research results that improve food and agricultural products. Through the years, the company achieved many successes in providing crop protection and plant nutrient products that help farmers achieve greater output.

Cargill is one of the many Minnesota companies that are committed to the future of agriculture. When funding was needed by the University of Minnesota to build a microbial and plant genomics research center, the Cargill Foundation contributed $10 million. Added to matching funds from the state, the contribution fortified the university's research capabilities, and in May 2003 a dedicated building was opened on the school's Saint Paul campus.

Left: *Minnesota's agricultural biotechnology research yields farming products that are reshaping the foods we eat and the medicines we take. Davisco Foods International, headquartered in Le Sueur created a new concept in the 1980s by adding supplementary whey protein to foods such as beverages, energy bars, and baked goods. Davisco's proprietary methods have yielded whey protein isolates that are low in carbohydrates plus high in nutrition. Here, a Davisco technician checks out a computer system which controls whey protein isolate production. The Le Sueur plant where this technician works processes more than a million pounds of milk into proteins and cheeses every day. Courtesy, Davisco Foods International, Inc.*

Above: *Minnesota's soybean crop is exported to the European Union, parts of Asia and Canada and Mexico. Soybeans make up 38 percent of the state's total agricultural income. Shown here is the soybean crushing facility in Fairmont owned by CHS. Opened in 2003, it now provides jobs for 45 Fairmont area families. CHS crushes 110,000 bushels of soybeans daily at Fairmont for use as soybean meal in animal feeds. Sixty miles away, CHS operates a larger facility at Mankato, which crushes a similar volume of beans, and refines more than one billion pounds of soybean into edible oil used for salad dressings, cooking oils, sauces, mayonnaise, margarine and dozens of other products. Courtesy David Lundquist, CHS*

Expectations are that this new center will help identify ways to develop crops, such as fortified rice, for use in developing countries.

Researchers at the University of Minnesota and elsewhere have now turned to the study of nanoscience. Still in its infancy, nanoscience will take biotechnology, cell manipulation, and engineering into the future. Imagine manipulating particles that are 100,000 times thinner than the thickness of a single human hair. Nanoscience technologies are being used to develop lighter, cleaner, and more precise products in the areas of medication encapsulation, tissue regeneration, and materials management among many others. Currently two major corporations, 3M Company and Donaldson Company, a global filtration system manufacturer, along with six other Minnesota companies have been spotlighted by the *NanoInvestor News* for leading the way in nanotechnology development.

Another nanoscience proponent, Cymbet Corporation in Elk River, announced recently that it can custom-make thin-film rechargeable batteries to as small as five to 25 microns (each micron is one millionth of a meter). Smaller than the human eye can see, Cymbet's battery can fit inside of a computer chip and can be used to power medical devices, personal electronics, security applications, and wireless communications to name a few applications.

Growth expectations indicate that by 2010 Cymbet and its sister companies will need thousands of trained nanotechnicians. One of the few U.S. technical colleges that is grappling with the challenge of supplying them is the Dakota County Technical College in Rosemount, Minnesota. With financial backing from the National Science Foundation and the support of a number of Twin Cities companies, the University of Minnesota and state colleges and universities, Dakota County Technical College offers an inventive two-year, associate of science degree for students want to go where the action is. Internships in nanotechnology laboratories will help students translate classroom training into the skills they'll need on the job.

At the Mayo Clinic in Rochester, the Gonda building represents another health-care breakthrough. The Mayo building offers patients the largest interconnected clinical facility of its kind in the world. More than 6 million people— including kings, presidents, and other notables—have been treated at Mayo through the decades. Courtesy, Mayo Clinic

OUTPACING WORLDWIDE COMPETITION: THE LIFE SCIENCES

Take a look at any list of leading worldwide medical technology firms and chances are, Minnesota will be represented. Medical products developed in Minnesota have not only saved many thousands of lives worldwide but have energized exceptional thinking and innovation in medical devices, clinical, and diagnostic capabilities, as well as pharmaceutical products.

Medical innovation in Minnesota began with a book-sized pacemaker, invented by an engineer named Eark Bakken, that was worn outside the body. Fifty-some years

later, Medtronic, which traces it's roots to Earl Bakken's invention is a luminary in worldwide medical therapies.

Today, Medtronic has continued to capture the attention of the medical community with innovations that are the result of its push to expand the application of implantable electronic devices and to make those devices smaller and more powerful.

Medtronic's support of innovation, and the clinically proficient people it hires, has spawned the development and growth of many new companies, some of which compete toe-to-toe with it. Guidant Corporation is one example. When Medtronic chose not to adopt the then-innovative lithium battery in 1972, a few Medtronic employees got together to form Cardiac Pacemakers, Inc. which has since become Guidant Cardiac Rhythm Management in Arden Hills. (Guidant is now owned by Johnson and Johnson). Today Guidant, Medtronic, and their sister Minnesota cardiac pacing corporation, St. Jude in Saint Paul, are major competitors in worldwide pacing innovation.

More than 520 companies in Minnesota produce innovative products for just about every body part and for acute, as well as chronic, illnesses. In 2001 the *Wall Street Journal* reported that Minnesota was rated a top performer in medical devices in a study conducted by the University of Massachusetts, Boston.

For the last fifty years, medical technology has been an energizing force in Minnesota's economy. By 1984 the geographic corridor between Rochester and the Twin Cities was particularly flourishing. Called "Medical Alley" by some, the name caught on, first as a marketing concept and later, to identify the trade association of businesses that provide education, lobbying, and promotion for the medical industry. Medical Alley member companies are located all over the upper Midwest and into Canada and employ more than 250,000 people.

Velocimed, LLC. has been a Medical Alley member and a great example of an emerging medical technology company that is beginning to make a difference. Their proximal embolic protection device helps eliminate problems that may occur in any of the more than 2 million angioplasties performed

Left: On August 6, 2002 two conjoined twins, fused together at the top of their heads, were successfully separated at the University of California, Los Angeles Mattel Children's Hospital. During the twenty-three hour surgery, the 130 employees of Vital Images in Plymouth, Minnesota had a difficult time concentrating on much else. The 3D software developed by the company had been used by the surgeons to plan each step. Precise 3D anatomical images gave the surgical teams exacting pictures, detailed enough to take measurements. A leading provider of 3D imaging software for disease screening, clinical diagnosis, and therapy planning, the company was named to Deloitte & Touche's "Technology Fast 500" list in 2001, 2002, and 2004. Courtesy, Vital Images, Incorporated

What do you want to learn about today? Papermaking? Cryogenics? How about doing a little of what the crime scene investigators do? Among 3M's many innovative programs is Visiting Wizards—an opportunity for 3M employees to show kids the wonders of science. Staff members train to be Wizards and volunteer their time for the very popular program. Since 1985 thousands of kids in hundreds of classrooms have participated in the Visiting Wizards program. What could be more fun that instantly freezing something in this cryogenics experiment? Courtesy, 3M

every year. The product traps and eliminates debris that can be loosened by opening the blocked vessel. Loose debris is then not capable of getting carried away in the bloodstream and creating blockages in other vessels, which may result in a heart attack or a stroke in the recovering angioplasty patient. St Jude Medical, Inc. a $2.3 billion cardiovascular device company in St. Paul became so intrigued by Velocimed's product capabilities, it purchased the smaller company in 2005.

Some of Minnesota's life science innovations are less complicated to understand than Velocimed, but just as valuable. Altimate Medical in Morton (population 600) has focused its research work on products that will help physically disabled children and adults become more independent. Standing and sitting, which seem so easy for the able, are now made possible for the less-abled, too. Altimate's standing frames and mobility aids gently hold each person upright until he or she is ready to change positions. Standing helps reduce pressure sores and improves bodily system function, such as breathing and efficient blood circulation. Altimate's products are sold in 30 countries including China, Japan, and Korea.

In order to keep the state's climate for innovation healthy, many researchers are looking for ways to uniting one scientific or technological solution with others. The word being used to describe this concept is "convergence."

3M got an early start on convergence when it introduced the first metered dose inhaler for asthma sufferers. Many product generations later, 3M has applied the convergence concept again so that precise doses of medication are propelled by a chlorofluorcarbon (CFC)-free technology. Not only did 3M originally converge disparate knowledge sets to create an innovative product, it has successfully converged the work of its own chemists and delivery system engineers with the capabilities developed at other pharmaceutical companies.

Big corporations, such as 3M and Medtronic, of course, have the research bench strength to stimulate innovation within their own walls, but most entrepreneurs depend on research centers typically connected with universities, private foundations, or large clinics.

No matter where the idea comes from, it is not easy to move a concept out of the lab to market. The University of Minnesota's University Enterprise Laboratories (UEL) was an exceptionally innovative idea all its own. Beginning with sixty different technologies developed in university laboratories, UEL offers space and resources to help start-up entrepreneurs transform those ideas into marketable products, converge with other technologies, or both. UEL founders are the first to explain that the idea and the building are in the beginning stages but the idea is catching on. Early in 2005, PRISM Research, a company which specializes in conducting clinical trials for new pharmaceutical and medical products selected the UEL incubator for its new 15,000 square foot home. The University of Minnesota is not the only major research institution. Just south of Minneapolis is the Mayo Clinic in Rochester.

Because both Rochester's Mayo Clinic and the University of Minnesota are both known for their research and the results they've achieved, they've linked their capabilities and research talent into the "Partnership for Biotechnology and Medical Genomics." They will collaborate on four clinical research initiatives, none of which could be accomplished by either institution alone. The results are intended to help physicians identify aggressive prostate cancers, understand how blood vessels and cells interact in early heart disease, discover how an individual's brain regulates the ability to lose weight, and locate brain indicators of Alzheimer's disease at the molecular level.

TUNING UP ALTERNATIVE POWER SOURCES

More than thirty years have passed since the first major energy squeeze. Now, in

If we could capture, market, and distribute all the wind power blown into the Buffalo Ridge section of southwest Minnesota, the state would be a world leader in energy. Today it ranks fourth in the United States for wind energy production. A showcase for windy wealth is the community of Lake Benton, now calling itself the "Wind Power Capital" of the American Midwest. Wind turbines across the landscape neatly blend the region's agricultural prowess with alternative energy innovation. Courtesy, Heritage and Windpower Learning Center

the new millenium, many Americans are feeling even more vulnerable to the unpredictable oil supply. There is nothing exceptionally innovative about alternative energy as a concept. But what is exciting, is the small business initiatives to investigate alternative energy concepts that are growing all over the state.

In Redwood Falls for example, a city of about 5,500 people, the Farmers Union Marketing and Processing Association is working with a rendering company called Central Bi-Products to transform an abundant supply of animal fat into biodiesel fuel. Biodiesel fuels, for example, are an alternative energy source that many believe burn more cleanly than petroleum-based diesel fuels and are renewable. The challenges are constant supply and costs the public will accept.

The animal fat rendering initiative estimates production of about 2.8 million gallons of fuel, which can be used for diesel-powered trucks, tractors, and equipment. It is an interesting solution that is worth exploring.

A statewide effort to investigate biodiesel was launched during the oil shortages of the 1970s and then re-launched in the 1990s during the Gulf War. Although efforts have focused on corn and soybeans as the prime bio-ingredient, animal fats and greases also make sense and may prove to be less expensive. The Redwood Falls Farmers Union initiative will be a beneficial addition to the 8 million gallons the state needs now that a new state law has kicked in, requiring all diesel fuel sold in the state to contain 2 percent biodiesel.

Wind energy is another energy alternative that has blown into Minnesota's economic consciousness. Driven by a state mandate, demand for wind power has increased over the last decade amd it's not just about isolated windmill here and there. Xcel Energy, in the 1994 legislature, was required to develop 425 megawatts of wind energy by 2002. The legislature also introduced an incentive package of subsidies and property tax relief for small wind power projects. As a result, these projects are sprouting up across the landscape, primarily in the southwest corner of the state where the wind blows steadily.

Tucked in an area of countryside, running diagonally from northwest to southeast across Minnesota and separating the basins of the Minnesota and the Mississippi Rivers, Buffalo Ridge is a mecca for wind lovers. The wind blows with such constancy, it's the home of more then 500 wind turbines. Xcel Energy, the fourth largest combination electricity and natural gas energy company in the United States, is one of many utilities

years later, with the introduction of the Original Snow Village, the brand "Department 56" was gaining interest from holiday happy shoppers. Consumer interest grew into mania and spread like wildfire across the United States, so much so that Bachman's spun the department off in 1984. Department 56 continued to introduce one ceramic hit after another, as collectors even built whole rooms to house the holiday collections.

Today, Department 56 is considered a jewel in the collectibles world. And its revenues hover around the $200 million mark.

Minnesotans enjoy shopping so much in their leisure time, an increasing number get more of that time by reducing the time they spend on weekly chores—such as grocery shopping. Minnesota's entrepreneurs have gladly stepped up to the plate. Schwan Food Company, headquartered in the southwestern city of Marshall, is a premier example of a Minnesota entrepreneur who pioneered "at home" grocery shopping. Founded in 1952 by Marvin Schwan, who got his start delivering ice cream to rural homes, Schwan's is now the largest branded frozen food company in the country. Its yellow trucks delivers more than 300 varieties of frozen food products to more than 5 million households in the United States but it sells throughout forty-nine other countries, as well. Ironically, Schwan's is said to be the fastest-growing pizza manufacturer in Europe, its facility in Germany the most technically capable pizza production plant.

While Schwan's limits its focus to frozen food, its upstart rival in the Twin Cities, called SimonDelivers, Inc., is taking online orders and delivering whole grocery orders including fresh produce and bakery products. Twin Citians seem to like the concept as demonstrated by the steady growth and the company's May 2005 announcement of its first profitable quarter since it was founded in 1999. While it's true that SimonDelivers is not the first or only online grocery delivery business in the United States, it may have given new hope to an industry that's not been all that stable. What's working apparently is the SimonDelivers' brand of customer service, which has been described as "the milkman on steroids."

Although some would argue that Minnesota's winter isn't one of the high points of our quality of life, entrepreneurs such as Dick Enrico have figured out how to help Minnesotans escape the blues through exercise—on used exercise equipment. His company, 2nd Wind Exercise Equipment, operates fifty stores throughout the Midwest and has grown so quickly—from a quirky idea to a well-recognized brand—that it is the second largest new and used fitness retailer in the country. Enrico has become somewhat of a brand himself, appearing on television commercials as the baby boomer who

226

hates to exercise but knows he's got to do it. As Minnesota's population ages along with the rest of the country, Enrico's a guy we'd like to buy from—because he's like us. Minnesotans specifically—and Midwesterners in general—like people who are like them. If they have to exercise, an increasing number prefer to do it in the privacy of their homes, dressed in old clothes. 2nd Wind is on a roll.

As aging accelerates in the state's population and over the next three decades, people over age sixty will probably exceed the growth of any other age group. Those Minnesota businesses which develop products to help older citizens maintain a quality of life are more highly regarded than ever before. The state is proud to be the home of hundreds of medical product companies, which have been on the cutting edge of medical product research for just about every organ and every chronic medical challenge. American Medical Systems (AMS), founded in 1972, is one, perhaps little less known than the behemoths Medtronic, Guidant, St. Jude and Boston Scientific. But AMS has targeted research to pelvic problems for both men and women including incontinence issues. The medical problems that AMS helps solve may not always be life threatening but the company's innovative solutions extend an aging person's quality of life. For fiscal year, 2004, AMS reported about $209 million and projected a bullish double-digit increase.

On a much smaller scale, other entrepreneurial organizations, such as Gentle Transitions in Minneapolis, work hard to help older people gain life quality. The concept for Gentle Transitions was Minnesota born in 1990 but the idea is spreading around the country. Seniors who are downsizing their lives can hire Gentle Transitions to not only plan, pack and move the possessions that are to go into the smaller space, but pack, donate or throw away those things that won't fit in the new space. It's a moving company with heart. And it's gaining in momentum.

OPPORTUNITY THE 21ST CENTURY WAY

Through the decades when the state was first populated with Europeans, the rich resources of the land and waterways cued "opportunity."

Most of our state's history is about opportunities taken with the land. Most of the chapters in this book tell those stories. But the back story is about innovative thinking. Minnesota-born invention always stimulated more invention—here and around the world. The genius of a man who built a transcontinental railroad—and who's ideas essentially gave birth to the country's transportation industry. The vision of another who used Minneapolis' waterfalls to power a flour industry that would generate food for much of the country then, and a worldwide food industry decades later. The people who studied cryptology and ended up as pioneers of the computer industry. The engineer who figured out that a machine could help a human heart beat correctly and whose work galvanized a belief in medical technology.

More than three centuries after the first Europeans arrived, our state is still a place of opportunity—just a different kind than the earliest explorers discovered. While the abundance of resources on the land required strong hands, backs, close family ties and the guts to keep going, the opportunities of the twenty-first century Minnesota demand facile minds, fresh ideas, worldview and the guts to keep going. Some even claim that brainpower is the primary resource in an opportunistic world that is decreasingly dependent on the natural resources that came with the land and increasingly dependent on the new ideas that have come with the people who have built their lives here.

Through the decades, Minnesota has proved to be a place that lures smart creative people. It fosters them and gives them courage to think bigger and better. It celebrates their successes too.

Who says that history is dry? In Minnesota, it's been alive. It's people doing wonderful things and seeing exciting results. Here, in fact, history is a daily happening. We're lucky to live here so that we can watch it.

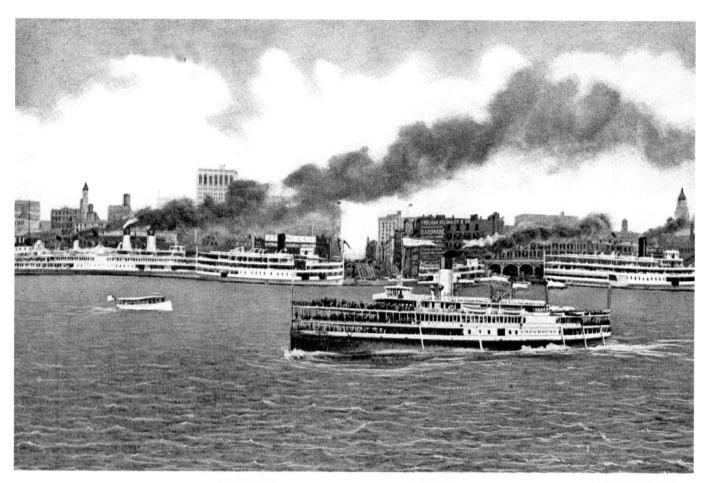

Two postcards from the early 1900s, the top one showing an excursion on Lake Superior and the lower one showing families enjoying a day at the park.

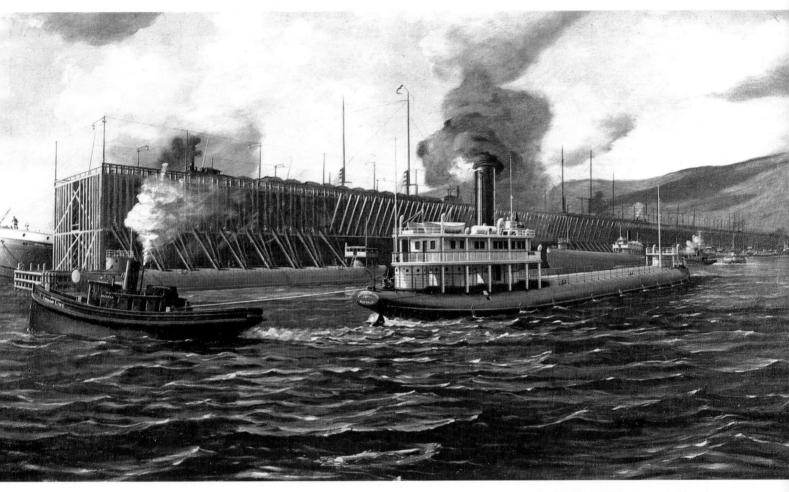

In this Howard Sprague painting, three of Alexander McDougall's innovative whaleback iron ore boats are depicted at the Duluth docks. From the mid-1890s for thirty years the efficient boats were workhorses of the Great Lakes iron ore shipping industry. Courtesy, Duluth, Mesabi and Iron Range Railroad

Following pages 230-231: Forest undergrowth blushes russet, gold, and vermillion in the gathering fall, soon to yield to winter's cold, silver rest. Photo by R. Hamilton Smith

Above: *The Mill City Museum is a tribute to Minneapolis' economic start as the "Flour Milling Capital of the World." The once-glorious Washburn A Mill is glorious once again as it hosts thousands of visitors each year. It offers visitors the opportunity to learn the history of flour milling; ride in a multi-media elevator, called the Flour Tower; and "meet" a few of the people who worked at the mill during its heyday. Courtesy, Assassi Productions*

Right: *If you've ever remodeled your home kitchen, you can appreciate General Mills' colossal effort when it remodeled its 14,000-square-foot Betty Crocker kitchen facility in Golden Valley. Betty Crocker cooks can now utilize fifty ovens, nineteen dishwashers, and eighteen refrigerators as they test more than 50,000 recipes every year. General Mills has roots deep in Minnesota history and has along grown with the state. Courtesy, General Mills*

Like many a sentinel along the lakeshore, Split Rock Lighthouse is part of Lake Superior's compelling history of navigation. Photo by Kay Shaw

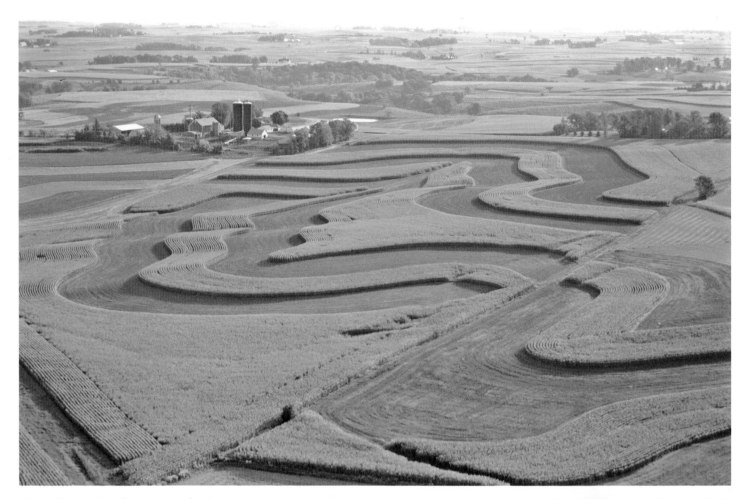

Above: The quality of Minnesota's food products has a direct relationship to the quality of its soil. Lester, or loam, is a favorite of farmers and those who are lucky enough to have it do a lot to keep it. Perhaps that's why 1.32 million acres of Minnesota farmland has been dedicated to conservation practices such as the contour farming shown here. Contour farming is one of the many techniques farmers use to preserve water quality, ease flooding, and even reduce the release of greenhouse gases. Courtesy, Minnesota Department of Tourism

Right: Wild rice grown in Minnesota's lakes is different from cultivated wild rice, which is raised in paddies. In spite of the fact that more than 95 percent of Minnesota's crop is actually cultivated, many of the northern lakes still offer the joys of a traditional September harvest. Through countless generations, Minnesota's Native American families relied on wild rice as a staple. Today their descendants follow the old ways of harvesting where a "poler" steers the canoe through a bed of rice while the "knocker" gathers the rice kernels in the bottom of the boat. Courtesy, Minnesota Department of Tourism

Above: There are few things as intimidating to a hiker as coming face to face with a moose. Standing six to seven feet tall and weighing in at 900 pounds or more, they don't exactly look welcoming. But real nature lovers know that a moose with a baby, such as the one here near Ely, is a rare and wonderful find. Courtesy, Steve Foss

Left: Those with a few hours to shed work responsibilities can soak in the sights, sounds and fragrances at the 1,000 acre Landscape Arboretum outside of Chanhassen. A part of the Department of Horticultural Science at the University of Minnesota, it's not only a beautiful place year round, there's a lot of research going on too. Scientists are working to develop Minnesota-hardy fruits, trees, plants and landscape environments. The revered Honeycrisp apple is a result of that research. So is the Northern Lights azalea shown here. Hike, take a guided tour or a special picnic, the Arboretum is a special "get away" place. In 2001, USA Today declared the Arboretum one of the "10 Great Places to Smell the Flowers" in America. Courtesy, Minnesota Landscape Arboretum

Above: *Hard to believe that Minnesota's State Capitol building was built on the grounds of a livery stable, but so goes the story. It's not hard to believe, however, that the building's architect, Cass Gilbert, was one of the country's best. Gilbert translated his vision into a soaring marble dome, which is one of the four largest in the world. The Minnesota State Capitol building overlooks the Mississippi River Valley as well as St. Paul's Cathedral. Courtesy, Minnesota Department of Tourism*

Right: *Minnesotans really know how to celebrate winter. In 2004 the city of St. Paul constructed a remarkable ice palace in tribute to the 118th Winter Carnival. Families from all over the Midwest flocked to tour the ice palace, amazed at the size of the rooms and the five towering turrets. About 1.5 million people viewed the structure, an obvious economic highlight for the city's hotels, restaurants, and other tourist spots. The St. Paul Winter Carnival is thought to be the oldest and largest winter festival in the country. Courtesy, PROEX Photo & Portrait*

Above: *Few legislative halls assert the rich simplicity of the Minnesota House of Representatives Chamber in the State Capitol in St. Paul. Photo by Greg L. Ryan*

Left: *The grand effect of architect Cass Gilbert's 1905 dome for the Minnesota State Capitol in St. Paul endures. Photo by Greg Ryan/Sally Beyer*

The best tastes of summer? Corn fresh from the fields. Tomatoes heavy with juice. When the harvest begins, it's the Saturday "thing" for city folk to go to the farmer's market. What Saint Paul residents like best is the knowledge that the people they buy from are the people who have planted the seeds and tended the crops. Only growers who live within a 50-mile radius of the city are allowed to sell. That's just the way it's been for more than 150 years. The main market is in the heart of downtown for weekend shopping, while thirteen neighborhood farmer's markets spread the harvest wealth into the suburbs. Even when it is not harvest time, the downtown farmer's market stays open to provide bakery products, meats, cheeses, maple syrup, eggs, honey, and even plants for springtime gardens. Courtesy, Saint Paul Farmers Market

Below: South from the Twin Cities on the Mississippi River Road is an extraordinary hand-carved carousel. L.A.R.K. Toys (L.A.R.K. stands for Lost Arts Revival by Kreofsky) draws more than 1 million visitors every year They visit the seven toy stores in the complex as well as the antique toy museum. But the carousel is the jewel. Everyone loves to take a few turns on one of its nineteen beautifully crafted figures. The carving took years but the carousel is an incredible accomplishment, and definitely worth the trip whether the visitor has kids or not. Courtesy, Chadd Maze Kreofsky

Right: After five years and 232,000 ceramic tiles, the Nay Ah Shing mural is a proud reminder for the Ojibwe people of the beauty of their Indian culture and its close relationship to the land. Located at the Mille Lacs band of Ojibwe's Nay Ah Shing Upper School in Onamia, this mural also represents the invaluable contributions that the Mille Lacs Band's two gaming casinos have made to the quality of life for the reservation. Courtesy, Mille Lacs Band of Ojibwe

The Twin Cities are "twins," but not identical. Minn-
eapolis is aggressively urbane. It's a serious city, aptly
nicknamed the "Mini-Apple," with the soaring office
towers to prove it. Across the river, Saint Paul looks and
feels different. There are fewer office towers, but a greater
number of historical buildings remodeled and upgraded
into contemporary spaces. Both cities have characteristic
skyways linking buildings, views of the river, and culturally
diverse populations that are holding steady against the
faster-growing suburbs. Minneapolis and Saint Paul share
their professional sports teams, a major airport, media
coverage, enthusiasm for downtown housing, and the
University of Minnesota. Pictured here is the skyline of
Minneapolis in autumn. Courtesy, Minnesota Department
of Tourism

239

Right: *When you're looking at this 120-foot drop of the Pigeon River, you're about as far north in Minnesota as you can get. Here, at Pigeon Falls in Grand Portage State Park, Canada is just a stone's throw away. It is the only park in the country that is managed through a partnership between the state and the local Indian band of Ojibwe. Courtesy, Debra Chial, © Debra Chial*

Below: *Lake Minnetonka, a 14,000-acre lake west of the Twin Cities, is a playground for boaters, skiers, and sailors in the summer. But when the legendary Minnesota winter cold sets in, those recreational boaters start looking for their fishing poles, heaters, cleats, and ice augers. With a four-inch ice base, icehouse cities grow nearly overnight on the lakes. The crisp air begins to smell of outdoor cooking as ice fishermen and women bait the hook and wait for a strike. Ice fishing is popular just about everywhere in Minnesota that there's an ice covered lake. Courtesy, Minnesota Department of Tourism*

240

Above: *The "Mighty Mississippi" doesn't look like much at its headwaters on the north arm of Lake Itasca, a few miles north of Park Rapids. Fewer than three feet wide and moving slowly, it's hard to imagine that this stream will ultimately carry more than 280 million metric tons of freight each year from Minnesota to the Gulf of Mexico. Minnesota's oldest state park, Itasca State Park, celebrates the river that has meant so much to Minnesota history, commerce, and quality of life. Courtesy, State of Minnesota, Department of Natural Resources, Reprinted with Permission, © 2002*

Left: *It's about a hundred years old and still working as hard as ever. The Duluth Aerial Bridge links the city with Minnesota Point. Ships that pass beneath are bound for the safety of the Duluth harbor. The bridge is raised whenever a ship (called a "Laker" by the natives) comes within 1-1/2 miles and cars are stopped until the ship has passed safely. The warning blast announcing that the bridge is about to be raised is a common and comforting sound for Duluthians. Courtesy, Duluth Seaway Port Authority, by Lisa Marciniak*

Right: *To the uninitiated it's called log rolling and it's fun to watch. To lumberjacks, it's called "birling" and it was serious business when logs were floated down river to the mills. Today it's a water sport that is monitored by the American Birling Association. Minnesota has its share of birling contests and legendary competitors that are nimble enough to stay upright on a log that's got other ideas. There's a Lumberjack Sports Camp in Stillwater so log rollers can become birlers in a day camp setting. Courtesy, Minnesota Department of Tourism*

Right: *Any good Scandinavian knows that lutefisk is made with dried cod and treated with lye—a favorite Christmastime dish. This 25-foot cod replica, celebrating Madison's claim that it's the "Lutefisk Capital of the World," is made of fiberglass. Some would argue that it's a contest of which tastes better, lutefisk or fiberglass. Nevertheless, this 25-foot fish named Lou T. Fisk has welcomed visitors to Madison since 1982. The uncontested champion of the November Norsefest lutefisk-eating contest downed eight-and-a-half pounds in one sitting. Courtesy, C. Edward's Studio, Madison*

242

Above: *This optimistic snowboarder is enjoying a great course down Lookout Run at Welch Village. Located between Hastings and Red Wing, Welch takes snowboarding conditions seriously. Welch Village offers downhill skiers and snowboarders 120 acres of snow, fifty runs and three chalets for warm ups and lots of fun. Courtesy, Randy Kirihara*

Left: *The 11,000-plus residents of Worthington say they're used to the wind. It is, in fact, an important resource for the southwestern part of the state where wind turbines are busy catching the wind and turning it into electricity. Nevertheless, Worthington likes to kick back and celebrate every year with their Windsurfing Regatta and Unvarnished Music Festival. Courtesy, Jon Okerstrom*

Above: *Bald eagle nests, such as the one shown here, are typically built in the tops of very tall trees and close to water. A newly-built nest may be about five feet in diameter, but since bald eagle pairs return to their nests every year, nests up to nine feet in diameter and weighing about two tons have been reported. Minnesota claims about 680 bald eagle nesting pairs. Courtesy, Minnesota Department of Tourism*

Opposite page, top: *Duluth is Minnesota's direct waterway connection to the Atlantic Ocean and points east. Outbound, coal, taconite and grain are shipped to waiting markets during a shipping season that lasts from mid-March to mid-January. An economic powerhouse for the area, the city appreciates the economic impact from about $210 million and the 2,000 jobs that the shipping industry offers during prime season. Around the port docks, the winter berthing of ships can be lucrative too. Each wintering-over ship needs maintenance, repairs and renovation that can add another $500,000 in labor and supplies. Courtesy Duluth Seaway Port Authority. Photo by Jerry Bielicki*

Opposite page, bottom: *If you're looking for a place to get away—really away, the Boundary Waters Canoe Area wilderness (BWCA) is the place to go. There are millions of acres of open land and at least 1,000 navigable lakes and streams to carry your canoe. Leave your computer and cell phone behind and imagine the crisp, clear nights and breathtaking sunrises. It's all there, as this couple knows. A week in the Boundary Waters, some say, is equal to three weeks anywhere else. Courtesy, Minnesota Department of Tourism*

Above: *This Rush Creek Valley view graces an I-90 rest area near Winona. Photo by Kay Shaw*

Left: *Shop 'til you drop, then catch your plane. Northwest Crossing at the Twin Cities Lindbergh International Airport offers seventy-five shops, eateries, and restaurants—something for every traveler. In 2003 the Airport Council International named the airport the best overall concession, and it's true. Northwest Crossing is one of the country's largest concourses with all the variety of your favorite mall back home. Courtesy, Metropolitan Airports Commission*

Opposite page: *A record late-July rainfall swelled Minneapolis' usually gentle Minnehaha Falls to this booming cataract. Photo by Kay Shaw*

Above: *They say that Paul Bunyan, the mythical logger who felled an acre of trees every time he swung an axe, had footprints so large that they created Minnesota's lakes. Babe, his ox, was blue because of the cold winters up in the North Country, or so the legend goes. Standing 18 feet tall next to Lake Bemidji, Paul and Babe's statues are made of concrete and have withstood winter blasts since 1937. Courtesy, Bemidji Visitors and Convention Bureau*

Right: *Visitors to Minnesota lakes are drawn to the melancholy sounds of loons. The name, loon, is derived from a Norwegian word that means "wild, sad, cry." Lucky Minnesotans can spot a mother loon carrying her baby on her back, a practical way to keep the young from being snatched by a predator. The loon was named the state bird in 1961. Today there are about 12,000 loons in Minnesota, more than any other state except Alaska. Courtesy, Minnesota Department of Tourism*

Above: *They say that if a shopper spends ten minutes in every store at the Mall of America in Bloomington, it would take more than eighty-six hours to complete the task. Standing inside, you can believe it. With a fully enclosed amusement park, it's the largest complex of its kind in the United States. With restaurants and stores of all types, play areas for kids, and an aquarium, the so-called mega-mall is something to see. More than 2.5 million visitors shop at the mall each year with most of the international shoppers coming from Great Britain, Canada, and Japan. Courtesy, Mall of America*

Left: *In spite of the fact that Minnesotans love the idea that the Vikings actually traveled to Minnesota during their western expeditions more than 1,000 years ago, the debate continues to rage among scholars. In 1982 this replica of a Viking longboat made the 6,100-mile trip across the ocean and proved that the journey was possible. Today the Hjemkomst Viking ship, pronounced Yem-komst and meaning "homecoming" in Norwegian, is on display at the Moorhead Interpretive Center. Courtesy, Minnesota Department of Tourism*

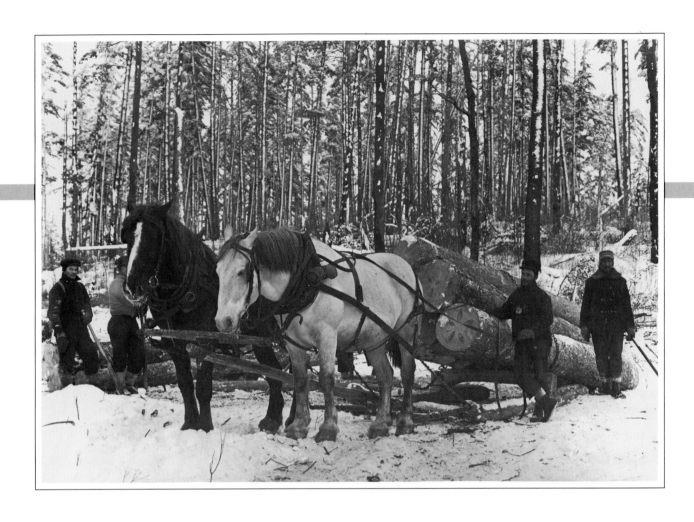

*To the first lumbermen in Minne-
sota, the pine forests looked like an
inexhaustible supply of timber.
Many farmers worked in the woods
in winter to earn cash to pay off
their land. They stacked the logs
by streams that would float them
to sawmills during the spring thaw.
Photo by William Roleff, Two
Harbors, Minnesota. Courtesy,
Minnesota Historical Society*

CHRONICLES OF LEADERSHIP

Economies aren't stagnant. Once or twice a century, new inventions and breakthrough thinking unglue the status quo. In Minnesota, for example, the transcontinental railroad and James J. Hill's dreams bolstered the evolution of manufacturing in the last decade of the 19th century. During the middle of the 20th, computer pioneer William Norris opened the floodgates for the instant worldwide communication and information accessibility we have today.

In both cases, lives of Minnesotans and people around the globe were changed. The ability of those in the state to generate innovative thinking ran counter to its reputation as a typical Midwestern, self-focused, self-sufficient throwback. In fact, innovative thinking emerged as a major competitive advantage.

Others agreed. The Milken Institute, a self-described "think tank" on economic growth issues in California, for example, named Minnesota eighth in the country in 2004 for its innovative climate. Growth and innovation go together, perhaps like never before.

There are a number of reasons why innovation has taken root as a way of life in Minnesota. The quality of the available workforce is often quoted as a critical competitive advantage and the state has made the training and education of a future workforce a top priority. The Minnesota Job Skills Partnership Program, for example, connects businesses and educational institutions to ensure the highest quality job training and re-training is available.

Another leading reason for its place as an innovative performer is the state's aggressive global presence. The top twenty-five multinational companies in the state gain 32 percent of their revenues from sales outside the United States. In 2003, according to the U.S. Department of Commerce, export shipments had grown 20 percent from 1999, compared to a 4.5 percent increase overall in the United States. Landlocked only by geography, Minnesota companies look worldwide for the ideas, talent, and markets that they need.

Minnesota clearly has grown into a highly diverse, globally aware, technologically savvy, and highly innovative state. But it's done that without losing the quality of life that has attracted millions throughout the decades.

AUGSBURG COLLEGE

Augsburg College, located in the heart of the Twin Cities of Minneapolis and St. Paul, is no ordinary college. The private institution, which has always enjoyed an association with the Lutheran church during its long history, emphasizes a "transforming education." This approach transforms students' unique gifts and interests into personal and professional callings that help others. It also alters the educational experience itself in constantly innovative ways, and motivates students to change the community and the world through positive means.

Experiential learning is an important part of the curriculum at Augsburg, which is the Evangelical Lutheran Church's most diverse urban institution in America. Taking learning out of the classroom and into the world is a key ingredient of the more than fifty undergraduate and six graduate programs offered. Augsburg's 3,000-plus students are encouraged to participate in community service, internships, and study abroad opportunities. These experiences not only enhance classroom learning, but also prepare students for life in a multicultural society.

As a major cornerstone of the transformative educational experience at Augsburg, the Center for Global Educa-

Dedicated on New Year's Day 1902, this building was known as "New Main" until the mid-1950s when the first "Old Main" was demolished. Now the oldest building on the Augsburg College campus, it is included on the National Register of Historic Places.

Georg Sverdrup was the second president of Augsburg College from 1876–1907. His leadership had directed every facet of Augsburg's development for more than a generation.

tion (CGE) was officially created in 1982. Unlike other study-abroad programs, the CGE focuses on non-traditional destinations where issues of social justice are prevalent. The recipient of numerous awards as the best experiential program, the CGE allows students to study topics such as globalization, indigenous rights, social justice, and the church in society.

Although the CGE's official christening came in 1982, it has actually been introducing students to foreign cultures since 1979. That's the year several students

piled into a van and headed to Cuernavaca, just south of Mexico City, for a semester abroad. The program was such a success that Augsburg purchased two guesthouses and a study center in the area—and hired permanent staff and faculty members to run them.

In the early 1980s the program branched out to locations in Central America, including Guatemala, Nicaragua, and El Salvador. In 1994 it branched out again, adding a program in Namibia, South Africa. At this site, students can take history courses that focus on apartheid; the church in society; and healthcare issues, including the AIDS epidemic in Africa.

Since its official debut in 1982, some 9,000 students have participated in the life-changing experience. In addition to the semester-long programs in Mexico, Central America, and Namibia, the CGE also includes short-term travel seminars in far-flung locales such as Palestine, the Philippines, Thailand, and Vietnam. Seminars in these locations have covered indigenous rights, the church in society, U.S. relations with the world, healthcare, globalization, and educational systems.

The CGE plays a key role in Augsburg's overall mission by showing students that it's important to be in service to the world. The program allows local people, who normally wouldn't be heard, to tell their stories. It gets young people to think about global connectedness and lets them realize that they can be agents of change.

Another pillar of the transformative education at Augsburg is the Center for Service, Work, and Learning. Established in 1990, the service learning program now plays an integral role in the education of Augsburg students. It is designed to help prepare them to make a difference in business, government, in their families and communities, and across the world. Over the past fifteen years the center has developed partnerships with hundreds of employers and organizations that provide internships and other learning opportunities for students. The center also offers career guidance, job search support, and graduate school assistance.

From the very first day they set foot on campus, Augsburg students are expected to take part in a service project. They may work in homeless shelters, nursing homes, schools, a community radio

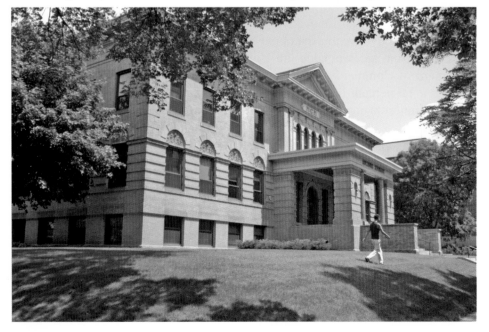

station, or a variety of other community organizations. These projects are designed to help new students learn about the city of Minneapolis and help them understand Augsburg's motto of "Education for Service."

Students' commitment to service continues throughout their college career. During their freshman and sophomore years, students are expected to participate in "Engaging Minnesota," which encourages civic engagement by sending students out into the community. Whether they're tutoring in a neighborhood school, working with an environmental organization, or urging people to get out and vote, students gain first-hand experience with the major issues facing society.

As juniors and seniors, students continue their service learning experience with the "Augsburg Experience." This program includes taking part in the Center for Global Education or signing up for courses with a service learning component. For example, journalism courses require students to tackle a

Augsburg College students gather to talk and relax on the quad in front of the Christensen Center, the hub of this small urban college.

"beat" such as homelessness, literacy, or domestic abuse. They must work in an organization that addresses that particular issue and then write about it.

Augsburg is one of only two colleges in all of Minnesota where service learning is integrated into the curriculum. Its commitment to the concept has earned the college accolades in publications such as *U.S. News & World Report* and *The Princeton Review*.

In keeping with its philosophy of a "transforming education," Augsburg also strives to help students transform their own lives with two innovative programs. CLASS is one of the largest programs for students with physical and/or mental disabilities. Augsburg is one of only three colleges in the nation to boast a Step-Up program, which admits students in recovery from alcohol abuse. Through the Step-Up program, Augsburg looks at a student's potential and doesn't pass judgment for things they've done in the past. The program has proven to be a tremendous success.

All of these efforts combine to make Augsburg a truly unique college where traditional and non-traditional students experience education in a most innovative way. With its commitment to providing

Augsburg College's location on the edge of downtown Minneapolis provides ample opportunities for hands-on, experiential internships to complement academic classroom study.

a transforming education, Augsburg College will continue to achieve its overall mission of nurturing future leaders in service for years to come.

BEST & FLANAGAN LLP

A Minneapolis institution for nearly eighty years, Best & Flanagan is a full-service law firm founded on the principle of building strong relationships with clients and fellow attorneys. Despite changes brought about by modern technology and increased competition, the partners at Best & Flanagan have maintained a culture of camaraderie and professionalism that is recognized throughout the Midwest.

The firm began as a partnership between two attorneys who specialized in trusts and estate planning. Today there are sixty-three attorneys, with expertise in business law, real estate law, public finance law, personal injury and dispute resolution, family law, litigation, government and development law, and Native American law.

Jim Best and Bob Flanagan became friends while they were students at Harvard Law School. After graduating in 1926 Best persuaded Flanagan to join him at his father's law practice in Minnesota. They opened an office in the seven-story New York Life building, located on the corner of Sixth Street and Second Avenue in downtown Minneapolis. Known as Boutelle, Bowen, and Flanagan, the group of attorneys included Jim Best, his father Eugene Best, Bob Flanagan, Fred Boutelle, LeRoy Bowen, Adrian David, and others. However, Best and Flanagan maintained a separate partnership from the rest of the group.

In 1931 Best, Flanagan, and their colleagues moved to the Rand Tower, as one of its first tenants. During the next five years, three more attorneys joined the firm. Len Simonet handled litigation and labor law, as well as many of the society divorces of the day. Herb Rogers and Ward Lewis, also graduates of

Robert J. Flanagan, founding partner, 1898–1974.

Harvard Law School, joined forces with Simonet in developing a business law division of the practice. National Tea (now Rainbow Foods) became an early corporate client and supplied the firm with work for decades.

From the beginning, social events were an important element in the lives of these hard working, serious-minded attorneys. Much entertaining was done back and forth between National Tea and the firm. Every summer National Tea officials were invited to Flanagan's house for his famous spaghetti dinner. His Christmas parties became legendary, with over 200 guests in attendance, and a menu that included roast suckling pig, smoked turkey, baked ham, and fresh oysters.

The spirit of collegiality was nowhere more evident than in the Tudor Court Restaurant in the basement of the Rand Tower. The daily lunches provided opportunities to discuss legal issues and politics and were times of great bonding between firm members. Flanagan and Best encouraged

this camaraderie among the attorneys, and continued to do so long after their numbers had increased from a mere handful to more than a dozen on staff.

The firm was renamed Best, Flanagan, Rogers, Lewis and Simonet in 1941. The three new partners continued the work of the firm while Best and Flanagan joined the war effort, serving respectively in the Marines and the Navy. In 1946 Charlie Bellows, a former combat captain in the

James I. Best, founding partner, 1902–1966.

Pacific, became a partner in the firm and initially worked as an estate and trust lawyer. In the early 1950s Bellows saw the need to expand the firm's expertise beyond its focus on probate law. He sought to establish more of a presence in corporate law and litigation, a move that led to the hiring of additional attorneys and helped shape the future growth and success of the company.

Herb Rogers left the business around this time to become president of Lithium

Best & Flanagan LLP's lobby, 2005.

The Boutelle, Bowen, and Flanagan offices in the New York Life Building, circa 1926.

Corporation of America. The company was a major corporate client of the firm during the post-World War II years and had been represented by Rogers. Upon his departure, the firm name was changed to Best, Flanagan, Lewis, Simonet, and Bellows. In 1960 Rogers rejoined the firm on an "of counsel" basis, but died a few years later. The next few years brought the additions of attorneys Archie Spencer, Bob Skare, Bob Crosby, and Len Addington to the partnership.

More changes were on the horizon. The firm moved from the Rand Tower to the First National Bank Building in 1960. Six years later Jim Best died suddenly at the age of sixty-four. Bob Flanagan, now sixty-eight, had started to slow down. The fading of the firm's founding generation opened the doors of opportunity for a group of young attorneys to make their mark. Walt Graff, Allen Barnard, and James Diracles were among the new hires.

At the time, the majority of the work centered around trusts and estates or business law. During the next several years, the firm broadened its business law and litigation practice, and was rapidly blossoming into a general practice law firm. By 1974 it had grown to include twelve partners and two associates.

Significant developments ushered in a new era for the company in the mid-1970s. Most symbolic was the passing of Bob Flanagan in 1974, at the age of seventy-five. That same year, the firm left its cramped and outdated offices at First National Bank and relocated to the fortieth floor of the new IDS building on Nicollet Mall. A strong rapport had been established between the Best & Flanagan attorneys and the real estate business run by George Maloney, Bud Carroll, and Jim Olson, whose offices were located down the hall from theirs in the First National Bank building. Soon after Best & Flanagan moved, there were discussions of a possible merger with the real estate company. Because of the long-standing

relationships between the two ventures, the merger took place uneventfully and Maloney, Carroll, and Olson joined their new partners in the IDS building in 1975.

The firm continued to grow steadily in the 1980s and 1990s, branching out into public finance, Native American law, and commercial real estate lending. More attorneys were added to the roster, and Best & Flanagan solidified its identity among the Minnesota legal establishment as a full spectrum law firm.

Much has changed in the practice of law in the decades since young Jim Best and Bob Flanagan launched their careers. In the 1960s legal secretaries still stuffed seven sheets of onion skin paper, with carbon paper in between, into their manual typewriters to transcribe shorthand notes the attorneys had dictated to them. Photocopiers and electric typewriters made the documentation process faster. With the advent of fax machines and e-mail, expectations were even higher for a rapid delivery of services. In today's world, clients are not content to receive paperwork the next day—they want it within the hour.

The culture of law has changed as well. An increase in competition and contentiousness among attorneys in the profession has at times produced a cutthroat mentality. The "good old boy" network appears to have largely disappeared.

Yet this is not the case for Best & Flanagan, says managing partner James Diracles, who has spent thirty-two years at the firm. The preservation of a collegial atmosphere and the success of maintaining long-term relationships with clients are hallmarks of the historic company, just as its original founders intended.

In 2004 Minnesota Law & Politics named fifteen Best & Flanagan partners to their thirteenth annual "Super Lawyer" list. Those partners include Charles Berquist, John Burton, James Christenson, James Diracles, Cathy Gorlin, Christopher Johnson, Paul Kaminski, Steven Kruger, E. Joseph LaFave, Roger Roe, Lenor Scheffler, Gregory Soule, Timothy Sullivan, Marinus Van Putten, and Frank Vogl.

"A lot of firms have lost the ability to maintain long-term relationships with their clients in today's legal market. Lawyers keep shifting around from one company to another," says Diracles. "We try to have a stable work environment and good relationships among our lawyers. It's not easy all the time and it is certainly not the norm."

CATCO PARTS AND SERVICES

Arthur Peterson first opened the doors to his clutch and transmission service shop on University Avenue in 1949. The 1,800-square-foot facility specialized in selling clutches and transmission parts for trucks and other heavy-duty vehicles, and featured about ten product lines for sale. Just happy to be serving customers in the Saint Paul area, Peterson never imagined the little shop would grow beyond that original space.

Today the headquarters for CATCO (an acronym for Clutch and Transmission Company) occupies 52,000 square feet on Long Lake Road. The company boasts fourteen additional retail locations as well as two rebuilding shops throughout four states—Minnesota, Wisconsin, North Dakota, and South Dakota. With nearly 300 employees and approximately 450

Harvey and Tom Peterson in front of a picture of Art Peterson, CATCO's founder.

CATCO at its Prior Avenue office in St. Paul, circa 1963.

product lines for sale, the little company Arthur Peterson started more than fifty years ago has survived three generations and emerged as an industry leader.

The firm's road to growth began when Peterson asked his son Harvey to join him in the business in 1951. Harvey, a college man who had spent two years in the U.S. Navy, had a different business philosophy than his father. While Arthur was content to service the local customers, Harvey was intent on expanding the business. One thing they both agreed on, however, was a fiscally conservative policy that put Harvey's plans for growth squarely in the slow lane.

In the meantime, Harvey learned everything he could about the business

from his father. He started out doing bookwork and acting as a "parts chaser." If a customer wanted a part that wasn't in stock, Harvey would buy it elsewhere and bring it back to the shop. After a few years, Harvey began taking on more responsibilities and hired a sales staff to help customers.

During this time Harvey learned some valuable business lessons from his father. Most important was the notion that people are the most important part of any busi-

ness. Arthur used to say that "businesses don't do business with businesses; people do business with people." He firmly believed that CATCO was in the people business—the company just happened to sell truck parts.

With that philosophy as the basis of their operation, the number of customers rose quickly and the hard-working team outgrew their original space and moved to larger quarters. As business grew, the company moved locations a number of times, always seeking out bigger spaces where it could showcase its ever-expanding product line. By 1957 Harvey's dreams of expansion were set in motion when their second location opened in Rochester.

The year 1966 marked a turning point for the business. That's when Arthur died suddenly at the age of 68, leaving Harvey to take over the business. It wasn't long before Harvey launched an aggressive expansion plan. That plan went into effect in 1973 when CATCO acquired Northland Brake and Supply Company in Burnsville. This move marked the company's foray into the brake business. Acquisitions continued with new branches being added in Fargo, St. Cloud, Mankato, and Bemidji, as well as Eau Claire, Fond du Lac, and Green Bay, Wisconsin.

Lia Peterson and Jane Wlazlo.

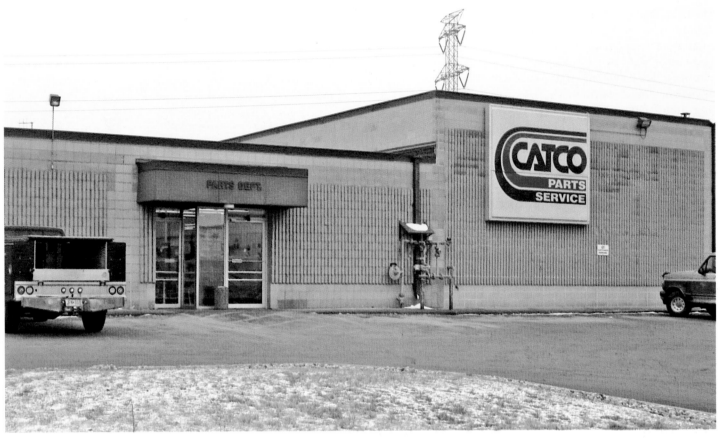

During the 1970s the company made a couple of other significant "acquisitions"—only these were of the human variety. In 1973 CATCO hired Dave Gerdes, who became an invaluable addition to the team and has since become vice president and COO. Four years later Harvey's son, Tom, took a part-time job with CATCO while he was still in high school. After graduation from Mankato State University, Tom became a full-time employee and worked in various departments to gain an overall understanding of the business.

By 1996 Harvey had relinquished the reins of the company to Tom, who took over as president and CEO. Although Harvey still serves as CATCO's chairman of the board, he stepped away from the day-to-day operations of the business in order for Tom to hold a clear leadership position. Tom, however, isn't the only third-generation Peterson at CATCO. His sisters Lia Peterson and Jane Wlazlo are in charge of office work and the human resources department, respectively.

As is the case in many family businesses, Tom maintains some of the business policies passed down from his father. For instance, Harvey didn't believe in cutting prices to win customers. Instead, he felt that by offering more service and higher quality products, he could stand by his prices. The strategy worked, and CATCO has earned a roster of about 25,000 customers who are willing to pay more for the firm's outstanding service and quality goods. CATCO's efforts have also been recognized within the trucking industry, and the company was named "Truck Parts Distributor of the Year" in 2002 and 2004.

Tom has also followed in his father's footsteps in terms of acquisitions. CATCO opened new locations in the late 1990s in Owatonna and Willmar and acquired an existing business in Wisconsin Rapids, Wisconsin. In 2002 Tom spearheaded the company's biggest acquisition to date, purchasing a trailer parts company called American Stores. That business had location in St. Paul; West Fargo, North Dakota; Sioux Falls, South Dakota; and DePere, Wisconsin.

The American Stores acquisition put CATCO in the trailer parts business, opening up a whole new line of products to offer customers. Now with everything under one roof, CATCO can service a truck from the front bumper to the back. A customer can get a wheel seal, brake shoes, and landing legs all in one place.

The CATCO Parts and Services office in St. Paul, circa 2005.

To make sure customers and employees understand the vast array of products and services offered, CATCO invests a lot of time and money in training. Employees are encouraged to attend factory and management schools, clinics, and seminars. But CATCO's commitment to training goes beyond its own employees. The firm holds fourteen different training clinics throughout the year geared to customers. These informational classes are not designed to be sales sessions, but rather a way to educate customers about things such as air brake systems, automatic transmissions, driveline and interaxle differentials, steering and suspension systems, and hydraulic brake power systems.

With its commitment to providing solutions for its customers and an emphasis on acquisitions, CATCO is poised to continue its expansion well into the future. And even though the company's founder wasn't keen on the idea of growing his clutch and transmission business, one can only think that Arthur would be very proud of CATCO's current success.

CROW WING POWER

These days, Americans don't think twice about flipping a switch to turn on a light or pushing a button to power up a computer. In fact, electric power has become so commonplace that it may come as a surprise to learn that only sixty years ago more than 90 percent of the U.S. population didn't have electric power. Even though electricity has been offered commercially in the U.S. since the 1880s, it was reserved mainly for city dwellers and those wealthy enough to afford generators.

In the 1930s Franklin D. Roosevelt realized that the nation's goals of industrialization and modernization couldn't happen if the majority of citizens didn't have access to electric power. In an effort to bring communities up to speed, Roosevelt became a backer of a national rural electrification program that would provide loans to bring power to America's country sides. A bill authorizing the Rural Electrification Administration was passed in 1935 and signed by the president.

In spite of this, established for-profit power companies were reluctant to take on the task of providing electricity to rural areas because they thought they wouldn't see profits quickly enough. Eventually, rural residents grew tired of waiting for the existing power companies to get the job done. Instead, they banded together to form their own electric companies—cooperatives that were owned by their very own customers.

One of the first such companies was Crow Wing Cooperative Power and Light Company, the official name of what is now commonly known as Crow Wing Power.

In 1937 the first line crews worked with residents to bring power to the rural regions surrounding Brainerd, Minnesota.

Formed in 1937, Crow Wing Power was created to bring electricity to the rural areas of Cass, Crow Wing, and Morrison counties in north central Minnesota. Farmers, rural residents, and businesses joined together to build the power lines that would provide them with electricity. On March 24, 1938 power to 140 rural farmers was "turned on" for the first time.

Like other electric cooperatives around the country, Crow Wing Power was created as a nonprofit organization. As such, it would distribute refunds to customers if there were any surplus funds remaining once the costs of providing electricity had been met. The board of directors of Crow Wing Power is elected by customers/owners and establishes policies on how the cooperative operates. And as a company where the owners are also the customers, it placed its emphasis on customer satisfaction right from the start.

During its first year in existence, it provided service for about 700 customers. But since that time, the Brainerd Lakes area has grown tremendously. In fact, the community has been experiencing a growth rate that is twice the state's average. With the recent influx of baby boomers looking to retire in the desirable area, the number of customers has ballooned to 35,000.

To stay on top of that growth, Crow Wing Power has had

There was no electricity on farms in the rural areas surrounding Brainerd in the late 1930s. Farmers and area residents banded together, joined the cooperative, and helped bring electricity to about 200 families in the first year of operation. By 1960 the cooperative served 10,000 people, and over 35,000 by 2005.

to expand considerably, adding miles of additional power lines and increasing the number of employees. As of 2005 the cooperative boasted 4,465 miles of line—2,542 miles of overhead lines and 1,923 in underground lines. The rural electric company employs 100 full and part-time employees, including thirty-one linemen and sixty-nine inside customer service personnel.

The company's original headquarters was located in a small house located at 9th and Maple streets in Brainerd. It is currently housed in a large facility about four miles north of Brainerd, along State Highway 371. Crow Wing Power has been in the same facility for twenty-six years; however several expansions of the building have been necessary to accommodate growth in service and employees.

In order to continue offering service at the lowest possible electric rates, Crow Wing Power made the decision in the late 1980s to form other subsidiary businesses. In 1989 People's Security was the first ancillary business formed to bring security services to the businesses and residents of the region. This for-profit security company is now the leader in its industry in the region and helps the cooperative.

In 1999 Crow Wing Power became the first electric cooperative in the history of Minnesota to launch a credit union to

serve the financial needs of its members. The cooperative's second subsidiary, Crow Wing Power Credit Union, was named the fastest-growing credit union in the nation for compound growth between June 1999 and June 2004 by Callahan and Associates. By the end of 2004 Crow Wing Power Credit Union had almost 3,000 members, over $18 million in total assets, more than $17 million in deposits, and total loans of more than $15 million. Today the credit union is a full-service financial institution, offering some of the highest savings rates and lowest loan rates in the region.

In 2000 the cooperative began yet another business called Access Plus, L.L.C., which offers digital wireless phone service to residents in the region. That same year, in one of Crow Wing Power's board of directors' most significant and unique undertakings, it also took over majority control and ownership interest of Hunt Technologies, a local firm that specializes in automated meter reader devices.

The cooperative's relationship with Hunt Technologies began in 1994 when it was one of the first electric utility customers to purchase its automated meter reading devices, known as Turtles®. In 2000 Hunt Technologies was seeking help to stabilize the family-owned business with management assistance and financial backing. Crow Wing Power stepped in and offered management services and debt guarantees in exchange for majority control and ownership interest in the

Line crews work together with state-of-the-art equipment to maintain and build lines for 35,000 cooperative members.

Crow Wing Power moved to this facility in 1978 and has renovated it several times to accomodate growth and several subsidiary businesses, including People's Security, a T-Mobile dealership, and Crow Wing Power Credit Union.

company. Today Crow Wing Power is the majority owner of the company and key in the company's management and successful operations. Hunt Technologies uses innovative technology to deliver industry-leading automatic meter reading (AMR) solutions to the electric, water, and gas utilities market. Based in central Minnesota, within Crow Wing Power's service boundaries, Hunt develops and supports hardware and software for more than 450 customers worldwide.

Crow Wing Power has branched out in other ways as well. In a nod to energy alternatives, the cooperative began offering wind energy to its members as a renewable resource for electricity in 1999. In the first six years of operation, more than 500 cooperative members enrolled in the program. Each year more and more members opt into the wind energy program.

Coming up with innovative alternatives and creating subsidiary companies has kept the cooperative successful for decades. However, its future success also depends on its ability to keep up with the rapidly increasing demand for service. Each year the cooperative sees a growth in membership of over 1,200 new services. Because the population in the Brainerd Lakes area is growing so quickly, the cooperative is faced with providing continual upgrades and additions to its power line infrastructure.

Crow Wing Power isn't alone in this mission. Over the next fifteen years, the infrastructure of the entire state's power grid will have to be updated. The challenge for Crow Wing Power will be to finance the increased electric infrastructure and help its electric customers understand the need for increased power lines in their backyards.

Customer satisfaction has always been a top priority at Crow Wing Power. The year 2004 marked the third consecutive time that the American Consumer Satisfaction Index survey placed Crow Wing Power above all other non-cooperative utilities included in the national survey for customer satisfaction and loyalty.

Crow Wing Power's commitment to its customer/owners is equaled by its dedication to the community it serves. In 1996 the cooperative began a special program called Operation Round Up, which allows cooperative members to round up their monthly electric bill to the nearest whole dollar. The change amounts to about $200,000 a year and is donated to local charitable organizations, such as rural emergency medical responders, fire and social organizations.

With this kind of community involvement, its emphasis on customer service, and its ability to diversify into other businesses, it's no wonder that Crow Wing Power has remained successful for more than sixty years. And as the cooperative forges its way into the twenty-first century, it promises to continue living up to its philosophy of working for people—not for profit.

FAGEN, INC.

Business success depends on so many variables. Of course, quality products, top-notch service, and great employees are all requirements. However, intangibles like "timing" can also play a very important part in a company's success.

Ron Fagen's timing couldn't have been better when he launched Fagen, Inc., a heavy-industrial contracting firm, in 1988. Fagen was a firm believer that the ethanol industry was poised for rapid growth and chose to focus much of his efforts on seeking out customers in that arena. The contractor's hunch proved to be right on. The ethanol production in the U.S. ballooned from 845 million gallons that year to 2.81 billion gallons in 2003. Fagen Inc. has grown as well.

Right from the start, ethanol played a key role in the company's success. In fact, the firm took on the construction of an ethanol plant as its first project. Fagen

Ron Fagen, CEO.

built the facility for the Minnesota Corn Processors, who remained one of its main clients for years after that.

Although ethanol customers continue to make up a large percentage of the firm's roster, Fagen, Inc. also services several

other industries—power, mining, automobile manufacturing, pulp and paper, meat packing, water and wastewater treatment, utilities, metal, rubber, food processing, grain and seed handling, and natural gas compressor stations. Among its clients are Hyundai, Phillip Morris, Mercedes-Benz, BMW, and numerous Fortune 500 companies, as well as local and agricultural concerns.

Even though Fagen, Inc. is considered a heavy-hitter in the industry, it has its roots in the small, rural town of Granite Falls. A longtime resident of the town of 3,000, Fagen was determined to launch the business near his home. He first set up shop in an airplane hangar on Airport Road, which is now called Winter Street. As Fagen, Inc. expanded, its founder was forced to add on to that space several times. Eventually, the company outgrew the hangar and in 1996 it moved to its current headquarters on West Highway 212. The current facility includes 18,000 square feet of office space and a 120,000-square-foot warehouse.

When Fagen, Inc. first started out, ten people worked in the field and only two manned the office. Fagen's wife, Diane, was one of the original staff, and is today an officer of the company and an integral part of the family business. It was with this lean, but talented, crew that Fagen, Inc. tackled its first projects.

In 1989 the firm took on the Boise Cascades expansion project. It followed that up by building the first brass melt shop in the U.S. in twenty-five years for PMX Industries. In 1990 the Minnesota Corn Processors hired the company once again to build a wet mill in Nebraska, and then again in 1995 to complete two plant expansions.

With each of these major projects, Fagen, Inc. expanded its work force and its capabilities. To keep up with the growing workload, Fagen, Inc. opened two branch offices. One is in Nebraska and employs approximately 120 people, the other is in South Carolina where approximately

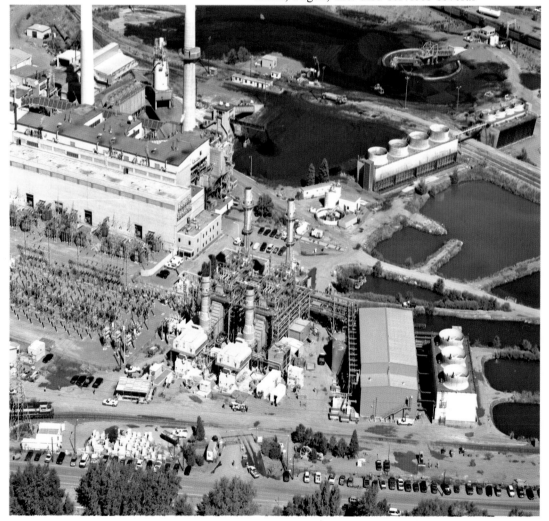

The Arapahoe Station combined cycle project in Denver, Colorado.

VeraSun Enengy, LLC in Aurora, South Dakota.

sixty workers are on the payroll. At the contracting company's headquarters, ninety-five people currently make up the corporate staff and anywhere from 600 to 1,200 workers are in the field, depending on the number of projects in progress.

At one point Fagen wasn't sure if he would be able to convince highly skilled workers to leave their jobs in metropoli-

Fagen's home office in Granite Falls, Minnesota.

tan areas to come and work and live in rural Granite Falls. However, Fagen's worries proved to be unfounded. The firm has consistently attracted an excellent staff to its small-town headquarters, including Fagen's two sons Aaron and Evan.

While growing up, the boys spent summers helping out at the family busi-

ness and eventually joined the firm full-time after college. Aaron is currently chief operating officer, and Evan is a project manager. Fagen is counting on them to carry on the company's mission long after he and his wife retire—which they say won't be any time soon.

Thanks to its first-rate staff and its broad range of services, Fagen, Inc. has earned a reputation as a contractor that can do it all. Positioned as a design-build firm, the company specializes in taking a project all the way from design to the operational phase. In order to provide all the necessary services to complete a project, the firm often partners with other companies. And to ensure customer satisfaction, Fagen makes sure that each and every project crosses the finish line on time, within budget, and with the highest quality craftsmanship possible.

The firm's commitment to seeing a project through from beginning to end has warranted accolades in the industry. For several years Fagen, Inc. has been ranked as one of the top 400 contractors by a top industry magazine. In a single year, its ranking jumped from number 371 to number 126. Better yet, among chemical contractors in the U.S., Fagen, Inc. is ranked number three.

For Fagen, awards aren't the only way he measures his success. Making his clients successful is the true barometer of his achievement. His commitment to them is equaled by his concern for the local community, the agricultural sector, and society at large. That's yet another reason why he has been so adamant about focusing on ethanol. The renewable energy source is very important, not only for his business, but also for the agricultural sector as well as the entire country.

Since the business is based in a rural area, Fagen is determined to do whatever he can to help neighboring farmers find ways to be successful. He is proud to see the benefits of this energy source paying off in his own hometown of Granite Falls, which is also the site of a Fagen built ethanol plant. However, his commitment to renewable energy sources goes beyond the ethanol industry. He is also pursuing wind as an energy source, and is a partial owner of a firm that erects wind turbines. Fagen hopes that by focusing on alternative energy sources, the company, its customers, and society as a whole will reap the benefits.

GRACO INC.

Once a family-owned business, Graco Inc. has become one of the world's premier manufacturers of fluid handling equipment and systems. The applications for its products and technology seem endless. For instance, Graco equipment is used by metal, wood, and plastic manufacturers to pump, proportion, and spray paint coatings on a wide variety of products from furniture, appliances, automobiles, and aircrafts to bridges, water storage tanks, and super tankers. In other markets, Graco pumps tomato paste onto frozen pizzas, meters and dispenses oil and lubricating fluids into millions of vehicles, sprays texture coatings and paint on residential and commercial buildings, and uses its sealant and adhesive equipment to bond parts that are used to assemble aircraft and cars.

By successful expansion into a number of applications, Graco's growth in recent years has been remarkable. Since 1993 Graco has grown its sales by over 65 percent and its net earnings by more than 800 percent.

All of this seems a long journey from a winter's day in Minneapolis in 1926. It was then that parking lot attendant and Graco co-founder Russell Gray figured there had to be a better way to lubricate cars than by using hand-operated grease guns—especially when the temperature dropped below zero and grease was difficult to move.

So, Russell developed a grease gun powered by air pressure. Favorable reac-

tion from service station owners and a growing automobile market led him and his brother, Leil, to form the Gray Company, Inc., which built and sold the innovative grease gun. The company generated sales of $35,000 during its first year of operation.

During the next two decades the brothers guided the company through sustained growth, primarily with lubrication equipment for automobiles. Russell was the inventive force behind the firm, while Leil, as the company's first president, provided the business acumen.

By the start of World War II Gray Company was doing $1 million in sales. The firm responded to the new demands and opportunities presented by America's rapid defense buildup with a variety of new lubricating products. When the war ended, Graco realized it could apply its fluid handling expertise to other areas beyond automotive servicing.

In 1948 the company found another foothold with its first paint pump, and a year later introduced a direct-from-the-drum pump for heavy-duty industrial fluids. By the mid-1950s the Gray Company was expanding into paint spraying and finishing, food handling, cleaning, and literally hundreds of different industrial fluid-handling applications. Sales rose to $5 million and the work force grew to 400.

With the development of the airless spray gun in 1957, which made Gray Company the market leader in spray finishing, the Graco of today began to take shape.

Graco's original plant was located at 10th and Marquette in Minneapolis.

Leil L. Gray (top, center) and Russell J. Gray (left) founded the Gray Company in 1926.

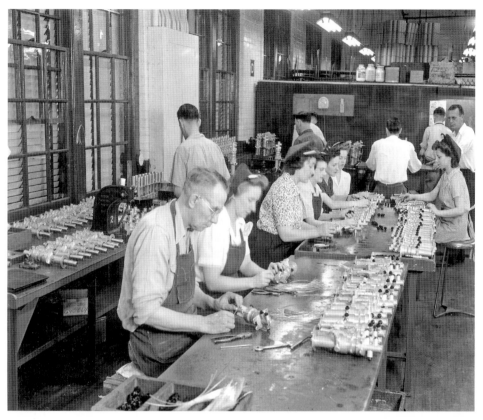

Harry A. Murphy, Leil Gray's successor, served from 1958 to 1962; upon his retirement, David A. Koch assumed leadership of the company. Koch set out to strengthen the firm's commitment to its constituencies —which he believed included the community, as well as customers and employees— by aggressively expanding the corporation.

When the Gray Company went public in 1969 and changed its name to Graco Inc., sales had reached $33 million.

Graco reached the $50 million mark in sales two years later, less than fifty years after the sale of its first grease gun. By the end of the 1970s sales doubled to $100 million. Important strategic deci-

sions were made that led to the growth, including the acquisition of an electrostatic painting equipment manufacturer that dramatically boosted Graco's position in the industrial and automotive finishing marketplace.

The remaining two decades of the twentieth century saw continued growth. Graco increased its funding in research and development, which resulted in more products introduced than any other period of the company's history. Acquisitions were made to expand its markets, and the company invested in new manufacturing facilities and equipment to keep pace with increasing production and quality demands. Today Graco has a presence throughout the world, including factories in Minneapolis and Rogers, Minnesota; Sioux Falls, South Dakota; a European

During World War II, Gray Company was designated as a U.S. Defense Plant. Its primary product was the Convoy Luber, a field lubrication unit that serviced motorized military vehicles such as jeeps, trucks, bulldozers, tanks, and aircraft.

Graco's Industrial/Automotive Equipment Division designs and manufactures equipment to pump, proportion, and spray a variety of coatings to finish wood, metal, and plastic products.

GROSSMAN CHEVROLET

The automobile ranks as one of America's best success stories. The beloved car has also changes the lives of thousands of business owners associated with the industry. One such company is Grossman Chevrolet Cadillac in Burnsville.

Its history dates back three generations to 1919 when L.S. Grossman launched his own car dealership after a year of selling cars for another dealer. Starting a car dealership in those days was a very dubious endeavor. But L.S. was a natural risk taker and didn't shy away from the chancy venture.

With the new business, he was taking a big gamble that the popularity of the automobile would skyrocket. Indeed, it did. In just one year from 1918 to 1919, the number of passenger cars in the U.S. doubled to 1,651,625. In those days the average cost of a new car was $826 and still considered a luxury since the average income was only $1,125 per year.

Grossman's Lake Street location, circa 1940.

The Lake Street showfloor in 1949.

Because of this, dealers at the time didn't have vast car lots like they do today. Instead, businessmen like L.S., who had a tiny lot at 1304 East Lake Street, would buy one car from the manufacturer and sell it before purchasing another vehicle.

Just as L.S. predicted, the automobile caught on in popularity and quickly became a necessity rather than simply a luxury item. His business expanded with the market, and he soon had cars lined up bumper to bumper on the lot. By the end of World War II there were so many car dealerships on East Lake Street that people called it "Automobile Row."

L.S. continued to take risks with the enterprise and was always at the forefront of the industry. By the 1950s his efforts had paid off handsomely, and Grossman Chevrolet had grown into one of the largest dealerships in the Midwest. It was about this time that L.S.'s son, Harold, joined his father in the booming business. While growing up, Harold had spent summers helping out at the dealership so it was no surprise when he signed on full-time. Harold's brother, Burton, also came on board as an employee at the dealership—making it a true family business.

By 1967 when L.S. decided to retire, he had built the company up to about 200 employees. Harold stepped up to buy the dealership from him, and Burton opted to move on to other endeavors at that time. To fill that void, Harold brought in his son Mike to become an integral part of the team.

Under L.S.'s watch, Grossman Chevrolet had experienced nearly five decades of growth, but hard times were on the horizon. An economic downslide in the 1970s resulted in fuel shortages and high interest rates, which put the brakes on car sales. Although Harold had learned the ropes from his father, his business philosophy couldn't have been more different. While L.S. thrived on taking risks and expanding the company, his son favored a different approach which

allowed the business to stay open during this difficult time.

Even as sales sputtered, Harold always vowed to "do the right thing" for customers and employees—regardless of the bottom line. His belief was that if you did the right thing, the economics would work out on its own. That philosophy created some very loyal customers and some equally loyal employees.

Several members of the dealership's staff logged twenty, thirty, or forty years of service for the company. One gentleman even spent more than fifty years on the payroll. Many of those employees have since retired, but they've been replaced by a new guard of equally loyal workers who have already been on staff for twenty to twenty-five years.

When Mike came on board full-time at the age of twenty-six in 1967, he was no newcomer to the business. As a young lad he had sold used cars in the summertime, and as a teenager he had worked in the service department. His first full-time position was in sales management.

Initially, Mike was mentored by one of the dealership's most experienced managers and soaked up as much information as he could. But his education was cut short when his tutor suffered a heart attack in 1968 and was unable to continue working. The tragedy forced Mike into the role of general manager, despite his limited experience. It proved to be a trial by fire for Mike, who was forced to learn on the job.

From the get-go, Mike and Harold were at odds when it came to running the business. Like his grandfather, Mike was a natural risk-taker and felt confined by his father's conservative approach. When the car industry took a nosedive in the 1970s, Mike came up with a dicey plan to keep the company on the upswing. His strategy was to buy dealerships that were in decline, build them back up, and then sell them for a profit. When Mike first approached his father with the plan, Harold was dead-set against it. With persistence, Mike was finally able to convince him to give it a try.

In 1974 Grossman Chevrolet acquired a slumping Chrysler Dealership. Mike sent one of his own managers to the new location to breathe life into it. The plan worked, and Mike sold the revived dealership to the former manager at a profit. When he showed Harold the check from the sale, Harold became a firm believer in Mike's plan.

The strategy not only bolstered the coffers of Grossman Chevrolet, but it also provided a golden opportunity for one of his employees to take a leap and become a business owner. That proved to be even more gratifying for Mike than making a profit on the sale. Following that success, Mike began searching for other dealerships to acquire and began grooming other managers within the ranks, with the hopes of giving them a shot at business ownership.

Mike's practice of rewarding workers who showed promise began long before he joined the family car business. In his former position as a wholesale parts jobber, Mike was always on the lookout for talented employees. When he spotted

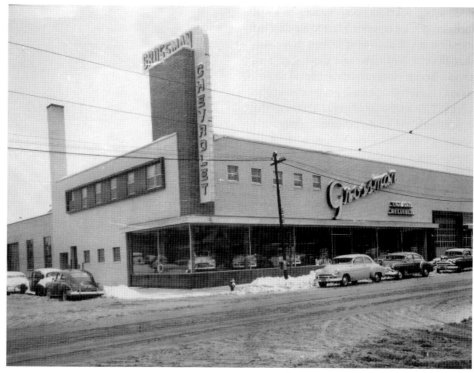

someone who stood out, he advanced them to the next level. That belief in employees and the willingness to let workers develop to the best of their potential paid off for everyone involved. It's no wonder Mike continued with the same policy at Grossman Chevrolet.

Following that first success with the acquisition, Mike continued to foster en-

The remodeled Lake Street location.

trepreneurship among his top employees. Grossman Chevrolet bought four additional dealerships and sold three of them to their former managers, at a profit.

As the dealership continued to hold up under the economic downturn, the

The remodeled Burnsville building, circa 2005.

need arose for additional space. In 1978 Grossman Chevrolet moved to its current location on West 141st Street. It's there that 600 to 700 new and used cars and trucks and a state-of-the art service and parts facility sprawl across sixteen acres. The ultra-modern site sits at the crossroads of two important interstate freeways for the Twin Cities area, making access a snap.

Two years after the historic move from their humble beginnings on East Lake Street, Mike took over the day-to-day operations of the business. After spending his entire career with the dealership, Harold walked away from it in 1990 when Mike bought it from him outright. Even though Harold no longer held an official role at the company, Mike still liked to run ideas by his father.

In 1994 Mike introduced a policy that Harold thought was sheer folly. Mike went against the grain of most other dealerships in the industry and set a "One Best Price for Everyone" policy, which means no haggling or negotiating. He also put the salespeople on salary with commissions, based not only on sales volume but also on customer satisfaction.

His reasoning behind the move harkened back to the "do the right thing" message he had learned from Harold. Over the years, Mike had noticed other

Burnsville showfloor, circa 2005.

dealerships increasingly engaging in practices that seemed unfair to consumers, and he wanted no part of it. As a reaction to that unseemly trend in the industry, Mike initiated the one-price policy as a way to keep everything above board.

Mike figured that there was no way customers could be as adept at negotiating a car sale when they only do it once every three to five years—and his salespeople were negotiating car sales on a daily basis. In addition, he felt the salespeople would be more inclined to "do the right thing" if their bonuses were reliant on customer satisfaction instead of solely being based on sales numbers. The radical notion worked and Grossman Chevrolet has emerged

once again as a leader in the area. In fact, Mike's willingness to take risks and go against the grain has increased the value of the business tremendously.

Although he has introduced some policies that didn't fit in with his father's business philosophy, Mike continues to follow many of the basic tenets Harold and L.S. shared. The company's longtime motto of "Bargains, Service, Integrity" hangs on a sign in Mike's office, and he has vowed never to stray from those mainstays. He is committed to offering the best prices to customers, providing the best service after the sale, and maintaining his integrity.

To that end, Mike has made a conscious choice to make all the company's advertising very straightforward. He feels that some firms are more interested in selling the "sizzle" rather than the steak, but Mike prefers to tell it like it is. Sometimes he has opted to shun advertising in favor of community involvement as a way to spread the word about the dealership. For example, the business has sponsored several basketball clinics for local youth.

After more than eighty years in the area, the company has earned a solid reputation for fairness and service. That has helped the dealership reach sales figures that L.S. could never have imagined. These days, the firm sells approximately 3,000 new and used cars, trucks, and SUVs each year. And Mike continues to find innovative ways to move the business into the next gear. In 2005 the company added Cadillac to its line of vehicles and officially became Grossman Chevrolet Cadillac. And although the firm has had a history of making acquisitions and then selling them off, Mike swears this one is here to stay.

As the auto industry continues to evolve, there's no doubt that the Grossman operation will maintain its place as a leader. The road ahead promises twists and turns, but years of experience and a willingness to try new things will help the company edge out the competition. And that's a true American success story.

The Burnsville used car facility, which was built in 1999.

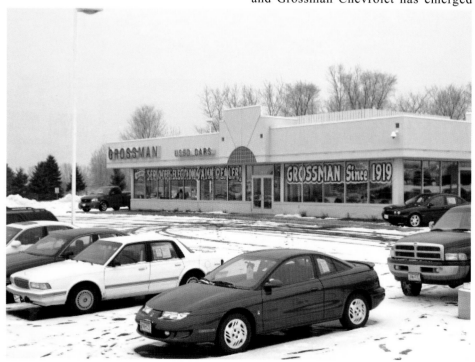

Winter's moods on Lake Superior range from capricious brutality to seductive beauty. Photo by R. Hamilton Smith

GROWING HOME

Growing Home is a social service agency which helps children, teens, and young adults with intense physical, mental, and/or emotional issues achieve independent living skills. Its services are accredited by the Council on Accreditation for Children & Family Services, Inc. Physically located at 450 N. Syndicate Street in Saint Paul, Growing Home actually exists in foster care homes across Minnesota—and in the hearts of the families who participate in its programs.

A quarter of a century ago, three good friends, who were also social service professionals, had a desire to help children at great risk. The children they wanted to help were not just ones who needed homes; they were physically and emotionally challenged children who needed special attention and care. These men, Burt Galaway, Joe Hudson, and John McLagan, decided to apply the foster care model to kids with special needs. In 1979 they formed the company which is now known as Growing Home.

The idea of placing SED (severely emotionally disturbed) children with foster families was a radical change from what was considered the norm for SED kids, at that time. Usually children with these types of issues were placed in group homes, residential centers, or other non-family settings. But the founders of Growing Home helped pioneer the theory that a family environment would better

Morgan Frazeur receives the Cliff Fox Award from Cliff's son, Jerry, as Growing Home's CEO Ghazi Akailvi looks on.

S. Ghazi Akailvi, Growing Home's president/CEO.

serve the emotional needs of the children and help them learn independent skills more quickly.

Over the years, the leadership has changed, but the mission of Growing Home has remained the same. It is to help children, youth, and families who are at risk of institutionalization or homelessness to realize their potential and contribute to their community. The social workers and youth care professionals at Growing Home face this foreboding challenge in a unique way. They apply a strength-based approach. Growing

Home's programs help identify and build upon a child's strengths. "A kid with severe issues is sometimes considered to be a basket of problems—a collection of negatives. But our agency takes a look at the whole thing, philosophically," says Ghazi Akailvi, president and CEO of the Minnesota-based agency. "We realize kids may have deficits, but they also have huge assets. A kid who burns a chair might also be a good artist," he adds.

To implement this more positive approach, the youth care specialists at Growing Home devised and honed an assessment tool called 4-D. It asks questions and sets goals to encourage a child's growth in the areas of knowing, belonging, becoming, and giving. There are several programs which aid in this development: treatment foster care, residential treatment alternatives, whole family placement, and Growing Home's most recent accomplishment, Seventh Landing; a unique supportive housing solution for young homeless adults transitioning out of foster care or other parts of the child welfare system.

Children and youth referred to Growing Home's Treatment Foster Care (TFC) program are placed with specially-trained care providers who work closely with a social worker to assure youth are able to achieve success in the program. Once the 4-D assessment is made, the social worker works with the youth and the care provider to develop an appropriate care plan. The hope is to provide a placement that allows the youth to develop a sense of belonging to family and society. From this safe place, the child is able to identify ways in which he or she can ultimately give back to the local community.

Growing Home's Residential Treatment Alternatives (RTA) services are for profoundly troubled children and youth, ages four to eighteen, who are in need of an alternative to residential treatment. Among other things, these children struggle with aggression toward self or others, suicide attempts, severe impulsivity, and/or severe family trauma. The goal of this program is for the youth to leave the initial placement for a less-restrictive environment, either returning to their family of origin, an adoptive home, or transitioning out of foster care completely.

The Whole Family Placement (WFP) program serves the entire family. Parents

Seventh Landing, Growing Home's supportive housing base.

entering this program may have a lack of ability, knowledge, or skills in how to meet their children's needs. They may struggle with homelessness, dependency, unemployment, or other issues equally as pressing. The Growing Home team of specialists helps these parents assess what is in the best interest of the child. Growing Home care providers give intensive hands-on training and mentoring for parents to help them cope with these issues. The goal of this program is to stabilize and train families so they can leave the foster household with sufficient skills to function independently as healthy families.

Growing Home's latest service offering, Seventh Landing, serves young adults, ages eighteen to twenty-two, who

have become homeless after exiting the child welfare system. It is a permanent, sober, supportive housing complex with twelve efficiency apartments, laundry, library/computer room, community space, and a support service office. It is not a temporary transitional program, group home, or shelter. Tenants sign standard one year lease agreements and may stay as long as they meet the expectations of their lease. One tenant, "Marnee," had been in foster care programs since she was twelve years old. When Marnee left the foster care system, she faced homelessness and had no means of employment. Now, at age twenty, Marnee is home at Seventh Landing with plans to attend college in the fall. The Seventh Landing program has earned rave reviews from supportive housing experts.

"Morgan" is another success story of Growing Home. In 2004 he was given the "Cliff Fox Award," named for a passionate advocate and champion of dis-

advantaged youth who was a former member of Growing Home's board of directors. The award is an honor bestowed, annually, to a foster care child who has truly met his potential.

Morgan first came into the foster care program when he was about ten years old. He came from a neglected home and was very troubled when he first joined his foster care family. But soon, Morgan belonged. He was involved in theatre in school; eventually he graduated, and then joined the United States Army. In August 2004, Morgan came by for a special ceremony and presentation from Growing Home. He is now serving his country in Iraq.

When "Kayla," a fifteen-year-old in Growing Home's foster care program, was asked "what is a home," she answered, "A home is somewhere a child is loved and loves back. A home is where a child can feel safe from all of the badness in the world." "Dallas," twelve, was asked the same question. His answer? "A home is a mom that loves you, feeds you good, and helps you do right."

These exceptional foster care families open their homes and lives to partner with Growing Home. Each child is encouraged to develop a sense of belonging to family and community. The ultimate goal is that she or he will be able to enhance the community in which they live. Growing Home has been striving for, and attaining, that goal for nearly three decades.

Lynda Meador, Growing Home's vice president.

HEALTHPARTNERS/REGIONS HOSPITAL

HealthPartners is a consumer-governed, nonprofit family of healthcare organizations whose mission is to improve the health of its members, patients, and the community. As Minnesota's only integrated healthcare organization, it provides healthcare, health improvement programs, and healthcare financing to more than 630,000 members.

HealthPartners has a long history of innovation. The company originated as Group Health Mutual, a cooperative formed in 1938. The goal was to help families budget in advance for medical care so they could afford to seek medical help when they needed it—not as a last resort.

In 1957 Group Health Mutual became Group Health Plan, a nonprofit provider of prepaid health care. It was the first organization in Minnesota, and among the first in the nation, to combine care delivery and financing. That same year Group Health opened its first medical clinic on Como Avenue in St. Paul. The clinic is still in operation today as HealthPartners Como Clinic, one of fifty-two HealthPartners Clinics that provide medical and dental care in the Twin Cities.

Group Health Plan continued to evolve to better meet the needs of the market and its members, and to achieve its mission. In 1992 Group Health merged with Med-

In 1957 Group Health Plan broke ground on its first clinic on Como Avenue in St. Paul. Today (see inset) that clinic serves patients as HealthPartners' Como Clinic.

Centers Health Plan to create HealthPartners. HealthPartners' ability to align care and health with financing and coverage has produced measurably better results for the community. HealthPartners ranks among the best in the nation in prenatal care, depression treatment, beta blocker treatment after heart attacks, and breast and cervical cancer screening. It's also the highest-rated health plan in the state.

In April 2002 Health-Partners embraced a system-wide program to improve the way it delivers health care and service. Backed by a $1.9 million grant from the Robert Wood Johnson Foundation and the Institute for Healthcare Improvement, the effort—known as Pursuing Perfection—set out to transform care systems to ensure that healthcare was safe, effective, patient-centered, timely, efficient, and equitable.

HealthPartners has launched many new products and services to improve patient care. Among other things, these innovations include electronic medical records in all HealthPartners Clinics, medication interac-

HealthPartners' corporate headquarters is in Bloomington, but it has clinics in locations throughtout the metro area and members nationwide.

tion alerts, and the ability for care providers to share real-time information with their patients and provide them with a printed report that includes personalized care directions. HealthPartners Clinics were also the first in the metro area to offer online appointment scheduling for their patients.

The HealthPartners Frequent Fitness Program, launched in January of 2004, encourages members to stay active. Those who join a participating health club receive a reduced rate on monthly dues if they work out at least eight times a month.

HealthPartners has also teamed with Metropolitan State University to build the country's first comprehensive Patient Simulation Center for Patient Safety. This facility uses state-of-the-art tools, including a lifelike patient simulator, virtual endoscopy, and a simulated emergency room to help caregivers learn new and better ways to care for their patients.

HealthPartners is proud to continue its long tradition of improving the health of its members, patients, and the community. It encourages healthy lifestyles and provides innovative care and financing, both in Minnesota and across the country.

Regions Hospital, part of the HealthPartners family of care, is a leading full-service, private facility that first began serving the St. Paul community more than 130 years ago.

Regions Hospital is a proud part of the HealthPartners family of care, and shares its mission to improve the health of the community—from encouraging healthy lifestyles to treating the most serious injuries. Regions Hospital is a leading full-service, private facility that first began serving the St. Paul community in the late 1800s.

Since 1993 Regions Hospital has proudly served as the only Level I adult and pediatric trauma center for the east metro and western Wisconsin areas. This excellence in treating traumatic injuries grows out of a supporting repertoire of specialties and services, as well as a solid infrastructure of people, facilities, and equipment to support quality healthcare.

Regions Hospital has one of the largest multi-specialty medical staffs in the region with more than 900 physicians in thirty-five specialties, including cardiology, oncology, breast health, surgery, burn, trauma, behavioral health, geriatrics, and more. Physicians receive the support of the hospital's dedicated medical professionals and enjoy access to the latest equipment and facilities for diagnosing and treating patients.

In addition to meeting the American College of Surgeon's rigorous standards as a regional Level I trauma and burn center, Regions Hospital is proud to have several other accreditations and recognitions, including those of the Joint Commission on Accreditation of Healthcare Organizations (JCAHO), the Commission on Accreditation of Rehabilitation Facilities (CARF), and the American Burn Association (ABA).

Regions Hospital, formerly St. Paul Ramsey Medical Center, joined the HealthPartners family of care in 1993 and adopted its new name in 1997. The HealthPartners enterprise, including Regions Hospital, employs more than 9,000 employees. That makes it the ninth largest employer in the state and the second largest employer in St. Paul.

Regions Hospital has completed more than $70 million worth of building expansion and renovation since 1999, supporting the community's growing need for high-tech, high-touch healthcare. Regions Hospital is proud of its new heart, digestive care, surgery, breast health, and cancer centers, as well as its high-tech Surgical Intensive Care Unit. In the hospital's new and remodeled space, patients and visitors enjoy stress-reducing color schemes, noise-minimizing features, increased privacy, and a three-story atrium with windows overlooking a landscaped garden created with stones and plants that are native to Minnesota.

Regions Hospital and HealthPartners are active members of the St. Paul community. Recently they joined with Randy Kelly, St. Paul's mayor, to challenge the city's residents to walk 10,000 steps a day for better health. They also maintain a presence at St. Paul's newest attraction, the Xcel Energy Center, by providing on-site medical direction during Minnesota Wild hockey games and other events in Regions Hospital health stations.

Regions Hospital not only focuses on the health of it patients today, it also keeps an eye to the future by actively training the next generation of physicians and medical staff. As a teaching hospital, Regions Hospital attracts residents from around the world for valuable training in an urban tertiary care center. The HealthPartners Institute for Medical Education supports residents' training and also provides continuing education for healthcare providers throughout the HealthPartners family.

Regions Hospital and HealthPartners are on a mission to improve the health of the community. They are dedicated to encouraging healthy lifestyles and providing all levels of care—when and where the community needs it.

A group of charitable women presented the hospital with its first ambulance in 1895, and an anonymous donor purchased two horses to pull it.

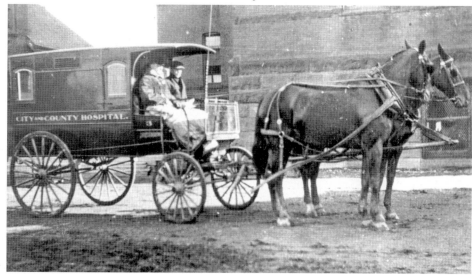

HENRY'S FOODS, INC.

In 2004 Henry's Foods Inc. celebrated its 75th year in business, a milestone that earns it the distinction of being a true American success story. When the company began in 1929, Henry Eidsvold was employed as a salesman for the Armour Creamery Company of Minneapolis. One day, a candy maker asked Henry to fill his Cole Eight touring car with candy bars and try to sell them while he was on his creamery sales route. Henry agreed and found that he enjoyed selling; he thought it was easy and fun. That marked the debut of what would eventually become Henry's Foods. That candy maker went on to become the largest candy manufacturer in North America—known today as the M&M Mars/Master Foods Company.

After a few more successful selling trips, Henry quit his job at the Armour Creamery Company and ventured out on his own with a candy and tobacco products distributing business. He set up shop in the basement of his home in Minneapolis and called the new enterprise Henry's Candy Company.

From the very beginning Henry's Candy Company was a family endeavor. While Henry focused on sales, his wife Maude checked in the freight and managed the basement warehouse. Their daughter Mildred kept the books until her untimely death in 1934. Their sons Harold and Lyman joined the family business on a full-time basis in the 1930s, after they finished their college educations.

The family sold candy bars and cigarettes mainly to grocery stores, drug stores, and pool halls. They were so suc-

Founder Henry Eidsvold (center), with his sons Harold (left) and Lyman (right), in the 1940s.

cessful that by the fall of 1929 Henry's Candy Company had outgrown its original basement location. Henry moved the business to Morris, located in west central Minnesota. The candy distributor chose this rural community because it was part of his previous creamery route and because two major railroads and a Minnesota Highway Department headquarters office were located there. The Eidsvolds selected the old LeGrande Hotel building on Pacific Avenue as their new place of business.

The venture continued to expand in large part thanks to Henry's outstanding salesmanship. Over the years, he developed strong relationships with his customers. He enjoyed talking to them not only about the candy bars he was selling, but also about their businesses and families. Henry always thought of his customers as business partners and felt it was his job to

help them improve their bottom line by providing the best quality products and service. This philosophy paid off, and by 1933 trucks had replaced the touring car and a second sales route had been added to the original one. To help handle the increase in business, Henry hired a salesman—the company's first non-family member.

In 1940 Henry's constructed its first new building on the corner of Pacific Avenue and 7th Street, where the company remained for thirty-four years. However, challenging times were on the horizon. During World War II sugar was rationed and chocolate was difficult to import, but Henry's showed remarkable resourceful-

Henry's fleet of trucks in the 1940s.

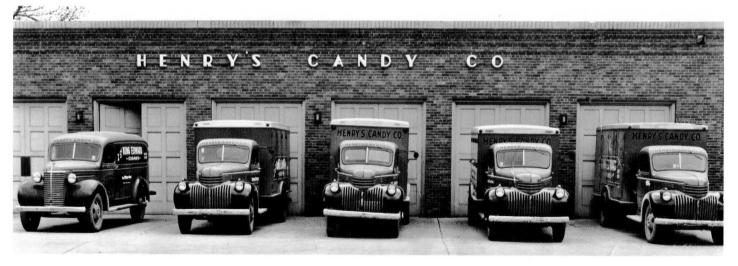

Seventy-fifth anniversary employee picnic.

ness. When sweetener proved hard to come by, they gathered corn from around the area, shipped it to the Mars factory in Chicago and had it processed into corn syrup. Henry's sold corn syrup-sweetened candy bars as fast as they were produced. Also keeping sales on the upswing during the war were other products that had been added to the distributor's mix, including oleo, mints, marmalade, and assorted novelties.

Following World War II chocolate became more readily available, and Americans devoured nickel and dime candy bars in record numbers. Henry's responded to the increased consumption by adding satellite warehouses in Wilmar, Montevideo, and Alexandria.

In 1974 the business moved to a new 25,000-square-foot building located at Green River Road in Morris, Minnesota. This site served as Henry's headquarters for sixteen years. In 1990 the company made its largest of many acquisitions when it purchased the grocery wholesaler Ludke & Company. Henry's then moved into that firm's offices and warehouse in Alexandria, Minnesota, where the company remains today. That same year the business changed its name from Henry's Candy Company to Henry's Foods, Inc.

Since 1990 Henry's headquarters has undergone three major expansion projects. Thirty-thousand square feet of dry storage was built in 1993, and over half a million cubic feet of freezer storage was

added in 1998. Two years later another 30,000 square feet of dry storage was completed. The business that humbly started out in a basement warehouse now spans 155,000 square feet of warehouse and office space, including 600,000 cubic feet of freezer space.

In addition to increasing the size of its headquarters, Henry's Foods has also expanded its product lines. The company that began by distributing a few candy bars out of a touring car now distributes more than 13,000 items, including a full line of food service, paper products, and wholesale groceries. Henry's Foods has also developed their own concept lines, including DeliMAX (a pizza, sub, and salad line), Java Classics (an upscale, gourmet coffee and cappuccino program), and Teco's Tacos (a mexican food line).

The company has also made a name for itself by staying on top of new technology. The firm's website allows customers to fully manage their accounts online, place orders, view promotions,

and more. A Voxware paperless picking system was installed in 2001, which greatly helped the company improve overall efficiency.

Today Henry's Foods is a distributing member of Pocahontas Foods USA/Progressive Group Alliance, a nationally recognized food service purchasing and marketing group. Henry's services convenience stores, grocery stores, restaurants, taverns, and other food service and retail outlets. Its territories include four-fifths of Minnesota, from the Canadian to the Iowa borders, including the Twin Cities metro area and the eastern halves of North and South Dakota.

In addition to products and distribution, the company's growth is also reflected in its personnel—which has grown from a single salesman to a staff of more than 160 people. However, in spite of the large number of employees, Henry's Foods remains a family-owned, family-operated, and family-oriented business. In 1963 Harold's son Tom joined the family business, and in 1970 Lyman's son Jim came on board. In 1992 Tom's son Brian entered the business.

The Eidsvolds who lead Henry's Foods today share the same passion and excitement for running the business that its founder exhibited back in 1929. Like Henry, they champion the independent business owner and consider their customers to be partners. As the business environment continues to change, the Eidsvolds display the same resourcefulness and creative thinking that Henry possessed. With seventy-five years of success behind them, Henry's Foods continues to be a Minnesota institution.

One of the thirty-five semi trucks that comprises Henry's current fleet.

JONES-HARRISON RESIDENCE

Visitors to Jones-Harrison Residence in its earliest days may have found its inhabitants collecting eggs in the hen house. Evening would have seen these same residents writing letters, working patches for quilting, or reading *Harper's* or the *Ladies Home Journal* by oil lamp. Folklore has it that early female residents, assured of a secure home in their old age, needed only to provide management with "$300 and a black dress to be buried in." What is certain is that since its inception this facility has proven to be visionary in providing a world of services to older adults.

Known in 1888 as Jones-Harrison Home for the Aged, it was founded through the generosity of its two original benefactors, Judge E. S. Jones and Mrs. William (Jane) Harrison. Both were area philanthropists. Jane Harrison, who had been active in the Woman's Christian Association, left a bequest in her will to be used for a home for the aged—"a new haven offering care for older adults." Judge Jones provided the land which included eighty acres on Cedar Lake, a few miles south of downtown Minneapolis and fifteen miles from Saint Paul. The "Octagon House," a four story concrete

Jones-Harrison Residence's cupola in the west courtyard. Photo by Eric Melzer

octagon encircled by porches, served as the home's first residence, along with "The Cottage," a comfortable farmhouse. A barn, chicken house, and an icehouse completed the grounds, which were heavily timbered.

In August 1890 Jones-Harrison admitted its first disabled ministers and their wives, who were housed at the farmhouse. Elderly ladies had been in residence in the Octagon House since its doors opened to them in 1888. In the days before indoor furnaces, the boarding home in Minneapolis served as a residence to the ladies during the winter months. The home's first board meeting was also held there, as horse-drawn buggies could not navigate winter roads to Cedar Lake.

Early residents lived well. Board minutes from the early 1900s note that "Gardens have been a real luxury with corn, melons, squash, beets, cabbage, turnips, rutabaga, asparagus, strawberries, and potatoes." A maid added local honey to the table when she started bee keeping in 1915. The Cedar Lake Company acquired ice from Cedar Lake, which in turn supplied ice to most of Minneapolis' citizens.

The early years were not without drama. Stolen chickens and even a little cattle rustling had one matron asking for a "Private" sign, a dog, and a gun to protect the property. The sign was provided. An early resident summed up the home's mission in a letter noting that "the future looks bright and cheerful for me in the security of such a pleasant home."

By the time its buildings were wired for electricity in 1911, the Jones-Harrison Home counted twenty-eight residents under its roofs. The year 1923 marked the first year that single men were invited as residents. A Minneapolis paper noted that the matron "would have her hands full with all the flirtations going on."

Residents sewed for the war relief effort during World War I, knitting "wristlets" for the French Relief and the Red Cross. Their efforts were partly rewarded during the home's Sunday chicken dinners, con-

Residents of Jones-Harrison Home in Minneapolis, circa 1925. Courtesy, Minnesota Historical Society

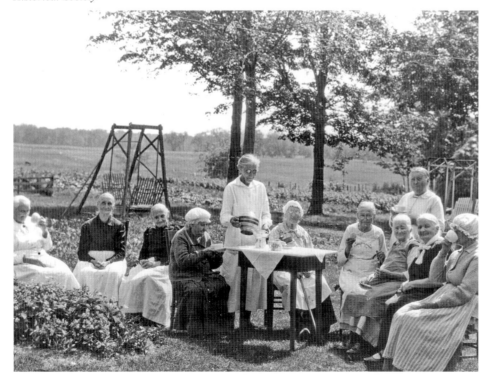

sidered so special that residents would not accept invitations out on those days. The farm continued to supply fresh fruit and vegetables, cream, eggs, and chickens to the table. Board minutes note that one hen, unable to adjust to modern times in the form of a new incubator, spread her wings over a litter of newborn kittens. In the days of World War II, the ladies gathered clothes for the Russians, with the needlework guild supplying quilts to the Red Cross.

On July 12, 1978 Jones-Harrison celebrated its 100th birthday with an outdoor buffet supper. One of the residents noted that "I will always include living at Jones-Harrison as one of my blessings." A cornerstone box, unearthed after the razing of Benton Hall, was opened to reveal mementos from early in the century—silver dollars, a Bible, newspapers, and a flag. The cupola from Benton Hall, saved from the wrecking ball, serves today as a gazebo and as Jones-Harrison's logo, a warm reminder of the graciousness of the home's early days.

Secretaries' notes from the home's first decade capture the impetus behind Jones-Harrison's founding. One report

Lindsay Lounge in Jones-Harrison Residence. Photo by Eric Melzer

noted that, after their early success at providing security to many, "The hearts of the board members still yearned to find all the discouraged old ladies and homesick ones, those tired of the slights so often heaped upon them, tired of the struggles of life where everything seems to be slipping from under them and to bring these ladies to this retreat that we may put new life and zest into them and make the existence of their last days the pleasantest ones of their life. To provide a comfortable happy home here until they shall be called to their 'Home' above."

Style and even language changes, but the vision behind Jones-Harrison's provi-

sion of services to older adults remains the same. Offering a loving and gracious home to seniors in the Minneapolis area remains the focus of this nonprofit organization. Jones-Harrison Residence today combines its 116-year tradition of skilled care and assisted living services with staggering advances in medicine and technology to provide cutting edge services to area seniors.

Residents, as well as community members, benefit greatly from the facility's dedication to improving the health of seniors, no matter their age. Jones-Harrison Residence is designed both for those able to live independently and for those requiring assistance. Skilled nursing staff provides comprehensive care to residents. All staff members share the organization's deep commitment to ensuring the dignity and independence of each occupant.

Jones-Harrison's visionary governance in elderly care has led to innovative programs in the treatment of memory loss and arthritis care. Five distinct "neighborhoods" greatly enhance the quality of care for residents diagnosed with memory loss. These popular neighborhoods are painted using different themes, ranging from a northern cabin to French country to Americana to an English garden. The artistic displays constitute a vital part of the

Early residents play croquet at Jones-Harrison Home. Courtesy, Minnesota Historical Society

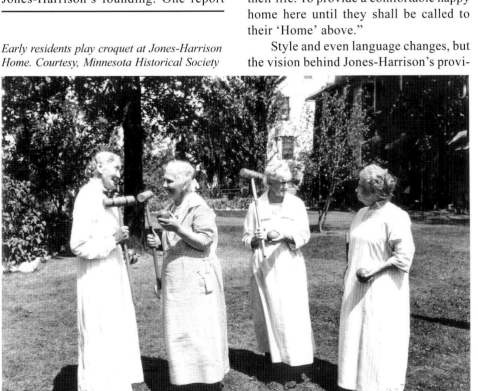

program, corresponding with themes that are interactive and comforting to residents.

Jones-Harrison Residence's most recent contributions to senior health care lie in its approach to arthritis care and geriatric strengthening (Club JHR). The program's concept is simple—it refuses to accept the conventional wisdom that the painful effects of arthritis are inevitable to aging and can only be managed through the use of medication.

With input from experts in arthritis care, physical and occupational therapy, geriatric rehabilitation, and exercise physiology, exercise programs and treatments are developed for each individual participant. Results after two months can be dramatic. Participants, in many cases, are able to "press" three times the weight

Right: The Promenade on the second floor is devoted to the treatment of memory loss. Photo by Eric Melzer

Below: The Harold L. and Harriet T. Holden warm water therapy pool. Photo by Eric Melzer

they could at the start of the program. As a result of increased strength and a reduction in pain, participants experience higher levels of independence and less need for prescribed medications. The program established Jones-Harrison Residence as the first in the state to create medical protocols to treat arthritis in a long-term care setting.

Today Jones-Harrison's residents and community members benefit from the emphasis on increased muscle strength as part of a comprehensive, holistic approach to arthritis care. Club JHR offers revolutionary treatments for wellness and arthritis care. The program offers a wide menu of treatments, including rehabilitation services, therapeutic massage, and land and water-based strength training. Residents help design their own programs, which focus on building strength and endurance. These programs serve as both a preventive measure and an effective treatment to relieve and reverse the symptoms of arthritis.

Many Jones-Harrison residents have dramatically improved their lives through exercise. One 100-year-old resident, who started swimming at the age of ninety-seven, notes that the programs leave her feeling "perfectly relaxed and at ease."

Residents point to increased independence as the program's most valuable outcome. The medical community has also taken note of Jones-Harrison's approach to exercise and aging. Doyt Conn, M.D., of Emory University, states that it should be considered for use in all long-term care facilities.

Since 1888 Jones-Harrison Residence has proven itself a visionary in the world of services for older adults. It has never lost sight of its mission of enhancing the lives of seniors. Current president, Lowell Berggren, envisions for its future another 116 years of "Honoring the Full Circle of Life." It is a vision that embodies the power behind "growing old gracefully."

*October 1987 was a great day for Minnesota
baseball fans, and more than a few of them
turned out to welcome the World Champion
Twins in front of the Capitol. Photo by Kay Shaw*

KATOLIGHT CORPORATION

Every day millions of hospital workers flip a switch or push a button and expect life-saving equipment to operate. But when power outages occur due to natural disasters or blackouts, the effects can be potentially devastating. It's times like these when Katolight Corporation comes to the rescue. For more than half a century the Mankato-based manufacturer of generator sets has been providing reliable backup and standby power not only to hospitals, but also to communications companies, government installations, and a host of other customers. Katolight generator sets can be found in thousands of places around the world, such as the National Institutes of Health in Washington, D.C., the Beijing Newspaper in China, and Telesat-Satellite Communications in Macau.

When this global corporation debuted, however, its focus was far more narrow. Katolight was the brainchild of Charles W. Pennington and Cecil H. Jones, a pioneer industrialist in the Mankato area who had already started two other businesses. The pair saw a need for emergency lighting among Midwestern farmers and dairymen and began to supply small generators known as "light plants." For some

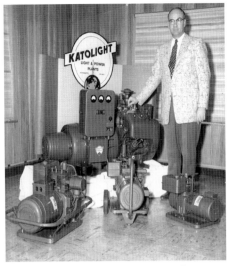

Chuck Pennington stands with several Katolight generator sets at a 1956 tradeshow.

time, the firm operated as part of Kato Engineering, one of Jones' other businesses. In 1952 they decided to spin off Katolight as a separate entity. The pair decided that Pennington would run the new company and Jones would remain at Kato Engineering.

After branching off from the parent company, Pennington set up shop next door to Mahowold's Hardware Store located on Front Street in Mankato. From the tiny office, which cost $350 a month in rent, Pennington and two employees set about the task of selling generator sets. The hard-working trio focused on sales

while the assembly of the generator sets was handled off-site. With only two employees, Pennington took on a multitude of duties most company presidents wouldn't think of performing. And even as the operation grew, he chose to carry out numerous tasks himself rather than delegate them to employees.

During that first year, the start-up firm carried only twenty-five standard items with the largest unit providing twenty-five kilowatts of power. Around that time, a fifteen-kilowatt generator set sold for $917. By comparison, the largest unit currently available from Katolight goes for upwards of $400,000 and produces 2.85 megawatts of power. By 1955 the manufacturer's standard line of engine-driven generator sets had grown to include sets ranging from .5 kilowatts to seventy-five kilowatts. That line continued to expand and by 1960 there were more than seventy-five standard items ranging from .5 kilowatts to 350 kilowatts.

Soon the growing venture needed additional manufacturing space so it moved to a building on First Avenue and Chestnut Street. Expansion continued during the 1970s and by the end of that decade Katolight boasted $6 million in sales. Not only that, the firm had grown to forty-five employees, prompting a move to an even larger plant.

The steady rise in business was thanks in large part to Pennington's determination to offer top-quality customer service. The company's leader believed that no sale was complete until the customer was completely satisfied. The benevolent Pennington also worked hard to make sure his employees were equally satisfied. Considering that Katolight began as a family business, he did his best to create a family atmosphere within the halls of the Mankato manufacturing plant.

Creating a family atmosphere was one thing, but keeping Katolight in the family wasn't as easy. The aging Pennington didn't have any children nor did he have a succession plan in place. By the late 1970s he realized that if he wanted Katolight to remain in the family, he would have to select a family member to join the firm.

That's when he zeroed in on Lyle Jacobson, the son-in-law of his brother-in-law Cecil H. Jones. At the time, Jacobson had a good job as an engineering manager at IBM's location in Rochester,

Katolight's staff pictured in 1952. From left to right: Judy Strusz, Chuck Pennington, and Stan Neubert.

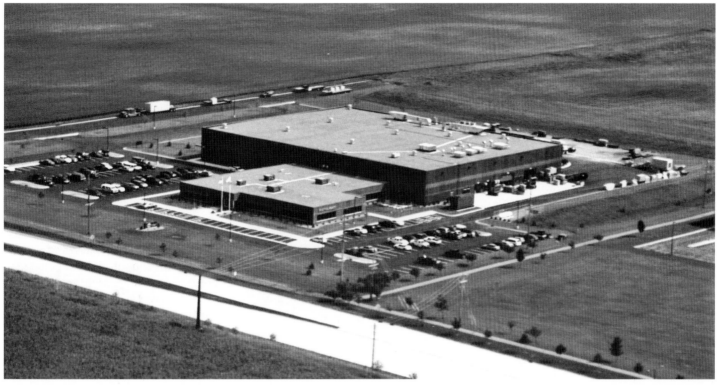

An aerial view of Katolight Corporation's headquarters in Mankato.

Minnesota. When Pennington asked him to come on board at Katolight, Jacobson had to think long and hard about it. "It was a tough decision for my wife, Kay, and me," recalls Jacobson. "Should I leave a very stable job at a major corporation for a small company? But the upside was that if I performed well I could be running it one day."

Jacobson decided to take the plunge and reported for duty at the long-standing business in 1979. As the head of internal operations he made immediate use of the skills he had gained at IBM in the fields of computers, software development, and general management. Marking a major milestone in Katolight's history and setting a precedent for staying ahead of the curve in terms of technology, Jacobson introduced the staff to computers. As with any change of this magnitude, the switch from manual procedures to computerized processes met with mixed reaction. Today however, there's no doubt it was the right move.

In addition to computerization, Jacobson implemented a management structure for the first time in the company's history. He hired managers and began delegating tasks, something Pennington had always shied away from doing. On top of that, he

worked with those managers to come up with a strategic business plan that would transform the Mankato-based business from a small operator into a global player.

Just as important as these changes, were the things Jacobson didn't change. The former IBM executive worked with Pennington for seven years before taking the reins as CEO and president upon the latter's retirement in 1986. During that time, Jacobson paid close attention to Pennington's style and took note of several things he chose to incorporate into his own management style.

The overall corporate culture that Pennington created is something that

Jacobson has fostered during his own twenty-five years with Katolight. Among the mainstays of that culture are respect for all employees and the promotion of a family atmosphere, instead of a corporate environment. To that end, Jacobson makes it a point to try to remember each and every one of Katolight's 200-plus employees by name. When talking about his business goals, he doesn't hesitate to

Lyle Jacobson, president and CEO, stands alongside two Katolight generators. An SP unit appears in the foreground and a CP unit in the background.

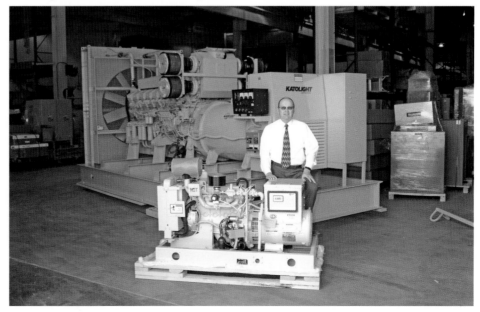

mention that he wants Katolight to be a place where people can be proud to work.

Jacobson's strategic plan also includes lofty goals in terms of revenues. The former IBM executive wanted the company to hit $50 million in revenue before his own retirement. Katolight reached and actually surpassed that goal in 1999 bringing in almost $60 million. Current annual revenues are already up to $70 million. "Now I'd like to reach $100 million before I retire," says Jacobson. Of course, at sixty-three years of age, the business leader has no plans to retire soon so that goal could go even higher.

Finding a niche in the marketplace is part of what has fueled the rapid sales growth. While many of its competitors focus on selling standard units, Katolight specializes in building custom generator sets ranging in size from fifteen kilowatts to 2,850 kilowatts that provide customers with exactly what they need. Although the manufacturer does offer a standard unit for customers who don't need a unique configuration, it's Katolight's ability to innovate and be flexible that sets it apart from others.

Also sparking sales is an increasing demand for emergency power. As Y2K approached, companies were forced to start thinking about the importance of backup power. Katolight experienced tremendous growth in 1999 as firms nationwide scrambled to obtain emergency backup

State-of-the-art facilities allow Katolight to design, build, and test generator sets to meet the most demanding quality and performance requirements.

An 85 kilowatt, gasoline-powered, water-cooled, three-phase Katolight unit that was common in the 1980s.

power before the new millennium. Natural disasters and power outages have also triggered jumps in sales. The blackouts on the East Coast in 2003 proved to be a boon for business.

To keep up with the increasing demand, Katolight moved into a new 80,000-square-foot facility designed to house both manufacturing and corporate functions. The move came in 2002, marking Katolight's fiftieth anniversary. By 2004 demand for

generator sets proved so great that Katolight reopened one of its former plants, "the Valley Plant," to keep up with orders.

Although orders are pouring in, Jacobson knows that in today's business climate companies can't simply hire more people to handle additional orders. In an effort to optimize production, he's implemented a lean manufacturing initiative, which calls for cost reductions, higher productivity, and improvements in customer service. Katolight has already distinguished itself in the customer service arena, offering outstanding "after-the-sale" support and twenty-four-hour telephone service.

Moving forward, Jacobson is channeling efforts into the international marketplace. However, he hasn't forgotten Katolight's roots in agriculture. Even today, he places a high degree of importance on this side of the business with a dedicated sales team comprised of individuals who know and understand these customers' needs. And just as Katolight units can be found around the globe, the firm's generator sets can also be found throughout the Mankato community. Immanuel-St. Joseph's Hospital, the Mankato Waste Water Treatment Plant, the Mankato Law Enforcement Center, and Minnesota State University, to name a few, are all equipped with Katolight generator sets.

Over the years Katolight has contributed to the Mankato community in numerous other ways. Pennington, Jacobson, and other executives have taken active roles in a host of local organizations, including Minnesota State University athletic programs, the United Way, the historical society, the local symphony, the Kiwanis Club, and the Rotary Club. In recognition of its many contributions, Katolight was inducted into the prestigious Mankato Chamber of Commerce's Business Hall of Fame in 2004. This honor is reserved for companies in the Mankato area that have been in business at least fifteen years and have made significant contributions to the economic and civic well-being of the community.

For Jacobson, the honor is one of many highlights associated with his long career at Katolight. And he anticipates many more highlights to come as he leads the firm in its quest to double in size over the next five years. However, the forward-thinking leader never forgets Katolight's roots, and he continues to look on the successes of the past with great pride.

Sugar beets remain an important Minnesota crop, exemplified by this Beltrami harvest scene. Photo by Kay Shaw

LAKE REGION HEALTHCARE CORPORATION

A tiny newborn joins the world; a troubled teen finds comfort and hope; an active senior citizen is welcomed into an assisted-living group—all examples of the good work happening at Lake Region Healthcare Corporation (LRHC). This organization, located in Fergus Falls, is more than a hospital; it is a medical community that serves its patients with the finest facility and staff in the region.

Lake Region Healthcare Corporation is the result of more than 100 years of growth and progress. The science of medicine has changed drastically since the organization first opened its doors in 1902, but since that time LRHC has either kept or set the pace of healthcare for rural northwest Minnesota. However, one thing at LRHC has remained the same over the years—individualized quality care.

This progressive and successful corporation actually began as a small, rural hospital named St. Luke's. In the 1890s Reverend Hulteng of Aastad recognized and voiced the great need for such a facility, but financial constraints prevented his vision from coming to fruition. Shortly thereafter, Reverend Skyberg of Aastad and Reverend Tjornham, a pastor at Fergus Falls' Our Savior's Lutheran Church, revitalized the plan. A group of

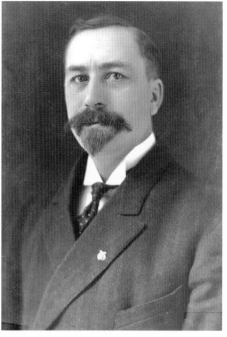

Dr. Olaf Sherping is one of the founders of St. Luke's Hospital. Courtesy, Otter Tail County Historical Society

local citizens drove the effort by approaching a prominent Minnesota physician, Dr. Olaf Sherping, who agreed and gave an initial donation of $1,000.

St. Luke's was officially organized in November 1902 and incorporated on March 23, 1903. It served as both a hospital and a Lutheran school where pastors instructed religion classes for the nurses, in respect to caring for the infirm and their families. A major step was taken in securing the hospital's future on September 11, 1903 when its first home, a beautiful neoclassical-style building, was dedicated. Upon opening, the hospital posted charges of $15 per week for a private room and $10 for the first week for a bed in the ward, $7 per week thereafter.

The hospital flourished filling a long overdue need for a healthcare institution in the area. Major additions to the facility soon followed, occurring in 1909, 1916, and 1928.

Around the same time St. Luke's was established, another hospital was in the process of being organized. The children of George B. Wright, who was instrumental in the early development of Fergus Falls, honored the memory of their father by founding a hospital in his name. The association to erect the George B. Wright Memorial Hospital was formed in September 1903, and the hospital opened its doors on New Year's Day 1906.

The George B. Wright Memorial Hospital's mission was to provide at-cost healthcare services to the area's ill and injured. This hospital also filled a definite need in the community as evidenced by its expansions, which added wings to the north and west of the main building by 1928.

Both St. Luke's and Wright Memorial grew and advanced in offering healthcare services during the 1930s and 1940s, with both hospitals adding modern equipment and establishing nursing schools. But

Below, top: Dr. Theodore Sherping and his staff at St. Luke's Hospital, 1910. Courtesy, Otter Tail County Historical Society

Below, bottom: An early operating room at St. Luke's Hospital. Courtesy, Otter Tail County Historical Society

Below, top: Northwest Territory Parade in Fergus Falls, 1938. Courtesy, Otter Tail County Historical Society

Below, bottom: George B. Wright Memorial Hospital in Fergus Falls, 1906. Courtesy, Otter Tail County Historical Society

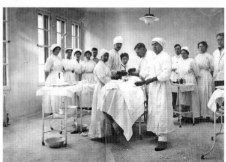

St. Luke's Hospital, circa 1903. Courtesy, Otter Tail County Historical Society

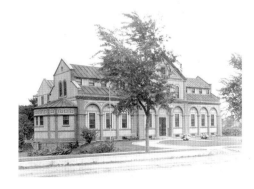

284

From its humble beginnings, today's Lake Region Healthcare Corporation has evolved into a sophisticated hospital.

Ed Mehl, CEO, Lake Region Healthcare Corporation.

by the early 1950s a national shortage of hospital personnel occurred, making it difficult for the area to operate two healthcare facilities.

Therefore, in 1951, St. Luke's and Wright Memorial merged, with the goal to more effectively utilize available personnel and streamline operating costs. The two hospitals, although competitors in the same industry, had worked hand-in-hand in the past—even sharing an ambulance in the beginning years—which made the transition an easy one.

The hospitals both remained in operation until the Wright Memorial facility was sold in October 1953 and finally closed on December 18th of that year. On December 30th patients from Wright Memorial were moved and the new hospital, known as Lake Region Hospital Corporation, began to operate as a single facility. Plans were quickly established to build an addition to the former St. Luke's building to accommodate more patients.

The 1950s continued with more positive changes, and expectations, for Fergus Falls' newly formed hospital. In 1954 Lake Region Hospital Corporation was honored with full accreditations. In January 1955 plans were completed for a new $1 million addition, followed by a groundbreaking in April. That same year the hospital also added a new X-ray unit and received an impressive $47,000 grant from the Ford Foundation.

In 1957 a tumor clinic was established and plans for a children's recovery room

were made. On June 28th of that year the hospital was officially dedicated, followed by an open house attended by 1,000 visitors.

The expansion moved forward in 1959 with the installation of state-of-the-art polio equipment, the opening of a children's convalescent ward, and the introduction of physical therapy. It appeared from all views that this merger of two small hospitals resulted in a progressive healthcare center for the community.

The 1960s brought with it turbulent and unsettling times across the country; however, Lake Region Hospital Corporation was on a steady course of growth. More renovations and expansions were planned, and donations were secured to make them happen. The next decade proved to be just as exciting for the hospital. In the 1970s a detox unit, a larger intensive coronary care unit, and an ultrasound diagnostic unit were added.

In the 1980s the hospital survived its second national nursing shortage crisis, while successfully continuing to give quality care. Even during this challenging time, Lake Region Hospital Corporation was able to introduce two new floors, an emergency room, a psychiatric unit, a sports medicine clinic, contemporary birthing suites, a mammogram unit, and several other improvements.

Toward the end of the 1990s the organization had grown beyond the traditional boundaries of a hospital. Therefore, the board accordingly elected to rename the institution Lake Region Healthcare Corporation.

Under a new name that better reflected its purpose, the corporation focused on maintaining its state-of-the-art status with a plan for further expansion at the dawn of the millennium. In 1999 a new operating room and ambulatory surgery area were opened. Three years later, in June 2002, $7.5 million in renovations began.

Today's Lake Region Healthcare Corporation, accredited by the Joint Commission on Accreditation of Healthcare Organizations and licensed by the Minnesota Department of Health, features cutting-edge technology and a skilled professional staff. In fact, LRHC is widely recognized as the best healthcare facility in northwest Minnesota.

Being a long-time partner of the community, LRHC places pride on providing the best possible care and comfort in a local setting. And although the organization has grown beyond the expectations of its founding fathers, the facility is designed to make area residents feel at

home. "Our medical staff of forty-one physicians, our 608 employees, and our fifteen-member volunteer board of trustees have worked together to utilize our collective skills and $69.8 million in facilities and equipment, to benefit our regional area and its communities," says Ed Mehl, LRHC's chief executive officer.

LRHC, along with the Fergus Falls Medical Group, is a progressive medical community. It includes Lake Region Hospital, a 108-bed, nonprofit facility that, on an annual basis, cares for more than 4,000 inpatients, 12,500 emergency room patients, and 39,500 non-emergency room outpatients. The hospital is the area's largest employer and generates $23.8 million in wages and benefits. The organization also consists of Lake Region Home Health Care Services, one of the area's oldest and most experienced providers for in-home care for people of all ages. Lake Region Skilled Nursing Facility is also part of LRHC and offers nursing facilities connected to Lake Regional Hospital for those who are no longer able to live at home, but will benefit from a transition step between acute care and home healthcare or assisted living.

The organization also owns and operates Lake Region Bridgeway Care Unit, an 14-bed unit providing access to comprehensive mental health services offering high-touch medicine in a positive environment; and Lake Region Center for Rehabilitation, an award-winning rehab facility featuring a physiatrist and licensed physical, occupational, and

Lake Region Hospital staff members utilize new surgical procedures and high-tech instruments to improve patient care.

speech therapists. LRHC also owns Mill Street Residence, an assisted-living community which offers a unique blend of housing and healthcare for seniors who need help with the routine activities of daily living. LRHC is also co-owner of Western Central Linen. All these sectors, and more, come together to make a full-service medical community.

Comprised of these many different sectors of the medical community, LRHC serves as a crossroad to join its varied divisions such as Lake Region Hospital and Mill Street Residence. It also provides direct access to the Fergus Falls Medical Group, P.A., an independent mulit-specialty group with physicians, mid-level providers, and medically trained professionals. To visually commemorate the forming of this medical community, LRHC erected an impressive architectural landmark at the corner of Vernon Avenue and Cascade Street, which serves as the entrance to the campus.

Behind the new gateway lies a complex dedicated to providing unparalleled medical care to the people of Otter Tail County, northern Granty County, and eastern Wilkin County. LHRC exists as a unique mix of expertise, technology, and specialized care to provide a broad range of quality diagnostic and treatment services.

Lake Region Healthcare Corporation is focused on its mission statement: *To provide quality healthcare service in a caring manner to each individual we serve.* Due, in part, to its dedication to this clear and meaningful goal, LRHC has been able to remain independent during an era of national corporate mergers and buyouts. The hospital is one of the very few remaining independent and self-controlled hospitals in Minnesota.

The leadership of LRHC looks for the future to indeed bring more growth and prosperity to this thriving organization— and more healing, comfort, and quality care to its patients. They are planning and preparing to meet the next 100-plus years by reflecting on a past of commitment to the Fergus Falls community that is truly unique to Lake Region Healthcare Corporation.

George B. Wright Memorial Hospital with major addition, circa 1928.

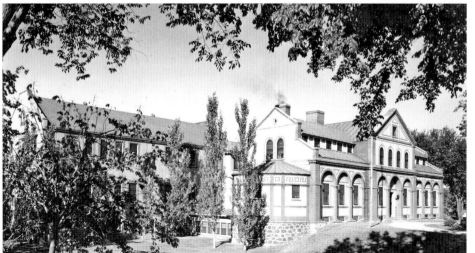

Emil Hastings' luminous oil painting,
Cornstalks, *brings to mind not only the
enormous importance of corn to the state's
economy but also the unique delight of fresh
sweet corn on the supper table. Courtesy,
Minnesota Historical Society*

LAWRENCE TRANSPORTATION SERVICES, INC.

Ask Stephen "Steve" Lawrence where his family's firm, Lawrence Transportation Services Inc. (LTSI), is heading and he doesn't hesitate to share his strategic plan for growth. But ask him about the company's start nearly seventy years ago, and the details aren't quite as clear. The truth is no one knows exactly when the little trucking company, that has since grown into LTSI, got its start.

Family recollections indicate that the business venture began when Lawrence's grandfather, Albert "A.V." Lawrence, was "blown out of Northeastern Montana" during the Dust Bowl years in the early 1930s. A.V. was simply looking for a way to support his family as the nation recovered from the Depression. To do so, he turned to trucking in the town of Red Wing.

A.V. wasn't alone in the enterprise for long. By 1938 the entrepreneur's son Alton "Tony" Lawrence had bought a truck and joined his father in the business. One of their first jobs was hauling livestock to stockyards in south Saint Paul, and feed and general commodities to Red Wing on backhaul.

At the time Red Wing was one of the state's leading centers of commerce. Companies such as Red Wing Shoes, S.B. Foot Tanning Company, and Red Wing Potteries had taken root in the area. With the increases in production came

Albert "A.V." Lawrence, 1886–1960.

a need for fast, reliable transportation. Tony was determined to provide trucking services for this growing market.

While trying to turn a profit, the fledgling business owners also had to deal with major changes regarding the trucking industry. In the mid to late 1930s the Minnesota Railroad and Warehousing Commission began regulating commodity hauling. Since the Lawrence family had already been in the trucking business, their company was grandfathered in for hauling general commodities.

During the same period the Interstate Commerce Commission also began requiring trucking companies to become licensed for state to state trade. Unfortunately, there was no "grandfather" provision. Several Red Wing businesses, including the Red Wing Shoe Company, the S.B Foot Tanning Company, Red Wing Potteries, and the Red Wing Sewer Pipe Company supported Lawrence Trucking and petitioned the Interstate Commerce Commission on its behalf. Thanks to its efforts, the company received operating authority to carry cargo across state lines.

Following World War II A.V. moved to California, leaving Tony to take over the company

along with his brother Vincent. Tony subsequently bought out Vincent's share to become the sole owner. With Tony now in the driver's seat, the company and the number of trucks grew throughout the 1940s and 1950s. After spending a number of years running things from his kitchen table, Tony moved the operation into its first office space on Main Street in downtown Red Wing. The office was located behind the "Flying A" service station in the site currently used as part of the Archer Daniels Midland's linseed oil production plant.

With no employees on the payroll, Tony relied on family members who volunteered to pitch in. With their help, Tony expanded his services in order to meet growing customer demands. Even though temperature control was still a touchy business at the time, Tony tried his hand at refrigeration and began hauling eggs to Texas and the East Coast. Then he began hauling sewer pipe throughout the Midwest for the Red Wing Sewer Pipe Company.

By the end of the 1950s Tony had added a car and a truck dealership to his roster of products and services. But it was in 1957 that Tony ventured into an area that would have great significance for the company. That was the year he leased his first trucks to three companies: Smead Manufacturing in Hastings, and the Red Wing Shoe Company and the S.B. Foot Tanning Company in Red Wing. The

Alton "Tony" Lawrence, 1916–2000.

Tony (left) and Vince (right) Lawrence.

288

Stephen Lawrence.

Eric Lawrence.

everything from Scouts and Suburbans to Class 8 trucks. During this same period, Tony took honors as the first Great Dane trailer dealer in Minnesota. Both of these dealerships were subsequently sold.

An important year for the firm was 1970. That's when Tony's son, Steve, first appeared on the payroll. But Steve was no newcomer to the business. He had been helping out with his father's endeavor since high school when he washed trucks, delivered freight, cleaned shops, and started learning the business. After graduating from Augustana College, Steve headed to the University of Tennessee Law School. While there, the law school student also worked for Hertz Truck Leasing where he learned even more about the industry. Steve returned to Red Wing in 1970 and opened a law office. In his spare time, he sold truck leasing for his father, beginning the company's growth in its truck leasing operations.

During the 1970s Tony began thinking about retirement and started spending a few months a year in Arizona. In 1974 he decided to sell Lawrence Motors, Red Wing Truck Rental, and Red Wing Transportation, which became subsidiaries of United Truck Leasing in Minnesota. Even though the companies were in the hands of a publicly traded company, the Lawrence family remained at the helm in

move marked the company's first experience in truck leasing, which has since evolved into Lawrence NationaLease—a very important subsidiary of LTSI. Equally important, the three companies involved in the deal remain valued customers to this day. With these moves, Tony was beginning to branch out and offer the multiple transportation products and services that have since become the hallmarks of LTSI.

The 1960s proved to be a decade of both diversification and consolidation for Lawrence Transportation Services. The company became a full-line GMC and International Harvester dealer selling

A.V. Lawrence (background) pictured with Lillian Lawrence (far left) holding baby Stephen, circa 1943.

terms of decision-making. In addition, Steve became more active in national transportation issues. In 1978 he was one of seven founding members of the Truck Rental and Leasing Association, a Washington D.C. based trade association that now represents every truck leasing company in the U.S. Steve subsequently became TRALA's president in 1981 and still serves as a member of its executive committee.

The 1970s proved to be a period of significant expansion for the company. By the time 1980 rolled around, United Truck Leasing and its Red Wing subsidiaries were sold to Hertz Truck Leasing.

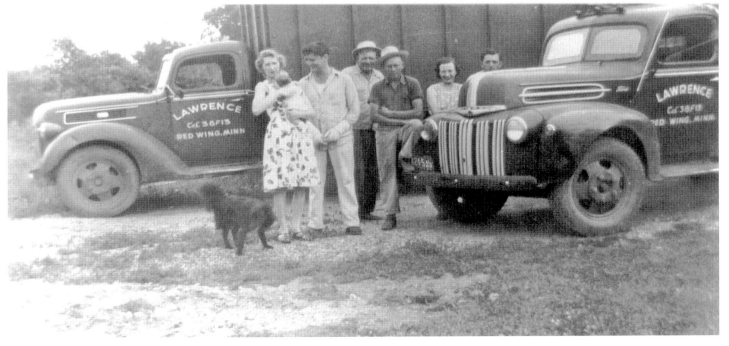

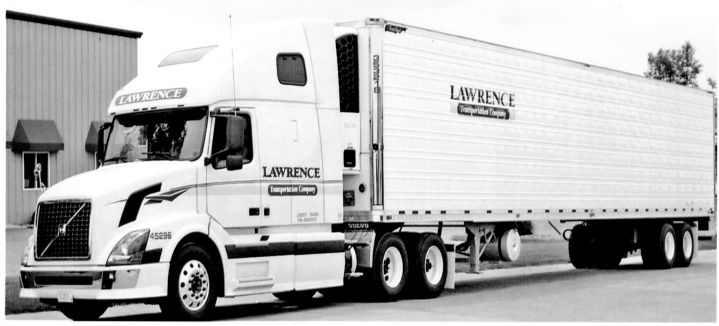

A Lawrence Transportation Company tractor and trailer.

However, it became immediately apparent that the Red Wing entities did not fit the Hertz business mold. In 1981 Steve Lawrence took a risk and repurchased Red Wing Truck Rental, Lawrence Motors, and Red Wing Transportation and created the parent company which has become Lawrence Transportation Services, Inc. (LTSI). Tony and Jay Lawrence became minor shareholders.

The timing couldn't have been worse. Interest rates had soared to 18 percent, and the trucking industry was reeling from the effects of deregulation. This proved to be very difficult for existing trucking companies, and few of those businesses survived. But because Lawrence had experience in full-service leasing and had begun to diversify its products and services, the company survived deregulation and was able to acquire several other companies.

Over the next five years LTSI aggressively grew its business, acquiring T-Line (trucking), AB Line (trucking), The Cartage Company (brokerage), Amarillo Thermal King (dealership) and Amarillo Personnel (driver leasing). The firm had grown nearly 500 percent, making it attractive to several major, national transportation companies that wanted to make an acquisition. However, the Lawrence family shunned those advances and instead sold to a company with compatible interests and a culture that matched its own—Whiteford NationaLease in South Bend, Indiana. This sale allowed Tony Lawrence to fully retire.

Unfortunately, the move that seemed so ideal quickly backfired. It turned out that one of Whiteford's sister companies had undisclosed financial difficulties, and Steve had to move his family to South Bend to help resolve those problems as Whiteford's general counsel and chief operating officer. Whiteford NationaLease was eventually sold to Lend Lease in

Minneapolis. Steve became Lend Lease's general counsel and executive vice president and was able to return to Minnesota with his family.

In 1991 Steve wanted to get back into the business on the ground level. He formed a group of investors whose goal was to develop a regional, multi-product transportation company that would serve Lawrence's long-term customers. The first step was the acquisition of Wilson Refrigerated Express in Rochester, which was owned by Steve's longtime friend and business colleague George Wilson. Today Wilson remains active in the company as a shareholder and officer of LTSI.

By 1992 Steve was proud to roll out a new truck-leasing venture called Lawrence NationaLease. In 1993 the new firm made its second major acquisition

The Lawrence NationaLease shop and headquarters in Red Wing.

by purchasing the three original Red Wing Truck Rental facilities in Rochester, Owatonna, and Red Wing. With these acquisitions came nearly all the employees who had been with Lawrence back in the 1970s and 1980s.

There have been quite a number of changes throughout the company's evolution, but the customer base has grown, remaining solid and intact thanks to its firm dedication to customer service. Considering the number of acquisitions and divestitures involved in LTSI's history, it's remarkable how many customers have remained with the company for the long-haul. In large part it's thanks to the firm's dedication to customer service. It was a philosophy that began right from the start with A.V. and has been carried on by all the Lawrences: Tony, Steve, Jay (who passed away unexpectedly at age fifty-one) and now by Steve's son Eric, who heads up the logistics subsidiary.

Even today with numerous subsidiaries and thirteen locations around the Midwest, LTSI is not a huge, impersonal organization headquartered far away from its customers. Instead, customers are treated with care and considered to be part of an extended family. LTSI's employees are also an important part of that equation and include approximately 350 drivers, owner/operators, diesel technicians, warehousemen, managers, and administrative associates who make up the firm's $14 million annual payroll.

Many workers have been with the company for decades, and LTSI boasts one of the lowest driver turnover rates in the trucking industry. Steve credits that loyalty to the corporate culture, which gives employees decision-making power and encourages people to work for everyone's benefit rather than self-benefit. However, the notion of family extends even further.

The people at LTSI realize that they share the nation's roads with families everywhere. That's part of the reason why safety and environmental issues are of the utmost importance to them. Lawrence subsidiary companies have proven to be leaders in both areas, often meeting and going beyond new regulatory requirements.

Lawrence's emphasis on the environment is evident in its "Green Shop," which is dedicated to maintaining environmentally-friendly practices in maintenance shops. The Green Shop idea originated

Stephen Lawrence, who also served as president of the Truck Rental and Leasing Association, with Vice President George Bush at the TRALA White House conference in 1982.

in Lawrence NationaLease maintenance facilities. It has since become a program in all 550 NationaLease shops across the United States.

The firm's commitment to safety has been recognized with numerous awards. Lawrence earned first place awards in the annual Minnesota Trucking Association (MTA) Safety Contest in seven of the last eight years. In 1992 and 1997 the company was honored with the MTA's "Grand Prize for Safety." In 1998 it was awarded with another "Grand Prize for Safety" (second place award) from the American Trucking Association. Lawrence Transportation Company was also the 2003 grand prize winner of the Truckload Carriers Association's "Fleet Safety Award."

There's no doubt that LTSI has an enviable safety record, and it also holds a unique position in the industry. Although other companies throughout the region provide individual products and services similar to Lawrence's, there are very few that offer such a broad range within the same company. With its vast selection and superior service, Lawrence is able to provide customized solutions to companies seeking one source for their transportation needs.

LTSI's subsidiary companies have come a long way since A.V. bought that first truck back in the 1930s. The firm currently boasts 500 trucks and 700 trailers in its Lawrence NationaLease subsidiary. It has approximately 150 tractors and 200 trailers in its trucking operations, carrying 21 million pounds of cargo per week and traveling more than 17 million miles each year. From its first loads of livestock, LTSI trucks and trailers now haul almost every sort of cargo imaginable to points on both coasts and in between. Lawrence companies have become a major regional player in full-service truck leasing, warehousing, assembly and packaging, and third-party freight brokerage. It also provides a broad range of risk management services to other agencies, companies, and fleets. Although the company has had its share of challenges, its fiercely loyal customers and employees have kept the 70-year-old story alive and well.

LOWER SIOUX INDIAN COMMUNITY

Minnesota's Lower Sioux Community has a rich, colorful history, woven with stories of oppression and pain; but survival is the strongest thread that runs through this tribe's past into its present.

Over many centuries, the Dakota nation survived the harsh climates of what is now the northern United States, fierce battles with their rivals—the Ojibwe, and a history-defining war with U.S. settlers, meant to banish them from their homeland forever. Through these struggles, the nation endured.

Today, as members of the Lower Sioux Community in Minnesota, these industrious and loyal Native Americans are living on the land their ancestors fought for with their lives. Part of the Mdewakanton band of Dakota, the Lower Sioux Community is moving forward, but they do so with a sense of honor and pride about all that their people have overcome.

The Dakota have a somewhat mysterious story, as its tribes frequently migrated and their history was not chronicled for many years. But what is most telling about the people is that Dakota, in their language, means "friend."

The Mdewakanton Dakota, like most of the nation's bands, had a deep spiritual connection with nature. They lived among the woodlands around the Mille Lacs Lake, but in 1750, they were displaced after a battle with longtime foes, the Ojibway (now known as Ojibwe). Many

The 28th annual traditional Pow Wow was held on the Lower Sioux Pow Wow grounds in 2005.

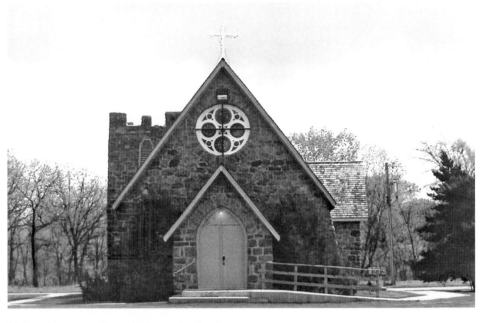

The St. Cornillias Episcopal Church is over 100 years old.

Mdewakanton gathered along the banks of the Mississippi, Minnesota and St. Croix rivers.

White settlers and the Dakota had a relatively peaceful coexistence for many years, but as the United States pushed westward, a struggle for ownership of the territory ensued. Treaties were formed and land concessions were made, but often not to the benefit of the Dakota.

In 1851 the Mdewakanton band and its home were renamed Lower Sioux. Sioux was a word that some of the tribe's people found hard to embrace, as it was taken from the Ojibway vernacular, translating to snake or enemy. This questionable name was not the first or last of the "compromises" to be presented to the Dakota.

After treaties were signed in 1851 and 1858, the Dakota people were once again removed from their homes and separated. Little Crow, the nation's chief at that time, is reported to have said that his people were like "little herds of buffalo left scattered." Approximately 7,000 Mdewakanton were relocated to a crowded and ill-equipped reservation along the Minnesota River. Making matters worse, payments from the U.S. Government to the band were often late, or stolen before reaching the band.

Forced to live a life that belied the freedom they once embraced, the Mdewakanton joined other area Dakota bands in an effort to revolt against the whites. The legendary war was bloody and brutal, resulting in the hanging of 38 Dakota warriors in Mankato. This mass execution was the largest of its kind in the history of the United States.

The Dakota nation was even further shattered, as bands retreated seeking shelter in exile. They moved to South Dakota, and some were later forced to walk to the Santee reservation in Nebraska. The Mdewakanton were defeated in the battle and were without a home, yet they were not a broken people.

Less than two decades after that devastating war, the Mdewakanton began to return to their homeland in Minnesota in the 1880s. This strong band reunited in south central Minnesota in Redwood County. And with the Acts of

June 29, 1888 (25 Stat. 228), March 2, 1889 (25 Stat. 9920), August 19, 1890 (26 Stat. 349) and the Indian Reorganization Act of 1934, their reservation was securely established.

Presently the tribe is comprised of nearly 800 members. They are led by an elected five-member council, with a priority to protect the interests of its people. The council oversees governmental and social needs as well as business operations. Housing, human services, higher education and economic development opportunities are among the top objectives.

The reservation is more than a physical home for the 400-plus members living there. It provides a shelter for the tribe's history, an incubator for its culture, and fertile ground for its enterprises.

With six strong businesses, not including mineral rights, the community is powered by its own economic engine. The tribe's successful business operations feature a diverse portfolio, and are often credited with drawing more of its members back to the reservation.

The most notable enterprise is the tribal-operated Jackpot Junction Casino and Bingo Hall. Opened as a bingo hall in the mid-1980s, and expanded to a casino in 1988, Jackpot Junction is a popular site for fun and excitement. The gaming operation is complemented by the Dakota Exposition Center, which offers top-name entertainment, a nightclub and several supporting food and beverage outlets.

The Indian community continued its strong foothold in the tourism industry with the introduction of the Lower Sioux Lodge and Convention Center. A deluxe hotel and more than 35,000 square feet of meeting space, contribute to making the center the area's premier meeting destination.

The Dakota Inn was built in 1991, as the demand for convention and visitor lodging rapidly grew. The 122-room hotel, located in the City of Redwood Falls, also offers a swimming pool for guests.

The Lower Sioux Community also added a recreational vehicle park. This fully equipped campground features 40 spaces for RV-style camping.

The Lower Sioux C-Store and Gas station was born out of combining two of the tribes smaller businesses to make

one larger, stronger effort. In 1991, the tribe combined the Lower Sioux Smoke Shop with its convenience store and gas station. Located next to the casino, the operation creates a solid profit for the tribe.

With the natural resources at hand and a progressive line of thinking for planning and development, the Lower Sioux seized the opportunity to draw more visitors to the reservation with a golf course. Located on 240 acres, the Dacotah Ridge Golf Club is located just four miles from the casino. The 18-hole championship course is a tour through the reservation's beautiful and abundant land.

The Dakota Ridge Golf Course is nationally recognized.

New Lower Sioux Community Youth Center also houses the Police Department.

The tribe's enterprises offer employment opportunities for its people and economic development for the community. However, the businesses are more than dollars and cents; they are a tangible representation of the tribe's ability to be progressive and self-sufficient.

Hundreds of years of struggle and pain are steeped into the Dakota history, with the Mdewakanton band triumphant. Today the Lower Sioux Community is a thriving and vibrant sector of Minnesota's cultural makeup, while maintaining itself as an autonomous society—a true hallmark of centuries of survival.

JACKPOT JUNCTION CASINO HOTEL

Jackpot Junction Casino Hotel, owned and operated by the Lower Sioux Indian Community, has been a sure bet for fun for tourists and residents of southwestern Minnesota for more than twenty years

The casino began as a bingo hall in 1984, providing career opportunities and economic benefits to the Lower Sioux Community, which is part of the Mdewakanton band of Dakota. The hall, located in Morton, was a success, and with the popularity of Native American gaming, expansion was soon to follow.

Just four short years after opening the bingo hall's doors, the community was able to create a full-blown gaming operation. Traditional table games and slot machines were added, and Jackpot Junction became Minnesota's first casino.

The public responded by coming from all areas of the country to play and enjoy the excitement of the new attraction. The community quickly reacted to the needs of their patrons by planning amenities that would round out the reservation into a full-service vacation destination.

In 1991 the casino was updated, adding state-of-the-art games and bigger, better facilities were on the horizon. The much-needed Dakota Inn was opened the same year with fifty-eight rooms, later expanding to 122 rooms with a swimming pool. A recreational vehicle park, with forty-unit spaces, was also opened.

Further growth and development occurred over the next five years. A new bingo hall, the Full Deck Grill, and the Portside Casino were introduced. And in

Jackpot Junction Casino Hotel.

Entrance to Jackpot Junction Casino Hotel.

1995, the Lower Sioux Lodge was opened, providing 168 deluxe rooms. The opening of a convention center followed the new hotel, which is connected to the casino. With 36,000-square-feet of meeting space, the Lower Sioux Community could now service large conventions and expositions.

In 1998 the casino was once again improved with its Skyline Casino expansion. By improving the gaming facility and upgrading the slot and table offerings, the Lower Sioux were able to maintain its share of the area's competitive gaming market.

An amphitheater was added and the AAA Three Diamond-rated Lower Sioux Lodge was expanded to offer 276 rooms in 1998. The following year, a big step was taken by offering another attraction to the reservation with the development of the Dacotah Ridge Golf Club. The

eighteen-hole championship course is located just four miles east of the casino. The club, centered in the beautiful natural resources of the reservation, has received recognition from national media outlets including *Golf Digest* and *Golf Magazine*.

Other food and beverage offerings were established, along with casino updates and a new live poker room, featuring all the most popular games. The Lower Sioux Community, lead by its five-member elected council, were focused on providing the best casino entertainment experience possible.

Today Jackpot Junction Casino is a first-class resort with 325,000-square-foot entertainment casino at its center. Players can choose from more than 1,600 video slot machines, twenty-four blackjack tables, six poker tables and a 375-seat bingo hall. Headliner entertainment is offered and there are three food outlets and four bars available. The property is also home to a New Horizon Kids Quest childcare facility, so that every member of the family can have fun.

The Lower Sioux Community continues to reinvest in its reservation and its people by constantly growing and improving the casino and all its product offerings. Jackpot Junction Casino Hotel has proved to be a winner for the tribe, the southwestern area of Minnesota and the countless visitors who have stayed and played over the past two decades.

St. Paul's Winter Carnivals vie from year to year in icy grandeur, as in this soaring Ice Palace. Photo by Kay Shaw

THE LUTHERAN HOME ASSOCIATION

The Civil War proved to be a pivotal event in the life of Sophie Boessling, a strong Christian woman who lived in the Belle Plaine settlement with Christian, her husband, and her son Ernst. Fifteen-year-old Ernst lied about his age and volunteered to serve with the Minnesota troops in the bloody conflict. Just two years later at the age of 17, he died and was buried on the battlefield in Vicksburg, Mississippi. Sophie was heartbroken by the loss and vowed to find a way to give meaning to Ernst's death.

Years went by and Christian passed away, but Sophie never lost the desire to do something that would honor Ernst's death and glorify God at the same time. Eventually, she came up with an idea. In the late 19th century, orphans and the aged were often relegated to harsh "poor houses" or "work farms." Sophie wanted to create a home where these forgotten people could live in peace and where spiritual care would be emphasized.

Knowing full well that she couldn't carry out such a project herself, Sophie headed to her neighborhood church. There she enlisted the assistance of Pastor Erich Moebus at Trinity Lutheran Church. Pastor Moebus instantly recognized the need for such a special home and encouraged his congregation to donate generously to the project.

Without reservation, Sophie herself donated her land, buildings, and $4,500 estate to make her dream come true. With assistance from Trinity Lutheran Church,

Sophie Boessling, founder of The Lutheran Home.

More than 1,500 supporters witnessed the dedication of the Hope Residence in 1977.

other congregations, and many caring individuals, construction on a three-story building designed to house twenty-two residents began in 1898. On November 6 of that same year, what would eventually become The Lutheran Home, but then called das Waisen und Altenheim (the Orphans and Aged Home), opened its doors on Main Street, just three blocks from Trinity Lutheran Church. Sophie had lived to see the glorious day arrive, but only two days later at the age of eighty-three, she died suddenly.

The Lutheran Home has since provided more than a century of care and has evolved into The Lutheran Home Association (TLHA). TLHA is a group of more than 200 Wisconsin Evangelical Lutheran

Synod and Evangelical Lutheran Synod churches nationwide that offer Christian care to people who have special needs. Among them are the elderly; people with Alzheimer's disease and other dementias; and those with developmental disabilities, mental retardation, and mental illness. TLHA maintains a system of nursing homes, assisted living facilities, senior apartments, an intermediate care facility, a group home, and various support services.

Over the past century, more than 2,600 people have been cared for at the Belle Plaine campus. In keeping with Sophie's wishes for a home that would administer to people's spiritual needs as well, the motto at TLHA says it all: "Where the Care of the Soul is the Soul of Care." But it all started back in 1898 with just seven "inmates" as they were called back then.

Along with one orphan boy, three men, and two other women, Sophie counted herself as one of those first residents, although her stay was short-lived. With Pastor Moebus as president and chaplain of "The Home," strict rules and guidelines were established. For example, a 7:00a.m. wake-up bell would sound each morning, residents would take a bath once a week, and devotions would be led by a chaplain or pastor. To earn a spot in the home, individuals needed a pastoral recommendation, had to be free of any contagious diseases, and were asked to pay what they could afford. For a fee of $500 to $1,000, a person could live out the rest of their life there. Donations from family and congregation members could be used to offset the fee if an individual couldn't afford it.

Life at the facility in the early 20th century was rugged at best. As a working farm, the small staff and residents grew their own fruits and vegetables and raised their own chickens. In 1905 the governing board voted to purchase a cow, and in 1917 three pigs were purchased. The diligent staff kept a journal of all the eggs gathered each year as a record. By 1937 more than 10,190 eggs were gathered annually by the slim staff of only five or six employees. In 1960, the year the chickens were sold, some 22,022 eggs were gathered.

The residence, which was built following a tragedy of the Civil War, also felt the effects of World War I. Because of the war, prices on everyday goods skyrocketed.

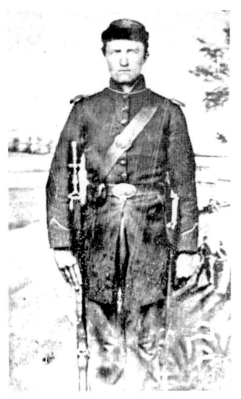

Sophie's son, Ernst, in whose memory The Lutheran Home was founded.

The cost of living and lodging at the facility had risen to approximately $5 per week. Due to the exorbitant cost of butter, its president asked that coconut butter be used instead of real butter.

The Great Depression proved to be another trying time as funds were in short supply. Years before the advent of any government assistance programs, the residence had to rely on the generosity of others to survive the economic downturn. In spite of the shortage of funds, it continued providing care during these difficult times thanks to the prayers and donations of individuals, communities, and church congregations.

In spite of its financial constraints, it didn't take long for the facility to outgrow its original three-story building in Belle Plaine. By 1917 planning had begun for a new addition that would allow for thirty more residents. The following year the three-story addition rose up on the southeast corner of The Lutheran Home's main building. In 1925 another construction project provided for a single-story addition to the 1918 project.

An increasing number of residents and an expanded array of services eventually put a strain on the existing buildings. However, it wasn't until 1951 that the residence underwent a far-reaching construction project. Commonly called the "West Wing," the new structure provided a new chapel, kitchen, dining areas, twenty-two beds for residential living, and a remodeled entrance and office space. Today the residence rooms remain in use and stand as the oldest part of the building on the Belle Plaine campus.

In 1961 the "South Wing" was created as part of yet another expansion project, this one to the tune of a quarter-million dollars. During the 1960s it became clear that the original building was no longer adequate for the facility's growing needs, and it was deemed to be beyond repair. In 1970 the original building was demolished to make way for a modern, two-story wing

Some of The Lutheran Home's residents, circa 1925.

with a chapel, kitchen, dining room, residence rooms, and offices.

The 1970s also saw the creation of the Hope Residence for individuals with mental retardation and developmental disabilities. Started in 1974, the construction was completed two years later. The project had been paid for entirely through private donations. In August 1977 the building was officially dedicated before a crowd of more than 1,500 supporters.

Home for the aged and orphans.

Construction projects continued and in 1996 the 20-acre Belle Plaine campus development began. It now offers the Boessling Lutheran Village Apartments; Kids Care Too, a child daycare center; and the Special Care Residence for people with Alzheimer's disease and dementia.

However, the folks at TLHA know that having top-notch facilities is only part of the equation when it comes to providing exceptional care. Having dedicated, caring employees is equally important. TLHA has been fortunate to have had several dedicated workers who have spent years, even decades, serving the residents of The Lutheran Home Association.

In 1924 Dr. H. M. Juergens became the "house doctor" and served in that capacity for forty-eight years. Martha Hertzberg was hired to serve as matron of the facility in 1933 and stayed in that position until 1949. Otto Schultz began his forty-one years of service in maintenance in 1935. And in 1941 Kathryn Turnblom Vatthauer began thirty-five years of service and took over as matron in 1949.

By 1954 thirteen people were on staff. In 1963 employees numbered thirty-six, and in 1970 there were sixty-two. With the continued addition of numerous other facilities and services since then, TLHA has welcomed a large family of workers. Today TLHA employs 742 people at its various locations, with 412 of them providing care for approximately 225 people on the Belle Plaine campus.

No one recognizes the hard work of these employees more than Michael Klatt, TLHA's president and CEO. "I'm very proud of our staff," Klatt says. "I am profoundly blessed to witness that in today's society of materialism, that there are people willing to dedicate their lives to a resident with Alzheimer's disease or a

Chaplain Dallas Miller shown leading a chapel service. Courtesy, Chuck Kajer, The New Prague Times.

person with profound mental retardation and who know that they will never get rich by doing this work."

With such a dedicated team on board and a campus that is continually being enhanced, Klatt has his eye keenly on the future. The strategic plan of The Lutheran Home Association for its Belle Plaine campus is to transform its present programs and services to meet the growing need for older adult services. Today 12 percent of Minnesotans are over the age of sixty-five. By the year 2030 more than 23 percent of Minnesotans will be sixty-five. The organization will be repositioning itself and the Belle Plaine campus services with the intent of creating a new model of senior care over the next decade. At the same time, TLHA is responding to the growing need for care in autism and other disabilities.

However, as TLHA and the Belle Plaine campus evolve, Klatt is determined to maintain the organization's core value, which began with Sophie Boessling—commitment to the care of the soul. "When people come to us, they come to us with a variety of profound afflictions, physical and mental disabilities, and emotional distress," Klatt says. "The love we share as the caregivers and the environment of healing is so very important, but what we *really* provide—a place where the soul is cared for and nourished and God's word is shared—makes this organization unique and defines us as a ministry."

From left to right: Representative Ray Cox; Minnesota Governor Tim Pawlenty; Michael Klatt, president and CEO of TLHA; and Kim Wasiloski, nursing assistant/registered, visit with Wilmer Malz, resident of The Lutheran Home's Belle Plaine campus.

The first appearance of anemones always declares that another Minnesota winter is giving way to spring. Anemones, which are tiny plants, only four to eight inches tall with five-petaled white flowers, grow at the edge of woodlands along roadways. They thrive in Minnesota's spring season. Courtesy, Steve Foss

MAYER ELECTRIC CORPORATION

Born of immigrant parents and gifted with an analytical determination to succeed, Richard A. Mayer (1916–2003) was the founder of Minneapolis-based Mayer Electric. A native New Yorker, Dick moved to California in the early 1940s. It was there that he worked as an engineering subcontractor for the Honeywell division that developed the B24 autopilot.

In 1946 Dick moved to Minnesota with his parents Ernest Richard and Bertha (Haas) Mayer and his brother, Ernest. There he lived a life of service to his family, community, and to his employees. In 1998 the electrical industry recognized Ernest Mayer, educated at the University of Minnesota and Dunwoody Industrial Institute, for fifty years of service as an electrician, contractor, and electrical inspector.

The brothers, Dick and Ernie, started informal contracting in the late 1940s by creating Mayer Electric which they later renamed Mayer Brothers Home Builders, Mayer Engineering, and finally, Mayer Electric Co., Inc. This company installed television antennas, built a few homes in Bemidji and Fridley, and took on electrical service calls. The business was at the cutting edge of wiring for the Minneapolis computer industry's printed circuit houses and electrostatic finishing companies.

The company forged upward as a base of school district and municipal contracts provided increased volume and employment. Dick never married, but Ernie and his wife Vivian had four children.

Jerry and Cherie Holm.

The brothers developed a reputation of honesty and hard work, forming a loyal network of employees who recognized their integrity.

As 1977 approached, Dick began to strategize for the future while feeling a need for change. He contemplated closing the doors of Mayer Electric and retiring. The jobs grew sparse and four electricians remained: Floyd Forsman, Myron Nash, Jerry Holm, and George Shaffer (who was nearing retirement age himself).

While talking with Jerry Holm in 1977, Dick made an offer to sell the business to the employees. Jerry turned to his co-workers who were young fathers with little time to grow savings accounts. All the men were members of Electrical Worker's Local 292, so they couldn't be contractors—but their adventurous wives could own the company.

Incorporation followed with Cherie Holm becoming president; Bonnie Forsman, secretary; and Thelma Nash, treasurer. Each woman went to her bank and took out a $5,000 loan. The husbands committed to sweat equity for the remainder of the purchase.

Mayer Electric Corporation opened its doors in September 1977 with its new owners facing the first payroll, a union strike, and the needs of growing families. The Mayer brothers stayed on for a year as teachers, guiding them through the entrepreneurial process. The transition was invisible to clients.

Jerry Holm became the electrical estimator early in the development of the new company. His willingness to please customers and commitment to the Mayer code of ethics has led the company to its present strength. The corporate officer's ability to make sound decisions and stay with them to the end proved to be worthwhile.

Today Mayer Electric Corporation has sixty employees and a broad base of construction, repair, and maintenance clients. Several accounts including Ritchie Engineering, Central Container, Creative Carton, Copper Sales, Avtec, Inc., Beckman-Coulter, and Hiawatha Rubber rely on Mayer Electric for solutions in times

Myron and Thelma Nash.

Richard and Ernest Mayer.

Richard A. Mayer.

of emergency. As in the stock and bond markets, it takes both maintenance and construction projects to carry Mayer Electric to financial stability.

Project size has grown and many Twin Cities-area businesses have benefited from doing business with Mayer Electric. A connection with the Gramercy Corporation led the company to its largest high-rise wiring contract, which was completed in 2004. That same year, Wirth Companies of Minneapolis pioneered the largest indoor water park in Minnesota named Grand Rios. Wiring by Mayer Electric and project management by Adolfson & Peterson, Inc. proved to be an enormous advantage to the owner. Long-term and trustworthy relationships are also enjoyed with general contractors such as Adolfson & Peterson, Inc., Grand T Builders, Frana and Sons, Inc., Greiner Construction, St. Paul Construction, Stahl Construction, and many others.

Low voltage wiring services may now be contracted directly from Mayer Electric. Property managers such as Liberty Property Trust, Northco Corporation, and Gittleman Management ride high on the favored list of service contracts. Time brought technology changes within Mayer Electric's infrastructure, therefore enabling it to compete with larger electrical contractors. An innovative online client-contractor interface with

Northwrite provides service clients with product-specific information.

Mayer Electric has been a benefactor to several nonprofit organizations, with the Jaques Art Center in Aitkin and the James Ford Bell Museum of Natural History at the University of Minnesota being high on its list of favorites. The sculpture titled *Encounter* by Ian Dudley, which stands at the entrance of the Bell Museum, was a gift from the company.

The baseball and tennis court lights, public sculpture, and other community projects in the Holm's home town of Aitkin are the result of Mayer Electric's corporate sharing. This sense of community involvement dates back to the 1970s when the firm helped support Champlin's athletic park and recreation programs.

Expectations of greater strength and determination are upheld by the new generation. Allan, Kelly, and Martin Holm are assuming their parents' positions in the company. Two members of the family's third generation have completed electrical trade school and are waiting to begin their apprenticeships. Mayer Electric's work force is diverse in talent, ethnicity, and specialties. One-third of Mayer's employees have been employed for more than fifteen years with the company and father-son teams are common.

Mayer Electric Corporation is in good hands as it faces the challenge of doing business in today's world—as a family.

Left: Floyd and Bonnie Forsman.

Below: Allan, Kelly, and Martin Holm.

MINNESOTA GRAIN, INC.

From its humble beginnings in a small farming town to its present status as a giant in the industry, Minnesota Grain, Inc. remains a true family enterprise. Anthony Robert Mensing and his son Donald started the company nearly a half century ago and watched it flourish under their strong leadership. Now Tom Mensing and his son Michael are building on that success to establish a modern company whose old-fashioned values never go out of style.

Originally known as Minnesota Grain Pearling Company, Anthony and Donald Mensing founded the business in 1956 as an offshoot of their Minnesota Malting Company in Cannon Falls. Workers processed barley into malt and sold it to breweries and distilleries. The barley used for pearling at Minnesota Grain was a by-product of the grain after it was cleaned and graded. This cheaper grade feed barley was processed and sold primarily to canned dog food manufacturers throughout the United States.

A new era began for both enterprises in the 1960s. Having outgrown its location next to the malting business, the pearling company moved in 1966 to a new and more spacious facility in East Grand Forks. That same year Tom Mensing joined the family company full-time after college. Tom's grandfather had died in 1958, and now his father Donald was overseeing the operation of both companies. Tom started out in the sales department. He worked hard to prove himself, and his efforts were rewarded when he became president of the pearling company in 1970.

Although Tom seemed destined to have a future in the family business, he needed some convincing. If not for the wise counsel of a family friend, history may have been written quite differently. "I originally envisioned going to work somewhere else after I finished college. I had been interviewing for industrial sales jobs," says Tom Mensing. "Dr. Robert Haman was president of the malting company at the time, and he had known me since I was eight years old. He called me and said, 'Aren't you going to come to work here?' He said I would end up joining the family business eventually, so why not start today?" Dr. Haman became his mentor and Mensing ended up succeeding him as president of Minnesota Malting in 1974.

Tom Mensing, president of Minnesota Grain.

The canned dog food segment of the pet food industry began to decline in the late 1970s, and Minnesota Grain Pearling Company shifted its focus to traditional foods. To diversify its product line, the company added cereal grains like wheat and rye to its already profitable barley market.

As president, Tom made his first major acquisition in 1972 when he purchased the company's biggest competitor, H. C. Knoke in Chicago. With this purchase Minnesota Grain Pearling became the largest supplier of pearled barley in the country, a position which the firm still holds today. In 1983 it closed the Knoke Company and expanded its East Grand Forks operations. During the late 1980s and early 1990s, the production plant

warehouse and office facilities were enlarged and new equipment was purchased. The plant now has the capability to pearl, cut, grind, steam, flake, and toast grains.

In 1997 the name of the company was shortened to Minnesota Grain to better reflect its multi-faceted product line. The firm markets several kinds of grain, including barley, rye, wheat, oats, and yellow mustard. Although it primarily sells grains for human consumption, about 25 percent of its barley products are still sold to major canned dog food suppliers.

Michael Mensing, the fourth generation Mensing on the staff of Minnesota Grain Pearling in Cannon Falls.

Mensing owns two grain elevators, one of which is located in East Grand Forks next to the processing plant. The other, in North Dakota, is in the heart of the area where durum wheat is raised. Durum is used to make puffed wheat in the cereal industry, and Minnesota Grain is one of the leading suppliers. The company also purchases rye from the United States, Canada, and the European Union, and sells the raw product to distilleries. The rye is transported via ships, barges, or trains to a storage site in Louisville, Kentucky, where it is sold and shipped to distilleries.

Tom Mensing became the sole owner of Minnesota Grain in 1983. His son Michael joined the company in 1996 and represents the fourth generation in the family business. He currently serves as executive vice-president of sales. Another major addition is Rick Fields, who came to the company in 1999 and is the current president. Soon after his arrival, Fields launched a trading and merchandising division to manage the procurement of raw product, and to supply unprocessed grains to the food and distillery businesses.

Several Minnesota Grain employees have worked at the company for thirty or more years. Tom said their longevity speaks well of the company and its emphasis on teamwork—and having a good time. "After thirty-eight years, it's still fun for me," he says.

In 1986 a personal tragedy forced Mensing to rethink his priorities. Relationships, not work, became his main focus and remains so to this day. "Beth, my wife, died of a brain aneurism while she was brushing her teeth one eve-

ning," Mensing says. "I was stunned. After that I changed my position about what's important in life and donated more time to charities and my family, which expanded my horizons."

One of the charities he became heavily involved in was the National Kidney Foundation. Beth had been a transplant nurse who worked with many kidney dialysis patients. At the time, dialysis was an arduous process and families needed somewhere to stay while their loved ones underwent the time-consuming treatment. Beth's dream was to start a "Kidney House" for those families with kidney disease. When she died, Tom took on her dream project. He was instrumental in buying an old hospital and refurbishing the fifty-six rooms to become temporary lodging for families. The facility was built in downtown Minneapolis and named the Beth Mensing Memorial Kidney House, in her honor.

Tom is now remarried. His wife Suzanne Bates runs her own interior design business, called Design Syndicate, Inc. He is proud of his four children and two grandchildren and hopes that someday there will be a fifth generation in the family business. "The company has a wonderful future. There aren't a lot of companies today that can claim four generations of management from one family and still be operating as successfully as us," Mensing says. "For this I am grateful and I thank my many employees and friends who have helped make some of my dreams come true."

The plant's reception office.

Minnesota Grain's East Grand Forks plant.

MINNESOTA PRODUCE INC.

The late 19th century wave of European immigrants who were searching for a better life in the United States included many Sicilians from the town of Termini Imerese. Among them was Agostino Piazza Palotto who, along with several brothers, found employment with the country's rapidly expanding railroad industry. Once established in Minneapolis, Piazza (the additional surname of Palotto was dropped during immigration) sent for his wife Rosaria Badali and their seven-year-old son, Leonardo Piazza.

Another son and three daughters were born to Agostino and Rosaria in Minneapolis. A skilled gardener who was used to feeding a family using what he produced on his tiny plot of land in Sicily, Agostino utilized his skills during the temperate Minnesota summer. He began growing the vegetables that he was familiar with: tomatoes, peppers, eggplant, and squash.

Following the Sicilian marketing method, he loaded his horse-drawn wagon and developed a domestic customer base in the neighborhoods of Minneapolis. A prolific winemaker, his garden was also adorned with grapevines on trellises. The

Frank Battaglia (far left) in a Faribault fruit store with Dave Piazza's sons, Gus and Sam.

Richard Piazza took shippers' quotes and customers' orders in the early days of Minnesota Produce.

Sicilian culture thrived in Minneapolis, and its sister city of St. Paul, because so many other families from Termini had found the opportunity they sought in these quaint communities. Several of Agostino's brothers had found their opportunity in Chicago, and young Leonardo visited his relatives there often. Imitating his cousin

of the same name, young Leonardo also took the Americanized nickname "Dave."

During Dave's early years in Minnesota, a relative of his mother, Provvidenza Badali, was sent from Termini to Winnipeg to live with her uncle. Employed at a young age, working the railroad route from Minneapolis to Winnipeg, Dave got to know Provvidenza. One day, breaking all tradition, Dave arrived home from Winnipeg with Provvidenza as his wife. From this union of Dave and Providence (Provvidenza used this as her Americanized name), and the blending of the Sicilian and American cultures, sprang forth offspring who were endowed with an entrepreneurial spirit.

In partnership with like-minded fellow members of the Italian American community, Dave became involved in various business ventures. The most notable was the Café di Napoli which opened for business on December 8, 1938 in downtown Minneapolis. Upon return from military service in World War II Dave's third son, Joe, assumed ownership of the restaurant and managed it for the next sixty years, eventually involving his daughter Nancy and his son David.

Joe's older brothers, Gus and Sam, became involved in another of their father's ventures—the D.L. Piazza Company, a produce brokerage business. Upon

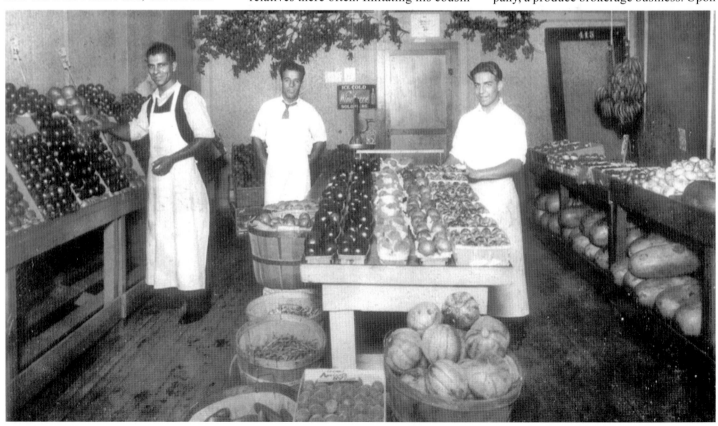

Taken at the Rock Island Terminal in Minneapolis, upon Paul's return from his junior year overseas at the Wimbledon School of Art, this 1972 photograph was used to promote the Minneapolis College of Art and Design's travel abroad program.

his return from World War II military service, Dave's fourth son, Richard, also began his career with the company. However, the business shut its doors in the late 1950s.

Richard followed his father's many examples and together with a financial partner, Robert Stillman, opened a new brokerage company, Minnesota Produce, in May 1961. At that time, over-the-road truck transportation was replacing railroad service as the dominant means of shipping fresh produce to market. So not only did Richard continue to handle rail shipments from California that carried items such as lettuce, celery, carrots, and oranges to customers in the Twin Cities, but he also began to develop relationships with customers outside of the metropolitan area that could only be reached by truck. The use of vehicles also enabled access to other shipping areas such as Texas, Florida, Washington, Idaho, and Michigan. That allowed Minnesota Produce to better serve its customers' fruit and vegetables needs. Minnesota Produce continued to grow due to the personal values of its owners and its willingness to grow its sales force.

Late in the summer of 1974 Richard's second son, Paul, while working in the stained-glass trade, recognized the opportunity and benefit of working for his father. When he found out that one of the

company's original salesmen was retiring, Paul asked for a job. Having grocery store produce department experience and rudimentary knowledge that he picked up from listening to his father's conversations with business associates, Paul joined the company in October 1974. He was twenty-two at the time and had just married his wife, Marilyn Nesenson.

When Paul came onboard, the company's office was still in its original quarters in the Rock Island Railroad Terminal in downtown Minneapolis. He learned a lot from the established produce wholesalers, a colorful and seasoned group of people who were capable of teaching newcomers like Paul some valuable business lessons.

A year later Paul received a phone call from his alma mater, the Minneapolis College of Art and Design, and was offered the opportunity to reenter the graphics field. In search of his destiny, Paul decided to accept the offer. However, after the first day at his new job, he began to feel the heart-crushing sensation that he had made a mistake. Viewing this as an opportunity to learn a real life-lesson, Paul returned to work for his father with the realization that he was destined for family business. He was humbled by his father's wisdom when he later learned that his employment at Minnesota Produce had never been terminated, but that his dad had only placed him on a leave of absence.

Within a year and a half of Paul's employment, the Minneapolis Industrial Development Commission condemned the Rock Island Railroad Terminal to construct the Metrodome. The only brokerage business on the Rock Island Terminal, Minnesota Produce relocated to its current

A delivery truck from Leonardo Piazza's produce wholesaling business in Chicago.

office just west of downtown Minneapolis on Wayzata Boulevard in July 1976. The wholesalers—Northwest Produce Supply, Malat Produce, Wholesale Produce Supply, and Twin City Produce—moved to the newly built Kasota Fruit Terminal. They were joined by Bergin Fruit, which relocated from the soon to be demolished Sixth Street market in Minneapolis.

The larger office space allowed for expansion of the sales staff, and within the next ten years the company reached its peak of eight salespeople. As is typical of the produce business, employment terms were at-will for both the employer and employee. As sales personnel gained exposure to the broader industry through employment at Minnesota Produce, it was common that eventually they would migrate to other produce companies in search of the ideal job. This natural attrition, combined with the affect of Richard's eventual part-time status as he moved toward retirement, caused the sales-force to shrink with few new prospects being recruited.

Then in October 1995 Richard suffered a disabling stroke and his active career ended. From that time, until his death in March 1998, he passed on all his knowledge about the company to Paul. The company continued to move toward a climactic moment with the departure of the only other remaining long-term salesman, Jim Cranston, who in his prime had produced substantial sales and profit. In June 1997, following the departure of the sole remaining short-term salesperson, Paul found himself alone. It was just him and the firm's two bookkeepers, and the viability of the company was threatened.

Recognizing the value of the business' thirty-six year history, and sustained by his father's spirit, Paul decided to trust in Divine Providence and keep going straight ahead. Unwilling to detach himself from that history, Paul retained both bookkeepers in whom so much of the company history was embodied. Cathy LeClaire, the same age as Paul, was also third generation in the business. Her grandfather had kept the books for Paul's grandfather, and her mother was her predecessor at Minnesota Produce. Michelle Gangl was the daughter of one of Robert Stillman's close friends, a successful produce retailer. Paul's faith was rewarded and new sales-staff and transportation managers helped to rebuild the company.

Throughout the history of the firm the marketplace continued to change. Growing up in a household in which his father received many business-related phone calls, Paul became familiar with the names of many shippers and receivers. A few years into his career Paul remembered feeling alarmed as many of these familiar businesses closed one by one. He was just beginning to realize that companies, reflecting their human founders, had a finite lifetime. But also reflecting the human spirit, new businesses were regularly springing to life.

Paul was only one member of the newest generation, and ultimately foodservice and processing companies owned by his peers became the core of Minnesota Produce's business. Paul also had colleagues in the brokerage business and, to the extent possible, he always chose to maintain cooperative rather than competitive relationships with them. The greatest threat to the business was the increasing "corporatization" of the industry. Some customers became so large that they could buy direct from shippers and load their own trucks. Others were acquired by large national distributors who desired a presence in the Twin Cities market, and national policy restricted purchasing to corporate buying offices. As some large customers disappeared from the accounts receivable roster, newer, younger, and smaller customers had to be found to replace them. Many of these came from the growing Asian community in the Twin Cities.

Not only did Paul's third generation experience sustain the business, but other family members who possessed Dave Piazza's entrepreneurial spirit have also achieved great success in other ventures as well. Richard's youngest brother, Jerry, after thirty years in the kitchen of the Café di Napoli opened his own business called Piazza's Ristorante. Jerry personally manages the kitchen, while his wife Marlys oversees the serving staff, and many young great-nieces and great-nephews have been given employment opportunities. That family-friendly approach reflects the early years of the Café di Napoli when their parents and grandparents had the same opportunity for employment. The embodiment of his gardening-loving grandfather, Agostino, every summer Jerry has grown tomatoes, peppers, eggplant, zucchini, and basil outside of the restaurant kitchen door, earning him local fame. Joe's third daughter Nancy, is another who went into the restaurant business. After spending most of her adult life working at the Café di Napoli, Nancy eventually opened her own restaurant named Pomodori.

Before his death, Richard had transferred his stock in the company to Paul. Robert Stillman, in his capacity as financial investor, had advised that as Paul gained managerial control of the company, he should retain as much equity in the corporation as possible. This practice eventually enabled him to purchase Stillman's stock. And so, on October 31, 2002 Paul became the sole stockholder and succeeded Robert Stillman as president. In turn, Marilyn Piazza succeeded her husband Paul as vice-president and became the business administrator of Minnesota Produce. Running the company like she ran her own household, Marilyn quickly repaid the company's debts and found ways to reduce operating expenses. That allowed Paul to focus on sales and generating profit along with the company's three current salesmen, Phil Klint, Jeff Goldish, and Ken Meyer.

Minnesota Produce has overcome many obstacles and Paul is honored to be at the helm of this third generation company. A humble and modest man, he considers his greatest success to be that he has adhered to the Fourth Commandment—honor thy father and thy mother. It's this commitment to family that has allowed Minnesota Produce to overcome the trying times and become one of Minnesota's true success stories.

Twin City Celery was a joint venture between Dave Piazza and Phil Malat. The Malats also had their roots in Termini Imerese, much like other local third generation produce families such as the DeLisis and Zuccaros.

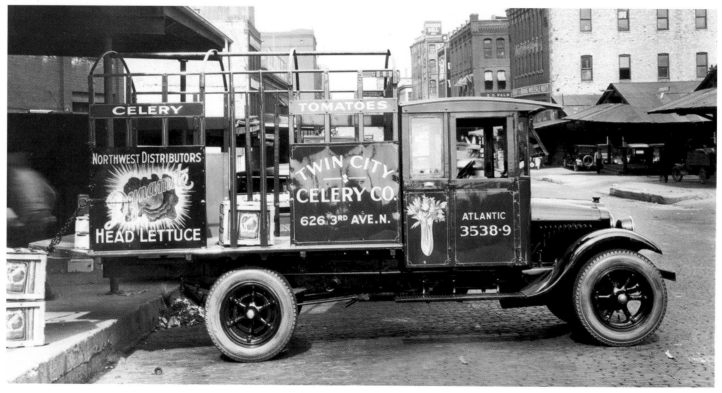

Postcard scene from early 1900s of families enjoying a casual summer day.

MURPHY WAREHOUSE COMPANY

In 1904 a St. Paul Irishman named Edward L. Murphy, Sr., bought a team of horses and a wagon. While he saw an opportunity to create a company, he probably didn't foresee that he was launching a family business and a legacy that would endure for more than a century.

Edward's business has evolved into what is now Murphy Warehouse Company, one of the Midwest's largest asset-based logistics companies, and Murphy Rigging and Erecting, a premier rigging and millwright organization in the region. Today these multi-million dollar operations employ approximately 225 people in multiple locations, operate more than 2 million square feet throughout the Twin Cities, and serve more than 200 customers nationwide including Fortune 500 and start-up companies.

Murphy Warehouse Company works with its customers to help them devise the most efficient and cost-effective way to manage, store, and move products throughout the entire supply chain, from raw materials to finished goods, resulting in "just-in-time" deliveries to production lines, distribution centers, stores, and consumers. The company offers its expertise across a diverse range of industries, from food and beverage to hospital supplies, retail to recreational, automotive to power generation, and paper to publishing. The company's services include warehousing, distribution, transportation, cross-docking, and fulfillment. It also offers international logistics through its Midwest International Logistics Center, which includes a designated U.S. Customs examination station and a Foreign Trade Zone which allows for modifications to products before they reach U.S. soil.

Murphy's fleet of trucks in the 1930s.

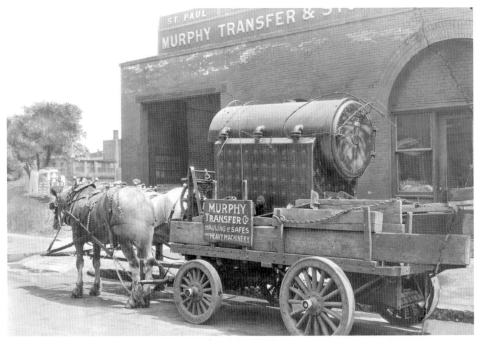

Murphy Transfer & Storage, circa 1919.

Richard Murphy, Jr., president and CEO, is currently the fourth generation to run the enterprise. "As a family we have come to recognize that our history is, in many ways, one of our most precious assets," says Richard, who continues to build on his family's legacy of strong customer service and continual innovation to meet the needs of an ever-evolving marketplace.

When Richard Murphy's great-grandfather, Edward, bought his horses and a wagon in 1904, St. Paul was a growing industrial center situated along the Mississippi River. Operating out of the family home on Front Street, the business began as a city delivery service. Murphy hauled goods between companies and off paddleboats on the Mississippi River, and delivered building materials to the new state capitol construction in St. Paul.

As demand grew, Edward continued to reshape his business with the introduction of motorized truck service in 1910

—one of the first such uses of these vehicles in St. Paul. But both triumph and tragedy lay ahead for the Murphy family —the Great Depression, a violent labor uprising in Minneapolis during the 1930s, the post-World War II economic boom, changing technologies and business practices, the trauma of transportation industry deregulation in the 1980s, and many generational handoffs. "I believe the Murphy family has survived because of our core values: courage and imagination in taking chances; pride, persistence, and humility during good and bad times; and above all, integrity in every matter," says Richard.

Though much has changed since 1904, Murphy Warehouse Company continues to operate under the same principle as its predecessor companies. It works with its customers as partners

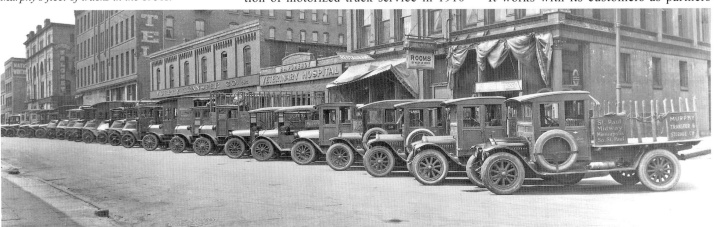

and develops creative solutions to maximize clients' strategic effectiveness through logistics services.

The business handles more than 3.4 billion pounds of products each year via 76,000 truck and 10,000 rail car shipments. More than 25,000 orders per month ship from Murphy distribution centers to customers nationwide—twenty-four hours a day, seven days a week.

The company handles products throughout their life cycle, from raw materials to in-process goods to finished products for food, consumer, or industrial markets. And it offers a range of services, including transportation, warehousing, consolidation, cross-dock, pool distribution, and other services such as packaging and labeling. According to Richard, even customers who serve similar industries or manufacture similar products have different logistics needs. "No two customers are the same," he says. "That is why each one is assigned a dedicated service professional to manage their logistics needs."

Murphy understands that a strong supply chain system is important to the health of a customer's business. That is why Murphy is ISO 9001 and OSHA MNSHARP Certified, ASI Inspected, and U.S. Customs Bonded. Since the company handles more than 35,000 different types of products, inventory control is a core

Murphy offers transportation services that cover North America.

Laurie Murphy, Richard Murphy, Jr., and Dick Murphy, Sr.

competency. The firm's high-value products are counted daily by a dedicated inventory control department which reports solely to the executive management.

With customers in the food and medical industries, Murphy's strict lot and rotation controls are critical for quality control and product-tracing purposes in the event of consumer recalls or product quality testing programs. All warehouses are operated under tight "plant-grade" sanitation standards and rely on scrutiny from in-house and customer assessments, along with independent, unannounced inspections from the American Sanitation Institute.

Depending on customer needs, Murphy can provide dedicated warehouse space in one of its facilities, custom build a distribution center in a key location, or operate a company's existing facility to manage its logistics needs—a solution that makes sense for an increasing number of businesses. In fact, Murphy built a 400,000-square-foot distribution center on land next to a customer's plant that was also designated as an EPA "Super-Fund" site. The project turned a polluted site into a busy, tax paying property and saved the customer more than $700,000 a year in local transportation costs.

In this case, Murphy shares part of the space with the customer to support the logistics needs of other companies. Unlike a traditional real estate developer, Murphy has the ability to offer the customer more or less space within the distribution center as its business and requirements fluctuate. This "movable-wall" lease, specifically designed by Murphy, worked well with this customer's long-term business strategy.

When Murphy builds or manages a customer's distribution center, its multimodal transportation services and truck fleet support it. "When a company allows us to operate its logistics functions, it can focus on its core business—not on man-

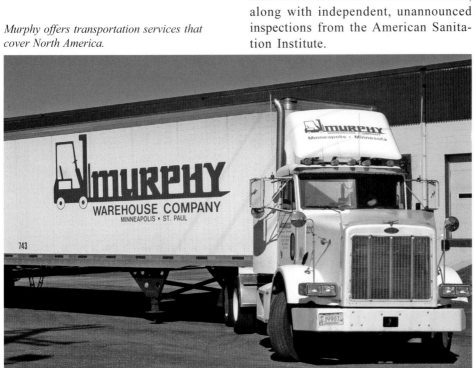

aging freight," Richard says. "We strive to offer the best value to our customers, squeezing every cost and extra minute out of our customers' supply chains."

Regardless of the scope of the assignment, Murphy offers its customers real-time access to inventory, order, and receipt information via the internet, full electronic EDI support, and global positioning system technology. Though customers have immediate, remote access to inventory and order activity, the security of every last piece of product is equally important. "When a customer contacts us to coordinate the delivery of an order, security verification measures are in place to ensure the integrity of our customer's inventory," Richard says. "Similar to a bank, we have strict control procedures to ensure that not just anyone can access a customer's inventory or place an order."

Murphy provides its international customers with more flexibility to ship and receive goods through its Midwest International Logistics Center. Working closely with the U.S. Department of Homeland Security, the site offers a U.S. Customs examination station, a customs container freight station, and a U.S. general order facility. To ensure that products meet requirements to enter the United States, Murphy works daily with onsite U.S. Customs agents and personnel from the Food and Drug Administration, the Bureau of Alcohol, Tobacco, and Firearms, and the Drug Enforcement Administration.

In 1989 Murphy activated the area's first general purpose Foreign Trade Zone (FTZ), where goods are considered to be on foreign soil and can be worked on for

The company's "paperless" warehouse utilizes RF and scanning technology.

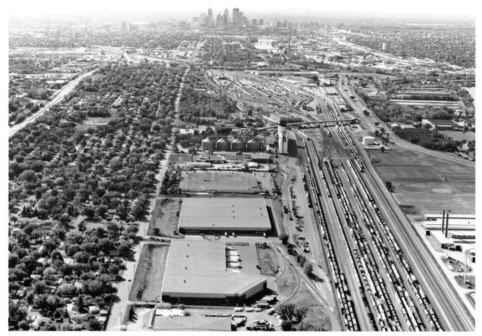

Two of Murphy's state-of-the-art distribution centers in Fridley, Minnesota.

value-added activities and/or customs corrective measures. "We have helped many companies over the years with issues like country-of-origin marking, tariff and quota challenges, export programs, and quality control/consumer product standards compliance," Richard says. In fact, U.S. Customs will often direct companies to work with Murphy's FTZ personnel to correct problems with their imports to reduce and/or eliminate financial penalties and allow goods to enter the country smoothly.

International customers also look to Murphy for logistics support to get its products to consumers across the United States. One Canadian-based camping equipment manufacturer relies on the firm to distribute its goods to all Wal-Mart, Target, Gander Mountain, Dick's Sports, and REI retail stores across the country. Another customer imports testing equipment from Europe and uses Murphy's FTZ to distribute throughout the United States and Canada. It pays duty only as orders are shipped, without having to go through the duty-drawback procedure.

The company runs extensive rail-to-truck, rail-to-rail, and truck-to-rail transload operations on the Burlington Northern and Santa Fe Railway, Union Pacific Railroad, Canadian National Railway, Canadian Pacific Railway, Progressive Rail, and Minnesota Commercial Railroad sites. In addition, the two major rail-intermodal yards in the Twin Cities lie within two miles of a Murphy facility.

The business operates six warehouses equipped with rail sidings—four indoor and two outdoor facilities. It offers a more cost-effective and secure alternative to truck-based shipping that brings product from remote locations into key markets—a big plus for the many paper companies that ship heavy paper, pulp, and other forest products. As the second largest rail user in the upper Midwest today, close to half of all Murphy rail loads carry paper-related products; the other half involves beverages, food, building materials, furniture components, and water treatment supplies.

Given all of that paper, it's no surprise that Minnesota is the fourth largest printing market in the U.S., and area printers and paper suppliers look to Murphy's storage and "just-in-time" capabilities. Murphy's rail, warehousing, and truck transportation services allow many remote plants to store finished paper rolls for delivery to printers throughout the nation and region. Its location in the Twin Cities offers access to multiple transportation resources which are needed to meet the paper industry's tight schedules.

Murphy's mass merchant retail support, via a 160,000-square-foot distribution center, helps customers such as xpedx (a division of International Paper)

supply all 1,300-plus Target stores across the country with materials that are needed to run the stores—including uniforms, bags, sales and promotional materials, and training manuals. Murphy also offers retail supply chain services to food retailers. One example includes creating end-of-aisle, sales promotion displays and multi-vendor pallets for area grocery stores. Murphy combines complimentary products and brands, such as pastas and sauces, or chips and condiments, onto display-ready pallets, which are in turn cross-docked and distributed to stores.

Food manufacturers such as United Sugars, Anheuser Busch, Malt-O-Meal, and Amport, also look to Murphy for support, storage, and shipment from their secure, temperature-controlled facilities to guarantee freshness of both raw and finished products. Some food industry customers, including Dakota Growers Pasta Company, also rely on the company's strict inventory control expertise to provide plant support and transportation management of all outbound shipments.

In the medical arena the firm distributes customized surgical kits for various hospital teams, ensuring "just-in-time" delivery to surgical suites. The company also disseminates medical and healthcare supplies to hospitals, primary care facilities, and nursing homes.

While many logistics companies may have limited capabilities in moving

Murphy Rigging and Erecting gave a two-ton bronze eagle sculpture an assist in flight to its new home at Lookout Park in St. Paul.

larger or heavier goods, Murphy is fully equipped to transport goods of any weight—with no limit. In these cases, Murphy Warehouse Company's sister company, Murphy Rigging and Erecting, becomes a true partner. The business is a rigging/millwright contractor with 100 years of experience. It specializes in machinery moving and erecting, millwright services, plant set-ups and relocations, maintenance, heavy lifts, and the handling of objects such as delicate art and medical equipment.

A typical customer today may be a high-tech medical company or hospital that is installing MRI units or sterilizers, a top-secret government supplier, an energy plant that is installing new equipment, or a manufacturer with many assembly lines and tight schedules. "Rigging is a mixture of science, art, and experience," Richard says. "Most of the people working for Murphy Rigging have learned the business from their fathers, brothers or uncles." Many of the Twin Cities' most notable features—from the large, concrete lions poised at the front door of the Minneapolis Institute of Arts, to the KSTP-TV radar dome, to the tunnel air exchange units for the Hiawatha Light Rail line—were supported by Murphy Rigging and Erecting's services.

In 2004 Murphy Rigging and Erecting transported and lifted a two-ton bronze Eagle sculpture into place at its new home at Lookout Park in St. Paul. "A core value that the Murphy family lives by is giving back to our community," says Richard. "It has blessed us in business and allowed us to support the lives of so many other community members who are employees, suppliers, customers, and friends."

Although the legacy of the Murphy family of companies began more than a century ago, the family continues to meet and exceed the demands of customers in an ever-changing business world. After all, the company's success and longevity can be attributed to its commitment to innovation and customer service. Murphy Warehouse Company and Murphy Rigging and Erecting are two of the most trusted names in their respective fields and are focused on using their expertise to help business customers grow and prosper.

Murphy's retail supply chain support operation with pick and pack services.

SEASONAL CONCEPTS

Most people go on vacation to stop thinking about business. But it was during a trip to California that a seed was planted in the mind of Arthur Stillman—an idea for a business that would eventually grow into a multi-million-dollar enterprise called Seasonal Concepts. On that sojourn, he ran across a wholesaler who specialized in selling plastic flowers and artificial fruit. Arthur, who had been the owner of a small chain of grocery stores thought, "I ought to do that."

Once the entrepreneur returned to his home state of Minnesota, he got started. In 1961 Arthur opened two retail locations—one in St. Paul and the other in Minneapolis. Originally called Flower City, the stores carried plastic trees, flowers, plants, and more.

Soon after he started the new venture, Arthur invited his son Marv to work with him. To help grow the fledgling business, the father-son team turned to Carl Wolk. Like Marv, this young man was a recent graduate of the University of Minnesota. In addition, he was a longtime friend of the family. Wolk jumped at the chance to be in business with his good friend Marv and became a partner in the start-up venture.

The partners worked together for decades, with each one tackling a different aspect of the business. Marv handled

An exciting array of merchandise for the home awaits at Seasonal Concepts.

the financial end of things as well as the long-range planning. Wolk found his niche in importing products from the Orient. Under their supervision, the firm grew rapidly.

In 1963 they launched additional stores in Tulsa, Atlanta, and St. Louis. It didn't take long for the business to earn a reputation for its natural-looking, durable Christmas trees. When the firm was just starting out, it offered about fifteen varieties of artificial trees ranging from six to seven feet in height and carrying a price tag of $39 to $79. Over the years, the company began branching out with other types and even added pre-lit trees to its offerings. Now, the renowned Christmas tree sellers boast more than 100 varieties of trees soaring up to eighteen feet in height and ranging in price from $59 to $2,000.

With the popularity of its Christmas trees, it's no surprise that the firm's sales skyrocket during the holiday season. During Christmastime employees can sell more than 34,000 trees. In an effort to increase revenues during the slower summer months, the partners added patio furniture to the product mix in 1978. The plan took off and its patio furniture business is now the second largest in the nation with sales accounting for approximately $36 million annually.

Back in the 1960s Wolk and the Stillmans were happy to be bringing in between $200,000 and $250,000 per store each year. Today each of the firm's sixteen locations gross an average of

more than $2.5 million annually, for a company-wide total of more than $44 million. Wolk credits Seasonal Concept's success to several things, including high-quality products, impeccable customer service, top-notch employees, and a commitment to staying on the cutting edge with innovative products and services.

For those looking for a traditional Christmas, Seasonal Concepts features a fantastic collection of nutcrackers, Santas, and snowmen.

Seasonal Concepts carries a beautiful selection of angels and nativity sets.

In 1983 the firm implemented the Christmas on the Mall program to make its products more readily available to holiday shoppers. Seasonal Concepts began contracting with major malls throughout the country to open retail shops from September through the first week in January. The concept met with immediate success and Christmas on the Mall now boasts contracts with about thirty major malls around the nation from California to New York.

Making it all happen are more than 300 full-time employees who work diligently to provide the highest-quality products and service. And although Seasonal Concepts has evolved into a large-scale business, Wolk is proud to say that employees are still treated like family members. Many workers have been on staff for thirty to forty years.

Some of those employees may remember the days when the start-up didn't even have an on-site warehouse. Today the company's Minnesota headquarters are housed in a facility that occupies more than 100,000 square feet and includes its own warehouse. Wolk insists that the attached warehouse helps streamline activities and improve efficiency. The firm also has warehouses in several other locations, including Des Moines, Tulsa, and Kansas.

In addition to holiday decor, Seasonal Concepts specializes in casual and outdoor furniture, as well as home accessories.

Back row, standing: Todd Swiler, Matthew Wolk, Marvin Burstein. Front row, sitting: Marvin Stillman and Carl Wolk.

In addition to adding warehouses, Seasonal Concepts has continually added new retail locations to its roster of stores. Today those stores number sixteen and include five in Minnesota, two in Iowa, two in Kansas, one in Oklahoma, three in Missouri, and three in Georgia. Wolk boasts that they have never had to close a single store in the company's long history —a true mark of success.

Arthur Stillman passed away in the late 1980s and was unable to witness the tremendous success of the small company he started more than forty years ago. However, his legacy continues to live on. His son, Marv, and Carl Wolk learned nearly everything they know about running a business from the eldest Stillman. They fondly remember his words of advice that included: "Always try to associate with good and honest people;" "When you attain your goals never forget the people who helped you;" "Make sure your relationships are honest and truthful, and try to listen instead of hurting people's feelings;" "Always remember that you have an obligation to the people you employ and serve;" and "If you are going into business, talk to everyone and get as much information as you can."

Following Arthur Stillman's passing, Carl Wolk and Marv continued to run the company with the elder Stillman's business philosophy in mind. Marv retired from the business in 2001, leaving Wolk at the helm as general manager. The energetic Wolk has no plans to retire and recruited a team of managers, including company president Todd Swiler, to help achieve his goals. The current management team is eagerly working on an ambitious four-year growth plan that includes opening an additional seven stores. And of course, Wolk is dedicated to keeping Seasonal Concepts on the cutting edge with innovations that will keep customers coming back for more—no matter what season it is.

UNIVERSITY OF MINNESOTA

When Minnesota residents think of their university, it is not so much the columned buildings, the broad lawns, or even students hurrying to class that come to mind. People in this state think of the "U" as a force for good in their lives—a collection of minds and hearts that has rescued failing farms, provided life-saving medical care and research, and given generations a chance to find their way in the world.

The university has been changing the face of Minnesota for more than 150 years, helping turn it into a vibrant, diverse, well-educated state, and the healthiest in the nation, according to the United Health Foundation. Along with its exciting, urban Twin Cities campus, the university has other locations serving distinct areas of the state.

The Morris, Crookston, and Duluth campuses shine in their own right. Morris is one of the country's best public liberal arts colleges; Crookston is a leader in technology education; and Duluth is an influential medical and large lake-related research institution. The University of Minnesota collaborative center in Rochester extends upper division undergraduate and post-baccalaureate degree programs to people in southeastern Minnesota. But the university, considered

The university's Academic Health Center improves lives in Minnesota and around the world by training health professionals, treating patients, and finding cures.

The university's Weisman Art Museum is home to more than 17,000 pieces and hosts a wide range of cultural activities.

one of the top five public universities in the country, had humble beginnings.

The 1851 charter establishing the University of Minnesota as a preparatory school specified a building site "at or near" the Mississippi's stunning St. Anthony Falls. The university's first permanent building, Old Main, was built in 1858. Six months after that structure opened, hard economic times following the Panic of 1857 and from the impending Civil War, forced the school to close. By 1864 Old Main had become a refuge for squatters. Turkeys were in one room, hay in another, and trespassers splitting wood had ruined the floor in the central hall.

John Sargent Pillsbury, a hardware merchant who was owed money by the university for material used in Old Main's construction, was ready to sue the school's regents to collect his debts. Instead, he became one of them and took on the mission of reviving the university and keeping it alive. He was elected state senator in 1863, and then governor in 1876.

Under Pillsbury's leadership, the regents freed the school from its burdensome debts through private donations (including Pillsbury's own), land sales, and skillful negotiations with creditors. In 1867 Pillsbury had the satisfaction of reporting to the legislature, "Gentlemen, the last claim against the university has been paid...the university's slate is clean."

In 1869 the school became an institution of higher education. William Watts Folwell was inaugurated as the first president of the university in December 1869. There were only nine faculty members and eighteen students that year.

Four years later at the first commencement, two students received bachelor of arts degrees. The first doctor of philosophy degree was awarded in 1888. The Duluth campus joined the university in 1947, the Morris campus opened in 1960, and the Crookston campus in 1966.

A Minnesota-style commitment to excellence and hard work turned the

More than 65,000 U of M students benefit from the expert faculty and unparalleled learning opportunities on campuses throughout the state.

university into an exceptional place, now known worldwide for the quality of its research and the distinction of its faculty. Among the university's many accomplishments is its standing as the world's leading kidney transplant center. Its health-related innovations, like the heart-lung machine and its use in the world's first successful open-heart surgery, the first heart pacemaker, and the development of the widely used Minnesota Multiphasic Personality Inventory (MMPI), have helped forge the school's reputation as a visionary institution, ready to push the edges of creativity. The University of Minnesota continues to be the state's leading educator of health professionals.

The school touches the lives of thousands of people every day. For example, more than 300 different university programs serve children and youth or assist other organizations that benefit young people. The University of Minnesota Extension Service, with a long tradition of contributions to the state, makes approximately 1 million contacts with Minnesota residents every year in areas ranging from crop management and gardening to nutrition and effective parenting.

The University of Minnesota also adds significantly to the region's artistic and cultural richness. Through art galleries, museums, concerts, theater productions, lectures, and films, the school showcases not only the time-honored works of artists in every creative field, but also the work of students—the next generation of artists—and the illustrious faculty who inspire them.

Aware that universities must contribute not only to the social, but also to the financial well-being of their states, the institution pays close attention to its role in Minnesota's economy. The U's alumni have founded 3,000 technology companies that add $30 billion to the state's annual economy. The school itself creates thirty-nine jobs for every $1 million spent on research. As tuition costs must rise, the university puts concerted effort into raising money for scholarships. The school's current President's Scholarship Match program doubles the impact of many endowed gifts of $25,000 or more.

The University of Minnesota prides itself on the quality of student life and the diversity it offers. Although about 70 percent of the U's more than 65,000 students are Minnesota residents, there

Set in the heart of the Twin Cities, the university is a vibrant cultural center.

are students and scholars from all fifty states and more than 110 countries. And nearly one-fifth of incoming freshmen at the Twin Cities campus in 2004 were students of color—African American, American Indian, Asian Pacific American, and Chicano/Latino. The University of Minnesota, Morris, once a Native American boarding school, has offered free tuition to Native students, according to a federal decree, since 1909.

Within the larger campus community at all university locations, smaller communities form around shared cultural heritage, ethnic and geographical backgrounds, values, and interests. These communities add up to a multicultural campus populaion that reflects the school's commitment to equal opportunity and access for all people. In a recent poll, 95 percent of students rated their satisfaction with the institution as high or very high after their first year.

With a happy and curious student body, a dedicated and ground-breaking faculty, and its home in a place of great geographical richness and beauty, one can see why Garrison Keillor called the University of Minnesota, "...one of the glories of the state."

The university is the state's only research institution, therefore it receives 98 percent of Minnesota's federally sponsored research grants.

A TIMELINE OF MINNESOTA HISTORY

1784–1802

Grand Portage, just south and west of the Minnesota/Ontario border, grew into a major trading center as fur traders and voyagers pushed deeper into the unexplored woods that would become northern Minnesota.

1819

War hero Josiah Snelling commanded the building of the fort at the junction of the Mississippi and Minnesota rivers. It was named after him in 1825.

1848–1849

Henry Sibley inspired settlers to build three towns so Congress would name that region a new territory. After separating from the Wisconsin Territory, the area was named Minnesota, meaning "cloudy water."

1851

The University of Minnesota was incorporated by the Territorial Legislature and opened as a preparatory school seven years later.

1858

Under the able leadership of Henry Sibley, the Minnesota was named the country's thirty-second state. Sibley was the first governor.

1861

Minnesota was the first state to offer troops to President Lincoln. Its First Minnesota Regiment served with distinction

For the American Indians and their ancestors, the tallgrass prairies of southwestern Minnesota were spiritual places. Between 3000 B.C. and A.D. 1750, archaeologists speculate that many tribes etched records, called petroglyphs, into the rocks. More than 2,000 of these etchings have been found. Courtesy, Minnesota Historical Society

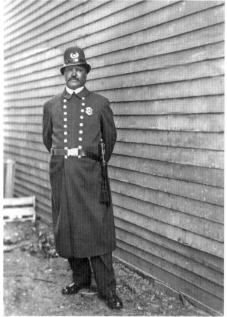

Whatever their circumstances, a steady stream of African American families found Minnesota to be the right place to build their futures. A few were slaves, brought to Fort Snelling by officers. But by the 1880s, African American physicians, teachers and lawyers were recruited to serve the growing population in the Twin Cities. By 1900, African Americans had established themselves throughout the economy. Shown is the first African American policeman in Saint Paul, thought to be James H. Burrell. Courtesy, Minnesota Historical Society. Location # HV9.11 r3, Negative # 46286

in fourteen major battles throughout the Civil War.

1873–1878

Although Minnesota had been the nation's breadbasket for the previous decade, farmers fought devastation by grasshoppers throughout the 1870s.

1878

A massive explosion at Minneapolis' Washburn "A" Mill, then the largest flour mill in the United States, killed eighteen workers—and the hopes of many farming families.

1883

The older of Dr. William Worrall Mayo's two sons, William J., joined his father's practice in Rochester and helped develop Saint Mary's Hospital (which eventually became the first in the Mayo Clinic complex).

1885

Realizing that the state needed educated people if it was going to prosper, the legislature passed a law that required all children between ages eight and sixteen to attend twelve weeks of school every year.

1886

In Redwood Falls, railroad freight agent Richard Sears bought a shipment of unclaimed watches and decided to sell them through the mail. This was the beginning of Sears, Roebuck and Company, whose catalog was a valuable asset in nearly every rural home

1887

The newly formed Department of Labor and Industry began to institute statewide laws regarding safe and healthful working conditions.

1889

Saint Mary's Hospital opened with twenty-seven beds.

1893

With the completion of the Great Northern Railroad, Minnesota was connected to the Pacific Ocean and open for Asian business.

1894

A hot, dry summer contributed to the explosive fire that readily burned through piles of logging slag and timber around the little town of Hinckley. In four hours the firestorm had destroyed six northern towns and blackened 400 square miles of land.

1895

A Minneapolis fireman hand-stitched the first softball, which was about the size of a grapefruit. By 1926 the game was being played around the country.

1902

With a $25,000 investment by Lucius Ordway, Minnesota Mining & Manufacturing Company (now 3M) was established as a struggling company in Two Harbors. It focused on manufacturing sandpaper.

1905

The state legislature set aside $15,000 to open a school to help train future farmers and homemakers.

1909

President Theodore Roosevelt designated more than 1 million acres in the northeast area of Minnesota as the Superior National Forest, which protected it from logging.

1910

International Falls and many other northern towns grew to become major paper milling focal points. The production of eighteen tons of newsprint was heralded as the first sign of the industry's growth.

1915

Farmers in North Dakota, angry about softening markets for their products,

introduced the Nonpartisan League, an ancestor of Minnesota's Democrat-Farmer-Labor Party.

1920
From one side of the state to the other, Minnesota's females banded together on behalf of women's suffrage. A garden at today's state capitol mall, called the Minnesota Woman Suffrage Memorial, commemorates twenty-five leaders who weathered the ridicule and eventually won equality for women.

1922
Mexicans came north for better lives and many stayed in the Twin Cities. In Saint Paul enough Mexican families had come together in a community that they formed the Anahuac Society, which provided a forum for solving community problems.

1925
In an attempt to promote tourism, the Northeastern Minnesota Civic and Commerce Association of Duluth selected "The Arrowhead" as the name for the northeastern part of the state.

1926
Northwest Airways took to the sky, carrying air mail from the Twin Cities to Chicago with a "fleet" of two rented, open-cockpit biplanes.

1927
Lumberman Thomas B. Walker brought a deep love of the arts to the Twin Cities. His art collection grew so large that he hired his own curator and opened his home to the public. The Walker Art Gallery was opened as the first public art gallery in the upper Midwest.

1927
It was the $25,000 prize that got Minnesotan Charles Lindbergh thinking about becoming the first person to fly between New York and Paris. With four sandwiches and 451 gallons of gas, he flew across the Atlantic and into history.

1929
Bronislav Nagurski or "Bronko," as he was called, became the University of Minnesota Gophers' football hero. He was named All-American for both his defensive tackle and offensive fullback performances.

1930
3M engineer Richard Drew was testing a sandpaper product when he got the idea for a stick-on tape that wouldn't damage any surface—the result was masking tape. But the big news was when his Scotch™ tape invention changed the

Saint Paul's District Energy plant is the largest hot water district heating system in North America. That plant plus a large, chilled water cooling system keeps downtown Saint Paul warm in the winter and cool in the summer. Remarkably, District Energy produces hot water, steam, or chilled water from clean, renewable wood waste. The plant has been operating as a nonprofit since 1983. Courtesy, District Energy, Saint Paul

way the world does a lot of things.

1934
In hopes of better working conditions and increased wages, 35,000 trade workers supported General Drivers Local 574 of the International Brotherhood of Teamsters in one of the nastiest and bloodiest strikes ever recorded. More than 200 people were injured and four people died as the battles between union workers and Minneapolis police, National Guard, and local militia raged.

1940
The November day was calm and clear, but within hours twenty-seven inches of snow had blasted itself into the record books. More than forty-nine Minnesotans and fifty-nine sailors on Lake Superior were killed in the surprise storm dubbed the Armistice Day Blizzard.

1941
With the advent of World War II, Iron Range mining swung into full production and many Minnesota factories were transformed into airplane and shipbuilding manufacturers. Cargill, then an international grain-shipping company, used its ship-building expertise on the Minnesota River near Savage to develop eighteen oil and gas carriers for the war effort.

1942
Honeywell introduced the electronic autopilot, an invention that proved to be essential to the Allied Forces during World War II.

The Guthrie Theater made national news when it opened—not only for its famous director, Sir Tyrone Guthrie, but for the power of its creative work. The Guthrie Theater opened in 1963. Courtesy, Minnesota Historical Society

1943

Governor Harold Stassen resigned four months into his third term in order to serve in the U.S. Navy.

1946

Sister Kenny, an Australian-born nurse, introduced treatments for polio. Some people thought they were radical, but most patients revered the ideas. With muscle education, some were able to regain limited use of their arms and legs. Today the Sister Kenny Institute continues the legacy of care for the disabled.

1950

Two Mayo Clinic doctors worked with a Swiss physician to develop cortisone, an important treatment for inflammation of joints and tendons. They were awarded a Nobel Prize for their efforts.

1950

St. Paul native Charles Schulz's *Lil' Folks* cartoon strip was changed to *Peanuts* and published in papers belonging to the United Features Syndicate. Through the years, *Peanuts* has appeared in more than 2,000 newspapers and translated into a number of languages.

1953

A small group of inventive and persistent pioneers established Engineering Research Associates (ERA) in a Saint Paul glider factory. Their job was to create a machine that would break enemy codes. Atlas II was delivered to the Armed Forces Security Agency, and with it came the age of computers.

Rochester has long been considered a cultural center and residents and foundations contributed the $8.2 million that was needed to build the city's celebrated Rochester Art Center. Arts education through workshops, lectures, and family programs constitute the core of the center's mission. Courtesy, Rochester Art Center

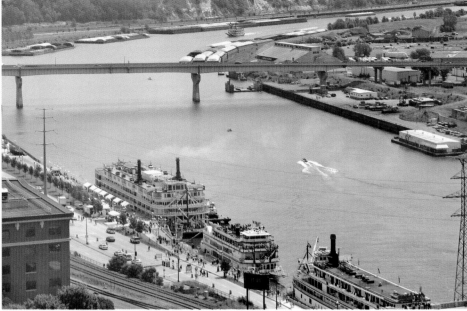

"Arriving here, as they did, a day before they were expected, the arrangements to receive them were not perfected..."so wrote Saint Paul's "Daily Pioneer" on Thursday, June 8th, 1854, reflecting the little town's embarrassment. The arrival of the country's ex-president, Millard Fillmore, and 1,200 other travelers who had enjoyed the trip up the Mississippi River from Rock Island, Illinois, was indeed a day early. One hundred fifty years later, Saint Paul more than made up for its mortification. The 2004 Grand Excursion was a combined effort of fifty Mississippi River communities, each welcoming the Grand Flotilla paddlewheel boats and their guests. The 1854 Grand Excursion celebrated the first connection of the railroad to the Mississippi River. Courtesy, Saint Paul Riverfront Corporation

1955

The Reserve Mining Company in Silver Bay began commercial production of taconite, a low grade iron ore which had been ignored when it was plentiful. The ability to mine taconite for the hungry steel factories around the world literally saved the iron ore industry for many years.

1956

With the growing population and rigorous climate of the Twin Cities, Southdale Mall (a ninety-five-acre, two-level, climate-controlled shopping center) was built to give growing families all the things they needed under one roof. Southdale was the first fully enclosed shopping center in the United States.

1958

Parades, banquets, commemorations, presentations, and parties were held throughout Minnesota in recognition of the state's centennial year.

1958

The land formerly called "Superior National Forest" in 1909 was renamed the Boundary Waters Canoe Area (BWCA).

1959

Four-hundred African American owned homes were torn down to build Interstate Highway 94.

1960

Minnesotans were joyful when Calvin Griffith moved his Washington Senators to Minnesota, bringing with them two batting stars, Harmon "the Killer" Killebrew and Bob Allison. In the first season at Met Stadium they lost ninety games and won seventy, but went on to win the American League Pennant four years later.

1961

Minnesota resident Bob Dylan, originally known as Robert Zimmerman, released his first album.

1963

Dayton's department store in Minneapolis opened its first animated holiday display. There have been changes in the store's ownership since then, but family passion for the displays has continued. More than half a million adults and children visit each holiday season.

1965

Two undercapitalized engineers chose a chicken coop to start Hutchinson Technology. Today the company is one of the world's leading manufacturers of disk drive suspension assemblies and is known for the high quality of its precision work.

1966

Best Buy was founded and sold audio components.

1968

The Twin Cities' pro-football team, the Vikings, won the NFC Central Division championship.

1969

Radio Talking Book was the first radio reading service in the United States, offering everything from newspapers to best sellers. Today 10,000 visually impaired people benefit from this closed circuit radio system.

As the iron ore industry grew, so did shipping and the need for navigational aids. Four years after a series of treacherous storms that took the lives of 116 seamen, construction of the Split Rock lighthouse began. Materials were hoisted up the 120-foot cliff to build the light itself and the keeper's house. The Split Rock lighthouse guided ships to safety between 1910 and 1969. Today a park and interpretative center helps visitors relive a time when reaching safe harbor on Lake Superior was a death-defying achievement. Courtesy, Minnesota Department of Tourism

1973

Minnesotan Justice Harry Blackmun, nominated for the U.S. Supreme Court by President Richard Nixon and confirmed by the Senate in 1971, wrote the lead opinion for Roe v. Wade which declared that state laws against abortion were unconstitutional.

1980

The Minnesota Public Radio variety show, *A Prairie Home Companion*, had grown so popular with Minnesotans, it was broadcast across the country, today reaching 4 million listeners through 558 public radio stations.

1983

The Minnesota AIDS Project (MAP) was founded by Bruce Brockway—the first Minnesotan to be diagnosed with AIDS.

1987

Minnesota Twins baseball fans waved the newly introduced "Homer Hankies" and cheered the team onto the World Series championship.

1990

As the Cold War ended, Soviet leader Mikhail Gorbachev looked to Minnesota's Control Data Corporation (now Ceridian Corporation) for computer capabilities. In celebration of the business they had done together, Gorbachev and his wife visited the state.

1996

Thermometers in northeastern Minnesota reflected the temperature to be an unprecedented 60 degrees below zero.

1997

Melting snow made the Red River flow

When an idea to bring people downtown to shop turned into a parade of lighted floats and storybook characters in 1992, that was the start of the Holidazzle holiday tradition. From Thanksgiving to Christmas, on every Friday night, Holidazzle works its musical, light resplendent magic down Minneapolis' Nicollet Mall. It takes thousands of volunteers to make Holidazzle an ongoing success. Some get to dance in storybook character costumes, others help collect food and checks for Food Shelves. Courtesy, Minneapolis Downtown Council

over the dikes, cresting twenty-six feet over flood stage. More than 60,000 people were driven from their homes and businesses in the twin towns of Grand Forks (North Dakota) and East Grand Forks (Minnesota).

2000

Professional hockey came back to Minnesota, after being gone for seven years. Called the Minnesota Wild, the team played its first game against the Anaheim Mighty Ducks in the new Xcel Energy Center.

2001

University of Minnesota alumni Roy Wilkins, NAACP leader for more than twenty years, was honored with a postage stamp bearing his likeness.

2003

The Children's Theater won the Regional Theatre Tony Award for its production of *A Year with Frog and Toad*.

2004

The scientific research world gained a new tool when IBM announced successful tests of its Blue Gene/L prototype supercomputer systems at its Rochester, Minnesota facility.

BIBLIOGRAPHY

Note: The following is a selective bibliography of sources used in this book. For further resource materials, contact your local reference librarian.

Agricultural Marketing Service. *Impact of the St. Lawrence Seaway on the Location of Grain Export Facilities.* Washington, D.C.: Government Printing Office, 1960.

"A Growing Problem." *Don Larson's Business Newlsetter.* (August 1, 1983):14-15.

Albertson, Don L. "Sister Kenny's Legacy." *Hennepin County History.* 37:1 (Spring, 1978):3-14.

Anderson, Antone. *The Hinckley Fire.* New York: Comet Press Books, 1954.

Anderson, Governor Wendell R. "Special Message - Restoring and Preserving Minnesota's Environment." Address to 67th Minnesota Legislature. St. Paul: April 1, 1971.

Andrist, Ralph K., ed. *The American Heritage History of the 20s and 30s.* New York: American Heritage Publications, 1970.

Appel, Livia, and Theodore C. Blegen. "Official Encouragement of Immigration to Minnesota in the Territorial Period." *Minnesota History Bulletin.* 5 (August 1923):167-203.

Appelbaum, Arlene. "Talented Entrepreneurs Help Minnesota Grow." *Minnesota Business* (August 1981) 32-37.

Atkins, Annette. *Harvest of Grief.* St. Paul, Minnesota: Minnesota Historical Society Press, 1984.

Auerbach, Laura K. *A Short History of Minnesota's Democratic-Farmer-Labor Party.* Minneapolis: Democratic-Farmer-Labor Party, 1966.

Baker, James H. "History of Transportation in Minnesota." *Minnesota Historical Society Collections* 9:1-34 (1901).

Bardon, Richard, and Grace Lee Nute. "A Winter in the St. Croix Valley, 1802-03." *Minnesota History* 28 (March, June, September 1947) 1-4, 142-59, 225-40.

Bell, Ida P. "A Pioneer Family of the Middle Border." *Minnesota History* 14 (September 1933) 303-66.

Benson, Thomas E. *Minnesota Resort Guide.* St. Paul: Itasca Press, 1972.

Bernstein, Irving. *Turbulent Years; A History of the American Worker: 1933-1941.* Boston: Houghton Mifflin Co., 1970.

Berthel, Mary W. *Horns of Thunder: The Life and Times of James M. Goodhue.* St. Paul: Minnesota Historical Society, 1948.

Blakeley, Russel. "History of the Discovery of the Mississippi River and the Advent of Commerce in Minnesota." *Minnesota Historical Collections* 8 (1898):375-418.

Blamer, Frank E. "The Farmer and Minnesota History." *Minnesota History* 7 (September 1926):199-217.

Blegen, Theodore C. *Building Minnesota.* New York: D.C. Heath and Company, 1938.

Blegen, Theodore C. *Grass Roots History.* Minneapolis: University of Minnesota Press, 1947. Reissued New York and London: Kennikat Press, 1969.

Blegen, Theodore C. *Minnesota: A History of the State.* Minneapolis: University of Minnesota Press, 1963. Reprinted with additional chapter, "A State That Works," by Russell W. Fridley. With additional readings.

Blegen, Theodore C., and Theodore L. Nydahl. *Minnesota History: A Guide to Reading and Study.* Minneapolis: University of Minnesota, 1960.

Boardman, Fox W., Jr. *The Thirties: America and the Great Depression.* New York: Henry Z. Walck, Inc., 1967.

Boese, Donald L. *John C. Greenway and the Opening of the Western Mesabi.* Grand Rapids, Minnesota: Joint Bovey-Coleraine Bicentennial Commission, 1975.

Borchert, John R. *A Look at Minnesota Industries.* St. Paul: Minnesota Education Association, 1954.

Borchert, John R. *Minnesota's Changing Geography.* Minneapolis: University of Minnesota Press, 1959.

Borchert, John R., and Donald P. Yaeger. *Atlas of Minnesota Resources and Settlement.* Rev. ed. St. Paul: Minnesota State Planning Agency, 1969.

Bowen, Dana Thomas. "Great Lakes Ships and Shipping." *Minnesota History* 34 (Spring 1954): 9-16.

Bridges, Leonard Hal. *Iron Millionaire: Life of Charlemagne Tower.* Philadelphia: University of Pennsylvania, 1952.

Buckman, Carol A. *Minnesota's Experimental City.* Pequot Lakes, Minnesota: Country Printing, Inc., 1973.

Buckman, Clarence B. "Lumbering and the Pine Forests." *Gopher Historian.* 13 (Spring 1959): 9-13.

Carley, Kenneth. *The Sioux Uprising of 1862.* St. Paul: Minnesota Historical Society, 1976.

Castle, Henry A. "General James Shields: Soldier, Orator, Statesman." *Minnesota Historical Collections.* 15 (1915):711-30.

Castle, Henry A. *Minnesota: Its Story and Biography.* Three volumes. Chicago and New York: The Lewis Publishing Company, 1915.

Chamberlain, John. *The Enterprising Americans: A Business History of*

the United States. New York: Harper & Row, 1961.

Chamberlin, Thomas W. "The Railroads of Minnesota." *Gopher Historian.* 11 (Spring 1957):21-22.

Colwell, James L. "From Stone to Steel: American Contributions to the Revolution in Flour Milling." *Rocky Mountain Social Science Journal* 6:2 (October 1969):20-31.

Control Data Corporation. *Chronology of Key Events in Control Data's History.* Bloomington, Minnesota: Control Data Corporation, 1985.

Cross, Marion E. *From Land, Sea and Test Tube. The Story of Archer-Daniels-Midland Company.* Minneapolis: Archer-Daniels-Midland, 1954.

Cross, Marion E. *Pioneer Harvest.* Minneapolis: Lund Press, 1949.

Davis, E.W. *Pioneering with Taconite.* St. Paul: Minnesota Historical Society, 1964.

Davis, Lee Niedringhaus. *The Corporate Alchemists.* New York: William Morrow and Company, Inc. 1984.

DeKruif, Paul. *Seven Iron Men.* New York: Harcourt, Brace, 1929.

Derleth, August. *Milwaukee Road: Its First Hundred Years.* New York: Creative Age Press, 1948.

Dobbs, Farrell. *Teamster Rebellion.* New York: Monad Press, 1972.

Donovan, Frank P. *The First Through A Century: A History of the First National Bank of St. Paul.* St. Paul: Itasca Press: Webb Publishing Company, 1954.

Dougherty, Richard. *In Quest of Quality: Hormel's First Seventy-five Years.* St. Paul: North Central Publishing Company, 1966.

Downward, William L. *Dictionary of the History of the American Brewing and Distilling Industries.* Westport, Connecticut: Greenwood Press, 1980.

Drache, Hiram M. *The Day of the Bonanza: A History of Bonanza Farming in the Red River Valley of the North.* Fargo, North Dakota: North Dakota Institute for Regional Studies, 1964.

Draheim, Kirk P. *Technological Industry in the Upper Midwest.* Minneapolis: University of Minnesota Upper Midwest Economic Study, 1964.

Drenning, June. *Selections from Minnesota History: A Fiftieth Anniversary Anthology.* St. Paul: Minnesota Historical Society, 1979.

Dunn, James Taylor. *The St. Croix: Midwest Border River.* New York: Holt, Rinehart & Winston, 1965.

Eliason, Adolph O. "The Beginning of Banking in Minnesota." *Minnesota Historical Collections.* 12 (December 1908):671-690.

"EMS Systems Transmits, Records EKGs Without Loss of Fidelity." *Minnesota Scientific Journal.* (November 1961):22.

Engberg, George B. "The Knights of Labor in Minnesota." *Minnesota History.* (December 1940):372-94.

Engh, Jeri. *Hamm's: The Story of 100 Years in the Land of Sky Blue Water.* St. Paul: Theo Hamm Brewing Company, 1965.

Evans, Henry Oliver. *Iron Pioneer: Henry W. Oliver, 1840-1904.* New York: E.P. Dutton & Co., Inc., 1942.

Federal Reserve Bank, Minneapolis. *Reflections from History: First Half Century of Minneapolis Federal Reserve Bank.* Minneapolis: Minneapolis Federal Reserve Bank, 1964.

Filipetti, George, and Roland S. Vaile. *The Economic Effects of the NRA: A Regional Analysis.* Minneapolis: University of Minnesota Press, 1935.

Firestone, Harvey S. *Man on the Move: The Story of Transportation.* New York: G.P. Putnam's Sons, 1967.

First Bank Systems: The First Fifty Years. Minneapolis: First Banks, 1979.

Fitzharris, Joseph C. *Minnesota Agricultural Growth, 1880-1970.* Minneapolis: Minnesota Institute of Agriculture, 1976.

Folwell, William Watts. *A History of Minnesota.* Four volumes. St. Paul: Minnesota Historical Society, 1921-1939. Corrected editions, 1965-1969.

Frame, Robert M., III. *Millers to the World: Minnesota's Nineteenth Century Water Power Flour Mills.* St. Paul: Minnesota Historical Society, 1977.

Furness, Marion Ramsey. "Governor Ramsey and Frontier Minnesota: Impressions from His Diary and Letters." *Minnesota History* 28 (December 1948):309-28

Gadler, Steve J. *Environmental Compatibility - A Perspective.* Minnesota Pollution Control Agency. Minneapolis: University of Minnesota, 1971.

Galvin, Kevin. "The Necessities of Life Available Early on the Frontier." *Ramsey County History* 11:2; 8-14.

Gates, Charles M. *Five Fur Traders of the Northwest.* Minneapolis: University of Minnesota Press, 1933.

General Mills. *A Collected History.* Minneapolis: General Mills, Inc., 1978.

Gilfillan, Charles D. "The Early Political History of Minnesota." *Minnesota Historical Collections* 9 (1901): 167-74.

Gilman, Rhoda R. "The Fur trade in the Upper Mississippi Valley, 1630-1850." *Wisconsin Magazine of History* 58 (Autumn, 1974): 2-18.

Gilman, Rhoda R., Carolyn Gilman, and Deborah M. Stultz. *The Red River Trails: Oxcart Routes Between St. Paul and the Selkirk Settlement, 1820-1870.* St. Paul: Minnesota Historical Society, 1979.

Goldberg, Ray A. *The Soybean Industry.* Minneapolis: University of Minnesota Press, 1952.

Goldston, Robert. *The Great Depression - The United States in the Thirties.* New York: Bobbs-Merrill Co., Inc., 1968.

Gove, Gertrude. "St. Cloud Editor and Abolitionist—Jane Grey Swisshelm." *Gopher Historian* 12:25 (Winter 1957-58).

Gray, James. *Business Without Boundary: The Story of General Mills.* Minneapolis: University of Minnesota Press, 1954.

Gray, James. *Our First Century: The Story of General Trading Company, Serving Transportation's Needs Since the Days of the Oxcart.* St. Paul: General Trading Company, 1955.

Greenleaf, William, ed. *American Economic Development Since 1860.* 2nd ed., Columbia, South Carolina: University of South Carolina Press, 1968.

Groner, Alex. *The History of American Business and Industry.* New York: American Heritage Publishing Co., 1972.

Haaverson, Judy. *All Together Now, Happy Centennial.* Minneapolis: Honeywell, Inc., January 1985.

Hage, George S. *Newspapers on the Minnesota Frontier, 1849-1860.* St. Paul: Minnesota Historical Society, 1967.

Hamel, Betty Jones. *Minneapolis: Frontiers, Firsts and Futures.* Minneapolis: '76 Bicentennial Commission, 1976.

Hanft, Robert M. *Red River: Paul Bunyan's Own Lumber Company.* Chico, California: California State University Center for Business and Economic Research, 1980.

Hartsough, Mildred L. *Development of the Twin Cities as Metropolitan Market.* Minneapolis: University of Minnesota Press, 1925.

Heilbron, Bertha L. *The Thirty-Second State: A Pictorial History of Minnesota.* St. Paul: Minnesota Historical Society, 1966.

Hendrickson, Robert. *The Grand Emporiums: The Illustrated History of America's Great Department Stores.* New York: Stein and Day, 1972.

Hicks, John D. "The Origin and Early History of the Farmers' Alliance in Minnesota." *Mississippi Valley Historical Review* 8 (June-September 1921): 92-132.

Hidy, Ralph W., et al. *Timber and Men: The Weyerhaeuser Story.* New York: Macmillan, 1963.

"History of Banking in Minnesota." *Commercial West* 77:24 (June 10, 1939):19-27.

"History of the Great Northern Ore Properties." *Skillings Mining Review.* Duluth, Minnesota, 33:48 (1964):11-28.

History of Winona County. Chicago, Illinois: H.H. Hill and Company, 1883.

Holbrook, Stewart H. *James J. Hill, A Great Life in Brief.* New York: Knopf, 1955.

Holcombe, Return I. *Minnesota in Three Centuries: 1655-1908.* New York: Semicentennial Publishing Society of Minnesota, 1908.

Holmquist, June D. "Minnesota's Waterways." *Gopher Historian.* 10:1-2 (Spring 1956).

"How Glaciers Shaped the Land in East Central Minnesota." *Gopher Historian.* 13:3-5 (Spring 1959).

Huck, Virginia. *Brand of the Tartan: The 3M Story.* New York: Appleton Century Croft, 1955.

Huck, Virginia. *Franklin and Harriet: The Crosby Family.* Minneapolis: Crosby Co., 1980.

Jarchow, Merrill E. *The Earth Brought Forth: A History of Minnesota Agriculture.* St. Paul: Minnesota Historical Society, 1949.

Johnson, H. Nat. *Minnesota Panorama, Saga of the North Star Empire.* Minneapolis: T.S. Denison, 1957.

Jones, Evan. *The Minnesota: Forgotten River.* (Rivers of America Series) New York: Farrar & Rinehart, 1937.

Jorstad, Erling. "Personal Politics in the Origin of Minnesota's Democratic Party." *Minnesota History.* 35 (September 1959): 259-71.

Kane, Lucile M. "Isaac Staples, Pioneer Lumberman." *Gopher Historian.* 7 (January 1953): 7-9.

Kane, Lucile M. *The Waterfall That Built A City: The Falls of St. Anthony.* St. Paul: Minnesota Historical Society, 1966.

Karlen, Arno, ed. *Superior: Portrait of a Living Lake.* New York, Evanston and London: Harper, 1970.

Karlstad State Bank. *Golden Anniversary 1925-1975.* Karlstad: 1975.

Kelley, John L. "Present Situation of the U.S. Iron Ore Industry." *Skillings Mining Review* December 7, 1985.

King, Franklin Alexander. *The Missabe Road.* San Marino, California: Golden West Books, 1972.

Kohlmeyer, Frederick W. *Timber Roots: The Laird Norton Story, 1855-1905.* Winona, Minnesota: Winona County Historical Society, 1972.

Kunz, Virgina B. *Muskets to Missiles: A Military History of Minnesota.* St. Paul: Minnesota State Centennial Commission, 1958.

Larsen, Arthur J., ed. *Crusader and Feminist: Letters of Jane Grey Swisshelm.* St. Paul: Minnesota Historical Society, 1934.

Larsen, Arthur J. "Early Transportation." *Minnesota History* 14 (June 1933):149-155.

Larson, Agnes M. *History of the White Pine Industry in Minnesota.* Minneapolis: University of Minnesota Press, 1949.

Larson, Don W. *Land of the Giants: A History of Minnesota Business.* Minneapolis: Dorn Books, 1979.

Lebedoff, David. *The 21st Ballot: A Political Party Struggle in Minnesota.* Minneapolis: University of Minnesota Press, 1969.

Leschak, Pam Cope. "Joe Samargia - Iron Range organizer." *Corporate Report* December 1979: 54-57, 92-95.

"The Life of the Voyageur." *Gopher Historian* 11 (Winter, 1956-57): 10-13.

"Living in Minnesota Territory." *Roots* 3:1 (Fall 1974).

Loehr, Rodney C. "Franklin Steele, Frontier Businessman." *Minnesota History* 27 (December 1946): 309-318.

"Louis Hennepin, The Franciscan." *Minnesota Historical Collections* 1 (1902):247-56.

Lukaszewski, Jim. "Business Takes the Initiative in 1980." *Minnesota Business* June 1980.

Lydecker, Ryck. *Duluth: Sketches of the Past.* Edited by Lawrence J. Sommer. Duluth: American Revolution Bicentennial Commission - Northprint Company, 1976.

Lyman, Clara C. "The World and Minnesota in 1849." *Minnesota History* 30 (September 1949):185-201.

Lyman, George D. *John Marsh, Pioneer.* New York: C. Scribner's Sons, 1930.

Manfred, Fredrick. *The WPA Guide to Minnesota: Compiled and Written by the Federal Writers' Project of the Works Progress Administration.* Reprinted. St. Paul: Minnesota Historical Society Press, 1985.

Marquand, Robert E. *Minnesota Agriculture - Prices.* Minnesota Department of Agriculture. St. Paul, Minnesota: 1959.

Matz, Samuel A. *Cereal Technology.* Westport, Connecticut: AVI Publishing Co., Inc., 1970.

Mayer, George H. *Political Career of Floyd B. Olson.* Minneapolis: University of Minnesota Press, 1951.

Mayo, Charles W. *Mayo: The Story of My Family and My Career.* New York: Doubleday and Company, Inc., 1968.

Mayo Clinic, Rochester. *Physicians of the Mayo Clinic and the Mayo Foundation.* Minneapolis: University of Minnesota Press, 1937.

Medtronic, Inc. *Toward Man's Full*

Life. Minneapolis: Medtronic, Inc., 1986.

Meyer, Roy W. "The Story of Forest Mills, A Midwest Milling Community." *Minnesota History* 35 (March 1946):11-12.

Mier, Peg. *Bring Warm Clothes: Letters and Photos from Minnesota's Past.* Minneapolis: Minneapolis Star and Tribune, 1984.

Miller, Curtis. *A Summary of Minnesota Labor's First One Hundred Years.* Minneapolis: University of Minnesota Industrial Relations Center, 1960.

Mills, Stephen E. *A Pictorial History of Northwest Airlines.* First published as *More than Meets the Sky.* Seattle: Superior Publishing Co., 1972, New York: Bonanza Books, 1980.

"Miniature Hearing Device Finds New Markets." *Minnesota Scientific Journal* (November 1961).

Minneapolis Moline Power Implement Company. *Special Regulations for Women Production Workers at the Hopkins Plant of the Minneapolis Moline Power Implement Company.* Minneapolis, 1940.

Minneapolis Star and Tribune Research Department. *Retail Revolution - 1955-1965.* Minneapolis: Minneapolis Star and Tribune, 1966.

"Minnesota Association of Commerce and Industry." *Minnesota Business Journal* (May 1979):18-20.

Minnesota Business Partnership, Inc. *The Minnesota Economy, How Does It Compare?* Minneapolis: 1980.

Minnesota Chambers of Commerce. *Anatomy of a Business Climate.* St. Paul, Minnesota: 1961.

Minnesota Department of Agriculture. *Inside Agriculture.* Minnesota: Department of Agriculture, 1961.

Minnesota Department of Economic Development. *Medicine in Minnesota: Focus on Life Sciences.* St. Paul: Minnesota Department of Economic Development, 1973.

Minnesota Department of Economic Development. *Minnesota Success Stories.* St. Paul, 1980.

Minnesota Department of Economic Development. *A Review of the Economic Impact of the Iron Mining Industry on the Minnesota Economy.* Duluth, Minnesota: 1970.

Minnesota Department of Natural Resources. *Forestry in Minnesota.* Division of Lands and Forestry.St. Paul, 1971.

Minnesota Department of Natural Resources. *Minnesota Resource Potentials in Outdoor Recreation.* St. Paul: Bureau of Planning, 1971.

Minnesota Economic Data, Counties and Regions. "Urbanization." University of Minnesota, No. 15, November 1969.

Minnesota Economic Date, Counties and Regions. "Wholesale and Retail Trade." University of Minnesota, No. 6, August 1967.

Minnesota Energy Policy Task Force. *Final Report and Recommendations.* Environmental Quality Council, St. Paul: 1973.

"Minnesota Firms Go International." *Minnesota Business* (November 1979) 16-19.

Minnesota Mining & Manufacturing Company. *Our Story So Far: Notes from the First Seventy-five Years, 1903-1978.* Privately published, 1978.

Minnesota Resources Commission. *Guide Book to Minnesota Industry: A Directory of Minnesota Manufacturers.* St. Paul, Minnesota: Minnesota Resources Commission, 1946.

"Minnesota: Restoring the Entrepreneurial Explosion." *Minnesota Business* (November 1980).

Minnesota State Department of Business Development. *Minnesota Welcomes New Industry.* St. Paul: 1956.

Minnesota State Planning Agency. *Iron Ore and Concentrates - Minnesota Waterborne Transportation.* Minneapolis: Minnesota State Planning Agency, 1969.

Minnesota State Planning Board. *Report of the Committee on Land Tenure and Farm Debt Structure in Minnesota.* St. Paul: Minnesota State Planning Board, 1937.

Minnesota Territorial Pioneers. *Pioneer Chronicles.* Minneapolis: Territorial Pioneers, 1976.

Minnesota Timber Producers Association. *Logging Today is Different: An Historical Review of the Minnesota Timber Producers Association.* Duluth, 1969.

Minnesota Travel and Recreation Guide. Rockford, Illinois: Rockford Map Publishers, Inc., 1984.

Morgan, Dan. *Merchants of Grain.* New York: Viking Press, 1979.

Morison, Bradley L. *Sunlight on Your Doorstep: The Minneapolis Tribune's First One Hundred Years, 1867-1967.* Minneapolis: Ross & Haines, 1966.

Morris, Lucy Leavenworth Wilder. *Old Rail Fence Corners: Frontier Tales Told by Minnesota Pioneers.* St. Paul: Minnesota Historical Society, 1976.

Neill, Edward D. *History of Minnesota.* Philadelphia: J.B. Lippincott & Co., 1858.

Neill, Edward D. "Occurrences in and around Fort Snelling, from 1819 to 1840s." *Minnesota Historical Collections* 2 (1889):102-42.

Nelson, Lowry. *A Century of Population Growth in Minnesota.* Minneapolis: University of Minnesota Press, 1954.

Nelson, Lowry. *The Minnesota Community: Country and Town in Transition.* Minneapolis: University of Minnesota Press, 1960.

Northern States Power Company. *Forever Yours.* Minneapolis: Northern State Powers, 1971.

Northern States Power Company. *Minnesota's Case for the Electronics Industry.* Minneapolis: 1959.

Northwestern National Bank of Minneapolis. *Minnesota's Electronics and Related Science Industries.* Minneapolis, Minnesota: 1968.

Northwestern National Bank of Minneapolis. *One Hundred Years of Service - 1872-1972.* Minneapolis: 1972.

Nute, Grace Lee. "By Minnesota Waters." *Minnesota Heritage* ed. Lawrence M. Brings. Minneapolis: T.S. Denison, 1960.

O'Brien, Kathleen Ann, and Sheila C. Robertson. *A Social History of Women: Linda James Bennett.* Minnesota: Women Historians of the Midwest, 1981.

Ojakangas, Richard W. and Charles L. Matsch. *Minnesota Geology.* Drawings, charts and graphics by Dan Beedy. Minneapolis: University of Minnesota Press, 1982.

Olson, Russell L. *Electric Railways of Minnesota.* Hopkins: Minnesota Transportation Museum, 1976.

Parkinson, C. Northcote. *Big Business.* Boston: Little, Brown and Company, 1974.

Peterson, Harold F. "Early Minnesota Railroads and the Quest for Settlers." *Minnesota History* 13 (March 1932):25-44.

Pfleider, Eugene P. *Minnesota's Iron Ore Future.* Duluth, Minnesota: Northeastern Minnesota Development Association, 1966.

Photiadis, John D. *Population of Minnesota: 1950-1960.* Minnesota: Agricultural Experiment Station, University of Minnesota, 1963.

Pine, Carol. *Northern States People: The Past 70 Years.* Minneapolis: North Central Publishing, 1979.

Pine, Carol. *Ticker Tape Tales: Piper, Jaffray and Hopwood 1895-1985.* Minneapolis: Piper, Jaffray and Hopwood, Inc., 1986.

Poatgieter, Herminia A. and James Taylor Dunn, eds. *Gopher Reader II: Minnesota's Story in Words and Pictures - Selections from the Gopher Historian.* St. Paul: Minnesota Historical Society, 1975.

"The Political Career of Ignatius Donnelly." *Mississippi Valley Historical Review* 8 (June-September 1921):92-132.

Posey, C.J. "The Influence of Geographic Features in the Development of Minnesota." *Minnesota History* 2 (August 1918).

Powell, William J. *Pillsbury's Best. A Company History From 1869.* Minneapolis: Pillsbury Company, 1985.

Price, Hugh Bruce. *Farmers Cooperation in Minnesota, 1917-1922.* St. Paul: University Farm, 1923.

Prosser, Richard S. *Rails to the North Star.* Minneapolis: Dillon Press, 1966.

Prucha, Francis Paul. "Minnesota 100 Years Ago, as Seen by Laurence Oliphant." *Minnesota History* 34 (Summer 1954):45-53.

Renz, Louis T. *History of the Northern Pacific Railroad.* Fairfield, Washington: Galleon Press, 1980.

Richards, Eva L.A. "Pioneers in Iron Land." *Minnesota History* 32 (September 1951):147-154.

Rippey, James C. *Goodbye, Central: Hello, World: A Centennial History of Northwestern Bell.* Omaha: Northwestern Bell, 1975.

Robinson, Edward Van Dyke. "Early Economic Conditions and the Development of Agriculture in Minnesota." *Minnesota History* 1915.

Roe, Herman. "The Frontier Press of Minnesota." *Minnesota History* 14 (December 1933):393-410.

Ryan, Ann. "Duluth and Superior: Doing the Impossible." *Corporate Report.* (April 1977) 38-41, 70-75.

Saby, Rasmus S. "Railroad Regulations in Minnesota, 1849-1875 " *Minnesota Historical Collections* 15 (1915):70-85, 120-151.

Sandvik, Glenn N. *Duluth: An Illustrated History.* Woodland Hills, California: Windsor Publications, 1983.

Sarjeant, Charles F., ed. *The First Forty: The Story of WCCO Radio (1924-1964).* Minneapolis: T.S. Denison for WCCO Radio, 1964.

Schlesinger, Arthur M. *The Coming of the New Deal.* Boston: Houghton Mifflin Company, 1958.

Schroeder, Leslie L. "Minnesota in the World of Aviation - Fifty Years of Flight." *Minnesota History.*

Schwartz, George M. "The History Behind Our Iron Ranges." Gopher Historian 6 (April 1952):1-13.

Schwartz, George M., and Thiel, George A. *Minnesota's Rocks and Waters: A Geological Story.* Rev. ed., Minneapolis: University of Minnesota Press, 1963.

Scott, Earl P. *The Growth of Minority Business in the Twin Cities Metropolitan Area, 1969-1975.* Minneapolis: Center for Urban and Regional Affairs (CURA), University of Minnesota, 1976.

Severson, Harold. *The Night They Turned On the Lights: The Story of the Electric power Revolution in the North Star State.* Privately published, 1962.

Severson, Harold. *Rochester: Mecca for Millions.* Rochester, Minnesota: Marquette Bank and Trust Co., 1979.

Shippee, Lester B. "Social and Economic Effects of the Civil War with Special Reference to Minnesota." *Minnesota History Bulletin* 2 (May 1918):404-409.

Shortridge, Wilson P. "The Transition of a Typical Frontier." *Gopher Historian* 12 (Fall 1957): 1-27.

Sister Elizabeth Kenny Foundation. *The Story of the Sister Elizabeth Kenny Foundation in the Fight Against Polio.* Minneapolis: Sister Elizabeth Kenny Foundation, 1950.

Skillings, David N. "U.S. Iron Ore Industry Continuing to operate at 50 Million Ton Production Level in 1985." *Skillings Mining Review* (July 27, 1985).

Smolen, Joseph S. *Organized Labor in Minnesota: A Brief History.* Minneapolis: University of Minnesota, Industrial Relations Center, 1964.

Smythe, Ted C. "The Birth of Twin Cities' Commercial Radio." *Minnesota History* 41 (Fall 1969):327-334.

Spalding, William W. "Early Days in Duluth." *Michigan Pioneer and Historical Society Historical Collections* 29 (1901):677-697.

Stevens, John H. *Personal Recollections of Minnesota and Its People, and Early History of Minneapolis.* Minneapolis: Privately published, 1890.

Stevens, Wayne E. "The Fur Trade in Minnesota during the British Regime." *Minnesota History Bulletin* 5 (February 1923):3-13.

Stewart, William J. "Settler, Politician and Speculator in the Sale of the Sioux Reserve." *Minnesota History* 39 (Fall 1964):85-92.

Sturm, Arthur C. "What Labor Wants in Minnesota." *Corporate Report.* (July 1975): 28-31.

Swanholm, Marx. *Alexander Ramsey and the Politics of Survival.* St. Paul: Minnesota Historical Society, 1977.

Swanholm, Marx. *Lumbering in the Last of the White Pine States.* Minnesota Historic Sites Pamphlet Series 17. St. Paul: Minnesota Historical Society, 1978.

Swanson, William. "The Spirit of '76." *Corporate Report.* (September 1975): 20-24.

Swenson, Harold. *Rochester: Mecca for Millions.* Rochester, Minnesota: Marquette Bank and Trust Company, 1979.

Ten Thousand Lakes Association of Minnesota. "Making Money for the State." *Western Magazine* 17:1 (1921).

Uphoff, Mary Jo and Walter. *Group Health - An American Success Story in Prepaid Health Care.* Minneapolis: Dillon Press, 1980.

Upman, Warren. "Groseilliers and Radisson, the First White Men in Minnesota." *Minnesota Historical Collections* 10:2 (1905):449-594.

Van Dusen, Larry. *Duluth-Superior: World's Largest Inland Port.* Au Train, Michigan: Avery Color Studios, 1977.

Wahlberg, Hazel. *The North Land.* Roseau, Minnesota: Roseau Historical Society, 1975.

Walker, David A. *Iron Frontier: The Discovery and Early Development of Minnesota's Three Ranges.* St. Paul: Minnesota Historical Society, 1979.

Walker, Platt B. *Sketches of the Life of Hon. T.B. Walker: A Compilation of Biographical Sketches by Many Authors.* Minneapolis: Lumberman Publishing Company, 1907.

Wohl, Stanley. *The Medical Industrial Complex.* New York: Harmony Books, 1984.

WPA Papers. *Works Project Administration: Writers Project.* Minnesota Papers, 1849-1942. Housed at the Minnesota Historical Society, St. Paul.

Youngdale, James M. "The Frontier Economic Boom and Intellectual Bust." *American Studies in Scandinavia* 8 (1976):1-16.

Ziegler, (William H.) Co. *Developing with Minnesota, 1914-1954.* Minneapolis, 1954.

Web Sites:

Business Web sites:
www.andersenwindows.com
www.bestbuy.com
www.bettycrocker.com
www.bixbyenergy.com
www.carlson.com
www.cargill.com
www.cargilldow.com
www.chsinc.com
www.cirrusdesign.com
www.crystalsugar.com
www.cymbet.com
www.DaviscoFoods.com
www.districtenergy.com
www.donaldson.com
www.easystand.com
www.ecolab.com
www.fairviewtransplant.org
www.faribaultfoods.com
www.generalmills.com
www.gentletransitions.com
www.guidant.com
www.htch.com
www.heatilator.com
www.honeywell.com
www.hormel.com

www.ibm.com
www.jennieoturkeystore.com
www.landolakesinc.com
www.larex.com
www.fields.com
www.mallofamerica.com
www.medtronic.com
www.mntwins.com
www.mspairport.com
www.mnwire.com
www.mtzcorp.com
www.naturalspaces.com
www.nwa.com
www.nwdna.com
www.piragis.com
www.restoremedical.com
www.riverfrontcorporation.com
www.schwans.com
www.schellbrewery.com
www.2ndwindexercise.com
www.selectcomfort.com
www.spam.com
www.starkey.com
www.target.com
www.tastefullysimple.com
www.thermoking.com
www.3m.com
www.vasclip.com
www.velocimed.com
www.visitams.com
www.vitalimages.com
www.welchvillage.com
www.wenonah.com
www.wild.com
www.xcelenergy.com

Special to Minnesota:
www.agriculture.com
www.arboretum.umn.edu
www.auri.org
www.bio.org
www.bizjournals.com
www.blandinfoundation.org
www.bvskiarea.com
www.businessnorth.com
www.cbi.umn.edu
www.cbs.umn.edu
www.childrenstheatre.org
www.cimananotech.com
www.deed.state.mn.us
www.des.state.mn.us
www.dnr.state.mn.us
www.doli.state.mn.us
www.downtownmpls.com
www.duluthport.com
http://events.mnhs.org/bookofdays
http://events.mnhs.org/timepieces
www.exploreminnesota.com
www.extension.umn.edu

www.fairviewtransplant.org
www.foodrecyclers.com
www.grandcasinos.mn.com
www.grandexcursion.com
www.gunflint-trail.com
www.guthrietheater.org
www.hamline.edu
www.hjemkomst-center.com
www.holidazzle.com
www.ironworld.com
www.ironrangeresources.org
www.lwvmn.org
www.mayoclinic.org
www.mayoresearch.mayo.edu/mayo
www.mbbnet.umn.edu
www.mcknight.org
www.medicalalley.org
www.metrocouncil.org
www.maes.umn.edu
www.metrocouncil.org
www.me3.org
www.mhta.org
www.midwestdairy.com
www.millcitymuseum.org
www.minnesotabusiness.com
www.minnesotafinlandia.com
www.MinneapolisFoundation.org
www.minnesotapublicradio.org
www.minnesota-resorts.com
www.minnstats.org
www.minnesotastatetechnology.org
www.minnesotatechnology.org
www.mnbio.org
www.mnhs.org
www.mnimpacts.umn.edu
www.mnindiangaming.com
www.mnsoybeans.org
www.mnsu.edu
www.mnwfc.org
www.mplib.org
www.mtn.org
www.nano.umn.edu
www.netstate.com
www.neweconomyindex.org
www.newhopeforparkinsons.com
http://news.minnesota.publicradio.org
www.nflhistorygide.com
www.northharvestbean.org
www.nps.gov
www.rochesterartcenter.org
www.pca.state.mn.us
www.research.ibm.com
www.ruralpolicyforum.org
www.saintcroixriver.com
www.sctimes.com
www.shgresources.com
www.soils.agri.umn.edu
www.sos.state.mn.us
www.spiritconnectionstore.com
www.sppa.com/economy

INDEX

GENERAL INDEX
Italicized numbers indicate illustrations